Rematriating Justice

Honouring the Lives of Our Indigenous Sisters

Edited by Jennifer Brant and
D. Memee Lavell-Harvard

Rematriating Justice
Honouring the Lives of Our Indigenous Sisters
Edited by Jennifer Brant and D. Memee Lavell-Harvard.

Copyright © 2024 Demeter Press

Individual copyright to their work is retained by the authors. All rights reserved. No part of this book may be reproduced or transmitted in any form by any means without permission in writing from the publisher.

Demeter Press
PO Box 197
Coe Hill, Ontario
Canada
K0L 1P0
Tel: 289-383-0134
Email: info@demeterpress.org
Website: www.demeterpress.org

Demeter Press logo based on the sculpture "Demeter" by Maria-Luise Bodirsky
www.keramik-atelier.bodirsky.de

Printed and Bound in Canada

Cover image: Leona Grandmond Skye
Cover design and typesetting: Michelle Pirovich
Proof reading: Jena Woodhouse

Library and Archives Canada Cataloguing in Publication
Title: Rematriating Justice: Honouring the Lives of Our Indigenous Sisters / Edited by Jennifer Brant and D. Memee Lavell-Harvard.
Names: Brant, Jennifer, 1981- editor. | Lavell-Harvard, D. Memee (Dawn Memee), 1974- editor.
Description: Includes bibliographical references.
Identifiers: Canadiana 20240383850 | ISBN 9781772585032 (softcover)
Subjects: LCSH: Indigenous women—Violence against—Canada. | LCSH: Indigenous women—Crimes against—Canada. | LCSH: Indigenous women—Violence against—Canada—Prevention. | LCSH: Indigenous women—Crimes against—Canada—Prevention. | LCSH: Missing persons—Canada. | LCSH: Murder victims—Canada. | LCSH: Social justice—Canada.
Classification: LCC HV6250.4.W65 R46 2024 | DDC 362.88082/0971—dc23

 The publisher gratefully acknowledges the support of the Government of Canada

This book is dedicated to all our stolen sisters who have been taken from us far too soon. We carry you in our hearts, and you will never be forgotten. To the families and children who have lost a loved one and struggle to carry on, we walk by your side and will continue to do this work to bring awareness, action, and change. With this work, we stand with you to bring honour and respect to the beautiful spirits of our women and girls who will be forever loved.

Acknowledgements

Saying "thank you" cannot convey the depth of gratitude to all those who made this collection possible. Many thanks go to Demeter Press and Andrea O'Reilly for having the vision, faith, and fortitude to see this project through to fruition.

Thank you to the mothers, grandmothers, aunties, sisters, and daughters who are leading the struggle and to all the relatives and kin who are on this journey upholding the safety of our Indigenous sisters and keeping the memories alive of those who were taken too soon. Whether you are leading the vigils or walking the streets after dark searching for yet another missing sister, you are strength and optimism personified, and you are our inspiration.

Thank you to the authors who put into words a reality that cannot be imagined unless you have experienced it firsthand, as this is the story of every parent's and relative's worst fear.

Thank you to the Elders, those grandmothers who guide us in our work, every day in every way, to make sure we are walking with good hearts and good minds. We thank you for your guidance, prayers, and wisdom. You have kept us on the right path and lifted us when we thought we could go no further.

Thank you to our mothers, our chosen families and to our community grandmothers and aunties. You taught us what it meant to be Indigenous women—to be strong, resilient, and proud of who we are and to never give up hope even when things seem truly hopeless.

Thank you to Leona Grandmond Skye for the beautiful cover art adorning this book, your gifts, and your relentless vision. Thank you to Jo Billows for helping us move this book to production. Thank you to

Maria Campbell and Kim Anderson for your guidance and words of wisdom during our virtual tea.

Thank you to those who have been writing, advocating, and pushing for justice over the years.

Most of all, thank you to our children: Autumn, Eva, Brianna, Jayden, and Quinten. On the days when this struggle gets too hard, when we feel like we cannot face another day with another story of loss and tragedy, on those days when the experts tell us we have to learn to distance ourselves, we carry on because we have you. You are the precious gifts that teach us what it means to mother in the spiritual and physical sense and uphold the responsibilities entrusted to us to care for the next seven generations.

Table of Contents

Introduction
Rematriating Justice:
Honouring the Lives of Our Indigenous Sisters
Jennifer Brant and D. Memee Lavell-Harvard
11

Part One
Centring MMIWG2S+
31

1.
Refusal and Reprisal: Colonial Fragility, Genocidal Violence,
and the Murder of Helen Betty Osborne
Robyn Bourgeois
33

2.
"Chantel Was Sunshine": Centralizing Indigenous
Mothering in an Honouring Story of Chantel Moore
Josephine Savarese
51

3.
Disrupting Mainstream Media Representations of
Missing and Murdered Indigenous Women and Girls
Sana Shah
81

4.
Healing and Motherhood: In Conversation with
D. Memee Lavell-Harvard, Anne Taylor, Sarah Lewis,
and Lisa Trefzger Clarke
*D. Memee Lavell-Harvard, MaangKwan Anne Taylor,
Sarah Lewis, and Lisa Trefzger Clarke*
99

5.
Accomplice
Alyssa M. General
117

Part Two
**Community Action and Education to
Address MMIWG2S+**
119

6.
Closing Thoughts: River Women Collective's Reflections
on the Final Ceremonial and Artistic Installation of
Walking With Our Sisters
Cheryl Troupe and Janice Cindy Gaudet
121

7.
A Walking With Our Sisters Syllabus
Rebecca Beaulne-Stuebing
137

8.
Pedagogical Considerations on Teaching "Missing and
Murdered Indigenous Women from a Global Perspective"
Brenda Anderson
155

9.

Human to Human
Chevelle Malcolm
171

Part Three
Transforming Our Worlds
173

10.

Indigenous Women's Literature:
The Power and Truth of Our Words
Jennifer Brant
175

11.

Disentangling Victimhood in Canadian Antihuman Trafficking:
A Transformative Justice Response
Rosemary Nagy
201

12.

Healing with Indigenous Feminisms: The Decoloniality
of Embodiment, Self-Love, and Desire
Jo Billows
225

13.

kimiyokîsikaw: Iskwewak Reclaiming Sovereignty,
a Love Letter from Decolonial Self-Lovers
*Lana Whiskeyjack, Janice Cindy Gaudet, Tricia McGuire-Adams,
and Jennifer Ward*
243

14.
Poems
Thamer Linklater
259

15.
To My Sister I Have Never Met
Sherry Emmerson
263

16.
Reflections and Virtual Tea
Jennifer Brant with Maria Campbell and Kim Anderson
265

Notes on Contributors
281

Introduction

Rematriating Justice: Honouring the Lives of Our Indigenous Sisters

Jennifer Brant and D. Memee Lavell-Harvard

> A nation is not conquered until the hearts of its women are on the ground. Then it is done, no matter how brave its warriors nor how strong its weapons.
> —Cheyenne proverb

We have long known that the survival of Indigenous nations rests on the shoulders of Indigenous women. The words of this oft-quoted Cheyenne proverb present a centuries-long reality for the Indigenous peoples of Turtle Island, a reality that began with first contact and has continued generation after generation. Indeed, Indigenous mothers and grandmothers have had to fight for the continued rights of our people to even exist on our lands. After the War of 1812, when the British felt they no longer needed Indigenous military alliances, the subjugation and eventual elimination of Indigenous nations was unquestionably the outcome openly envisioned and desired by the colonial government. To eradicate and replace, as they "sought to create a new nation" on Turtle Island, settler colonialism must "first set out to destroy" the original nations "that were already here" (National Inquiry 233). Indeed, arguing the government should not "protect a class of people who are able to stand alone" as members of independent nations, Duncan

Campbell Scott (the highest ranking Indian Affairs official) admitted the policy of his department specifically, and the Canadian government was "geared towards a Final Solution" of the so-called Indian Problem as they actively worked towards a nation where "there is no Indian question and no Indian Department" (Rheault 3). In the context of a nation-state working to eliminate Indigenous nations, those who possess the ability to reproduce—to birth future generations of Indigenous people—are inherently capable of thwarting colonial agendas, and their very existence therefore poses a significant threat to the overall colonial project. Thus, violence against Indigenous women, girls, and 2SLGBTQQIA+ people was historically, and remains currently, integral to the ongoing process of colonial expansion and the attendant theft and exploitation of Indigenous lands. In fact, the long-awaited final report of the National Inquiry into Missing and Murdered Indigenous Women and Girls confirmed what we have long known: "the history of colonization is gendered" (231). Indeed, as documented therein, the "structures and attitudes that inspired historical abuses of human and Indigenous rights exist today" (231) and the impact of such violence "amounts to a race based genocide of Indigenous Peoples ... which especially targets women, girls, and 2SLGBTQQIA+ people" (50). As Indigenous rights activist Pam Palmater points out, contrary to the arguments put forth by those who have been excusing this violence for generations now, such violence is obviously not the result of a few bad apples but rather is deeply embedded in the entire system. By providing a space for Indigenous voices to share their experiences, stories, and understandings, we endeavour with this volume to add to a much-needed understanding of this violence as a sociological phenomenon shaped by history and founded upon the pillars of systemic racism, colonialism, and heteropatriarchy.

Throughout history, the continued presence of Indigenous families posed a threat not only to the peaceful narrative of Canada (and the disappearance of Indigenous nations as a justification for European settlement on supposedly unoccupied Indigenous lands) but also to the narrative of the Canadian family (and the supposed natural order of the white supremacist, patriarchal social structures of Western families). Therefore, as the bearers of children and egalitarian (or matrilocal, matrilineal, and even matriarchal) social structures, Indigenous women needed to be undermined and controlled to achieve and maintain the colonial dream.

INTRODUCTION

Attacks on Indigenous women's rights to conceive, birth, and raise their own children were integral to the colonial project (i.e., the eradication of Indigenous peoples). This involved the systemic dismantling of Indigenous families and kinship structures through the residential school system, the Sixties Scoop, forced tubal ligations, and numerous legally sanctioned initiatives targeting Indigenous women. Through centuries of legislative and physical violence, Indigenous women and gender-diverse kin who were once honoured and respected within Indigenous nations were disempowered, quickly becoming what Kathleen Jamieson refers to as "citizens minus" in the eyes of the colonial state. Advocating for the rights of Indigenous women as part of the federal Advisory Council on the Status of Women, Jamieson amplifies the voices of numerous Indigenous women who spoke out against the racialized, and gender-based violence that sought to dismantle the rightful place of Indigenous women, including the late Mohawk poet and writer Tekahionwake E. Pauline Johnson, who was writing about this before the turn of the nineteenth century.

Interestingly, Indigenous women's power needed to be disrupted not only to weaken Indigenous families, communities, and nations but also to keep white women in their place and uphold the patriarchal structures of Western families. A series of moralizing campaigns and propaganda deeming Indigenous women as uncivilized and uncivilizing ensured that many white women would become complicit in the racialized, sexualized, and gendered violence against Indigenous women and girls. For instance, early white maternal feminists supported the sterilization policies of Indigenous women. As we continue to see maternal feminists such as Nellie McClung and Emily Murphy revered for their role in women's suffrage, we also see a profound silence on their roles as proponents of the eugenics policies that targeted Indigenous women. Recent cases of forced and coerced tubal ligations of Indigenous women are directly linked to the racist and sexist legislation these early white feminists advocated for.

The dismantling of Indigenous women's power and place in Indigenous communities is solidly embedded in a series of racist and sexist pieces of legislation culminating in the Indian Act of Canada (1876). The fight against the Indian Act has been long and arduous, as women such as Jeannette Corbiere Lavell, Yvonne Bedard, Mary Two-Axe Early, Sandra Lovelace, and Sharon McIvor, and Lynn Gehl brought legal challenges

to the highest domestic courts and, failing that, on to international courts and tribunals. Our women led countless marches, rallies, vigils, and teach-ins to raise awareness about the violence against Indigenous women, girls, and 2SLGBTQQIA+ people. Indeed, our mothers and grandmothers, sisters and aunties, and daughters and granddaughters have upheld their rightful places as the warriors of our nations with their relentless activism and advocacy, making their voices heard from the courts and council chambers to community centres and kitchen tables.

After decades of family members and Indigenous leaders demanding justice and a process fraught with missteps and delays, on June 3, 2019, the National Inquiry into Missing and Murdered Indigenous Women and Girls released its final report titled *Reclaiming Power and Place*. After more than two years of testimony from Indigenous Knowledge Keepers, experts, and 1,484 survivors and family members, in addition to public hearings and evidence gathering from many Indigenous and non-Indigenous groups and individuals across Canada, the final report was unveiled at the Canadian Museum of History in Gatineau, Québec. Chief Commissioner Marion Buller, Commissioner (and former Native Women's Association of Canada President) Michèle Audette, and Commissioners Qajaq Robinson and Brian Eyolfson, along with Prime Minister Justin Trudeau, family and friends of the missing and murdered, as well as national and provincial Indigenous leaders, including former Native Women's Association President D. Memee Lavell-Harvard, gathered to release the findings of the inquiry to the public. The two-volume report spanned more than one thousand pages and contained 231 individual "Calls for Justice." These were not merely recommendations to be read and then set aside but legal imperatives demanding immediate action from Indigenous and non-Indigenous governments, institutions, social service providers, industries, and individual Canadians of all walks of life. Chief Commissioner Marion Buller declared that "Despite their different circumstances and backgrounds, all of the missing and murdered are connected by [the] economic, social and political marginalization, racism, and misogyny woven into the fabric of Canadian society." The report condemned Canadian society for its inaction and described the violence as "a national tragedy of epic proportion." It has been eight years since the release of our first book exposing the crisis of violence against our sisters, and four years since the aforementioned Calls for Justice were released, and still we have seen little movement toward the widespread

systemic changes that are needed. In a small but significant way, with this collection, we aim to do our part to satisfy Call 11.1 for educators to "provide awareness to the public" about Indigenous women, girls, and 2SLGBTQQIA+ people and about the "issues and root causes of violence" that arise out of centuries of settler colonialism on our lands. Although such an awareness threatens the convenient narratives the Canadian state is founded upon, it is in fact for this reason that our stories "must include historical and current truths about the genocide" against our peoples (Call 11.1). By shining a light on the stories of our stolen sisters we add our voices to the ever-increasing demands for accountability and policy change in the hope that unlike so many previous generations our daughters and granddaughters, our children and grandchildren will have the opportunity to thrive and not just merely survive.

Although the national public inquiry is not the starting place for the tireless efforts of Indigenous families, communities, and nations (indeed we have been demanding justice coast to coast to coast across Turtle Island for decades), by adding to the chorus of voices presented in *Forever Loved: Exposing the Hidden Crisis of Missing and Murdered Indigenous Women and Girls in Canada* (2016), for this new collection, we deliberately start with the inquiry to increase attention and press for immediate action on the 231 Calls for Justice. After the years of advocacy, walks, roundtables, and vigils that brought us to this moment, the release of the national public inquiry offered a pivotal moment for Canadian society to contribute to social justice for Indigenous families. Unfortunately, it has proven to be a missed opportunity, following in the tradition of land acknowledgements and other equally empty gestures—a moment of performative grief within acts of "feel good" reconciliation that while acknowledging the legacy of abuse and exploitation does little to actually address the resulting structural and systemic inequalities and the pervasive and persistent marginalization of Indigenous people. Although many Canadians acknowledge, and perhaps even conveniently reference the Truth and Reconciliation Commission's 94 Calls to Action, comparatively few Canadians know about the National Inquiry into Missing and Murdered Indigenous Women and Girls or the associated Calls for Justice. Yet Indigenous peoples know all too well that there can be no reconciliation without justice, and there is no justice without truth. As Leah Gazan writes, "We have the resources to end this genocide and ensure that Indigenous women, girls, and gender-diverse individuals can be safe in

their communities. What we lack is the political will."

A national public inquiry was finally called after decades of grassroots organizing and political campaigns urging the Canadian government to take seriously the ongoing travesty of violence against missing and murdered Indigenous women and girls in Canada. Not only is this an issue that we engage with through scholarly and community activism, but it is also one that touches our lives as we continue to mourn the loss of our kin while working to ensure the safety of our mothers, daughters, sisters, aunties, and our children. We are doing our best to protect them from a racist system while teaching them how to protect themselves in a society where they will be targeted simply because they are Indigenous and women. We hear the same story over and over from young mothers working frantically to ensure our parenting can withstand the inevitable excessive scrutiny upheld by the legacy of moralizing campaigns that continue to deem Indigenous women and girls as uncivilized and uncivilizing while fetishizing and hypersexualizing them. Numbers that are merely statistics to others are deeply internalized for many of us who "experience gnawing feelings of fear, trauma, or threat to our own safety and that of our sisters, daughters, nieces, mothers, aunties, and grandmothers" (Anderson xxi). We know that Indigenous women and girls are underprotected and overpoliced, experience higher rates of violence, and are overrepresented as victims of crime. We know that Indigenous women and girls are twelve times more likely to be murdered or missing than non-Indigenous women. We also know our two-spirit and gender-diverse kin are additionally targeted because of gender identity and/or sexual orientation.

In October 2004, Amnesty International released a report titled *Stolen Sisters: A Human Rights Response to the Discrimination and Violence against Indigenous Women in Canada* in response to the appalling number of Indigenous women who are victims of racialized and sexualized violence. This report noted over five hundred missing or murdered Indigenous women. Tragically, since this initial report, the numbers have continued to rise.

Noting that Indigenous women are eight times more likely to die as a result of violence, a 2014 RCMP report documented 1,181 missing or murdered Indigenous women and girls between the 1980s and 2012. However, Indigenous communities estimate the numbers to be much higher. The recent 2021 *Missing and Murdered Indigenous Women, Girls,*

and 2SLGBTQQIA+ People National Action Plan points out that "the exact number of missing and murdered Indigenous women, girls, and 2SLGBTQQIA+ people in Canada is unknown as thousands of these deaths or disappearances have been unreported or misreported over the decades and indeed over centuries" (14).

The failure of the government to effectively respond to this issue resulted in a national grassroots movement to call for a national public inquiry. Not only did the conservative government of Canada fail to respond, but Prime Minister Stephen Harper also dismissed the crisis altogether during an interview with Peter Mansbridge in 2014 when he stated that the issue of missing and murdered Indigenous women is "not really high on his radar" (Kappo). The deliberate refusal to even acknowledge that there is an issue has been evidenced over and over by previous governments in the lack of follow through on recommendations from numerous reports. Earlier in 2014, in a disgraceful display of resistance to the push for a national public inquiry, Justice Minister Peter MacKay declared that the government had already completed 40 initiatives to address missing and murdered Indigenous women. When MacKay was asked if he was prepared to table the reports, he threw a stack of papers on the House of Commons floor and invited the opposing party to walk over and pick the documents up themselves (Mas). Such complete disregard has sent out a clear message that devalues the lives of Indigenous women and girls. This nation was founded upon the suffering and violent oppression of Indigenous peoples generally and the targeting of Indigenous women specifically as the bearers of future generations. Today, state violence has come top down and reverberates across Turtle Island in the acceptance of the daily attacks against Indigenous women and girls. This is becoming understood as a sociological phenomenon buried under layers of colonial abuses that continue to directly target Indigenous women and girls. For Indigenous women and girls, "centuries of persecution and oppression" are certainly not a thing of the past (Lavell-Harvard and Anderson 1). We continue to hear and read about our missing sisters across Turtle Island.

In the introduction to *Forever Loved*, we note that over forty separate reports have outlined the increase in racialized and sexualized violence against Indigenous women, yet the recommendations they contain are ignored. Unfortunately, the 231 Calls for Justice have also been largely ignored. While these inquiries and final reports seek to educate the

Canadian public on the extent of the problem they are often read from a statistical lens and position that distance Canadians from this issue. Victim-blaming narratives continue to perpetuate ongoing discourses that deem violence against Indigenous women as just another "Indian problem." This is not just an "Indian problem," or a women's issue, it is a national tragedy and a national shame. The stories of our stolen sisters deeply affect the lives of all Indigenous peoples in Canada and arguably should affect the lives of all Canadians. As Brenda Anderson argues in an earlier book stemming from the 2008 Missing and Murdered Indigenous Women Conference held in Regina, Saskatchewan: "Within these profoundly disturbing accounts, we see the interplay of sexism and racism within the context of a country traumatized by practices of assimilation, residential schools and cultural genocide. A country cannot be considered healthy if any of us are comfortable with that reality" (5). After conducting an extensive investigation in Canada, in March 2015, the United Nations Committee on the Elimination of Discrimination against Women (UNCEDAW) issued a report condemning Canada for its ongoing failure to protect Indigenous women and girls. The ongoing racialized, sexualized, and gender-based acts of violence targeting Indigenous women and girls attest to the ill health of this country and the continued trauma inflicted on the Indigenous peoples of this land.

Our intention with this book is to underscore the reality of violence that is all too familiar and resonates within the hearts of Indigenous communities but also to highlight the humanity of Indigenous women, girls, and two-spirit people. These are the voices of our sisters, mothers, daughters, aunties and grandmothers. At almost every Indigenous conference we attend there is yet another moment of silence. Our intent is to honour our missing sisters, their families and honour their lives and remember their stories so they are no longer just another statistic.

INTRODUCTION

Weaving the Stories

> This genocide has been empowered by colonial structures, evidenced notably by the Indian Act, the Sixties Scoop, residential schools and breaches of human and Indigenous rights, leading directly to the current increased rates of violence, death, and suicide in Indigenous populations.
> —National Inquiry into Missing and Murdered Indigenous Women and Girls 50

There is an intergenerational pattern to this violence that deepens the connection to this violence as a national genocide against Indigenous peoples as alluded to in the above excerpt from the public inquiry. As the inquiry documented, this violence is inextricably linked to other legislated policies, such as the Indian Act of Canada, the residential school system, and the Children's Aid Society. This is a reality we knew well before the inquiry began, as it characterizes the lived experiences of Indigenous peoples. Thus, writing and teaching about racialized, sexualized and gender-based violence require intentionally layered and textually curated material about the multiple types of colonial violence that have historically and currently targeted Indigenous peoples and communities in Canada, especially women who spiritually and physically birth the future of our nations. Indeed, the layered and intricate nature of Indigenous women's stories helps us understand the intergenerational pattern of these violences as tools of colonial violence, patriarchy, and white supremacy.

As we were moving *Forever Loved* to publication in 2016, the community of Attawapiskat had just declared a state of emergency after many youth suicides had swept across the community. In response, Idle No More activists occupied the offices of Indian and Northern Affairs Canada (INAC) demanding the abolishment of the Indian Act of Canada. Others noted that the whole country should declare a state of emergency for its treatment of Indigenous peoples. MMIWG2S+, while understood as a human rights issue, rests within this larger colonial context and must be understood as a sociological phenomenon that is rooted in the persistent and multilayered violence that characterizes the nation-state of Canada. It also rests and persists in a deafening silence. This new collection comes five years after the release of the National Inquiry into Missing and Murdered Indigenous Women and Girls and the associated

231 Calls for Justice. Since the release of this report, Canada has largely remained silent while Indigenous organizations have continued to take matters into their own hands. On June 5, 2023, four years after the inquiry, a CBC analysis found that sadly, and perhaps predictably, only two of the 231 Calls had been completed. CBC's "Mother. Sister. Daughter" project tracks the progress of the Calls by weaving the stories of Indigenous mothers, sisters, and daughters still searching for justice. In their own words, Indigenous women share stories that highlight the intergenerational pattern of these types of violence (Carreiro). The core thread is genocidal violence against Indigenous communities, including residential schools, foster care, human trafficking, and police violence.

Rematriating Justice

Our first collection, *Forever Loved*, is adorned by the cover art of Alyssa General. The cover art is of a painting that represents the story of Thunder Woman, who destroys the horned serpent. There are numerous stories across our communities that centre the role of women. These are community narratives of strength, reminding us of the sacred role of women in our communities. We chose *Rematriating Justice: Honouring the Lives of Our Indigenous Sisters* as the title of this second collection to represent the work that still needs to be done—the work of not just returning to the land of our ancestors (as signalled by repatriation) but rather the critical process of genuinely reconnecting and rebuilding our sacred relationships. In many ways, the sentiment of rematriation expresses a returning and a reclamation. In other writing, Jennifer Brant offers visions for matriarchal worlding that call us back to a time when Indigenous women were safe from white supremacy, patriarchy, and colonial violence. When we think of the work that still needs to be done, Canada's ongoing erasure of Indigenous women's stories, the silences that fill these lands, and the lack of political will to honour and protect Indigenous women, we know we must work against the backdrop of a colonial justice system that fails to protect Indigenous women and girls—a criminal justice system that is complicit in this violence as told by the stories of our sisters, including Tina Fontaine, Chantel Moore, Regis Korchinski-Paquet, and Eishia Hudson.

We offer *Rematriating Justice* to move beyond calls for returns and reparations that are often transactional towards an expression of deeper

relations with Land—with honouring Land, being in reciprocity with Land, and taking care of Mother Earth. We know that, just as the violence against our women was deeply embedded within a Land theft paradigm, respect for Indigenous women begins with respect for our Land. *Rematriating Justice* connects us to the work of the late Lee Maracle, who expressed in *Daughters Are Forever* that she envisioned a time when Turtle Island women had no other reason to fear other humans—a time when our daughters will not have "to go out and protest" (Silman 239) because we are doing it for them now. Our experiences and the memories of our sisters and missing kin tell a collective story, a shared reality demonstrating that we are not yet at this time. The chapters in this collection highlight the work that still needs to be done to reach a time when Indigenous women and girls have no reason to fear other humans.

Outline of the Book

Part One: Centring MMIWG2S+

In the first section of this anthology, centring MMIWG2S+, the authors bring our attention to the stories of Helen Betty Osborne, Chantel Moore, Rosianna Poucachiche and Shannon Alexander. Their stories are but a few among the thousands of women and girls who were murdered or are missing in Canada, a few among the thousands who are deeply missed and loved.

In chapter one, "Refusal and Reprisal: Colonial Fragility, Genocidal Violence, and the Murder of Helen Betty Osborne," Robyn Bourgeois highlights the intersection of colonialism, deeply embedded racism, sexism, and the systemic failures that enabled Osborne's murderers to evade justice. Bourgeois shows how societal and legal indifference in this case reflect the broader dynamics of colonial domination in Canada, which relies on the dehumanization of and violence against Indigenous peoples, especially women, to sustain itself. Bourgeois highlights the Cree concept of "wahkohtowin," emphasizing relationships, reciprocity, and collective wellbeing as foundational to opposing colonial violence.

In chapter two, "'Chantel Was Sunshine': Centralizing Indigenous Mothering in an Honouring Story of Chantel Moore," Josephine Savarese weaves together legal outcomes, community responses, and scholarly analysis. Centred on the murder of Chantel Moore, a young Indigenous mother killed by law enforcement during a wellness check, the chapter

highlights systemic issues in policing: the normalization of violence against Indigenous women, the lack of accountability, and the tendency to blame the victim, reflecting the longstanding deeper societal and institutional biases against Indigenous peoples.

In chapter three, "Disrupting Mainstream Media Representations of Missing and Murdered Indigenous Women and Girls," Sana Shah examines the role of media coverage and the impact of family activism on changing mainstream narratives. Through examples of coverage of the cases of Rosianna Poucachiche and Shannon Alexander, Shah emphasizes how family members have been instrumental in shifting media discourse away from negative stereotypes and moving towards addressing the broader issues of colonialism, racism, and systemic oppression. Deeply ingrained stereotypes in Canadian society have shaped media coverage; however, families and communities have been fighting against these narratives, pushing for justice for their loved ones. The transformation in media coverage observed in recent years is attributed by Shah to persistent activism by families of MMIWG2S+.

Chapter four, "Healing and Motherhood," unfolds as a conversation between D. Memee Lavell-Harvard, Anne Taylor, Sarah Lewis, and Lisa Trefzger Clarke, who discuss the effects of MMIWG2S+ on motherhood. The authors share from the perspectives of their personal journeys, advocacy, research, and community initiatives on issues of gender-based violence, Indigenous identity, and motherhood under the shadow of MMIWG2S+. The authors highlight the significant role of Indigenous mothers in advocating for their communities and underscore the importance of traditional knowledge, cultural practices, and community solidarity in healing and resistance.

This section of the book finishes with chapter five, "Accomplice," a poem by Alyssa M. General, who also draws upon themes of motherhood. The poem is a call to action—to rally, to challenge mainstream narratives, and to protect and empower younger generations so that they might have the safety to imagine a different future.

Part Two: Community Action and Education to Address MMIWG2S+

This section opens with chapter six, "Closing Thoughts: River Women Collective's Reflections on the Final Ceremonial and Artistic Installation of Walking With Our Sisters" by Cheryl Troupe and Janice Cindy Gaudet. In this chapter, the authors reflect on the year-long process of organizing and hosting the installation Walking With Our Sisters (WWOS), a community-led and commemorative art installation honouring MMIWG. The installation took place at historically significant sites along the South Saskatchewan River and emphasized the importance of Métis women's leadership, community engagement, and connection to the land. The chapter discusses the challenges faced, lessons learned, and the significance of the event in raising awareness and fostering healing within the community.

Next is chapter seven, Rebecca Beaulne-Stuebing's "A Walking With Our Sisters Syllabus." Beaulne-Stuebing, who has been a helper to the WWOS project, offers the syllabus to be picked up, shared, and engaged with. The syllabus emphasizes citational practices, Indigenous articulations of harm reduction, and the intersections of Indigenous artmaking, resistance, and ceremony. The syllabus closely examines both the experiences of WWOS host communities and the broader context of systemic violence. Some of the vital offerings made by Beaulne-Stuebing include considering the role of ceremony in grieving and resistance, remembering practices, and honouring as a theory of change. The syllabus includes an eleven-week reading schedule and three learning activities to engage and deepen—to do something—with the learning.

In chapter eight, "Pedagogical Considerations on Teaching 'Missing and Murdered Indigenous Women from a Global Perspective,'" Brenda Anderson reflects on her experiences teaching a university course on missing and murdered Indigenous women from a global perspective, with a focus on Indigenous and feminist methodologies. She explores the roles and responsibilities of non-Indigenous allies, ethical considerations in teaching trauma, and effective pedagogical approaches. The chapter is offered to others who may be teaching these themes and aims to contextualize the history of colonialism in Canada and its impact on Indigenous women while also examining global patterns of violence against Indigenous women.

Again, we close this section with a poem, chapter nine, "Human to Human" by Chevelle Malcolm.

Part Three: Transforming Our Worlds

In chapter ten, "Indigenous Women's Literature: The Power and Truth of Our Words," Jennifer Brant explores the power of Indigenous women's literature as a form of resistance. Brant underscores the importance of denouncing victim-blaming narratives and stereotypes, presenting Indigenous women's literature as a vital counternarrative that showcases resilience and cultural continuity and demands justice. Brant discusses her own research and experiences teaching courses on Indigenous women's literature and reflects on the powerful legacy of Indigenous women's words to inspire action, confront injustices, and contribute to the healing.

Like Brant, Rosemary Nagy denounces the victim-blaming narrative in chapter eleven, "Disentangling Victimhood in Canadian Antihuman Trafficking: A Transformative Justice Response." Nagy examines the changing racialization of the victim-subject in Canadian antihuman trafficking policy and discourse, explaining that while Canada's first decade of modern antitrafficking efforts failed to see Indigenous women and girls as victims of violence, the current hypervisibility of Indigenous women as victims of trafficking is also problematic. Nagy explains that the homogenizing language of "vulnerability" to trafficking fails to account for the differential racism at work in narratives of victimization as well as the role of the settler state in producing the structural conditions of "vulnerability." The chapter proposes the idea of transformative solidarities (Kaye) as a means of resisting the victim label and relational othering. Nagy concludes by offering an overview of community-based transformative justice strategies specific to trafficking and other forms violence in the sex industry.

In chapter twelve, "Healing with Indigenous Feminisms: The Decoloniality of Embodiment, Self-Love, and Desire," Jo Billows offers a textual map towards healing by weaving together a series of reflections on the texts, poems, and practices that have helped them on their path towards healing. Jo reminds us that violence against Indigenous bodies and violence against the land are connected and through textual offerings curates a language of healing as expressions of the decoloniality of embodiment, self-love, and desire. Jo concludes by offering a land/self-portraiture as a photography practice for decolonial self-love and healing, including portraits accompanied by a practice of embodied writing.

INTRODUCTION

Chapter thirteen, "kimiyokîsikaw: Iskwewak Reclaiming Sovereignty, a Love Letter from Decolonial Self-Lovers" offers the decolonial self-love visions of four Indigenous women scholars who came together to envision and enact their codes of wellness. This chapter weaves together the reflections of iskwewak and decolonial self-lovers Lana Whiskeyjack, Janice Cindy Gaudet, Tricia McGuire-Adams, and Jennifer Ward who share their journeys, their stories, and their voices, as a collective spirit fire from their ahcahk iskotew. Each author denounces white feminism and comments on the epistemic violence of academia that contributes to the unwellness of Indigenous women academics. In contrast, they offer visions of kinship and sisterhood that reorient readers with matrilineal understandings of Indigenous women's power and place. Their stories are offered as intellectual gifts for healing, decolonial love, and wellness.

Part Three ends with the beautiful poetry of Thamer Linklater, chapter fourteen, and Sherry Emmerson, chapter fifteen. These healing poems are creative expressions that honour the shared and connected realities as felt experiences (Million). These poems also come together to express the love we collectively carry for our missing sisters and our visions for rematriating justice.

The final chapter of this collection, "Reflections and Virtual Tea," brings us full circle by affirming the importance of rematriating justice. It offers reflections from a virtual tea with Jennifer Brant, Maria Campbell, and Kim Anderson who discuss the importance of language revitalization, storytelling, and word bundling. As the authors share, our visions of community safety have always been translated through stories, and we need to be doing this work in ways that speak to and empower our own communities.

Recently, we have seen demonstrations urging the government of Canada to call for the search of the Brady Landfill in Winnipeg, where it is believed the remains of several Indigenous women will be found. Four Indigenous women were killed in Winnipeg in 2022: Rebecca Contois, Morgan Harris, Marcedes Myran, and an unidentified woman referred to as Mashkode Bizhiki'ikwe or Buffalo Woman. A daughter of one of the victims—twenty-two-year-old Cambria Harris—has been pleading for a search for her mother's remains and has been camped outside of the landfill for months. Citing costs, former premier of Manitoba Heather Stephanson had denied the call to search the landfill only days after wearing a red dress pin for photo ops during her campaign.

This superficial act of window-dressing in the name of reconciliation while silencing the voices and ignoring the bodies of Indigenous women is an extension of the patriarchy and misogyny that have become a defining feature of Canada. It is hoped that the election in November of 2023 of Wab Kinew, the first Indigenous premier in Manitoba since 1887, and his public commitment to search the landfill will mark the beginning of a new reality for Indigenous women in the province, one where their voices are heard and respected. The chapters in this collection hold a mirror to all Canadians to understand the violence that was brought to this land. In the spirit of radical hope, we offer *Rematriating Justice* as a reckoning with the current state of affairs and a vision for returning to what once was in these lands. The chapters offer a collective theoretical map that marks the pathway towards a renewed and women-centred justice. As Brenda Anderson articulates in the introduction to *Torn From Our Midst*: To understand the connections between colonialism, racism, and sexism, we need to hear personal stories from around the world and in our backyards. We also need to keep our theoretical maps of these worldviews and paths to justice accessible, understandable and responsive to all communities" (3).

This collection brings together memoir, academic and creative prose, as well as personal stories and poetry. It is adorned by the beautiful cover art of Leona Skye, who powerfully reflects the vision of rematriating justice and reclaiming power and place through imagery. All pieces are creative expressions in honour of the love we collectively carry in our hearts for our Indigenous women and girls. Understanding the issue of MMIWG2S+ involves us all, and it is our hope that change takes place within the spirit of this dialogue. It presents a vision of healing, plants the seeds of hope, and expresses our love for all our sisters—for those whose spirits walk among us and whose beautiful voices are carried in the wind, as well as those who we continue to dance with as we collectively work to rematriate justice.

The work involved in putting this book together has been an emotionally arduous process, as the issue is deeply close to our hearts. Like our first book, the essence of "forever loved" is expressed throughout the chapters that honour our missing sisters—their families, lives, and stories. We offer this book in the hopes that it will provide some solace to the families affected as we work to honour the memories of their loved ones and that it will offer lessons to non-Indigenous allies and supporters

so that we can work together towards a nation that supports and promotes the safety and wellbeing of Indigenous women, girls, trans, and two-spirit peoples. This book demands accountability and policy change. Simply put, the time has come for real action behind the words. The contributors of this collection come together to work towards effective and immediate action. This second collection is offered in the spirit of rematriating justice and upholding the power and place that will empower all to end this genocide and ensure the safety of Indigenous women, girls, trans, and two-spirit peoples. This collection is one of many, and we close this introduction with a curated list of scholarly anthologies, memoirs, and poetry collections that will guide readers in joining us in creating a safer nation for Indigenous women, girls, trans, and two-spirit peoples.

Further Reading

Anderson, K., et al. *Keetsahnak: Our Missing and Murdered Indigenous Sisters.* University of Alberta Press, 2018.

Anderson, B., et al. *Global Femicide: Indigenous Women and Girls Torn from our Midst.* University of Regina Press, 2021.

Daniel, D. *Daughters of the Deer.* Random House Canada, 2022.

Dean, A. *Remembering Vancouver's Disappeared Women.* University of Toronto Press, 2015.

McDiarmid, J. *Highway of Tears: A True Story of Racism, Indifference and the Pursuit of Justice for Missing and Murdered Indigenous Women and Girls.* Penguin Random House, 2019.

Missing and Murdered Indigenous Women, Girls, and 2SLGBTQQIA+ People National Action Plan, 2021. https://mmiwg2splus-nationalactionplan.ca/

Sterritt, A. *Unbroken: My Fight for Survival, Hope, and Justice for Indigenous Women and Girls.* Greystone Books, 2023.

Vries, M. de. *Missing Sarah: A Memoir of Loss.* Penguin, 2003.

Walter, E. *Stolen Sisters: The Story of Two Missing Girls, Their Families and How Canada Has Failed Indigenous Women.* HarperCollins, 2015.

Works Cited

Anderson, B. "The Journey from Awareness to a Conference to a Book ... and Beyond." *Torn from Our Midst: Voices of Grief, Healing, and Action from the Missing Indigenous Women Conference, 2008.* Edited by Brenda A. Anderson et al., University of Regina Press, 2010, pp. 1-16.

Anderson, K. *Keetsahnak: Our Missing and Murdered Indigenous Sisters.* University of Alberta Press, 2018.

Brant, J. "Indigenous Literary Expressions of Matriarchal Worlding as Kinship" *Canadian Literature*, vol. 254, 2023, pp. 13-35.

Carreiro, D. "Mother. Sister. Daughter." *CBC News*, 5 June 2023, https://www.cbc.ca/newsinteractives/features/mother-sister-daughter. Accessed 26 Apr. 2024.

Gazan, L. "No Reconciliation without Justice for MMIWG." *The Hill Times*, 28 Sept. 2022, https://www.hilltimes.com/story/2022/09/28/no-reconciliation-without-justice-for-mmiwg/271445/. Accessed 26 Apr. 2024.

Kappo, T. "Stephen Harper's Comments on Missing, Murdered Aboriginal Women Show Lack of Respect." *CBC News*, 19 Dec. 2014, https://www.cbc.ca/news/indigenous/stephen-harper-s-comments-on-missing-murdered-aboriginal-women-show-lack-of-respect-1.2879154. Accessed 1 May 2024.

Lavell-Harvard, M. D., and K. Anderson. "Introduction: Indigenous Mothering Perspectives." *Mothers of the Nation: Indigenous Mothering as Global Resistance, Reclaiming, and Recovery.* Eds. Memee D. Lavell-Harvard and Kim Anderson. Demeter Press, 2014. pp. 1-11.

Maracle, L. *Daughters Are Forever.* Polestar, 2002.

Mas, S. "Tempers Flare on Eve of Report into Missing and Murdered Aboriginal Women." *CBC News*, 6 March 2014, https://www.cbc.ca/news/politics/tempers-flare-on-eve-of-report-into-missing-and-murdered-aboriginal-women-1.2561475. Accessed 1 May 2024.

Million, D. "Felt Theory: An Indigenous Feminist Approach to Affect and History." *Wicazo Sa Review*, vol. 24, no. 2, pp. 53-76.

National Inquiry into Missing and Murdered Indigenous Women and Girls. "Calls for Justice." *Reclaiming Power and Place: The Final Report of the National Inquiry into Missing and Murdered Indigenous Women and Girls*, vol. 1b, 2019, pp. 167-218.

Palmater, Pamela. "Shining Light on the Dark Places: Addressing Police Racism and Sexualized Violence against Indigenous Women and Girls in the National Inquiry." *Canadian Journal of Women and the Law*, vol. 28, no. 2, 2016, pp. 253-84.

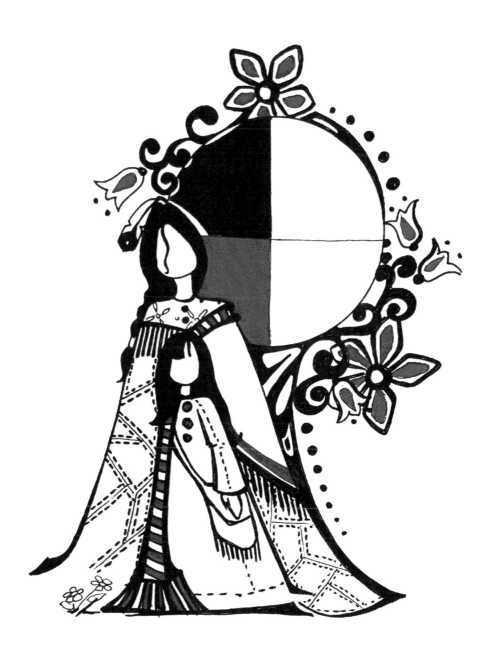

Part One

Centring MMIWG2S+

1.

Refusal and Reprisal: Colonial Fragility, Genocidal Violence, and the Murder of Helen Betty Osborne

Robyn Bourgeois

> It is clear that Betty Osborne would not have been killed if she had not been Aboriginal. The four men who took her to her death from the streets of The Pas that night had gone looking for an Aboriginal girl with whom to "party." They found Betty Osborne. When she refused to party she was driven out of town and murdered. Those who abducted her showed a total lack of regard for her person or her rights as an individual. Those who stood by while the physical assault took place, while sexual advances were made and while she was being beaten to death showed their own racism, sexism and indifference. Those who knew the story and remained silent must share their guilt.
> —Aboriginal Justice Inquiry of Manitoba

In the early morning hours of November 13, 1971, Helen Betty Osborne, a nineteen-year-old Cree woman from Norway House First Nation, was approached by four white men in a car as she walked home on the snowy streets of The Pas, Manitoba. They asked her to come "party"— that is, consume alcohol and engage in sexual activity—with them. Betty, as she was known to family and friends, refused. Instead of moving on, these men sought reprisal: They abducted her, physically and sexually

assaulted her, and left her to die alone on the frozen outskirts of the city. Although her body was discovered that same day and people in the community, including police, came to know the identities of her murderers soon after, it would take sixteen years before any of them were brought to justice. In the end, only one would ever serve prison time for his role in the murder. Why was Betty's "no" met with violence from the perpetrators, and why was her murder met with societal indifference and injustice?

Building on the 1991 findings of the Aboriginal Justice Inquiry of Manitoba (AJI), cited above, that the murder of Helen Betty Osborne was fuelled by racism and sexism, this chapter further unpacks the actions of white people—both the perpetrators and those who enabled them—to expose the inherent fragility of the colonial project and, thus, the necessity of widespread violence to sustain it. Betty's refusal was met with reprisal, I contend, because she resisted playing her assigned stereotypical role as an Indigenous woman in the colonial order of things. Her white male murderers approached her to "party" not only because of colonial racist and heterosexist beliefs about the inherent sexual availability of Indigenous women and girls but also because of their belief that as dominant white male subjects who benefit from colonialism, they had the right to objectify and access the bodies of Indigenous women like Betty to achieve their desires. By refusing to take part in this ideological and lived colonial fantasy, Betty disrupted and threatened it, and the four white men chose violence to restore the colonial order of things, resulting in a myriad of white people and their colonial social systems enabling, excusing, and erasing the violence of these four white men. That a single "no" from Helen Betty Osborne so threatened the colonial order of things that it seemingly required murder and a web of white settler complicity, I argue, exposes the inherent fragility of colonial domination and, thus, why genocidal violence against Indigenous women and girls is an essential part of the colonial project.

The first section of this chapter is theoretical, outlining the Indigenous feminist antioppression framework that guides the analyses in this chapter and how this framework is used to explicate the workings of colonial domination in Canadian society. After a section honouring the life of Helen Betty Osborne, these theoretical foundations are employed in unpacking the actions of the four white men who murdered her and the people and social systems surrounding them. This chapter concludes

with recommendations on how to end violence against Indigenous women and girls.

Before commencing this discussion, I need to outline some linguistic and conceptual practices employed in this chapter. The term "Indigenous" is used to refer to First Nations, Métis, and Inuit (FNMI) peoples in Canada. Although "Aboriginal" is also commonly used in Canada to refer to these groups, I choose not to use it because it is a term rejected by many. I make use of the term "Indian," a colonial fiction, strategically to trace the operations of the *Indian Act* on First Nations people. In this chapter, "Indian" refers to someone who is officially recognized as Indigenous under the Indian Act. Finally, I privilege the use of Indigenous names for Indigenous peoples in the appropriate Indigenous language whenever possible.

Wahkohtowin: Colonialism, Systems of Domination, and the Need for an Indigenous Feminist Antioppression Theoretical Framework

As nêhiyawak (Cree people), the concept of wahkohtowin is central to our worldview and way of being. Wahkohtowin tells us that all things in creation are related and, consequently, interconnected. Natural law provides guidance on how to honour and respect these relationships to promote collective wellbeing, balance, and harmony. Central to this is an ethic of "do no harm," and when harm occurs, be accountable and make amends. Indeed, as Saysewahum, the nêhiyaw activist and scholar also known as Sylvia McAdam makes clear, it is a breach of Cree natural law "to remain silent or take no action while a harm is being done to another human being or anything in creation" (40).

These teachings establish for me the necessity of employing an Indigenous intersectional feminist antioppression framework to understand, expose, and dismantle colonial domination. While often derided and dismissed by Indigenous people as being "untraditional, inauthentic, and non-liberatory for Indigenous women" (Green 3), Indigenous feminist theoretical frameworks are indispensable to untangling Indigenous peoples, their communities, and nations from colonialism and other dominant social systems of oppression. Colonialism is a foreign (i.e., non-Indigenous) system of harm predicated on the theft and illegal occupation of Indigenous lands achieved through domination over

Indigenous peoples. It operates in interlocking ways with other social systems of oppression—for example, racism and white supremacy, heteropatriarchy, capitalist exploitation and exclusion, and ableism (to name but a few)—to secure a global elite. Wahkohtowin tells us nêhiyawak that all things in creation are related and interconnected, and the same holds true for these harmful social systems of oppression that dominate our worlds. Though not of our making, colonialism has ensured that these systems structure our lives as Indigenous peoples. This comes at a genocidal cost for Indigenous people, especially women, in Canadian society. One of the insidious strategies of these systems of oppression is the infiltration of targeted communities to secure their complicity with collective domination through false promises of belonging and access to privilege. Mechanisms of colonialism—including the *Indian Act*, residential schools, Christianization, and capitalism (to name but a few)—have ensured the replication of dominant interlocking systems of oppression in Indigenous communities. Therefore, although Indigenous ways of knowing and being are essential for our survival as Indigenous peoples, so too are theoretical and methodological frameworks that can identify and dismantle dominant systems of oppression. Indigenous feminisms offer this possibility.

The analyses in this chapter are guided by an Indigenous feminist antioppression framework which I first articulated in *Making Space for Indigenous Feminisms* (255-57). The foundation of this framework is a commitment to ending all forms of oppression and violence simultaneously, with the goal of collective freedom and wellbeing. After all, Indigenous experiences of colonialism are shaped simultaneously by the same dominant interlocking social systems of oppression that while creating Indigenous-specific realities are also responsible for the experiences of other socially marginalized people, and vice versa. In other words, our freedom is interdependent and, as Mary-Louise Fellows and Sherene Razack argue, "[b]ecause these systems rely on one another in ... complex ways, it is ultimately futile to attempt to disrupt one system without simultaneously disrupting the others" (335-36). Thus, while privileging Indigenous ways of knowing and being, especially my nêhiyaw ways of knowing and being, this framework draws on feminist, antiracist, antihomophobic and transphobic, anticapitalist, and antiableist theory and praxis to expose the operations of dominant interlocking systems of oppression in the lives of Indigenous peoples, particularly

Indigenous women and girls, and the interconnections of our experiences of oppression and violence with others.

In addition to collective freedom from oppression, this framework strives to secure basic human rights for everyone. In accordance with nêhiyaw (Cree) ways of knowing and being, I believe that all human beings, by virtue of sharing the common spark of creation, are deserving of the basic survival needs: safe and secure water, food supply, housing, as well equitable access to education, healthcare, and unfettered access to resources and wealth. Moreover, we deserve to live lives free from violence, and if violence does happen, we deserve an immediate end to violence and justice through social mechanisms that demand change and make amends for the harm caused. This framework, as such, is not only theoretical but also practical: It aims to change the world in meaningful ways that secure these basic human rights for everyone.

A critical component of this framework is locating myself in the topic. As a knower and knowledge producer, this necessarily informs how I explore and examine the world around me. I am a mixed-race nêhiyaw iskwew (Cree woman) whose nêhiyaw family comes from Treaty 8 territory, the Lesser Slave Lake region of Northern Alberta. My white kin comes from Scotland, England, France, and Ukraine. I am also connected to the Six Nations of the Grand River through my three "Creeyuga" (Cree and Cayuga) children but do not claim this belonging as my own. I came to study the topic of violence against Indigenous women and girls because I am an Indigenous woman who has experienced multiple forms of violence. In addition to my scholarly work, I have spent more than twenty years involved in activism and community organizing to address violence against Indigenous women and girls across Turtle Island. In 2018, I was called to testify at the National Inquiry into Missing and Murdered Indigenous Women and Girls as an expert and experiential witness on sexual violence and human trafficking. While my intimate connection to this topic may be framed by proponents of colonial Western objective knowledge as personal bias, this elides the truth: If people are involved, all knowledge is necessarily biased because it is grounded in the knower/knowledge producer's existing knowledge systems and frames of reference. It also negates personal experience as a valid source of knowledge in favour of socially distanced researchers who "know better" than the people they study and benefit professionally and personally from extractive research, thus reinforcing racist academic

hierarchies. Instead, my lived experience as an Indigenous woman who has experienced this violence and has worked with communities to address it makes me an insider to this knowledge and, thus, an asset to understanding this violence and exploring how to address it.

In the next section, I use this framework to further explicate the operations of colonialism in Canada, drawing attention to how domination and violence have been indispensable to the colonial order of things in this country.

Domination, Dehumanization, and Violence: The Foundations of Canadian Colonialism

Unpacking the actions of the four white men who murdered Helen Betty Osborne and those of the white people around them requires an understanding of how colonialism operates in Canadian society. This context not only helps us make sense of their behaviour but also resists the reduction of their actions and this violence to the product of a "few bad apples" and not the dominant social systems of oppression we all live under. In other words, this context allows us to hold both individuals and society responsible for the murder of Helen Betty Osborne and the injustice that followed. It also encourages us, as members of Canada's colonial society, to consider our complicity in these systems.

Canada is a colonial nation-state established on stolen Indigenous lands. Indigenous peoples have, and continue, to live in a relationship with the lands claimed by Canada since time immemorial, and innumerable generations before white settlers ever set foot here. I say "Indigenous peoples" because it is essential to recognize the diversity of Indigenous nations who have long called these lands home. Although we share common ways of knowing and being, we are distinct nations with ways of knowing and being unique to us and our relationships with land and creation. This recognition disrupts the colonial desire for pan-Indigeneity and the ability to paint all Indigenous peoples as the same, and the same according to how colonial society needs to define us stereotypically for its existence. I say "live in relationship with the lands" because our claims to the lands illegally occupied by Canada are not based on private property and ownership but instead, on relationships, reciprocity, and respect. For example, the nêhiyaw concept of wahkohtowin introduced earlier establishes all things in creation, whether animate or inanimate,

as being related like family and, therefore, we live according to natural laws that honour and nurture these relationships with the goal of collective wellbeing. We have lived in reciprocal relationships with the land since time immemorial, and it is on these grounds that we claim them. These relationships supersede the claims of white settlers to own the lands occupied by Canada and, thus, undermine their veracity and legitimacy, which, in turn, establishes Indigenous peoples as a perilous threat to the colonial order of things.

For this reason, Canada's theft and occupation of Indigenous lands have depended on domination over and elimination of Indigenous peoples, which is rationalized through delusions of white supremacy achieved through the dehumanization of Indigeneity and Indigenous peoples. Dominant social systems of oppression like colonialism operate through hierarchies established through binaries such as superior "us" (i.e., white settlers) and inferior "them" (i.e., Indigenous peoples), with the superiority of "us" only being established by imposing the inferiority of "them." Colonial ideologies, as such, portray Indigenous peoples and their ways of knowing and being as innately problematic and subordinate. Within these racist logics, Indigenous peoples are claimed to be inherently backwards, dysfunctional, deviant, and degenerate to establish the innate supremacy of white settlers and, thus, their right to control Indigenous peoples and their lands. For example, the preservation of lands in a natural state, or the lack of resource extraction and development, by Indigenous peoples was presented as colonial proof that Indigenous peoples are undeserving of the land. Not being Christian established Indigenous peoples as heathens, requiring colonial domination to save them from themselves. This was the foundation for the fifteenth-century papal bull known as the Doctrine of Discovery, which gave European nations the holy blessing and the legal right under European law to steal Indigenous lands as was done in Canada. In contemporary times, the negative consequences of colonialism for Indigenous peoples—for example, poverty, addiction, criminality, and violence—are presented as proof of ongoing Indigenous inferiority to maintain erroneous notions of white supremacy and legitimate colonial control over Indigenous peoples.

As noted in the previous section, dominant systems of oppression work in interlocking ways so that colonial racism is established and reinforced through heteropatriarchy. Heteropatriarchy, which privileges masculinity, cisgenderism, and heterosexuality, confines Indigenous

peoples to colonial gender and sexuality norms that eliminate, exclude, and endanger gender and sexually diverse Indigenous peoples, who have always existed in Indigenous communities. Contained to cisgender male or female binary only, heteropatriarchy accords power and privilege to Indigenous men and boys over Indigenous women and girls by their masculinity. This is best illustrated by the Indian Act, which between 1876 and 1951 attempted to undermine matriarchal power in Indigenous communities by legislating patriarchal lineages to determine recognition as an Indian, denying status to Indian women and their children for marrying a non-Indian man and excluding Indian women from participating in band governance, whether as the elected or electorate. The marriage clause also demonstrates the centring of heterosexual relationships as a means of reinforcing patriarchy and male control over women. While accorded this privilege, Indigenous masculinity is devalued against white masculinity and white femininity when gender and racism collide. Indigenous men are falsely portrayed as inherently violent "savages," from whom superior white men need to protect vulnerable, valuable white women and children, reinforcing the right of white men to dominate them all. This is why Indigenous men, such as Dudley George, Neil Stonechild, Colten Boushie, and others, have been murdered by white settler men with impunity.

Within these colonial logics, Indigenous women and girls are subjected to their racist variant of the Madonna-Whore dichotomy: the Indian Princess and the Squaw. The Indian Princess is a useful Indigenous woman who reflects the values of white-settler society and reinforces its power. This is best exemplified by Disney's portrayal of Pocahontas as a noble and chaste Indigenous woman who falls in love with a white man and betrays her community to advance colonialism. In other words, a good Indigenous woman willingly conforms to and upholds colonialism. Far from the love story portrayed by Disney, Pocahontas was an underage human trafficking victim violated by white men and colonial systems. The life of the real Pocahontas more accurately reflects the colonial stereotype of the Squaw: an inherently sexually available and, thus, violable Indigenous female who is both disposable and traffickable. As Vincent Shillings's research makes clear, none of the Disney version is true; instead, viewed as a sex object who has been denied her humanity, Pocahontas was kidnapped, raped, and likely murdered by white men to advance colonial control of Indigenous peoples and their lands. This

colonial belief in the hypersexuality of Indigenous women and girls, as I have written elsewhere, has resulted in the conflation of Indigenous femininity with prostitution, trafficking, and further dehumanization, social marginalization, trafficking, and violence in colonial Canadian society (Bourgeois, "Race" 397).

Colonial supremacy, as such, is legitimated through racist and heterosexist myths that dehumanize Indigenous peoples and therein lies the problem. When your claims of supremacy are fiction then this supremacy is inherently vulnerable to truth and resistance. For this reason, Indigenous people pose a mortal threat to colonial supremacy because they can undermine and dismantle the legitimacy of Canada's claims to Indigenous lands. The logic of colonial domination, as such, is not just us and them but, more accurately, us versus them, with violence serving as necessary reinforcement when colonial claims to dominance are denied. "Might makes right" is the credo of social regimes based on totalitarian domination. As Robyn Maynard and Leanne Betasamosake Simpson write, "[d]ispossessing Indigenous peoples on our lands and maintaining that system required and requires a complicated and multi-pronged structure of control where direct violence, threats of direct violence, and symbolic violence, all deployed in a gendered way, are foundational to the construction and maintenance of Canada" (182). In other words, violence against Indigenous peoples is an essential component of Canadian colonialism.

A Gift to This World: Honouring the Life of Helen Betty Osborne

As I am a nêhiyaw iskwew (Cree woman) like Helen Betty Osborne, her life and death have long fuelled my commitment to ending violence against Indigenous women and girls. Before turning my attention to the actions and violence of white people in her death, I want to honour and celebrate her life. The telling of her story, however, also requires exposing the operations of colonialism that led Betty to The Pas and contributed to her death.

Helen Betty Osborne was born on 16 July 1952, the eldest of twelve children born to Joe and Justine Osborne. She was a member of Norway House Cree Nation, which is located nearly 950 kilometres north of Winnipeg. A brilliant student, Betty dreamed of becoming a teacher, but

to achieve this goal, she needed to leave her community to secure her high school degree. While the Indian Act obligates Canada to provide education for Indian people, this does not guarantee that this education can be pursued on reserve; instead, like Indian residential schools, status Indians like Helen Betty Osborne are often forced to leave their communities to pursue secondary education at institutions guided by colonial educational principles, curriculum, and pedagogical practices. Thus, in 1969, at the age of seventeen, she moved alone to The Pas to pursue her high school diploma. Another manifestation of colonialism met her there; Betty was housed at the Guy Hill Residential School and commuted sixty-six kilometres roundtrip via bus to The Pas to attend high school at "the mostly white Margaret Barbour Collegiate" (Priest 22). The Department of Indian Affairs and Northern Development covered the cost of room and board, school supplies, and a twenty-dollar monthly allowance. However, as journalist Lisa Priest claims in her book about the murder, this "was all part of an Indian Affairs program designed to desegregate the schools by bussing in Indian kids from their remote reserves" and "[e]ach school would get a fixed price for every Indian it attracted to the classroom" (22). In other words, instead of offering secondary education on reserve, the federal government pursued assimilation and offloaded its treaty commitments and, more importantly, minimized its fiduciary responsibility to provide education for Indian students to provincially funded public secondary school institutions for pay—at the expense of Indigenous students who are forced to leave their families and communities and navigate colonial learning institutions in pursuit of their educational dreams and at the expense of Indigenous families and communities who were deprived of time with and the gifts of their children.

Nêhiyaw natural law teaches us that all things in creation are relatives and, thus, gifts to this world. Helen Betty Osborne was a gift of creation, but the gift of her life was denied to her family, community, and the world through colonial violence and the actions of white settlers. It is time to turn our attention here and hold them accountable for their actions.

Refusal and Reprisal: Colonial Fragility and the Murder of Helen Betty Osborne

On the evening of November 12, 1971, four young white men—seventeen-year-old Lee Colgan, eighteen-year-old Dwayne Johnston, twenty-three-year-old James Houghton, and twenty-five-year-old Norman Manger—came together for a good time. According to the final report of the AJI, Colgan borrowed a car from his dad, picked up Houghton and Manger, and purchased beer. After they finished the beer, they broke into a friend's apartment and stole wine. The trio went to a dance at the local Legion—an association for veterans that operates drinking establishments for its members—and drank more beer before picking up Johnston. Cruising around the snowy streets of The Pas, the four men "formed a common plan to find an Indian girl with whom to drink and have sex" (AJI). Seeing Helen Betty Osborne walking home alone, they approached and asked her to join them. She said "no," and instead of leaving her alone and going on their way, they kidnapped, physically and sexually assaulted, and murdered her.

I return to the question I posed in the introduction: Why was Helen Betty Osborne's "no" met with violence? Or stated another way: Why did these four white men murder Helen Betty Osborne for saying "no"? Betty's refusal was met with reprisal from these four white men, I contend, because of colonial fragility and the necessity for violence to ensure the colonial order of things. Living in colonial Canadian society, the four white men who murdered Helen Betty were led to believe, thanks to the ideologies of white supremacy and heteropatriarchy, that they were "princes" of this colonial castle. While they might have faced personal challenges due to heteropatriarchy, capitalism, and ableism, each of them had access to the power and privilege of whiteness and cisgender heterosexual masculinity to use at will. Moreover, regardless of personal failings, their whiteness and masculinity confirmed their right to walk in the colonial world as dominant subjects.

When Helen Betty Osborne said "no," her refusal threatened this perception of dominance and, by extension, the colonial order of things. As colonial "princes," the racist and sexist stereotypes about the promiscuity and sexual availability of Indigenous women led them to believe they had a right to approach Betty and ask her to fulfill their goal of "find[ing] an Indian girl with whom to drink and have sex" (AJI). By

refusing, Helen Betty disrupted their colonial fantasies of being dominant colonial princes with the right to access the bodies of Indigenous women. Suddenly, their superior sense of selves and their understanding of how the world should operate was being undermined by the refusal of someone they viewed, based on race and gender, to be their inferior. This would have been incredibly destabilizing for these four white "princes," effectively transforming Helen Betty, in their minds, from a target of pleasure into a threat to their supremacy.

While they could have still driven away, the four white colonial princes chose, instead, to seek reprisal and punish and eliminate this threat in an extraordinarily violent way. This choice, I contend, is the outcome of colonial fragility, rage, and the use of violence to secure colonial dominance, and the Federal Bureau of Investigation's (FBI) concept of "overkill" helps show this. While Betty was subjected to multiple forms of violence, a brutal fact that has stuck with me is that she was stabbed upwards of fifty times in the face with a screwdriver.

This excessive violence constitutes what the FBI refers to as overkill, which is driven by rage and "violence beyond what is necessary to kill the victim" (Vronsky 29). In his discussion of sexual serial murders, historian Peter Vronsky locates overkill in the category of perpetrators characterized as "anger retaliatory," whose primary motive is a "need to avenge, get even with or retaliate against a female who somehow offended him" (29). This rage, he notes, "is often inspired by a female with power over the offender in the past or present" (29).

Overkill helps us make sense of the actions of the four white men who murdered Helen Betty Osborne. While Betty's refusal represented an exercise of agency and power in that she enacted her right to self-determination and bodily autonomy, it also positioned her as a threat to the dominance of these four white men and, thus by their perception, an exercise in power over them. How could someone they understood, because of colonialism, white supremacy, and heteropatriarchy, as inferior and sexually available, refuse their request to party and engage in sexual activity with them? Moreover, how dare she do so? Betty's "no," as such, threatened their sense of self as dominant subjects and, by extension, the colonial hierarchy they sat atop and the privilege they enjoyed. Angered by this refusal and its potentially negative consequences for them, the four white men chose reprisal through the excessive violence that ended Helen Betty Osborne's life. They avenged themselves

as dominant white male colonial "princes" by murdering an Indigenous woman.

"I Don't Know Why They Just Didn't Leave These Guys Alone": White Complicity in Colonial Violence

There is a line from journalist Lisa Priest's account of the murder of Helen Betty Osborne that has haunted me since I encountered it. In response to the arrests and pursuit of criminal charges against the four perpetrators including her husband James Houghton, Shannon Houghton is claimed to have made the statement: "I don't know why they [police] just didn't leave these guys alone" (Priest 140). A young Indigenous woman was brutally murdered and instead of justice and accountability, this white woman dismisses this violence by opposing holding her murderers accountable. In doing so, she devalues the life of Helen Betty Osborne in favour of protecting the lives of the four perpetrators and, by extension, her life as the wife of one of the murderers. Her statement, like the actions of the four white men who murdered Helen Betty Osborne, is aimed at restoring the colonial order of things, where white people rule and Indigenous people disappear. Ironically, her support of the four men also reinforces heteropatriarchy under which, as a woman, she is largely denied power and privilege.

There are multiple explanations here. Her marriage secures proximal access to male privilege that may benefit her despite being a woman. Shannon's complicity with heteropatriarchy, as noted above, could be the outcome of a desire to protect her life from disruption and an unknown and potentially precarious future. We also know from Razack's analysis of colonial peacekeeper violence in Somalia that systems of oppression operate by inviting the participation of marginalized people; their complicity requires that they not only ignore the violence perpetrated against them but also participate in forms of violence that ensure the ongoing domination and oppression of nonwhites. White supremacy and colonialism allow her to be a dominant subject at her own expense as a woman living under heteropatriarchy. In any case, Shannon Houghton chose to obscure the violence, which enabled colonial domination. She is not alone: the actions of many white people associated with this case reflect efforts to restore the colonial order of things by minimizing and disregarding the life and death of an Indigenous woman in favour of protecting four

white men and, thus, colonial domination and violence.

Although some white people in The Pas community knew the identity of the perpetrators, many chose to protect these "princes" by not sharing this information with the police. For their part, police bungled the initial investigation. For example, despite having evidence that the Colgan vehicle might be linked to the murder, the police did not immediately search the vehicle. In May 1972, an anonymous letter linking the four perpetrators to the case was received, and investigators found a piece of strap linked to a bra found at the murder scene. During this early phase, police also focussed their attention on friends of Helen Betty Osborne and, as the AJI made clear, engaged in problematic and violent racist behaviour towards them. The case was passed from officer to officer throughout the later 1970s and early 1980s until charges were laid—sixteen years after the murder. The Canadian justice system demonstrated its complicity with colonial domination by exonerating all but one of the men who murdered Betty.

The final report of the AJI also exposes the complicity of community members in The Pas in actualizing the colonial racist and sexist society that contributed to the murder of Helen Betty Osborne and the miscarriage of justice that followed. The inquiry found that Indigenous people living in The Pas were subject to racist segregation, criminalization, and violence. Of importance to this analysis, the final report noted the following: "Non-Aboriginal men sexually harassed Aboriginal women, seemingly with impunity. They cruised the streets of The Pas regularly, trying to pick up Aboriginal women and girls for the purpose of having sex with them, a practice apparently well known to and ignored by the RCMP."

The actions of Colgan, Houghton, Manger, and Johnston were not isolated incidences; instead, they were the normalized actions of white men living in colonial Canadian society and exercising their right to use violence as a form of control. They lived in a colonial community that established and supported their dominance as white men with the right to access the bodies of Indigenous women and girls for their sexual gratification. They also lived in a community where violence against Indigenous peoples was justified through racism and, thus, normalized. Members of this community who did not actively oppose colonial domination were complicit in the murder because colonialism killed Helen Betty Osborne.

Conclusion

Helen Betty's refusal was powerful because it exposed the fragility of colonialism, white supremacy, and heteropatriarchy. Her "No" threatened to undermine the colonial order of things, particularly the four perpetrators' sense of self as dominant privileged subjects with the right to access the body of an Indigenous woman. To eliminate this threat, they murdered Helen Betty Osborne. But that was not enough—the fragility of this domination led numerous white people to collectively deny Helen Betty Osborne, her family and friends, her community, and Indigenous peoples justice. The refusal of one Indigenous woman required the complicity of myriad white folx to protect and reinforce colonial white supremacy and heteropatriarchy. This exemplifies the fragility of the entire system.

At the same time, this response demonstrates the level of individual and collective complicity required to maintain the colonial order of things. Dominant social systems of oppression are designed to secure a global elite, and while many of us can access elements of power, privilege, and material wealth, few of us are among that elite with unfettered access to these things. Instead, because these systems require our complicity, we are seduced by illusions of supremacy and the possibility of not only accessing power, privilege, and material wealth but also escaping the violence required to sustain these systems by resorting to violence to retain access to these things. In our attempt to escape violence, we become the weapons of dominant social systems of oppression, which are willing to sacrifice all of us to secure the global elite. While some of us are more likely to be targets of violence, no one is safe as long as dominant systems of oppression exist. This is the consequence of living in a global death cult.

This leads me to an important point: Violence against Indigenous women and girls and all Indigenous peoples will persist as long as colonialism does. As my analysis of the murder of Helen Betty Osborne makes clear, colonialism requires the dehumanization and elimination of Indigenous peoples. We will always be seen as threats to the colonial order of things and, consequently, always be subject to violence. While we can create interventions that better protect Indigenous women and girls from violence, decolonization is the most effective means to ending violence against Indigenous women and girls. In the meantime, critical interventions that can save lives—Indigenous or otherwise—including

universal basic income, access to safe and secure housing, access to physical and mental health supports, and greater government funding for organizations and services addressing violence are desperately needed.

I am frequently asked what people can do to help end violence against Indigenous women and girls, and wanting to encourage and support this type of complicity, I offer the following suggestions. First, further educate yourself about violence against Indigenous women and girls in Canada and share this with other people. A great way to do this is to read the final report of the National Inquiry into Missing and Murdered Indigenous Women and Girls (MMIWG). It and other important content can be accessed on the inquiry's website: https://www.mmiwg-ffada.ca/. The inquiry also informs my second recommendation: It issued *231 Calls for Justice* to meaningfully address violence against Indigenous women and girls, so I encourage you to identify those you can support and take immediate action to actualize that support in your personal, professional, and community life. Although the federal government released a federal action plan in response to these calls, it has done little to enact it; consequently, I also encourage you to demand that the federal government take immediate action to implement the plan. My third recommendation is to amplify and support the efforts of Indigenous women, their organizations, and communities to address this violence. We need allies and accomplices, not saviours. Trust us to lead these efforts but show up and/or contribute to support them. Finally, push Canadian governments to honour existing treaties and take immediate action to address inequities faced by Indigenous peoples but, more importantly, pursue decolonization. Helen Betty Osborne died because of the violence embedded in Canadian colonialism, and Indigenous peoples will continue to die because of colonial domination. Will you continue to be complicit?

Works Cited

Aboriginal Justice Inquiry of Manitoba. *Report of the Aboriginal Justice Inquiry of Manitoba*, http://www.ajic.mb.ca/volume.html. Accessed 14 Apr. 2024.

Bourgeois, Robyn. "Perpetual State of Violence: An Indigenous Feminist Anti-Oppression Inquiry into Missing and Murdered Indigenous Women and Girls." *Making Space for Indigenous Feminism*, 2nd ed. Edited by Joyce Green. Fernwood Publishing, 2017, pp. 253-73.

Bourgeois, Robyn. "Race, Space, and Prostitution: The Making of the Colonial Subject." *Canadian Journal of Women and the Law*, vol. 30, 2018, pp. 371-97.

Fellows, Mary-Louise, and Sherene Razack. "The Race to Innocence: Confronting Hierarchical Relations among Women." *The Journal of Gender, Race, and the Law*, vol. 335, no. 1, 1998, pp. 335-52.

Maynard, Robyn, and Leanne Betasamosake Simpson. *Rehearsals of Living*. Alfred A. Knopf Canada, 2022.

McAdam, Sylvia (Saysewahum). *Nationhood interrupted: Revitalizing nêhiyaw Legal Systems*. Purlich Publishing Ltd., 2015.

Priest, Lisa. *Conspiracy of Silence*. McClelland & Stewart, 1989.

Razack, Sherene. *Dark Threats and White Knights: The Somalia Affair, Peacekeeping, and the New Imperialism*. University of Toronto Press, 2004.

Shilling, Vincent. "The True Story of Pocahontas: Historical Myths Versus Sad Reality," *Indian Country Today*, https://indiancountrytoday.com/archive/true-story-pocahontas-historical-myths-versus-sad-reality. Accessed 14 Apr. 2024.

2.

"Chantel Was Sunshine": Centralizing Indigenous Mothering in an Honouring Story of Chantel Moore

Josephine Savarese

We, the Hawiih (hereditary chiefs) and elected Council, stand with the Martin, Masso and Moore families devastated by the death of our beautiful young mother and granddaughter, Chantel Moore.

We, the Hawiih (hereditary chiefs) and elected Council demand "better" for her 6 year old surviving daughter Gracie and justice for Chantel.

No one needs to give up their life on a wellness check—NO ONE. We demand answers on why the officer used such brutal force that was both uncalled for and unnecessary. We demand answers on why, when questioned about how many shots the officer fired, that the responding police representative laughed—adding more fuel to an already ignited fire.

This killing was completely senseless.

—Tla-O-Qui-Aht First Nation Hawiih (Hereditary Chiefs) and Elected Council Statement of the Shooting Death of Twenty-Six-Year-Old Tla-O-Qui-Aht Mother Chantel Moore (Martin), July 2020

Introduction

This chapter honours aspects of the life story of Chantel Moore, a young Indigenous mother who passed from this physical world on June 4, 2020, in Edmundston, New Brunswick, from gunshots fired at close range by law enforcement. This horrific incident highlights the urgency of systemic transformation to address the normalization of police violence in criminal legal systems (Ritchie; FAFIA). To pay tribute to this young mother, this text amplifies the alarm sounded by the Tla-O-Qui-Aht First Nation Hawiih (Hereditary Chiefs) and Elected Council in the opening statement. Chantel Moore's violent death is explored alongside Andrea J. Ritchie's finding that the devaluation of Indigenous women is a factor in deadly policing encounters (19-25). This violence is also theorized through the work of Australian anthropologist, Amanda Kearney. In her 2021 article "To Cut Down the Dreaming: Epistemic Violence, Ambivalence and the Logic of Coloniality", Kearney describes the long-lasting, even permanent consequences of settler violence (312-34).

In this chapter, the fatal shooting, and the responses to it are tracked to illustrate the continuation of "epistemic violence," or acts of delegitimation against the Indigenous peoples who are the guardians of occupied lands, including the territory called Canada (Kearney 312). For Kearney, this violence is evidence of "axiological retreat" or the "dismissal of value and worth" (312) embedded in "settler relations and state interactions" with Indigenous nations/communities (Kearney 316). This chapter supports the Moore, Martin family, community, elected leaders, council members, friends, and allies in demanding justice for a mother who relocated to New Brunswick to shelter and guide her then five-year-old daughter. As the Tla-O-Qui-Aht First Nation Hawiih (Hereditary Chiefs) and Elected Council stated in their call for murder charges against the officer: "We are all humans and not animals ... we expect to be treated with honour and not anger" (Tla-O-Qui-Aht First Nation Hawiih (Hereditary Chiefs) and Elected Council, "Chantel Moore was Promised").

This chapter honours Chantel Moore and brings significance to her life. It denounces the inadequate responses by government and policing agencies as well as the muted public outcry to the fatality. For example, limited disciplinary action was taken against the police officer. On July 4, 2020, only weeks after the shooting, he returned to the force in an administrative role following a brief paid leave of absence (Quon and Brown). In June 2021, the Government of New Brunswick's Public Prosecutions

Service publicized its decision not to pursue criminal charges based on a review that determined that there was no reasonable prospect of conviction (Magee). More recently, the shooting was described as a homicide by a May 2022 inquest (Government of New Brunswick, "Coroner's").

Bearing Witness to the Depth of What Is at Stake

To theorize the state responses to the murder of Chantel Moore, this chapter examines what might be an unexpected source, namely Indigenous knowledge from outside of Canada. It draws from Yanyuwa Elders' stories about the demolition of an Ancestor in 1979 who manifested in a magnificent Cycad palm in Yanyuwa country in the southwest Gulf of Carpentaria in the country called Australia (Kearney). The communities' experiences of the loss of this great Being, holder of song lines and ceremony, shared with Australian anthropologist, Amanda Kearney, were examined in greater detail to inform this writing honouring Chantel Moore. The incidents discussed in this chapter, from the demolition of a prized palm to a shooting death, may appear dissimilar. The outrage experienced by the Indigenous Australians who lived in harmony with the Ancestor is highlighted to bring disquiet to the loss of another precious beloved, now ancestor, Chantel Moore (Kearney). The Yanyuwa Elders are located on another land and reference different cosmologies. The Elders describe what unfolds when "Dreaming ancestors" are "blown up, cut down or harmed" by "incoming agents" (Kearney 316). Their accounts bear witness to the harm from violations of Indigenous Law.

The destroyed Cycad palm was particularly important because it was an extraordinary being, namely Yulungurri, the Tiger Shark Dreaming Ancestor. According to Yanyuwa historians, Yulungurri travelled vast distances to arrive in Yanyuwa country. During Yulungurri's journey, he "called the names for country he passed," bringing them "into being" and created "the basis for human engagements with them" (Kearney 319). In 1979, a non-Indigenous worker at a pastoral station shocked the Yanyuwa community by cutting down a Cycad grove, including the Cycad tree that manifested the Dreaming Ancestor. The injury was compounded because the destruction was largely treated as inconsequential by the settler agents (321-322).

In contrast to muted settler accounts, the Yanyuwa leaders expressed outrage and grief regarding the Ancestor's destruction. They denounced

the impact on families and communities, a theme the Martin/Moore family has repeatedly emphasized in public statements. Chantel Moore's advocates and kin have condemned the "horrific acts of aggression" towards their daughter and beloved relative in ways that are unique to their story (327). The fact that these hurts are significant and long-lasting is a theme that reverberates through both stories. That these violent disruptions "reconfigure lives in the most dramatic of ways, affecting constructs and expressions of identity" is a teaching that this chapter works to emphasize by drawing from two seemingly disparate situations, united by the threads of colonialism, encroachment, systemic racism, violence, and indifference countered by kinship and love (327).

The Elders and community members' statements cited in Kearney's study are affirmations of the Martin/Moore family and advocate's urgent request that settlers hear "the depth of what is at stake when such violence occurs" (316). Analyzing the destruction of the Dreaming Ancestor reinforces why denouncing the epistemic violence and disruptions occurring in Indigenous homelands, including the trauma of violence to Indigenous women and girls in Canada, matters. The enduring harms to the Yanyuwa are set alongside the wounds to Chantel Moore's body, family, and spirit to challenge the settler indifference to destruction and death. This lack of caring was evident in state responses that exonerated those responsible for the June 2020 murder described as "senseless, avoidable and an act of systemic racism" (Tla-O-Qui-Aht First Nation Hawiih). The harm done provides an "opportunity" to consider what Kearney refers to as "axioms of violence" (313). The gunshots that caused the death of Chantel Moore and the unanswered questions surrounding her death are made prominent to denounce ways that the denigration of Indigenous peoples and lands can be used to justify, downplay, or excuse harms ranging from the destruction of a beloved Dreaming ancestor, Yulungurri, to the use of extreme force by law enforcement on the body of a twenty-six-year-old Tla-o-qui-aht mother during a wellness check.

In a time of grief and devastation, Chantel Moore's mother, Martha Martin, has demanded justice for her daughter. She persists in her advocacy so that "her daughter has a voice" (Brown). Martha Martin stated that she felt like she was being pushed to "forget" that her daughter was fatally shot. She worried that "not enough" was being said on her daughter's behalf. As a result, she acted as "the voice" for her daughter (Brown).

Seeing and Feeling the Hate

Healing walks were held on 13 June 2020 across the Maritimes in Edmundston, Aqpahak (Fredericton), Moncton, New Brunswick, and in Membertou and Kijipuktuk (Halifax), Nova Scotia, in response to the murder. A member of Moore's family who attended the Edmundston walk reminded the public that they had been "hurt too many times" (Brown and Moore). The person queried, "How can we ever trust any police force?" (Brown and Moore). In a protocol circulated for the healing walk in Kijipuktuk/Halifax on June 13, 2020, the event was described as "Ikatomone"—a word that translates to "'let's guard' our way of life, our languages, our ceremonies, our rights to declare justice" (CBC News, "Hundreds Walk to Honour Chantel Moore").

Given the outrage connected to this death, it is understandable that Annie Bernard Daisley, then-president of the Nova Scotia Native Women's Association, issued a call in July 2020 that governments denounce the violence directed towards Indigenous people. She stated: "You have treated our lives as though we are disposable, that we do not matter. Our lives come and go to you. We are just a number. You took from us and you still do. You do it quietly and secretly. You hide behind inquiries, you hide behind the police force, you hide behind a "knife", you hide your hate. But we see and feel it" (Bernard Daisley).

Jennifer Brant's work on Indigenous maternal histories explains why Indigenous women have been targeted for the violence that Bernard Daisley denounces. According to Brant, women posed challenges to settler agents seeking control over Indigenous lands and waters: "Attacking the women, specifically through their role as mothers, was an intentional move that satisfied the colonial invasion of this land" ("From" 40). The fatal shooting of Chantel Moore is a tragic illustration of Brant's assertion that Indigenous women are vulnerable because they threaten settler claims to Indigenous homelands and waters.

Overview/Background Information

In 2020, Chantel Moore left her community, the Tla-o-qui-aht First Nation, in British Columbia, to relocate to the small city of Edmundston, New Brunswick to be closer to her family, particularly her mother and young daughter. A few months later, she was fatally shot by an officer

with the Royal Canadian Mounted Police in that northern New Brunswick location. The officer who killed Moore went to her residence to perform a wellness check after a friend Chantel dated before he returned to Québec contacted police out of concern. The friend reported that Chantel feared a person who was harassing her. The friend received some disturbing texts on the evening of the fatal shooting over Facebook Messenger written in the third person. The officer, who is unnamed in this text, stated that he knocked on a window of Chantel Moore's apartment on his arrival. After knocking, the officer moved to the entrance door of the apartment. According to the officer, he saw Chantel retrieving something metallic.

The officer later stated that Chantel Moore was holding a knife when she opened the door. According to the officer, he commanded that Chantel Moore drop the knife. He spoke in French, a language she did not understand. The officer claimed that she continued towards him blocking his movement on the balcony, forcing him into a defensive position. He reported that he had already removed his gun from his holster due to his claim that he observed her approaching the apartment door with a knife (Magee). The officer further admitted that it was only a matter of seconds from the time that Moore opened her door to the time he shot her (Titian, "Why Weren't Charges Laid"). He claimed he was in a difficult predicament because Moore was wielding a knife and appeared threatening.

More Heartbreak for the Family

At the request of the New Brunswick government, Moore's death was investigated by an oversight agency, the Bureau des enquêtes indépendantes du Québec (BEI). That report was not released publicly or shared with the family. The BEI findings, however, were considered by the Public Prosecutions Service of New Brunswick to determine whether criminal charges were warranted (Titian, "More Heartbreak for Family"). In the statement released on June 7, 2021, the New Brunswick Public Prosecution Service announced that no charges would proceed against the officer based on a review of the BEI report (Basu). The statement cited subsection 25(1) of the Canadian Criminal Code in its determination that the officer was justified in "doing what is required or authorized to do and in using as much force as is necessary for that purpose" (Government of New Brunswick, "Statement").

The statement was accompanied by a twenty-page legal opinion summarizing the evidence prepared by the BEI (Government of New Brunswick, "Statement"). The Public Prosecution Services of New Brunswick shared the finding that "no other reasonable options" were available to the officer apart from using "lethal force to subdue a real threat to protect himself from potential severe bodily harm or death" because of the "circumstances" of the incident and "the physical surroundings" (Office of the Attorney General 19).

The New Brunswick Police Commission also investigated a complaint filed by legal counsel for the family against the police officer responsible for the fatality. After an investigation, the New Brunswick Police Commission declared that the officer did not commit any wrongdoing in firing fatal shots at Chantel Moore. The commission released its findings in November 2021 through a news release by commission chair Marc Léger. The Commission found there was no breach of the Code of Professional Conduct Regulation. The Regulation sets out standards in section 34, including the requirement that officers "respect the rights of all persons" in Article (a). Officers are also required to abide by article (h), which dictates that officers must "treat all persons or classes of persons equally, regardless of race, colour, religion, national origin, ancestry, place of origin, age, physical disability, mental disability, marital status, sexual orientation, sex, social condition, political belief or activity" (Code of Professional Conduct Regulation, NB Reg 2007-81, Police Act, SNB 1977, c P-9.2.). The commission concluded there was insufficient evidence to find that the officer breached the professional standards (Cox, "No").

Discrediting Scripts

An alarming feature of the legal opinion circulated by the New Brunswick government summarizing findings related to Chantel Moore's death is that it reverts to the discriminatory scripts informed by the victim-blaming discourses that scholars have denounced for decades. These denunciatory frames fuelled the demands for a national inquiry to compel action towards Indigenous women's safety (see, for example, various chapters in Lavell-Harvard and Brant). Adopting the reasoning that scholars and advocates rebuke, the opinion stated:

Ms. Chantel Moore's death, although deeply regrettable, was as a result of her being severely impaired by alcohol and combined with her actions, specifically exiting her residence brandishing a knife, steadily advancing upon Officer 1, who was restricted in movement by the confined space of the third-floor balcony and not responding to his clear orders to "drop the knife" (Government of New Brunswick, "Review" 19).

This wording diminishes Chantel's humanity and fails to adequately probe the alternative presentations of Chantel that describe her as incapable of posing a threat. The claim of extreme intoxication was contradicted by evidence shared at the inquest in May 2022 by a forensic toxicologist, James Wigmore. He reported that Moore's blood alcohol content was equivalent to five bottles of beer. While this amount exceeded the legal limit for driving, it was not enough to even produce signs of intoxication (Moore, "Former"). In contrast to statements valorizing the actions of the officer responsible, Chantel Moore's family and community have emphasized systemic discrimination and indiscriminate violence. They have criticized official pronouncements that blame "lifestyle choices" for the violence towards Chantel Moore (Ha-Shilth-Sa).

Honouring Chantel Moore

The Moore/Martin families have reinforced Chantel Moore's worthiness and the grievability of her death to counter and challenge the settler state's failed response to the murder. With their supporters, the family has made repeated demands for recognition and accountability. Commentators rejected the likelihood that Chantel was the aggressor. Then-president of the Nova Scotia Native Women's Association, Annie Bernard Daisley, released an opinion where she described the officer as a "big strapping man, full of strength and power, a police officer". She was incredulous that he feared "a 100-pound woman" prompting him to shoot her five times (Bernard Daisley). Others have emphasized Chantel Moore's positive qualities while denouncing unprovoked violence irrespective of the victim's qualities. They describe her as "a good mom,"—a person who made friends easily, a person who "loved to make people laugh" (B. Morin, "The Indigenous People").

Chantel's community and family, along with Indigenous activists,

scholars and allies have called upon the Canadian state and its residents to confront, rather than further conceal, the "vulgarity of whiteness and racialized privilege" (Formanack qtd. in Kearney 329). For Kearney, exposing the links between coloniality, "the lasting and enduring condition set into play by colonisation" (313) and repugnancy is very important. The "logics of war, destruction, racism, sexism, inequality and injustice" lie beneath these intertwining oppressions of vulgarity and coloniality (329). These factors are used to justify epistemic and other violence/s that erupt in coloniality's wake (329). The logics that secure coloniality's place in settler societies were influential in the decision to use lethal force against Chantel Moore, a young, diminutive, and vulnerable mother, surprised by a law enforcement officer knocking on her window in the early hours of the morning. Ironically, the officer was there to respond to a concern about a potentially threatening intruder. Jean-René Lévesque, a private investigator, was hired by the New Brunswick Police Commission, testified at the inquest. He stated that Chantel Moore likely could not see that the person at her door was a police officer, which may account for the startled and wary response described by the gunman (CBC News, "Inquest Witnesses Elaborate").

Cutting Down the Dreaming

Throughout this chapter, I centralize and theorize the tragic death of a vital human being. I searched into the Yanyuwa stories and Kearney's 2021 article "To Cut Down the Dreaming: Epistemic Violence, Ambivalence and the Logic of Coloniality" for evidence of the injurious consequences of settler violence (312-34). To prepare her text, Kearney spent over two decades working with the Elders and residents to document the impacts of the colonial violence imposed on Indigenous lands and communities in Yanyuwa country in the Gulf of Carpentaria (313). The stories of the lingering heartbreak and outrage that resulted from the loss of Yulungurri—a living being, a bringer of ceremony, the embodied Ancestor, and a bearer of culture, history, and knowledge—bring insight into the great sadness and demands for change that resulted from the passing of Chantel Moore, a mother, sister, and friend, another living and cherished being. Chantel Moore served as a vital link in the relational moral and kinship orders that Brant brings into the Canadian context in her work on maternal knowledge.

Like Kearney and her Yanyuwa partners, I wish to open discussion on "the relationship between dominant patterns of thought and systems of value that linger with coloniality" and to explore ways these foster or rationalize "the attempted destruction of the Dreaming" in the Australian context or the eradication of Indigenous women in the Canadian context (313). Statements by Chantel Moore's family and community bring insight to the historical and systemic factors that brought about the tragic shooting of a young woman, a sacred being, who like Yulungurri, the Dreaming Ancestor, was positioned to pass on important teachings to the next generations in her motherhood role and due to her importance in her kinship networks.

Examining Impunity

A prosecution was also rejected against an officer following the shooting death of an Indigenous man, Rodney Levi, in New Brunswick only days after Chantel Moore died from gunshot wounds. Rodney Levi's death several weeks later is briefly discussed; it is one of the events that affirms the importance of this chapter. Amanda Myran, an organizer of a healing walk for Chantel Moore in the summer of 2020, stated that "having two Indigenous people killed in Wabanaki territory" over eight days "speaks to the fact that this is a crisis" and demonstrated that "it needs to be addressed as such" (S. Morin, "Calls for Justice"). As Amanda Myran and others stated, these tragic deaths of two Indigenous people within days of each show that policing violence is a way Indigenous peoples are "disappeared," undermining their role as life-givers and community builders as well as leaders and protectors (Kuokkanan 166).

Valuing Indigenous Lifeworlds

Thinking with Kearney, this chapter reads the fatalities as examples of the "existential condition of indifference" directed towards "Indigenous needs, interests, values, and cosmologies" that enlivens "the lifeworld of the settler colonial actor" and that is realized "in an ontology of 'failing to care'" (Pipyrou and Sorge 236). The legal opinion released by the Public Prosecution Services on June 7, 2021, is an example of what Kearney labels "epistemic violence," following Spivak (325). The term "epistemic violence" applies because it includes both intentional acts as well as the

failure to see that harm has consequences—that it is commensurate with losses (316). Thus, it includes "the silencing that occurs when dominant and powerful forces encounter and narrate the 'other,'" (325)—a suppression that is noticeable in the state responses to the fatal shooting of Chantel Moore, which treated Indigenous voices and outcry as nominal. One example is the refusal to create an inquiry that Indigenous leaders have demanded (Metallic).

Furthermore, the New Brunswick government described the shooting in muted terms as an "unfortunate tragedy" even while it "found no criminal conduct" by the constable in his actions on June 4, 2020 (Government of New Brunswick, "Review" 20). This pronouncement and others minimized the community and family's grief and outrage. Expanding on Kearney's reasoning, it is through official statements like these that the epistemic violence shown in her 2021 text is realized and implemented. This violence takes place when "a group's ability to speak or be heard is damaged, when the very existence of other ways of knowing are denied or obliterated by the dominant majority" (325).

In contrast to the muted statements from officials, Chantel Moore's supporters have called for recognition. At the Halifax healing walk, one speaker, Raven Davis, an Anishinaabe, two-spirit, transgender, disabled multidisciplinary artist, activist, and educator, emphasized Chantel Moore's importance as a mother: "Chantel Moore left behind a five-year-old girl. A girl who will grow up knowing the police murdered her mother. A girl who will grow up mourning her mother every time she sees a police car" (Devet). Davis continued:

"Chantel Moore left behind a girl who will be permanently affected for the rest of her life as a result of the murder of her mother by the police. Chantel's little girl is going to bed today without a hug from her loving arms. She is going to bed without a story that puts her mind in a fairy tale. She is going to bed without a song, a lullaby, or a chant. She is going to bed without a kiss from her mother. She is going to bed without a prayer spoken by her mother. Most unfortunately, she will never have the opportunity to know Chantel Moore, her mother, and her incredible resilience, strength, and beauty" (Devet).

Family members have also reported that Chantel's daughter is longing for her mom. In particular, she "misses her mum's cuddles" (Cave). She wishes she could draw with her mom; she misses her "in every way." For the family, it is hurtful and heartbreaking to hear these pleas (Cave).

In response to the inaction and weak response by the state agents authorized to deliver justice, this chapter ponders Kearney's query: "Why [is] greater value ... not seen in Indigenous lifeworlds?" (314) This concern is presented as one that is "worth asking" in the "context of a study of violence" (314). As such, it is a provocative reflection for this study on the murder of a Tla-o-qui-aht mother, shot during a "wellness check."

Chantel Was Sunshine

The downgraded status granted to Indigenous mothers needs to be further troubled to identify ways it can be used to justify or excuse excessive force by law enforcement (Brant, "Indigenous"). Brant's analysis regarding acts of ongoing gendered and colonial violence that persistently focus on Indigenous mothering practices foregrounds this discussion ("Indigenous"). Brant highlights the need for research exploring the intersections between violence and Indigenous mothering. Her recommendation that future scholarship examine the connections between contemporary forms of violence against Indigenous women and the ongoing systemic attacks on Indigenous motherhood is one that this text attempts to take up by honouring the loss of a young Indigenous mother and by denouncing the unjustified violence that led to her untimely demise.

Rauna Kuokkanen's critique of the ways that Indigenous women are alternatively valorized as "mothers of the nation" while being afforded a muted political voice and limited power over their own lives and the lives of their children offers insight into the structural constraints that govern Indigenous women's lives (166). This chapter works to theorize ways that the devaluation of Indigenous women and parents may have underscored the officer's violent response during what might have otherwise been a routine call prompted by a concern for Chantel Moore's safety. Scholars argue that the "horrific stereotypes" of Indigenous women that operate due to colonialism and the patriarchy have created an oppressive legacy that materializes as "real horrific actions" directed towards Indigenous women (Marques and Monchalin 86).

This text affirms ways forward towards the greater valuing of Indigenous women and mothers that might dismantle colonial projections of Indigenous women, mothers, and girls as menacing, degenerate, and threatening. This was the case in the shooting of Chantel Moore under review here. Supporters have expressed outrage that she was described

as intimidating even while her leg was broken, her body was bruised, and her back and torso were riddled with at least four bullets, with more suspected by the family (Cave). In contrast to these narratives, a firekeeper at the funeral and ceremony held in New Brunswick in June 2020 stated: "Chantel was love. She was sunshine" (Canadian Press).

What Kind of Wellness Check?

This text finds similarity in the indifference that Kearney and her Indigenous collaborators describe in the findings of the various tribunals that exonerated the officer, as well as the Government of New Brunswick's failure to create the inquiry demanded by six elected leaders of the Wolastoqey Nation in New Brunswick. Their call was reissued in May 2022 following a finding by a coroner's inquest that the officer's actions constituted a homicide. Chief Allan Polchies of the St. Mary's First Nation in the capital city of Aqpahak (Fredericton), New Brunswick urged the creation of the inquiry to promote more accountability for Moore's death. He told reporters: "We need action. We need justice. We need justice for every single person" (qtd. in Bissett). Following Kearney, the reluctance to establish the inquiry could be seen as the "axiological retreat," or the collapse of a principled stance. This retreat can be seen in "the dismissal of value and worth," which reinforces "a tendency to erase, devalue or silence a pre-existing and continuing moral order" (316).

A further example of moral retreat is the legal opinion shared by the New Brunswick agency. It references yet gives little weight to a concern that the knife found on the scene was planted, given that it was not seen by the emergency personnel who were the first responders. One of the witnesses, Witness 11, who was at the apartment building on the night of Chantel's death, stated that he believed "the police added/placed the knife at the scene" (Government of New Brunswick, "Review" 9). The attorney general did not conclude that the knife was "intentionally moved or placed by anyone"; it was hypothesized that it was likely moved when Chantel Moore's body was turned over to apply pressure to the gunshot wounds (Government of New Brunswick, "Review" 20).

The disconcerting finding that the forensic analysis of the knife revealed "digital fingerprints" that were not of sufficient "quality/clarity" to "positively identify and/or to assign to a specific individual" was noted in a factual, clinical tone in the Government of New Brunswick's "Review

of the Report from the Bureau des enquêtes indépendantes du Québec (BEI) of its investigation following the death of Chantel Courtney Moore and Legal Opinion" (19). This finding is surprising, given that the officer described Chantel Moore as clutching the knife in a threatening fashion. An RCMP officer who testified at the May 2022 inquest confirmed that the knife was not visible when responders arrived at the crime scene. It was discovered when an investigator moved a piece of cardboard on the balcony disclosing a steak knife beneath the heavy paper (Sweet, "'Heavy Day' for Family").

In the June 2021 statement by Public Prosecutions Services, the circumstances surrounding the death of Ms. Moore were described as "tragic." It was acknowledged that Chantel Moore was a "beloved daughter, mother, sister and friend" (Government of New Brunswick, "Statement"). Overall, the findings were unacceptable to the family and community. The grandmother of Chantel Moore, Grace Frank, for example, expressed outrage regarding the failure to pursue criminal charges against the officer, stating there was "a lot more to the story" (Moore, "Family"). Grace Frank saw her granddaughter's body before the burial and came away with unanswered questions, particularly regarding her injuries. She asked, "Why did she have a broken leg? Why did she have a broken arm? Why were there bruises on her body?" (Moore, "Family"). Frank was troubled by the "bruises around her waist and inside of her thighs." In Frank's assessment, the injuries made it appear as though "something happened to her before they killed her" (Moore, "Family").

Chantel Moore's family and community have expressed bewilderment and horror at the circumstances of her death. Family and community members have described official accounts of the shooting as incredulous and unconvincing, given the absence of any record of violence during Chantel's lifetime. They emphasized that the officer's response was extreme given that Chantel was shot at least four times, with earlier reports stating she was shot five times. Her mother, Martha Martin, asked in 2021, what "kind of wellness check" had occurred, noting that her daughter was shot three times in the back and twice in the chest. In addition, the bottom half of her leg was "completely broken" (Cox, "Chantel").

In July 2020, Indigenous leaders from various nations in New Brunswick affirmed the call for an independent, Indigenous-led public inquiry to investigate systemic racism, citing the deaths of Chantel Moore and Rodney Levi, the two police shootings of Indigenous people in 2020, as

well as other incidents (Canadian Press). In response to the deaths and the calls for an inquiry, Amanda Myran, then the University of New Brunswick's assistant vice-president of Indigenous engagement, the university's Piluwitahasuwin, demanded Indigenous, civilian oversight over police agencies, reinforcing a main recommendation of the federal inquiry into murdered and missing Indigenous women and girls. For Myran, it was important to acknowledge that there was "systemic racism in policing and the justice system" (MacDonald) and that racism was killing Indigenous peoples.

A coroner's inquest into the shooting death of Chantel Moore by the police officer was eventually held in May 2022 after a several-month delay. For Chantel Moore's mother, Martha Martin, the postponement was frustrating; it was "a slap in the face" to the family who wanted more information and some degree of closure (Moore, "Mother"). In May 2022, the inquest jury determined that Chantel Moore's death was a homicide. In a statement, Justice and Public Safety explained that the homicide "classification" does not "imply culpability," which is outside of the mandate of the coroner or the jury ("Coroner's Inquest"). Tla-O-Qui-Aht First Nation has consistently demanded that the "police officer that killed Chantel be charged with murder under Canada's Criminal Code" (Tla-O-Qui-Aht First Nation Hawiih), since the killing in June 2020.

Following the jury's pronouncement, the six chiefs of the Wolastoqey Nation in New Brunswick repeated the demand for an Indigenous-led inquiry into systemic racism. A Wolastoqi Elder, Alma Brooks, denounced the focus on "Tasers, training and broken equipment," refuting the suggestion that firing a taser rather than a gun would have been the appropriate response to a mental health-related check. She called for measures to address police-led "violence" and "corruption" and urged funds for more "significant change in the system" (qtd. in Sweet). In her remarks, Martha Martin, Chantel's mother, simply stated "We've had enough" (qtd. in Sweet).

Confronting Epistemic Violence

Many voices informed this theorization of the everyday violence/s towards Indigenous peoples behind the shooting. Drawing from Kearney and her Yanyuwa partners, this text suggests that Chantel Moore's death violated what Indigenous Australians call "the kincentric order," where

"dreaming places are relationally held" and where human connections are prized (327). In contrast to the findings from state investigations, Indigenous peoples and concerned observers have mutually recognized "the actuality of co-existing lifeworlds and logics" (327). By extension, the violation of the harmony agreed to in peace and friendship treaties signed in Atlantic Canada is grounds for denouncing the officer's injurious actions that resulted in a homicide.

Martha Martin and Chantel Moore's community and supporters have strongly rebuked that the shooting was justified. They have asked legal systems, including policing institutions, to see the shooting as preventable and incomprehensible. Rather than defensive policing, it was experienced "as violence" for her loved ones (Kearney 327; Cave). The ongoing nature of the tragedy is sadly illustrated by the fact that in November 2021, fewer than six months after Chantel's passing, Mike Martin, her twenty-three-year-old brother, died in custody while detained in a British Columbia correctional centre (Brown and Moore).

Kearney uses the concept of ambivalence to account for the destructive settler actions, documented throughout this chapter, to show that this seemingly "innocuous state of mind, a feeling without consequence" conceals "epistemic tendencies" that range from "doubt and indecision to equivocation and lack of attentiveness" (312). Ambivalence, in the context of Kearney's research and, by extension, this chapter, on "dominant settler colonial attitudes to the lives, Laws, lands and waters of Indigenous peoples" is a strong indicator of the "lasting effects of frontier violence" (312). For Kearney, the ambivalence of settler's societies "towards Indigenous knowledge and presence" is what "leads to and shrinks the magnitude of actions which destroy or damage the Dreaming" (314). In the development of this chapter, Kearney's emphasis on ambivalence was relied on to ponder the rationalities that were mobilized by police and oversight agencies to exonerate the officer by finding that he acted with reasonable force against an Indigenous mother described as typically upbeat and happy. Her grandmother, Grace Frank, recalled: "[She] was the kindest, [most] caring, loving, supportive, bubbly person. She never had hate for anyone. People loved her" (B. Morin, "The Indigenous People"). Statements from Indigenous families and supporters, like Grace Frank and the Hereditary Chiefs and Elected Council, counter state ambivalence and the violence it makes invisible. Naturally, the Martin/Moore supporters oppose violence, irrespective of the victim's traits.

Still Less Visible: Police Violence and Indigenous Women

The focus on policing violence addressed in this chapter has been a topic of outrage for decades. The outcry seemed to reach a crescendo in North America with the murder of a Black father, George Floyd, in Minneapolis in the summer of 2020 on 25 May. While the deaths of vulnerable men are heartbreaking and outrageous, scholars, and activists, including Andrea J. Ritchie, author of *Invisible No More: Police Violence Against Black Women and Women of Color*, are urging a shift towards an increased focus on violence towards Black, Indigenous, and women of colour as a topic deserving of greater attention and advocacy. Ritchie maintains that stories and accounts of police violence against women are important to amplify "because the lives and experiences of Black women, Native women, and women of colour matter" (235). Her words affirm Chantel Moore's life story and this study of the lethal force that caused her death. Ritchie's comment that "forms of police violence uniquely or disproportionately experienced by women" as well as the "contexts" in which women regularly encounter police "need to be subject to greater scrutiny" supports this chapter's significance (234).

In the Canadian context, a 2022 report by the Feminist Action Alliance for International Action (FAFIA), *Toxic Culture of the RCMP: Misogyny, Racism, and Violence against Women in Canada's National Police Force*, reinforces the concern and demands for action. The FAFIA report was authored by a coalition of Indigenous and feminist advocates to call attention to systemic discrimination and violence in policing, particularly the Royal Canadian Mounted Police. The FAFIA report bolsters calls from the National Inquiry into Missing and Murdered Indigenous Women and Girls. The commissioners called upon Canada to address the genocide committed against Indigenous peoples, particularly women, in its final report *Reclaiming Power and Place: The Final Report of the National Inquiry into Missing and Murdered Indigenous Women and Girls* published in 2019. The commissioners cited the "deaths of women in police custody" as one of the many examples of the ongoing genocide (53). In her 2022 article, Sylvia Rich presents the sexual violence of police organizations towards Indigenous women as a corporate crime that should be prohibited by the Canadian Criminal Code (135-53). To preface her arguments, she cites the incidents in Val D'or Québec, where it was reported that police of-

ficers from the Sûreté du Québec beat and sexually exploited Indigenous women. The story first became public in October 2015 through a Radio-Canada investigative report, in which Indigenous women share accounts of their mistreatment by law enforcement. While no criminal charges commenced against the officers, the Public Inquiry Commission on Relations between Indigenous Peoples and Certain Public Services in Québec was established to investigate the complaints (Fundira and Montpetit).

This chapter is written at a time when Indigenous women are overincarcerated, intensely vulnerable to violence and disappearance to the extreme of homicide, and subject to hyperregulation through the child welfare system and other oppressive systems, including the health system. This backdrop formed the basis for this scholarly investigation into policing violence and for attention to its impact on Indigenous mothers, like Chantel Moore. An example of the view that Indigenous women are threatening appears in the summary of the officer's evidence: "Scared that [Chantel Moore] would hurt or kill him, Officer 1 said he fired his gun until the threat was no longer present" (qtd. in Magee).

Equally alarming is the fact that Chantel Moore's furrowed brow was cited as one reason for the reaction by law enforcement at her apartment door, along with the possible presence of a kitchen knife, which was disputed by the family and one witness (Bisset, "No Charges"). One of Chantel's neighbours, identified as Witness 9, testified that Chantel was reasonable and even contrite only a few hours before the shooting. The neighbour reported to the BEI that she spoke with Chantel around 11 p.m. on June 3, 2020. Witness 9 reached out to Ms. Moore to complain about the noise coming from Chantel's apartment. A female friend was also present. Witness 9 described Ms. Moore as "very friendly, happy" and "a bit drunk"; Moore apologized for the noise (Government of New Brunswick, "Review" 7). The neighbour reassured her that "as long as [they could] talk to each other there [would] be no problems" (7). They introduced themselves and shook hands. The neighbour awoke at her home in the early hours of June 4 to the sound of gunshots (7).

For Ritchie, it is important to acknowledge the interlocking oppressive systems that propel and justify police and other forms of violence. She asks us to notice white supremacy's insistence on "complete control of Black women and women of color," which means that very little is needed to characterize marginalized women "as out of control" especially

when combined with "gendered perceptions that women are always out of control" (236). Richie's finding that officers often perceive themselves as physically threatened when a Black woman or woman of colour questions or ignores law enforcement commands was a factor in the murder of Chantel Moore (236-37).

The Continued Disappearance of Indigenous Women

Research studies verify the concern about the targeting of Indigenous people for violence during policing. A 2017 study reported that an Indigenous person in Canada is over ten times more likely to be fatally shot by a police officer than a lighter-skinned resident. Chantel Moore's death is the leading life story discussed in the article (B. Morin, "The Indigenous People").

In their scholarship, Olga Marques and Lisa Monchalin also suggest that the deaths and disappearances of Indigenous women, like Chantel Moore, are not accidental. While their scholarship focuses on criminalized women, it brings insight into the multiple ways that Indigenous women have disappeared and how Chantel Moore was victimized and brutalized in the seven minutes between the arrival of a solitary police officer at her apartment and her death. As they state, "In facilitating the continued disappearance of Indigenous women from communities and families, white settler colonialism is upheld, people are extracted from their communities, and practices of racial and gendered violence are facilitated" (95).

In a recent publication, Christopher Grieg and Kimberley Hillier specifically comment on Chantel Moore's death. They observe that she was shot just over a week after the murder of George Floyd in the United States, an incident that galvanized outrage towards state violence and that seemed to increase police defensiveness (80). They argue that Moore's death coincides with Audra Simpson's idea of the colonial state's "ongoing project of dispossession" through law enforcement (81). These scholars urge us to note that Moore's death tragically illustrates how "the white colonial settler state 'moves through bodies, through flesh,'" made plain by the disproportionate number of fatalities from policing and by "the bodies of the murdered and missing Indigenous women and girls" (81).

Revisiting the Fraught Promise of Reflexivity

Given the depth of this egregious violence, it is understandable that the scholarship on the shooting of Chantel Moore is increasing. In a 2020 edition of the *Canadian Medical Association* journal, Nikisha Khare and her colleagues discuss several fatalities caused by policing violence, including the death of Chantel Moore. These authors call upon us to question "systems of patriarchal, racist and economic oppression, exacerbating socioeconomic inequities in Canada" (E1220) and argue that we "must replace oppressive institutions with equity-affirming ones, with the success of society measured by the well-being of its communities" (E1220). They contend that shifting resources towards "upstream" non-punitive supports is the "best way forward in achieving safety for all, through this pandemic and beyond" (E1220). Nahid Widaatalla calls for "an increased, active role of public health in collaboration with communities, to create justice systems that are effective and accountable." Law Professor Naiomi Metallic has also penned an article for the *Journal of New Brunswick Studies/Revue d'etudes sur le Nouveau-Brunswick* advocating for an inquiry into systemic racism in New Brunswick, citing the deaths of Chantel Moore and Rodney Levi. This chapter works to counter ways that Chantel Moore's death is presented as exceptional and outside of the norm rather than the routine occurrence described by Black and Indigenous scholars (Ritchie; Monchalin and Marques). After Chantel Moore was shot, Grand Chief Stewart Phillip of the BC Union of Indian Chiefs commented on the regularity of policing violence towards Indigenous people. He stated that the absence of dedicated effort to "dismantle the white supremacy foundational to policing" means that Chantel's death was "one in a pattern rather than an exception" (British Columbia Assembly of First Nations) and that we need "to tear down the systems that allow for the pattern to continue" (British Columbia Assembly of First Nations).

Arguably, what is important to take notice of are the rare "intersubjective moments" that "challenge the colonial nature of the encounter" (D'Arcangelis 348-349). This chapter is written to expose policing violence against Indigenous women as as a regular component of colonial relations. It is presented as evidence of the violence that permeates structures and relations. In the next section, I return to calls by the Yanuwa for justice and recognition following the deliberate destruction of their ancestor. The concern here is also with destruction, given this chapter's

focus on the loss of Indigenous life, the indifference to the Martin and Moore family's mourning, and their demands for accountability.

Disrupting the Emplacement of Indigenous Law

This chapter suggests that the demolition of Yulungurri and the murder of Chantel Moore are both examples of the "naturalisation of violence in everyday life" (Kearney 312) as it manifests in two settler colonial contexts: Australia, and Canada. Kearney's reminder that coloniality "thrives on a spectrum of entanglements with Indigenous presences that range from ambivalence to dislike, disregard and enmity" informed this chapter (314).

Rather than routine policing, the Yanyuwa commentators in Kearney's work on the reverberations from the cutting of a magnificent Cycad tree help us see what results from the destruction of lands, symbols, peoples, and manifestations of knowledge—all examples of what is held precious for future generations. When an Indigenous mother, a holder of ancestral "blood memory" (Brant, "From"), is lost through preventable violence, it needs to be seen that "the effect is one of harm" (Kearney 313). Furthermore, the cause is "a form of violence" which effectively "ruptures the local empiricism of Indigenous Law as it is emplaced" (Kearney 313).

The Return of the Dreaming

In this chapter, I have reviewed ways that the status of Indigenous women is affirmed within families and communities, with a focus on their roles as life-givers, caretakers, and mothers, whether biological or social. This appreciation exists regardless of the downgraded status dominant societies afford Indigenous women. Specifically, I tracked the ways that the denigration of Indigenous women as mothers could play into or justify policing violence, the hyper willingness to apply excessive force. While a central focus of this chapter is denouncing violence in policing, it is also founded on the literature on missing and murdered Indigenous women and on texts that offer thoughtful analysis of the perils of Indigenous mothering under the dominant societies' discrediting scripts and practices.

The life story and death of Chantel Moore, as presented in mainstream and alternative news media, illustrate the prominent themes in this edited collection, including mothering, missing and murdered Indigenous women, and the ongoing operation of colonialism that is exacerbating the precarity of Indigenous peoples, particularly women. Joining with Kearney and her Yanyuwa research partners, this chapter has worked to expose various themes, including coloniality, epistemic violence, and ambivalence.

While it is not possible to return the Dreaming Ancestor or a human being to a state of vitality, Kearney reminds us—with cautious optimism—that "the potency of the Dreaming returns time and again" (324). This is so because the Dreaming is "immutable, despite having been desecrated in its physical form" (324). In a similar tone, Chantel Moore's family has emphasized her continued presence in their lives. At her funeral in New Brunswick, in memoriam, Chantel's spirit was honoured and reassured that her physical being would "never be forgotten"; she would "always be remembered as the sweetest soul" who now watched over the family. Although her earthly body had passed, her spirit was assured that "no one" would "ever replace" the physical being that her family mourned and remembered (Canadian Press).

Inspired by her Indigenous collaborators, Kearney suggests that it is in these displays where harm is recognized, and loss is honoured that transformation is possible. Change has occurred due to the coalitions that have emerged between Indigenous and settler youth who are affirming Indigenous teachings and recognizing the preciousness of the environment as its own lifeworld. The youth coalitions have affirmed future possibilities, articulated as "the need to care for country," which may be the only way to achieve "sustainable futures" (324). Youth activists have cogenerated "Aboriginal centric political commentaries and voices" and have advocated for the "need to safeguard ancestral lands and waters," which house "the essence and actuality of the Dreaming" (324). In some ways, this advocacy aligns with the efforts made by and in solidarity with the Moore and Martin families to promote recognition to generate resolve for security and safety to create more authentic reconciliation. For settlers, it provides an opportunity to confront their role in the machinery that facilitates ongoing incursions into Indigenous beingness and sovereignty.

In closing, I bring attention to the loving persons who appeared at the 2022 inquest to offer drumming and smudging. A Wolastoqi singer

from Neqotkuk (Tobique) First Nation and 2018 Polaris prize winner, Jeremy Dutcher, sang "The Strong Woman Song" as family members entered the conference room (Sweet). The voices of activists who have called for remembrance and action about Chantel Moore have been called in at gatherings. At the 2020 healing walk in Kjipuktuk (Halifax), Raven Davis shared these words: "Don't wait for our lives to be taken, support us now. Do the work you need to do to understand how you are implicated in harming and oppressing Indigenous and Black people" (Devet).

Davis continued:

"I am here today to ask you to consider how you have been complicit in harm, racism and oppression, ableism, transphobia, and white supremacy in Kjipuktuk, Halifax, the city you live and work in—anywhere that suppresses Indigenous and Black lives.

We can no longer continue to erase the violent history of Canada when Indigenous and Black lives are not yet free. In government and academia, as well as in our organizations, institutions, health-care system, correctional services, and prisons, this violence must be addressed" (Devet).

With the voices of family members and activists, Kearney's emphasis on "the repugnant self," who carries out the violence of coloniality and who remains "hidden through structures of the nation," has also shaped this analysis. (330). For Kearney, the "repugnancy of coloniality" is made evident "every time a Dreaming ancestor or place" is damaged or destroyed or, as this chapter has argued, when an Indigenous woman and mother dies because of a shooting during a check supposedly driven by an interest in wellbeing (330).

Works Cited

Basu, Brishti, "Disbelief and Outrage after No Criminal Charges against Police Officer Who Killed Chantel Moore." *Capital Daily*, 9 June, https://www.capitaldaily.ca/news/disbelief-and-outrage-no-criminal-charges-against-police-officer-who-killed-chantel-moore. Accessed 18 Apr. 2024.

Bernard Daisley, Annie. "Chantel Moore Will Be Forgotten Because She Is Indigenous." *The Nova Scotia Advocate*, 4 Aug. 2020, https://ns-advocate.org/2020/08/04/chantel-moore-will-be-forgotten-because-she-is-indigenous/. Accessed 18 Apr. 2024.

Bisset, Kevin. "After N.B. Police Killing of Indigenous Woman, Chiefs Demand Systemic Racism Inquiry." 20 May 2022, *The Toronto Star.* https://www.thestar.com/news/canada/2022/05/20/after-nb-police-killing-of-indigenous-woman-chiefs-demand-systemic-racism-inquiry.html. Accessed 18 Apr. 2023.

Brant, Jennifer. "From Historical Memories to Contemporary Visions: Honouring Indigenous Maternal Histories." *Journal of the Motherhood Initiative for Research and Community Involvement*, vol. 5, no. 1, 2014, pp. 35-52.

Brant, Jennifer. "Indigenous Mothering: Birthing the Nation from Resistance to Revolution." *The Routledge Companion to Motherhood.* Edited by L. O'Brien Hallstein et al. Routledge, 2019, pp. 111-21.

British Columbia Assembly of First Nations, "Indigenous Leaders Condemn Police Actions in Death of Chantel Moore." British Columbia Assembly of First Nations, 8 June 2020, https://www.ubcic.bc.ca/indigenous_leaders_condemn_police_actions_in_death_of_chantel_moore. Accessed 18 Apr. 2023.

Brown, Laura. "'I Try to Be the Voice for My Daughter': Six Months since Chantel Moore's Death, Family Still Seeking Answers." *CTV News Atlantic Reporter*, 30 Nov. 2020, https://atlantic.ctvnews.ca/i-try-to-be-the-voice-for-my-daughter-six-months-since-chantel-moore-s-death-family-still-seeking-answers-1.5211165. Accessed 18 Apr. 2024.

Brown, Laura, and Nick Moore, "Healing Walks in Memory of Chantel Moore Held across the Maritimes." *CTV News*, 13 June 2020, https://atlantic.ctvnews.ca/healing-walks-in-memory-of-chantel-moore-held-across-the-maritimes-1.4983127. Accessed 18 Apr. 2024.

Canadian Feminist Alliance for International Action (FAFIA). *The Toxic Culture of the RCMP: Misogyny, Racism, and Violence against Women in Canada's National Police Force.* FAFIA, https://fafia-afai.org/en/a-report-on-the-toxic-culture-of-misogyny-racism-and-violence-in-the-rcmp/. Accessed 18 Apr. 2024.

Canadian Press. "Shooting Victim Chantel Moore Remembered as 'the Sweetest Soul.'" *Alberni Valley News*, 11 June 2020, https://www.albernivalleynews.com/news/funeral-held-for-young-indigenous-woman-shot-by-police-in-northern-n-b/. Accessed 18 Apr. 2024.

Cave, Rachel. "Chantel Moore's Family Haunted 'Day and Night' after Viewing Her Body in B.C." *CBC News*, 12 October 2020. https://www.cbc.ca/news/canada/new-brunswick/chantel-moore-body-viewing-haunted-1.5759603. Accessed 15 Dec. 2020.

CBC News. "Hundreds Walk to Honour Chantel Moore Saturday in Halifax." *CBC*, 13 June 2020, https://www.cbc.ca/news/canada/nova-scotia/halifax-chantel-moore-healing-walk-nova-scotia-1.5611101. Accessed 18 Apr. 2024.

CBC News. "Inquest Witnesses Elaborate on Chantel Moore's Blood-Alcohol Content, 4 Bullet Wounds." *CBC*, 18 May 2022, https://www.cbc.ca/news/canada/new-brunswick/chantel-moore-alcohol-inquest-1.6457755. Accessed 18 Apr. 2024.

Cox, Aidan. "Chantel Moore's Mother Demands Accountability, Transparency a Year after Police Killed Her Daughter." *CBC*, 4 June 2021, https://www.cbc.ca/news/canada/new-brunswick/chantel-moore-indigenous-police-shooting-1.6052529. Accessed 18 Apr. 2024.

Cox, Aidan. "No Wrongdoing by N.B. Officer who killed Chantel Moore, provincial police commission finds". CBC, Nov. 2021, https://www.cbc.ca/news/canada/new-brunswick/chantel-moore-new-brunswick-police-commission-1.6253487. Accessed 18 Apr. 2024.

D'Arcangelis, Carol Lynne. "Revelations of a white settler woman scholar-activist: The fraught promise of self-reflexivity." *Cultural Studies Critical Methodologies,* vol. 18, no. 5, 2018, pp. 339-53.

Devet, Robert. "Hundreds Gather in Halifax for Solemn Healing Walk in Memory of Chantel Moore." *The Nova Scotia Advocate*, 13 June 2020, https://nsadvocate.org/2020/06/13/hundreds-gather-in-halifax-for-solemn-healing-walk-in-memory-of-chantel-moore/. Accessed 18 Apr. 2024.

Fundira, Melissa, and Jonathan Montpetit. "Quebec Premier Announces 2-year Inquiry into Treatment of Indigenous People." *CBC News*, 22 Dec. 2016, https://www.cbc.ca/news/canada/montreal/quebec-public-inquiry-indigenous-people-1.3906091. Accessed 18 Apr. 2024.

Government of New Brunswick. "Coroner's Inquest Makes Recommendations Regarding Police Interventions, Training and Equipment." *Government of New Brunswick*, https://www2.gnb.ca/content/gnb/en/departments/public-safety/news/news_release.2022.05.0255.html. Accessed 18 Apr. 2024.

Government of New Brunswick. "Review of the Report from the Bureau des enquêtes indépendantes du Québec (BEI) of Its Investigation Following the Death of Chantel Courtney Moore and Legal Opinion," *Government of New Brunswick*, 7 June 2021, https://www2.gnb.ca/content/dam/gnb/Departments/ag-pg/PDF/review-report-bei.pdf. Accessed 18 Apr. 2024.

Government of New Brunswick. "Statement Regarding Crown Review of Investigation into Death of Chantel Moore." *Government of New Brunswick*, 7 June 2021, https://www2.gnb.ca/content/gnb/en/news/news_release.2021.06.0444.html. Accessed 18 Apr. 2018.

Greig, Christopher, and Kimberly M. Hillier. "Men, Masculinities, and the Global Pandemic: Exploring the Politics of Masculinities and Interlocking Relations of Power During the Initial Stage of COVID-19." *Intersectionalities: A Global Journal of Social Work Analysis, Research, Polity, and Practice*, vol. 9, no. 1, 2021, pp. 75-97.

Ha-Shilth-Sa. "No Wrongdoing Found: Officer Who Fatally Shot Chantel Moore Walks." *Ha-Shilth-Sa*, 19. Nov. 2021, https://hashilthsa.com/news/2021-11-19/no-wrongdoing-found-officer-who-fatally-shot-chantel-moore-walks. Accessed 18 Apr. 2024.

Kearney, Amanda. "To Cut Down the Dreaming: Epistemic Violence, Ambivalence and the Logic of Coloniality." *Anthropological Forum*, vol. 31, no. 3, 2021, pp. 312-34.

Khare, Nikisha, et al. "Reimagining Safety in a Pandemic: The Imperative to Dismantle Structural Oppression in Canada." *Canadian Medical Association Journal*, vol. 192, no. 41, 2020, pp. E1218-E1220.

Kuokkanen, Rauna. *Restructuring Relations: Indigenous Self-Determination, Governance, and Gender*. Oxford University Press, 2019.

Lavell-Harvard, D. Memee and Jennifer Brant. *Forever Loved: Exposing the Hidden Crisis of Missing and Murdered Indigenous Women and Girls in Canada*. Demeter Press, 2016.

MacDonald, Michael. "Pressure Mounts on New Brunswick to Get Indigenous People Involved in Inquiries." *Global News*, 16 June 2020, https://globalnews.ca/news/7072826/pressure-mounts-on-new-brunswick-to-get-indigenous-people-involved-in-inquiries/. Accessed 18 Apr. 2024.

Magee, Shane. "New Brunswick Police Officer who Fatally Shot Chantel Moore Won't be Charged" *CBC News*, 7 June 2021, https://www.cbc.ca/news/canada/new-brunswick/chantel-moore-no-charges-officer-shooting-police-1.6056025. Accessed 18 Apr. 2024.

Marques, Olga, and Lisa Monchalin. "The Mass Incarceration of Indigenous Women in Canada: A Colonial Tactic of Control and Assimilation." *Neo-Colonial Injustice and the Mass Imprisonment of Indigenous Women*. Edited by George Norris et al. Palgrave Macmillan, 2020, pp. 79-102.

Metallic, Naiomi. "New Brunswick Needs a Public Inquiry into Systemic Racism in the Justice System: Nova Scotia Shows Why." *Journal of New Brunswick Studies/Revue d'etudes sur le Nouveau-Brunswick*, vol. 12, no. 1, pp. 7-14.

Moore, Angel. "Family of Chantel Moore Outraged with Decision to Not Charge Officer Who Shot Her." *APTN National News*, 8 June 2021, https://www.aptnnews.ca/national-news/family-of-chantel-moore-outraged-with-decision-to-not-charge-officer-who-shot-her/. Accessed 18 Apr. 2024.

Moore, Angel. "Mother of Chantel Moore says delay of inquest 'slap in the face'" *APTN National News*. 7 February 2022. https://www.aptnnews.ca/national-news/mother-of-chantel-moore-says-delay-of-inquest-slap-in-the-face/. https://www.aptnnews.ca/national-news/mother-of-chantel-moore-says-delay-of-inquest-slap-in-the-face/. Accessed 18 April 2024.

Moore, Angel. "Former RCMP Officer Creates Video Re-enactment of the Night Chantel Moore Was Shot." *APTN National News*, 18 May 2022, https://www.aptnnews.ca/national-news/former-rcmp-officer-creates-video-re-enactment-of-the-night-chantel-moore-was-shot/. Accessed 18 Apr. 2024.

Morin, Brandi. "The Indigenous People Killed by Canada's Police." *Al Jazeera*, 24 Mar. 2021, https://www.aljazeera.com/features/2021/3/24/the-indigenous-people-killed-by-canadas-police. Accessed 18 Apr. 2024.

Morin, Sarah. "Chantel Moore's Family Calls for Justice, Public Inquiry during Healing Walk." *CBC News*, 14 June 2020, https://www.cbc.ca/news/multi-lineup-listing/healing-walks-chantel-moore-1.5610194. Accessed 18 Apr. 2024.

National Inquiry into Missing and Murdered Indigenous Women and Girls (Canada). *Reclaiming Power and Place: The Final Report of the National Inquiry into Missing and Murdered Indigenous Women and Girls.* National Inquiry into Missing and Murdered Indigenous Women and Girls, 2019. https://www.mmiwg-ffada.ca/final-report/

New Brunswick Police Commission. "New Brunswick Police Commission Concludes Conduct Complaint about Edmundston Police Officer." *New Brunswick Police Commission,* https://nbpolicecommission.ca/content/nbpc-cpnb/en/media/november-18-2021.html. New Brunswick Police Commission. Accessed 18 Apr. 2024.

Pipyrou, Stavroula, and Antonio Sorge. "Emergent Axioms of Violence: Toward an Anthropology of Post-Liberal Modernity," *Anthropological Forum,* vol 31, no. 3, 2021, pp. 225-40.

Quon, Alexander, and Silas Brown. "Edmundston, N.B., Police Officer Who Shot Chantel Moore Now Back at Work." *Global News,* 2 July 2020, https://globalnews.ca/news/7132713/edmundston-police-officer-chantel-moore/. Accessed 18 Apr. 2024.

Rich, Sylvia. "Police Violence as Organizational Crime." *Canadian Journal of Law and Society / Revue Canadienne Droit Et Société,* vol. 37, no. 1, 2022, pp. 135-53.

Ritchie, Andrea J. *Invisible No More: Police Violence against Black Women and Women of Color.* Beacon Press, 2017.

Sweet, Jennifer. "'Heavy Day' for Family of Slain Chantel Moore as Officer Who Shot Her Testifies at Inquest." *CBC News,* 17 May 2022, https://www.cbc.ca/news/canada/new-brunswick/chantel-moore-jeremy-son-coroner-inquest-1.6456391. Accessed 18 Apr. 2024.

Titian, Denise. "More Heartbreak for Family: No Charges Laid against Police Officer Who Fatally Shot Chantel Moore." *Ha-Shilta-Sa,* 7 June 2021, https://www.hashilthsa.com/news/2021-06-07/more-heartbreak-family-no-charges-laid-against-police-officer-who-fatally-shot. Accessed 18 Apr. 2024.

Titian, Denise. "Why Weren't Charges Laid against the Officer Who Shot Chantel Moore?" Ha-Shilta-Sa, 9 June 2021, https://hashilthsa.com/news/2021-06-09/why-werent-charges-laid-against-officer-who-shot-chantel-moore. Accessed 18 Apr. 2024.

Tla-O-Qui-Aht First Nation. "Chantel Moore Was Promised but Did Not Receive Better." *Docdroid*, July 2020, https://www.docdroid.net/4rpMnOp/tla-o-qui-aht-first-nations-hereditary-chiefs-elected-council-statement-of-the-shooting-death-of-26-year-old-tla-o-qui-aht-mother-chantel-moore-martin-pdf. Accessed 18 Apr. 2024.

Widaatalla, Nahid. "Public Health and Police Violence." *Canadian Public Health Association*. 26 June 2020, https://www.cpha.ca/fr/public-health-and-police-violence?fbclid=IwAR2q6O8201pdQUnDKvMYjBz1RQ7WL_Fz3OX9VfW3S5qK6EdzHkF0YQoa38c. Accessed 18 Apr. 2024.

3.

Disrupting Mainstream Media Representations of Missing and Murdered Indigenous Women and Girls

Sana Shah

Introduction

For decades, Indigenous families and communities have been fighting for a national inquiry into the cases of missing and murdered Indigenous women and girls (MMIWG). This activism is evident in the annual march and memorial organized by families and communities of MMIWG in Downtown Eastside (DTES) Vancouver since 1991 (Bourgeois, "Perpetual"). They have also used online spaces, such as Twitter, to voice their concerns and highlight the need for a national-level inquiry (Saramo 210). However, their plea for an inquiry was continuously ignored by the federal government. The previous government, under the leadership of Stephen Harper, did not deem the ongoing disappearances and murders of Indigenous women and girls an urgent matter that required investigation. Instead, Harper publicly stated that the ongoing violence against Indigenous women and girls was not a priority (Bourgeois, "Perpetual" 253; Saramo: 208). The Harper government also undermined the need for an inquiry by describing the cases of MMIWG as individual occurrences (Printup; Saramo 208).

The final report of the National Inquiry into MMIWG cites that it has "honoured the struggles taken up by the families and survivors over the past 40 years" (8). Given that the inquiry was the direct outcome of ongoing family activism and struggles, it prioritizes the voices of Indigenous families and communities. However, an initial issue was the lack of communication and transparency extended to the families of MMIWG regarding the inquiry's proceedings (Brant). Moreover, an ongoing concern raised by both families and activists was whether the inquiry would be relevant, as the government was allocating funding to resolve a problem it was responsible for producing. Despite the release of the final report, both provincial and federal governments have yet to take serious action in response to the violence against Indigenous women and girls (Palmater 150).

Media coverage of MMIWG plays an essential role in how the Canadian population perceives the violence inflicted on Indigenous women and girls. As Verna St. Denis argues, "The media has had a big influence in shaping public opinion and encouraging misinformation and hostility" (43). Mainstream media, as a Canadian institution, works within an oppressive colonial framework (Bourgeois, "Perpetual" 261; Craig 6). Colonial discourses of MMIWG—as evidenced in mainstream news platforms, such as the *Toronto Star, The Globe and Mail, National Post,* and the *Vancouver Sun*—reduce Indigenous women and girls to racist, gendered, and sexualized stereotypes, which serve to objectify and dehumanize them (Eberts 71; Gilchrist 375-76; Hargreaves 14-16; Jiwani and Young 899). Family and community members have been actively fighting to disrupt these dominant colonial narratives. This chapter works towards filling this prominent gap by shining light on the activism of family and community members through exploring the media coverage of Rosianna Poucachiche, who was murdered in 2000 and Shannon Alexander, who has been missing since 2008. The analysis that follows looks at media coverage found in Canadian news platforms, which include CBC News, *The Globe and Mail, Ottawa Citizen,* Canada NewsWire, and the *Montreal Gazette*. A total of twenty-one articles between the time frame of 2000 and 2018 were included, of which six focussed on Rosianna and the other fifteen on Shannon. In the face of ongoing colonialism and racist oppression, Indigenous families and communities continue to fight for their missing and murdered loved ones, and their activism is largely responsible for the advancements made in the media coverage of MMIWG.

Colonial Images of Indigenous Femininity

Colonial violence and oppression are at the heart of the dehumanization and objectification of Indigenous women and girls. Robyn Bourgeois argues that "the effects of colonialism are gendered, and the colonial gaze has a gender-specific derogatory and essentialized frame for Indigenous women" ("Perpetual" 260). Before colonial contact, Indigenous communities valued egalitarian principles and empowered Indigenous women to be in positions of authority, granting them the opportunity to take part in governance, trade, and ceremonial life (Barker 260-62; Hargreaves 11). However, these ways of knowing and being were disrupted upon the arrival of European settlers, which marginalized Indigenous women within their communities (Bourgeois, "Perpetual" 260-62; Eberts 70; Green 175).

The Indian Act gives the federal government of Canada control over Indigenous peoples, as it controls and determines many aspects of their lives (Barker 259; Bourgeois, "Perpetual"; Eberts 69-70). Under this Act, residential schools were mandated, and in the mid-1870s, it required all Indigenous children to attend these schools (Kubik et al. 22; Larmer 92). One of the main purposes of these schools was to impose Eurocentric standards and Western "gender roles" on Indigenous children, to civilize them (National Inquiry 262). This colonial "civilizing" was further imposed through controlling and containing the sexuality of Indigenous girls (Anderson 50-55). This control correlates with the sexist colonial and racist stereotypes attributed to Indigenous femininity.

Stereotypical images of Indigenous women have been created and depicted since European contact, as settlers viewed Indigenous women as "exotic sexual commodities" (Tucker 8). The Hudson Bay Company (HBC) records depict Indigenous women and girls as "immoral, lustful, and expendable" (Hargreaves 90). The "squaw" stereotype emerged from these records and is a product of settler colonialism. This stereotype is race, sex, and gender specific, whereby the bodies of Indigenous women and girls are equated with land in the eyes of European settlers, both disposable and available for their consumption (Anderson 79-80; Green 711). These stereotypical images that deem Indigenous women and girls as sexually available and disposable "foster cultural attitudes that encourage sexual, physical, verbal, or psychological violence against Indigenous women ... [they] also function as sentinels that guard and protect the white eurocanadian-christian-patriarchy" (Acoose 55). Thus,

producing a hierarchy that constructs Indigenous womanhood/femininity as defiant and impure in contrast to the purity of white womanhood/femininity (Bourgeois, "Race"; Gilchrist 375; Longstaffe 238). These negative stereotypical images have been the foundation of most mainstream Canadian media coverage of MMIWG.

Hierarchical Mainstream Media Coverage of Missing and Murdered Women

Media coverage not only has a strong influence on public perception of important issues, but it also perpetuates a hierarchal narrative whereby racialized and colonized bodies are disseminated as the "other" (Feldman 406). Within this model then, MMIWG are portrayed as the racial "other," whose violation is not simply ignored but normalized. Moreover, the role of racism is often ignored when the cases of MMIWG are covered by the media (Jiwani 65-66; Jiwani and Young 901). Stereotypical images ascribed to certain groups perpetuate "common-sense notions: attributed to their likelihood of being victims of violence (Jiwani and Young 902). There is an evident racial divide in the mainstream coverage of the cases of missing and murdered women and girls, whereby Indigenous women and girls are depicted as defiant and deviant individuals, not worthy of respect or grief.

Mainstream media operates on a binary. The coverage of nonracialized women that go missing sharply contrasts with the cases of racialized women and girls. Concerning the coverage of the cases of missing persons, mass media tends to romanticize the image of a "damsel in distress," who must meet the criterion of being white and pure (Conlin and Davie 38; Sommers 287-88; Stillman 492). Based on this criterion, Indigenous women and girls are immediately excluded, as Indigenous femininity is deemed inferior and impure in comparison to white femininity; hence, they are considered unworthy of concern or protection. As Caitlin Elliott argues, victims of violence are either presented as damsels in distress or those that transgress the limits of respectability; in this context, racialized women are then viewed as beyond "help or respect" (64). Respectability is often associated with "whiteness" and anyone who fails to fit within these confines is deemed unrespectable (Elliott 31). This lack of respectability attributed to a person makes their loss unworthy of grief and mourning. However, based on Butler's work on grievability, to say

that a life is not grievable is to consider that "it has never counted as a life at all" (38). This lack of respectability and erasure of grief is evident in the historical stereotyping of Indigenous women and girls who were sexualized as objects available for white settlers to use and dispose of at their will.

The cases of missing and murdered white women not only receive more respectable coverage but also garner greater and wider coverage as well, while the cases of MMIWG get buried in "soft news," which is considered entertaining (Gilchrist 380). Moreover, MMIWG tend to not receive detailed biographies, with no pictures, and when they are shared, they are either mugshots or passport sized (Gilchrist 382; Tucker 7). This combination of lack of biographies and pictures, alongside the coverage being buried in soft news, diverts attention away from the violence inflicted on Indigenous women and girls, which is made invisible.

The dominant discourses of media coverage focus on the individual and exempt the colonial state from any accountability (Saramo 206-210; Jiwani and Young 901). By focussing on them as individual cases, the larger systems of colonial oppression and violence are ignored, which have been the foundation of media representations of MMIWG. All too often, the blame is shifted onto the so-called risky lifestyles of Indigenous women and girls. Cases of MMIWG that are assumed to be involving drugs and prostitution, garner greater media traction, in contrast to those that do not, as the blame can be shifted onto the victim (Culhane 594; Jiwani and Young 897-900). By fixating on these factors, attention is taken away from the role of physical and sexual violence in the deaths and disappearances of Indigenous women and girls. These risky lifestyles are underpinned by drugs, prostitution, and living in marginalized spaces that are predominantly marked by violence and poverty. However, MMIWG are associated with deviancy, regardless of their involvement in said activities or not. Through her analysis of early newspaper articles, Sherene Razack found that North American "Newspaper records of the nineteenth century indicate that there was a conflation of Aboriginal woman and prostitute and an accompanying belief that when they encountered violence, Aboriginal women simply got what they deserved. Police seldom intervened, even when the victims' cries could be clearly heard" (130). By blaming the victim, MMIWG are further put on trial for making reckless decisions about their lives, which led to their eventual deaths and disappearance. However, the perpetrators either run

free, or in cases where they are charged, they are given brief sentences (National Inquiry 696-97). Therefore, there needs to be an active dismantling of stereotypical images of Indigenous women and girls to end this ongoing cycle of violence.

Families and communities have been working hard for decades to disrupt these dominant images, arguing that the cases of MMIWG are linked to a broader pattern of violence that no one is safe from (Culhane 603). It is through ongoing family and community activism that the past decade has seen a rise in mainstream platforms, such as CBC News and *The Globe and Mail,* bringing attention to the colonial state's complicity in the violence perpetrated against Indigenous women and girls.

Initial Response to the Cases of Rosianna and Shannon

In October 2000, Rosianna Poucachiche, only sixteen-years-old, was murdered at her home in Lake Rapid, an Algonquin reserve located north of Ottawa. Her parents found her body in her room the next day. Her murder was not covered by the media, and the police investigation was inadequate, because of which the case soon grew cold. When Rosianna was murdered, she was reported as "another dead Indigenous girl." Her life was reduced to a "cold case" in the eyes of Canadian newsreaders. Only one piece of news coverage reported on Rosianna's death in 2000; however, there were no details offered, nor was the family contacted by the reporter. Thus, no personal details about Rosianna were included.

Rosianna's murderer was not arrested until 2017, seventeen years after her death. Brittney, Rosianna's cousin, argues that whether Rosianna received justice was questionable, given how long it took the police to arrest and charge her perpetrator (Poucachiche). The arrest took place around the same time as the National Inquiry into MMIWG was underway. Brittney questions the way police handled Rosianna's case, as the police interest in her case was nonexistent until the National Inquiry gained momentum (Poucachiche). This begs the question as to whether the arrest and legal proceedings surrounding the case were rushed and performative because the inquiry scrutinized the police for its negligence in the investigation of the cases of MMIWG.

Shannon was seventeen years old at the time of her disappearance in September 2008. She disappeared with her friend Maisy Odjick, from her home in Maniwaki, QC, located near the Kitigan Zibi First Nation

reserve, a few hours from Ottawa. Their families found their disappearance to be suspicious, as their belongings were left untouched at Shannon's home, and they had not taken anything from the house (Baker; Canada NewsWire; Kennedy; Sibley and Dimmock; Ottawa Citizen; Pilieci). Both the girls attended a dance at the school and were supposed to be having a sleepover at Shannon's home afterwards. Shannon's father, Bryan Alexander, was the last to have seen the two girls at their home.

The police response to Shannon and Maisy's disappearance was inadequate, as it centred on the assumption that both the girls had run away from home. The initial media coverage of Shannon's disappearance did not offer details about what had happened, since the police did not investigate their disappearance. The assumption that the girls had simply run away dictated much of the limited coverage provided. Given both the lack of action on the police's part and the limited coverage, Brittney noted that family and community members had to take it upon themselves to bring attention to Shannon's disappearance (Poucachiche). It was through posting on online social media platforms that family members were able to raise some awareness. This was a platform not as readily available when Rosianna was murdered.

Media Coverage of Rosianna and Shannon

The initial coverage of Rosianna's murder simply addressed how she had died, as well as where and when it took place. It was not until 2017, when the case was resolved, that the media took notice and offered more coverage. News articles published in 2017 focussed on the violence inflicted on her. These descriptions included the phrases "beaten to death" (CTV Montreal; Spears), "bruised and beaten body" (Canadian Newswire), "severely beaten and found unconscious" (Cherry), and "badly beaten body" (CBC News). This dehumanization limited Rosianna's life to the violence she had endured. Such representations further colonial control over the bodies of Indigenous women and girls, as they limit them to mere body parts.

CBC News shared a more empathetic coverage of Rosianna's case. This platform not only included and discussed Rosianna's sister, Marylynn's account but also provided a picture of Rosianna as well. That being said, the coverage is not always consistent, as while the content offers sensitive coverage, the wording of the headlines does not always reflect

empathy. The same article discussing the narrative of Rosianna's sisters refers to her as merely a "cold case victim" (Kupfer). Considering the content shared in the article, a more sensitive headline would have shown respect to both Rosianna and her family. Regarding Shannon, the *Ottawa Citizen* offered detailed coverage of Shannon's disappearance. Brendan Kennedy covered the disappearances of Shannon and Maisy and interviewed the families of both girls.

These articles offered in-depth information about both Shannon and Maisy and their families. However, there is some discrepancy in the content included in the articles. One of the articles reports that Shannon was a happy kid who enjoyed partaking in outdoor activities with her father but later refers to her as an "angry and argumentative teen" (Kennedy, "Without" para. 46). The same article also defines Shannon's father as a "former crack addict who struggles with alcoholism" (para. 48). Another article from the same platform labels Shannon's mother as a crack addict and her father as a recovering addict and alcoholic (Ottawa Citizen). This form of coverage is rather counterproductive, as it places an unnecessary amount of focus on the victim's past, implying that they are somehow to blame for their circumstances. Feeding into this victim-blaming narrative, another reporter from the *Ottawa Citizen* (2009) states both Shannon and Maisy were "living a narrative, too common among aboriginal people, that more often than not ends badly" (para. 10). This statement stigmatizes and stereotypes an entire community, prompting the narrative as one commonly lived by Indigenous people. Thereby, the focus is yet again shifted away from racism and colonial violence and is instead placed on the lifestyles of Indigenous women and girls (Culhane 595).

Although it is important to note that stereotypical representations remain within mainstream coverage of MMIWG, it is equally important to focus on the shift in more recent news reports. Other reports from the *Ottawa Citizen* also mention Shannon's father's history; however, they address his struggles compassionately by highlighting that he had beaten his drug addiction, but losing his daughter proved to be the most devastating hardship he faced (Sibley and Dimmock). Thus, attention is drawn towards his love and care for his daughter. By portraying family members of MMIWG as individuals with agency, media coverage can actively produce empathetic accounts that are respectful towards both the victims and their families.

Ongoing Family Activism towards Better Media Coverage

Family and community members continue to be at the forefront of raising awareness about the cases of MMIWG. The coverage concerning Shannon is different given that she remains missing to this day, while Rosianna's murder has been resolved. However, the coverage that both cases received is a product of the tireless efforts of family and community, who continue to fight for justice and accountability for their missing and murdered loved ones.

Coverage from CBC News brought attention to the role of family in the investigation of Rosianna's murder. However, Rosianna's sister highlighted that it was not until two years before the perpetrator was arrested that the police contacted her (Kupfer). Even though no details were offered regarding how the family assisted the police, this is still an important finding, as it shows that media coverage is drawing attention to family resilience and activism. Furthermore, through incorporating her sister's account, the coverage discussed Rosianna's life in a context that was not limited simply to her being a victim of brutal violence. Instead, her sister brought to light how Rosianna was a kind-hearted and ambitious person, who was deeply loved by her family and friends (Kupfer). This presents Rosianna in a positive light. However, the need to highlight such personal attributes demonstrates the burden placed on families to present their loved ones as respectable, given the prevalence of stereotypical images of Indigenous women and girls. Thus, including accounts of family members about MMIWG is an active step towards shifting away from colonial discourses about Indigenous femininity that have dominated mainstream coverage for decades.

Shannon and Maisy have been missing since September 2008, and the search for these young women has been an ongoing struggle for the family. The families of Shannon and Maisy have created an online platform to raise awareness about their disappearance and receive any assistance. This website was created immediately after their disappearance, and the *Ottawa Citizen* reported that "The families and friends of the missing teens have set up a website at www.findmaisyandshannon.com and a Facebook group" (Kennedy, "Parents" para. 6). Alongside this website, family members annually organize vigils and marchers in their memory (Seguin; Hurley). These vigils and marches have garnered

media attention, which continues to draw attention to their disappearance and ensure that the search is ongoing.

Reporters from the *Ottawa Citizen* reported that the first extensive ground search for Shannon and Maisy was organized and led by their families, with the help of community members (Aske; Kennedy, "The Search"). Not only does this bring to attention the family resistance and resilience, but it also highlights the lack of action taken by the police, leaving families with no other option but to take matters into their own hands. Drawing attention towards larger systems of oppression, such as police inaction, has been a recent shift in media coverage of MMIWG.

Shifting Dominant Discourses: Addressing Racism and Colonialism

The treatment of MMIWG cases as individual ones, detached from larger systems of oppression, has fostered a lack of accountability at the hands of the government of Canada (Saramo). By denying that racism and colonialism are the reasons behind MMIWG, the number of Indigenous women who are missing or murdered has only risen. As mentioned earlier, by placing focus on the individual and their lifestyles, media coverage has perpetuated a victim-blaming discourse, which does not actively address the role of colonialism. Often these so-called lifestyle choices result from a lack of choice and are rooted within structural issues of colonialism and racism, pushing Indigenous women and girls into neighbourhoods that are underpinned by "poverty, addictions, sex work, violence, and criminality" (Longstaffe 247). However, the past few years have seen a shift in how mainstream media is addressing MMIWG.

News articles about Rosianna and Shannon have placed some focus on the lack of trust that Indigenous communities have towards the police. In the case of Rosianna, CBC News reported that Rosianna's family had "lost confidence" in the police, as they had not actively investigated her death until the National Inquiry into MMIWG was launched (Kupfer para. 7). The *Ottawa Citizen*, while the inquiry was underway, reported that "... recent publicity over the cases of missing and murdered Indigenous women had highlighted her [Rosianna's] death" (Spears para. 5), making it seem that the pressure from the inquiry pushed the police to actively investigate Rosianna's murder. This lack of trust towards the police has been evident in Shannon's case as well.

Some of the articles discussing Shannon's case focus on the increased vulnerability of Indigenous women and girls being victims of homicide in Canada, despite making up only a small proportion of the Canadian population (Galloway; Kennedy, "The Search"; Sibley and Dimmock). As Gloria Galloway from *The Globe and Mail* affirms, "According to the Native Women's Association of Canada (NWAC), about 50 percent of the violent deaths of aboriginal women and girls result in homicide charges—compared with 76 percent for the general population in 2011" (para. 10). This focus on the gap in the arrests of perpetrators of Indigenous women and girls shines light on how they are oppressed and violated not only during their lifetimes but after their death as well. Some writers from the *Ottawa Citizen* and *The Globe and Mail*, in their reporting of Shannon's disappearance, briefly mention that the cases of MMIWG are rooted in racism and colonialism (Galloway; Hurley; Kennedy, "Parents"; Seguin; Sibley and Dimmock). Kennedy further discusses that some Indigenous organizations, such as the Assembly of First Nations (AFN), believed that racism played a role in the police's assumption of Shannon and Maisy being runaways.

Some of these recent advancements made in the media coverage of MMIWG have been possible because families and communities continue to bring attention to how colonialism undermines and undervalues the lives of Indigenous women and girls. This is evident in the impact that the inquiry has had, as it has brought greater attention to the cases of MMIWG by centring the stories of families. While both the cases of Rosianna and Shannon predate the inquiry, their cases may have been impacted by it. As Brittney argued, it was not until the inquiry was underway that police actively began to investigate Rosianna's death and arrested her murderer (Poucachiche). Moreover, soon after the inquiry was launched, investigators not only released updated sketches of Maisy and Shannon but also appealed again to the public for any information that they may have on the whereabouts of the girls (Aske; Carlucci; Pilieci). While the advancements in both cases may not be a direct outcome of the inquiry, it still might have placed pressure on the police to take the cases seriously and the media to report on them.

Conclusion

Indigenous women and girls continue to be targets of violence and are more likely to experience life-threatening forms of violence. As a result, they are more likely to disappear and become victims of homicide in comparison to any other demographic in Canada. The foundation of this violence is systemic racism and colonialism. Stereotypical images of Indigenous women and girls that are a product of settler colonialism have long dictated the mainstream media discourses about MMIWG. It is evident through the media coverage of Rosianna's murder and Shannon's disappearance that the settler colonial state and its institutions continue to be active agents in the violence against Indigenous women and girls, as victim-blaming discourses continue to persist in some coverage. However, ongoing family and community activism as well as resilience are disrupting these discourses to gain more respectful media coverage of MMIWG. As a result, the past decade has witnessed some positive shifts in media coverage of MMIWG, which include an effort to centre the voices of families and communities and draw attention to the role of racism, colonialism, and police negligence in the violence against Indigenous women and girls. This shift towards holding the settler colonial state accountable for the cases of MMIWG is an outcome of ongoing family and community activism. The positive changes observed in media coverage of MMIWG as discussed in this chapter are an outcome of ongoing family activism, whereby they actively held vigils, marched, and contacted media outlets. Reflecting on the active role played by family members in disrupting problematic colonial representations of MMIWG, they must be included in the coverage to offer both respectful and timely coverage. This research thus demonstrates an urgent need for a large-scale analysis of media coverage of MMIWG from across Canada to examine whether these shifts are consistent across all platforms.

Works Cited

Acoose, Janice. *Iskwewak—Kah' Ki Yaw Ni Wahkomakanak: Neither Indian Princesses nor Easy Squaws*. Women's Press, 1995.

Anderson, Kim. *A Recognition of Being: Reconstructing Native Womanhood*. Women's Press, 2016.

Aske, Sherry. "The Search for Shannon Alexander and Maisy Odjick."

CBC News, 20 July 2017, https://www.cbc.ca/news/canada/ottawa/timeline-disappearance-shannonalexander-maisy-odjick-1.4212703. Accessed 15 Apr. 2022.

Baker, Carleigh. "Lost Girls: Emmanuelle Walter Brings a National Crisis into the Public Conscience." *The Globe and Mail*, 14 Nov. 2015, p. R20.

Barker, Joanne. "Gender, Sovereignty, Rights: Native Women's Activism against Social Inequality and Violence in Canada." *American Quarterly*, vol. 60, no. 2, 2008, pp. 259-66, https://doi.org/10.1353/aq.0.0002.

Bourgeois, Robyn. "Perpetual State of Violence: An Indigenous Feminist Anti-oppression Inquiry into Missing and Murdered Indigenous Women and Girls." *Making Space for Indigenous Feminism*. Edited by Joyce Green. Fernwood Publishing, 2017, pp. 253-73.

Bourgeois, Robyn. "Race, Space, and Prostitution: The Making of Settler Colonial Canada." *Canadian Journal of Women and the Law*, vol. 30, no. 3, 2018, pp. 371-97, https://doi.org/10.3138/cjwl.30.3.002.

Brant, Jennifer. "Missing and Murdered Indigenous Women and Girls in Canada." *The Canadian Encyclopedia*, 8 July 2020, *Historica Canada*, www.thecanadianencyclopedia.ca/en/article/missing-and-murdered-indigenous-women-and-girls-in-canada. Accessed 10 Apr. 2022.

Butler, Judith. *Frames of War: When Is Life Grievable?* Verso, 2009. Canada NewsWire. "AFN Women's Council Appeals to Public and Media for Help in the Search for Maisy Odjick and Shannon Alexander on National Day of Remembrance and Action on Violence against Women." 6 Dec. 2008, *Brock Library Database*.

Carlucci, Mario. "Police Hope for New Leads in Disappearance of Kitigan Zibi Teens." *CBC News*, 6 Sept. 2018, https://www.cbc.ca/news/canada/ottawa/disappearance-shannonalexander--maisy-odjick-10-years-1.4813286. Accessed 10 Apr. 2022.

CBC News. "Quebec Man Charged with Murder in 2000 Slaying of Indigenous Girl." *CBC*, 7 July 2017, https://www.cbc.ca/news/canada/ottawa/rosianna-poucachichearrest-murder-cold-case-1.4194908. Accessed 10 Apr. 2022.

Cherry, Paul. "Suspect Charged in Long-Unsolved Homicide on Lac-Rapide First Nation." *Montreal Gazette*, 8 July 2017, https://montrealgazette.com/news/suspect-charged-in-long-unsolved-homicide-on-lacrapide-reserve. Accessed 10 Apr. 2020.

Conlin, Lindsey, and William R. Davie. "Missing White Woman Syndrome: How Media Framing Affects Viewers' Emotions." *Electronic News*, vol. 9, no. 1, 2015, pp. 36-50, https://doi.org/10.1177/1931243115572822.

Craig, Elaine. "Person(s) of Interest and Missing Women: Legal Abandonment in the Downtown Eastside." *McGill Law Journal*, vol. 60, no. 1, 2014, pp. 1-42, https://doi.org/10.7202/1027718ar.

CTV Montreal. "Cold Case Cracked? Police Arrest Suspect in Teen Girl's 2000 Murder." 7 July 2017. https://montreal.ctvnews.ca/cold-case-cracked-police-arrestsuspect-in-teen-girl-s-2000-murder-1.3493374.

Culhane, Dara. "Their Spirits Live Within Us: Aboriginal Women in Downtown Eastside Vancouver Emerging into Visibility." *American Indian Quarterly*, vol. 27, no. 3/4, 2003, pp. 593-606, https://doi.org/10.1353/aiq.2004.0073.

Eberts, Mary. "Being an Indigenous Woman Is a 'High-Risk Lifestyle.'" *Making Space for Indigenous Feminism*. Edited by Joyce Green. Fernwood Publishing, 2017, pp. 69-102.

Elliott, Caitlin. *You Will Be Punished: Media Depictions of Missing and Murdered Indigenous Women*. 2016. Wilfred Laurier University, MA Thesis.

Feldman, Allen. "On Cultural Anesthesia: From Desert Storm to Rodney King." *American Ethnologist*, vol. 21, no. 2, 1994, pp. 404-18, https://doi.org/10.1525/ae.1994.21.2.02a00100.

Galloway, Gloria. "AFN Demands Investigation of Missing Native Women." *The Globe and Mail*, 7 Dec. 2012, p. A4.

Gilchrist, Kristen. "Newsworthy Victims?" *Feminist Media Studies*, vol. 10, no. 4, 2010, pp. 373-90, https://doi.org/10.1080/14680777.2010.514110.

Green, Joyce. "ReBalancing strategies: Aboriginal Women and Constitutional Rights in Canada." *Making Space for Indigenous Feminism*. Edited by Joyce Green. Fernwood Publishing, 2017, pp. 166-91.

Green, Rayna. "The Pocahontas Perplex: The Image of Indian Women in American Culture." *The Massachusetts Review*, vol. 16, no. 4, 1975, pp. 698-714.

Hargreaves, Allison. *Violence Against Indigenous Women: Literature, Activism, Resistance*. Wilfrid Laurier University Press, 2017.

Hurley, Meghan. "Families of missing girls cling to hope; Maisy Odjick and Shannon Alexander disappeared two years ago today, and police are still stumped, reports Meghan Hurley." *Ottawa Citizen*, 6 Sept. 2010, p. B1.

Jiwani, Yasmin, and Mary Lynn Young. "Missing and Murdered Women: Reproducing Marginality in News Discourse." *Canadian Journal of Communication*, vol. 31, no. 4, 2006, p. 895-917, https://doi.org/10.22230/cjc.2006v31n4a1825.

Jiwani, Y. "Symbolic and Discursive Violence in the Media Representations of Aboriginal Missing and Murdered Women." *Understanding Violence: Contexts and Portrayals*. Edited by Marika Guggisberg and David Weir. Inter-Disciplinary Press, 2009, pp. 63-74.

Kennedy, Brendan. "Parents Plead for Girls' Safe Return; Friends Went Missing from Reserve North of Ottawa Last Month." *Ottawa Citizen*, 5 Oct. 2008, p. A5.

Kennedy, Brendan. "The Search for Maisy and Shannon: 'I Feel Like I'm Fighting This on My Own,' Mother Says." *Ottawa Citizen*, 2 Mar. 2009, p. B1.

Kennedy, Brendan. "Without a Trace: Maisy Odjick and Shannon Alexander Disappeared from the Kitigan Zibi-Maniwaki Area One Year Ago Leaving Countless Questions but No Clues. Controversy and Confusion Plague an Investigation That Is Also Clouded with Charges of Racism. Day by Day, the Case Grows Colder." *Ottawa Citizen*, 6 Sept. 2009, p. A6.

Kubik, Wendee, et al. "Stolen Sisters, Second Class Citizens, Poor Health: The Legacy of Colonization in Canada." *Humanity & Society*, vol. 33, no. 1-2, 2009, pp. 18-34, https://doi.org/10.1177/016059760903300103.

Kupfer, Matthew. "'She'll Be Able to Rest in Peace': Sister of Cold Case Victim Speaks after Murder Charges Laid." *CBC News*, 8 July 2017, https://www.cbc.ca/news/canada/ottawa/rosianna-poucachiche-cold-case-murder-lacrapide-1.4195934. Accessed 10 Apr. 2022.

Larmer, J. Robert. "The Highway Runs East: Poverty, Policing, and the Missing and Murdered Indigenous Women of Nova Scotia." *Dalhousie Journal of Legal Studies*, vol. 27, 2018, pp. 89-136.

Longstaffe, Meghan. "Indigenous Women as Newspaper Representations: Violence and Action in 1960s Vancouver." *The Canadian Historical*

Review, vol. 98, no. 2, 2017, pp. 230-60, https://doi.org/10.3138/chr.3215.

National Inquiry into Missing and Murdered Indigenous Women and Girls. *Reclaiming Power and Place: The Final report of the National Inquiry into Missing and Murdered Indigenous Women and Girls.* 2019, https://www.mmiwg-ffada.ca/finalreport/. Accessed 10 Apr. 2022.

Ottawa Citizen. "Missing Maisy and Shannon." *Ottawa Citizen*, 11 Sept. 2009. p. 10.

Pilieci, Vito. "Quebec Police Hope to Find New Leads in Search for Young Women Missing 10 Years." *Ottawa Citizen*, 2018, https://ottawacitizen.com/news/local-news/policehope-to-find-new-leads-to-help-with-10-year-old-case. Accessed 15 Apr. 2024.

Poucachiche, Brittney. Interview. By Sana Shah, Jan. 2020.

Printup, Nick, director. "Our Sisters in Spirit." *YouTube,* uploaded by Nick Printup, 9 Feb., 2018, https://www.youtube.com/watch?v=zdzM6krfaKY.

Razack, Sherene H. "Gendered Racial Violence and Spatialized Justice: The Murder of Pamela George." *Race, Space, and the Law: Unmapping a White Settler Society.* Edited by Sherene H. Razack. Between the Lines, 2002, pp. 122-56.

Saramo, Samira. "Unsettling Spaces: Grassroots Responses to Canada's Missing and Murdered Indigenous Women during the Harper Government Years." *Comparative American Studies*, vol. 14, no. 3-4, pp. 204-20, https://doi.org/10.1080/14775700.2016.1267311.

Seguin, Rheal. "Vigil to Mark Two Years since Native Girls Went Missing." *The Globe and Mail*, 6 Sept. 2010.

Sibley, Robert, and Gary Dimmock. "'Is She Alive? Is She Dead?': Nearly Six Years after His Daughter, Shannon, Vanished from a Maniwaki Reserve, Bryan Alexander Is Frustrated by All the Mixed Messages on Her Whereabouts." *Ottawa Citizen*, 20 May 2014, p. A7.

Sommers, Zach. "Missing White Woman Syndrome: An Empirical Analysis of Race and Gender Disparities in Online News Coverage of Missing Persons." *The Journal of Criminal Law & Criminology*, vol. 106, no. 2, 2016, pp. 275-314.

Spears, T. "Man Charged with First-Degree Murder 17 Years after Death of Algonquin Girl." *Ottawa Citizen*, 7 July 2017, https://ottawacitizen.

com/news/local-news/man-chargedwith- first-degree-murder-17-years-after-death-of-algonquin-girl. Accessed 15 Apr. 2024.

St. Denis, Verna. "Feminism Is for Everybody: Aboriginal Women, Feminism and Diversity." *Making Space for Indigenous Feminism*. Edited by Joyce Green. Fernwood Publishing, 2017, pp. 42-62.

Stillman, Sarah. "'The Missing White Girl Syndrome': Disappeared Women and Media Activism." *Gender and Development*, vol. 15, no. 3, 2007, pp. 491-502, https://doi.org/10.1080/13552070701630665.

Tucker, Angie. *Media and the Perpetuation of Western Bias: Deviations of Ideality: Media's Role in the Reinforcement of Negative Stereotypes of Indigenous Identity and the Manifestations of Violence Toward Murdered Women*. Institute for Community Prosperity, 2016.

Walter, Emmanuelle. *Stolen Sisters: The Story of Two Missing Girls, Their Families and How Canada Has Failed Indigenous Women*. HarperCollins Publishers Ltd, 2015.

4.

Healing and Motherhood: In Conversation with D. Memee Lavell-Harvard, Anne Taylor, Sarah Lewis, and Lisa Trefzger Clarke

D. Memee Lavell-Harvard, MaangKwan Anne Taylor,
Sarah Lewis, and Lisa Trefzger Clarke

Boozhoo, aaniin. Waubmemee ndi'zhinikaaz. Wikwemikong ndo nijibaa. Odawa Anishinaabe Kwe nda'aaw. Hello and welcome. My name is Waubmemee (which means White Dove in our language), and Dawn is my English name. I am a member of the Wiikwemikoong First Nation, and I am Odawa Ojibway from Manitoulin Island.

Boozhoo aaniin. MaangKwan ndi'zhinikaaz. Ngig ndoodem. Wshkiigmong ndo nijibaa.

Michi Saagiig 'Anishinaabe Kwe nda'aaw. Hello and welcome. My Michi Saagiig name is MaangKwan (Loon Feather), and my English name is Anne Taylor. I am of the otter clan from Curve Lake First Nation, originally known as Wshkiigmong. I am Mississauga Ojibway.

Boozhoo aaniin. I am Sarah Lewis (she/her), an Anishinaabe Kwe (Ojibwe/Cree) spoken word artist, activist, community organizer and mother. I have ancestral roots in Curve Lake First Nation, Ontario as well as Pukatawagon, Manitoba. I was Peterborough (Nogojiwanong),

Ontario's Inaugural Poet Laureate from 2021-2022 and a semifinalist at the Canadian Festival of Spoken Word in 2019.

My name is Lisa Trefzger Clarke. My paternal family immigrated from Lörrach, Germany to Canada, and my mother's family was sponsored by the Jewish Canadian Association as refugees from Berlin to settle in Canada after WWII. As a non-Indigenous cisqueer mother, I have settled for the last twenty-three years on the traditional territory of the Michi Saagiig Anishinaabeg.

Motherhood is a deeply personal topic for all four of us. Together, we have spent the past decade sharing our experiences, in professional and personal spaces, of gender-based violence, motherhood and the impact of missing and murdered Indigenous women, girls, and two-spirit (MMIWG2S) people on our lives. When we first began working together on issues of sexual violence against women and girls in the region of Peterborough Dawn, Anne, and Sarah's leadership was integral to our process, as we worked to lift the voices of missing and murdered Indigenous women and girls in this area. We found that the names and voices of our missing sisters and their families had not been recorded in our area. Together we began to ask questions of Elders and Knowledge Keepers from Curve Lake First Nation, Hiawatha First Nation, and Alderville First Nation (just outside of Peterborough County) where the Anishnaabe Kwewag Gamig Regional Women's Shelter operates.

Several of the Indigenous families and service providers in the region became not only closer colleagues but also friends as we worked together. We began to design, through our workplaces and with other service agencies, programming specifically for the healing and care of Indigenous survivors of sexual violence. Much of the passion and traditional healing models were led by Anne Taylor, who was the cultural archivist for Curve Lake First Nation during the years of research. Following the research, Anne collaborated with several Indigenous and settler-run community services, and community-based artists, to offer Indigenous and arts-based healing workshops for survivors of sexual violence. Before the COVID-19 pandemic, the demand for these workshops grew throughout the region.

Together, we celebrated Sarah Lewis as she became the first poet laureate of the City of Peterborough. Since COVID-19, she has travelled across Turtle Island sharing her words of love for Indigenous resurgence and culture and truth telling of five hundred years of colonial trauma on her people.

With our shared understanding of gender-based violence and our experiences of mothering, we wanted to take the opportunity, within these pages, to reflect on our work over the past decade together, in memory of the murder of Cileana Taylor of Curve Lake First Nation in 2020 (The Canadian Press) and the issue of sexual violence against Indigenous bodies in this region.

Lisa:

We published the findings from the *Lessons from Behind the Door* report in 2015. I am forever grateful to you both for sharing your stories of friends, family members, and community members who had been affected by the ongoing genocide of MMIWG2S. We also spoke so much about mothering during that time, mothering when your child is missing or murdered, mothering postresidential school incarceration, and mothering as a survivor of sexual trauma.

As I left frontline services during the COVID-19 pandemic to pursue my graduate studies and address the workplace trauma exposure I had experienced, I felt worried about people at home or precariously housed during lockdown, the children asked to adapt to institutional policies in the education system, and the risk of increased violence to women, children, and the 2SLGBTQIA+ community.

Dawn, as an Anishinaabe Kwe from the Wiikwemikoong First Nation, you have been advocating this issue locally and internationally, from the Canadian government to the United Nations and beyond. Anne, as a Michi Saagiig Anishniaabe Kwe, you have walked beside so many survivors of sexual trauma to share your knowledge of traditional Michi Saagiig Anishinaabeg medicines for healing and reconnection to Spirit. A decade since our journey together began, we have continued to learn and transform together. How has this journey together influenced your understanding of the impact of MMIWG2S in this region? Are you mothering in new ways? Are you having new types of conversations in community all these years later?

Dawn:

The inspiration for this book was the impacts of missing and murdered Indigenous women and girls (MMIWG) on Indigenous motherhood. The MMIWG inquiry brought to the floor of the House of Commons the conversation about the incredibly high levels of violence against Indigenous women, but we did not initially talk about its impacts on us as mothers; twenty, much less thirty years ago, we had to fight to have the issue recognized even among our own people. In conversation with you, Lisa, and your wife Rachael, I once mentioned how I would take a picture of my girls before they went out the door because I wanted to remember what they were wearing and have a recent photo in case I needed one for a missing person poster. I remember how shocked you were at that. As a mother of teenage girls, I am always aware of the stories of other mothers having to make a police report when their daughters went missing. I knew I would have a panic attack if that ever happened because I would never be able to remember what they were wearing, so it was best to have a photo of them. I'm sure I can't be the only one who thinks of this, it is very much at the forefront of many Indigenous mothers' minds when their teen daughters are heading out with some friends. I lie awake at night worrying about whether that mother and daughter might be us next.

This anxiety is part of our generation now, and I think of how our mothers and grandmothers seemed so calm as we walked out the door. Did they not feel this anxiety, or maybe they were better at hiding their fears so that we would not feel like we were being held back? When I was a teenager going off with my friends or cousins, we were conscious of the racism and violence, but it didn't feel so all-encompassing as it does now that I am a mother. This legacy of violence has been generational, in my community, for over three hundred years. Every time our Indigenous daughters, sisters, and aunties go out the door, there is a real possibility that they might not come back because of this crisis of violence. Now, as a mother, I hold my daughters more tightly and cherish each moment because I know how quickly it can all be taken away.

Anne:

I was raised by a single mom. What's interesting to me is that when I used to hitchhike to Curve Lake First Nation on Fridays to come home to the rez once I moved to Peterborough, I had to make sure I was home for the 10:30 pm curfew. When I was at home with my mom on the rez, if I wasn't in the house by 10:30, then I was in serious trouble. When I stayed in Peterborough, I had no curfew. I was able to roam around. God, I'd be walking out on Lansdowne Street at 1:32 am, and I'd walk the train tracks. I felt safe in Peterborough, but when I was on the rez, I definitely had to be in the house by curfew. If I wasn't then my brothers' friends would tell me, "You know babe, it's time you go home. Come on I'll walk you. You gotta go home." So, I was very, very protected. I respected my mom's decisions, and she always knew where I was. She always knew who I was with.

With my kids, my girls, they would get so mad at me and tell me I was embarrassing them because I'd wait until they got inside the house they were visiting, even when we drove their friends home. I would insist we wait until the friend got in the house. Now that my daughters are older they understand why. When you spoke of having pictures of your girls, Dawn, I thought, I have no pictures of mine. They hate having their pictures taken. And yes, I would live in fear that something would happen to them, and I would need to send a photo to the police. All I had were school photos, and that wouldn't help anyone recognize them.

In my conversations with Elders here, we discuss the marginalization of our women, the mothers, and the poverty that they have experienced through the Indian Act and colonization. Our women would have to sell themselves in the 1940s and 50s if they needed groceries or extra money for their families. This was not our tradition; the community cared for their families, and before colonization and the treaties (Treaty 20 and Williams Treaties), we had what we needed. This difficult history for our women has carried on through racism and stereotyping, damning our girls and women, leading to so much violence and death.

Dawn:

This is part of our history, our marginalization. The interactions with colonizers created a violent pattern of sexual harm, disenfranchisement, and survival for our people, especially our women and girls.

Lisa:

In Helen Knott's book *In My Own Moccasins: A Memoir of Resilience*, she shares her story as a Dane Zaa, Nehiyaw, and mixed Euro-descent woman from Northeastern British Columbia who experienced multiple forms of sexual violence and coped through substances. She is a mother, social worker, and a global change maker featured by the Nobel Women's Initiative for being committed to ending gender-based violence in 2016.

To begin her first chapter, she writes: "You can feel a mother's lament in her voice. The tone of her words penetrates the skin and hits bone, it hits something deeper than bone, it hits spirit" (3). This sentiment immediately resonated with me as a mother. Throughout the book, she speaks about her ancestors', her mother's, and her own experiences of colonial gender-based violence and her own experiences of missing and disappearing as an Indigenous woman. The author wonders, following these poignant lines, do you have to be a mother to feel that lament? Does her description also resonate with your experiences of raising children in the MMIW2S crisis?

Anne:

As we built the memorial for the missing and murdered behind our health centre, we still had to be so careful. People still get offended when we speak the truth about this harm.

Dawn:

Yet this is a fallout of colonization. Our women couldn't leave the reserve without permission from a white man, the Indian agent, so they were dependent on his goodwill to survive. My grandmother told me of a time she had a couple of piglets from her sister, and she brought them home to fatten them up and sell them to earn enough money to survive for the

winter. But she needed permission from the Indian agent to leave the reserve to sell the pigs. She figured she could sell these pigs for at least twenty-five dollars to the merchant in town, they were nice and big and several hundred pounds; they had been eating in the bush all summer. That Indian agent refused to give her a pass and permission to sell her pigs. He said: "I'll buy those pigs off you for five bucks." She said back, "To heck with that. For that price, I'm keeping my damn pigs." So she took them home and her whole extended family ate a lot of pork that winter. Her point was that the Indian agent controlled everything, where she went, and what she did. She was worried about what would happen if he took those pigs then she would have nothing for her children to eat, she already had nothing left to sell for money to buy food. The only thing the Indian agent couldn't take away was our bodies—that was the only thing many women were left with. I know that if I had to feed my babies, I would have no qualms about what I would have to do to survive.

It brings such an important and different perspective to what happened to our people. When we think of how the RCMP stole children, taking them to residential schools, and then the Sixties Scoop taking our children because of the level of poverty the Canadian government created, we can see how the exploitation of women has been integral to the colonial project. How do you get rid of a nation of people? You take away their future, their future generations. For generations now we have had to fight for our children.

Anne:

Canada is finally recognizing the damage done to Indigenous women, their children, and their communities, as well as their stigmatization, marginalization, poverty, trauma, mental health issues, and all of the addictions they use to cope with this genocide. You can now see the plan, the path of the Crown, and at the same time, our teachings can carry us forward on this treacherous path despite so many traps along the way. You can now see how this happened. This truth has been buried in residential school graveyards. It should never have been acceptable to treat a whole population of people with more than basic human dignity and standards. Our tradition was a matrilineal community, where everyone was equal and where genders lived in balance with their community roles.

Dawn:

I remember seeing an article discussing how the Indian agents and priests would actively discuss, recommending the best ways to put women in their proper place. Our culture is often blamed for our experiences of violence, as if Indigenous people are inherently more violent. But it is not our culture that is the source of the problem, it is in fact the breakdown of our culture and family systems. This was deliberate. By breaking down the power of Indigenous women, colonizers could also control Western women—English and French women—so that they didn't get the idea in their heads that they could have rights and they could be seen as human beings and not property. Yet, ironically those non-Indigenous were given basic human rights protections long before our women. This is embedded in the Indian Act. When a community struggles under colonization and the resulting deliberate community breakdown, you will find the women oppressed and disempowered.

Indigenous people began to believe the lies the colonial government told them; it's like Stockholm syndrome. This is why my generation doesn't speak the language; our parents were taught, in ways that were often incredibly cruel and painful, speaking our own language would inevitably hurt their own children and leave them disadvantaged. Parents made sure to promote English to protect their children after their own horrific experiences in residential schools. Denying us our language, culture, and identity, in exchange for an immediate lessening of state-enforced pain, created long-term psychological, spiritual, and soul-crushing pain. This is trauma. But it wasn't our parents' fault; it was the church and state.

Lisa:

All three of us have been navigating the academy through our pursuit of and resistance to graduate education. In fact, Dawn, your doctoral thesis interrogates how Indigenous women create transformative resistance while navigating a post-secondary experience (Harvard). Now, two of your children are also pursuing a university education. Anne, you have focussed your work over the past few years to honour your responsibility to your nation, and your relationship with your mentor Elder Gidigaa Migizi-ban (Doug Williams-ban) to become a fluent speaker of the Michi

Saagiig Anishinaabemowin.

Another voice of resistance in the academy comes from Dr. Leanne Betasamosake Simpson, a member of the Alderville First Nation. In her 2015 EMMA Talk, Leanne shares stories and critiques colonial gender binaries, state-run education, gender violence, and environmental contamination. These critiques are so poignant as she shares the story of how Binoojiinh (a fictional ancestral child) discovers maple sap, a traditional teaching in the Michi Saagiig Anishinaabeg tradition. Childhood curiosity is met by familial love, patience, and trust, resulting in the delicious discovery of maple syrup. Leanne then asks, "What if Binoojiinh had been missing or murdered before they ever made it out to the sugar bush?" (187). This question encompasses the fear and the heart of resistance to colonial genocide for Indigenous mothers here and globally.

Dawn and Anne, you have been two of my greatest mentors, demonstrating how to get momentum for change in social justice and healing—gracefully and purposefully. How do you see acts of resistance and resiliency by Indigenous mothers, as more than survival? How have you translated your acts of Indigenous resistance into mothering your children?

Dawn:

There are colonial rules and ways to resist these rules. I want my girls to understand safe firearm handling because, I believe, they need to understand traditional food security. I don't teach my kids Western society teachings about women. I want them to be strong Anishinaabe Kwe, understand self-defence, and speak for themselves. I don't want them to be cowed when a fourteen-year-old boy starts calling them racist names or slurs. I don't want them to feel crumpled in a heap of sadness or fear. I want to teach them how to resist.

We have the tradition of the spirit horse—that horse and spirit give strength and bring peace and grounding. I know from my girls, that even when they were very little, riding a horse helped them feel grounded and connected, and able to control their mental and emotional anxieties. There is something so powerful about connecting with a fifteen-hundred-pound powerful animal that gives our youth confidence so that they are not shaking when those inevitable bullies start talking harshly. In my family, I understand through teachings from my grandfather that we

didn't have gendered roles like we see in Western culture. Every grandchild and great-grandchild did the dishes, boys and girls alike; your gender didn't matter. Everyone had to work in the garden. If you wanted to eat, you needed to help cook and do the dishes. My daughters know how to shovel, care for animals, and drive a tractor, and it's important in our traditions that women could light a fire even though traditionally men were firekeepers. They didn't freeze.

Anne:

That's the lovely thing right about our language—we don't have a gendered one. We have beautiful inherent strengths and equality. My mom had my older brother and me without going to the trouble of getting married, and good for her, but because of that I was supposed to be part of the Sixties Scoop. I made it home, thank goodness, but that strength my mom learned was from her Auntie Audrey, who when she married a non-Indigenous man refused to sign the papers, stating that she would give up her Indian status. My mom refused too, and that caused a lot of trouble, but she stuck by it. I remember one of the things my mom said when I first moved in with my partner at the time: "You know, don't marry him. You live with him for at least ten years before you figure out whether you want to marry him or not." Well, I decided to wait thirty-two years, and then I thought, no I don't want to marry him. I don't even want to live with him. But I look back on the women in my family and see their strength. Even now, I look at my little cousins, and I see how incredibly strong young women they are; they are raising sons, and they're doing such an incredible job at raising good men who respect women.

Dawn:

I think that says a lot about the strength of Indigenous women and mothers who can wade through all of the difficulties and still raise their sons to be good, respectful men. I know that's hard for women to do, but they're doing such an amazing job. This parallels many experiences of marginalized mothers living under racism, poverty, and oppression, who are single mothers raising incredible men.

Lisa:

To better understand my familial trauma history with WWII and the Holocaust, I have been learning more about the impacts of epigenetics. According to Mark Wolynn, the emerging field of epigenetics explores the heritable changes to our gene function, through noncoding DNA, which can be affected by environmental and emotional stressors, such as genocide, climate change, poverty, and marginalization. Meaning that we are born with biological preparedness in our genetic makeup to be able to survive similar traumas that our parents experienced. In parallel, I have been studying the history of eugenics as a white colonial project in Canada (de la Cour; Moss et al.; Stote; Strange and Stephen).

I am not sure about you, but my sons have said numerous times that past generations have destroyed the world, and they are not having children. When I think about the impacts of both the eugenics movement and the science of epigenetics, I feel like the next generations will be navigating a dystopian landscape of hopelessness in humanity. Neoliberal policy and capitalism certainly are at the forefront of my existential dread. As a mother, I want to nurture hope, love, and a spiritual belief in human goodness in my children, especially as I raise men. More importantly, I want to see a world where marginalized communities realize justice and equity, peace and sustainability. Have you had similar conversations in your families and circles? As a mother, how do you navigate the hope for our children, and the future of their children, with the legacy of Indigenous genocide and the crisis of MMIWG2S?

Dawn:

I am so inspired by the power of DNA. It makes me so proud to be a woman who carries the eggs for my future descendants and that my mother carried my children and my grandmother carried me, and this goes back to my great great great great great great great grandmother. I'm here today because of the women who carried me and passed me on all the way to my mother. I was brought into this world through all that life. It flows through me to my girls and is part of them; it's so empowering to think about those generations. How differently would young girls feel if they were taught about this, to think about themselves with so much honour and beauty? Children were not our property,

traditionally, but belonged to our nations through the mother's family. Uncles and grandfathers were responsible for caretaking too, but we traced our lineages through our mothers. This gives such a different perspective on motherhood.

How do we navigate these next generations when the government controls our status and wants to eradicate our culture? How do we even navigate love, relationships, and children if we want to maintain our Indigenous identity and "status." Is the government willing to create a sperm bank of certified Anishinaabeg sperm so that our daughters can get IVF to ensure blood quantum? The history of eugenics in Canada is frightening—when your parentage is connected to your rights, yet you've lost so many family members, identity, and culture to violence. None of this makes sense.

Our children have been taken in many ways, beyond going missing or being murdered. Motherhood means fighting for our inherent rights that are also being taken away, like the land, our food sources, and our communities. We, as mothers, feel this pain collectively. When an Indigenous woman loses a child, we all feel the devastating loss because that loss also impacts our future generations.

Anne:

I often think of one of my family members who was murdered. There was very little repercussion. There was no justice for the loss of this beautiful young woman even though they know who killed her. He basically got a slap on the wrist for taking a life. But she was not the only one taken. A family where the mother and two daughters are gone. Children have lost their mothers here. You look at these families, whose generations have intimate knowledge of residential schools, they survived only to face more tragedy. It is such horrible violence and trauma, and we carry this fear.

Dawn:

Yet as women, we hold that fear, put on our battle armour, and get up every day. So many of us will face something that puts us in a position of having to defend ourselves spiritually, mentally, emotionally, or physically. Whether it's lateral violence from another community member,

the taxi driver who picks us up, the person who serves us coffee, or a stranger throwing physical or verbal stones. We protect ourselves daily, and we protect other women. We are warriors in battle fatigues, and we are tired; we have PTSD. Having children can feel scary and can be an act of defiance. It can be an act of survival in a country that would prefer that there were no more of us. This is a country with notions of eugenics, who deserves to be in the gene pool to reproduce and have their genes carry on.

Simply having a child is an act of survival and resistance; bringing that new life to those future generations is life itself and such an important part of the struggle. Our beautiful girls are simply life itself, a creation of life, in a nation-state that is trying to eradicate your people and eliminate your way of life. This is why we need to honour and recognize our missing and murdered relatives because every child we have brought into this world is an act of resistance to genocide. This system is trying to kill us, from the ancestors who have been murdered, stolen, institutionalized, and incarcerated to the unwed mothers, the penance with the church, and the shunning.

In our culture, a pregnant woman is something that's beautiful and to be celebrated. A new baby is a celebration, not a shame, yet pregnant women, in the Western worldview, are the reminder of sex and sin. For us, every pregnant woman is cherished and filled with powerful medicine. Every child is a gift.

I want to bring this conversation to a close in a good way by inviting another important voice into this discussion on mothering in the context of the MMIWG2S crisis. I have had the opportunity to know Sarah Lewis, a member of Curve Lake First Nation, as she was studying in the Bachelor of Social Work program at Trent University, a colleague in community and social services, a new mother of her sweet boy Sawyer, and Nogojiwanong's (the City of Peterborough) first poet laureate. Sarah understands the loss of this crisis too well. In response, she has led memorial events and performed as a spoken word poet to lift the voices silenced through the violent legacy of colonization on Turtle Island.

I See Red
By Sarah Lewis

At sixteen years old I sat outside my school, watching as classmates released balloons into the sky
Little messages tied to string
If only our pain our worry our wonder would also burn into the sun
I wonder if they know how much we miss them
I put my tobacco down,
And ask creator to make sure she tells them

Slowly
The sun disappears
The people at the vigil disappear
The balloons disappear
The women disappear
Calls to Action disappear
I close my eyes, I see red

Leah Anderson never came back to school after Christmas break
We ran on the same cross-country team, my sister, my kin, lost the race

Merry Christmas
We are gifted candlelit vigils and protests around government offices

No pride in genocide
No pride in genocide we all yell

And hell yes the revolution will not be televised
The revolution will not sit behind cell phone screen, complacent
Behind RCMP desk
in building that promises to protect yet refused to incarcerate the man who had brutally assaulted two different women three days prior
Who would eventually kill my aunt Theresa Merasty twenty-four hours after his release

HEALING AND MOTHERHOOD

The revolution is not racist, does not stereotype me as a drunk or a sex worker
that I'm probably out partying or on a bender
so as to use as an excuse to not file me as a missing person, to not look for, to stigmatize
to not care about

I'm tired, I'm tired of Indigenous women only existing in my prayers, or on a missing person poster

We deserve better
Who else has a day dedicated to the alarming rates at which they die
As if we are war veterans
As if we had a choice to be at war with this system
As if they actually honour us
I don't want your badge of honour
I want your oath of protection
I'm tired,
I'm tired of trying to wake people up

The revolution looks like red-skinned people destroying red-bricked residential schools, burning the red blood I mean leaf off of white hands I mean flag, looks like red white yellow brown black coming together like the medicine wheel
We will heal together

The revolution will empower our women to thrive, that we will be crying because our sister has graduated college, not because we found her body
Balloons will be released to sky, and candles lit because of another birthday not another funeral or vigil

The revolution will continue to grieve and mourn, will decolonize, will learn our languages back, learn our traditions and culture back, you will give land back, we will take our sisters back

I see red, I wear red because we were taught that this is the colour spirit recognizes, the colour to let them know we are thinking of

them, that we remember them, are calling to them
I put my red tobacco tie into the fire
I close my eyes
I see red

I look at all our blood
we are all the same
we are all the same
All connected

Those spirits remind me
We are the change
We are all the change

© 2023 Sarah Lewis, reprinted with permission

Works Cited

Cour, L. de la. *From "Moron" to "Maladjusted": Eugenics, Psychiatry, and the Regulation of Women, Ontario, 1930s–1960s*. University of Toronto, 2013.

Harvard, D. M. *The Power of Silence and the Price of Success: Academic Achievement as Transformational Resistance for Aboriginal Women*. 2011. University of Western Ontario, PhD dissertation.

Moss, E. L., et al. "From Suffrage to Sterilization: Eugenics and the Women's Movement in 20th Century Alberta. *Canadian Psychology/Psychologie canadienne*, vol. 54, no. 2, 2013, pp. 105-14.

Simpson, L. B. "Two Stories." *Radiant Voices: 21 Feminist Essays for Rising Up Inspired by EMMA Talks*. Edited by carla bergman, Brindle & Glass, 2019, pp. 231-47.

Stote, K. "The Coercive Sterilization of Aboriginal Women in Canada." *Gender and Women's Studies: Critical Terrain*, 2nd ed. Edited by M. Hobbs and C. Rice. Women's Press, 2018, pp. 502-12.

Strange, C., and J.A. Stephen. "Eugenics in Canada: A Checkered History, 1850s–1990s." *The History of Eugenics*. Edited by A. Bashford and P. Levine. Oxford University Press, 2010, pp. 523-38.

The Canadian Press. "Family Calls for Upgraded Criminal Charges Following Curve Lake First Nation Woman's Death." *Global News*, 23 Mar. 2021, https://globalnews.ca/news/7714367/family-upgraded-criminal-charges-curve-lake-first-nation-woman-death/. Accessed 15 Apr. 2024.

Trefzger Clarke, L. (2015). *Lessons from Behind the Door: A Community Report Addressing Access to Services in the Response to and the Prevention of Sexual Violence against Women and Girls in the City and County of Peterborough*. Kawartha Sexual Assault Centre, 2015, http://kawarthasexualassaultcentre.com/KSAC-WIP/wp-content/uploads/2019/12/KSAC_FinalCommunityReport_Web.pdf. Accessed 15 Apr. 2024.

Wolynn, M. *It Didn't Start with You: How Inherited Family Trauma Shapes Who We Are and How to End the Cycle*. Penguin Books, 2016.

5.

Accomplice[1]

Alyssa M. General

How grisly this game of hide and seek has become.
Body instead of a being.
Still childish in believing our hiding spots will be unveiled, recovered.
To hear the shrill glee in our surprise instead of the attack and decay
of a vacant timbre.
The sharp exhalations that grieve our names.
Like childhood nightmares
The monsters are faceless, nameless,
Kin to the dark.
Protected,
And somehow we are in hell.

Did we inherit this statistic?
Our vices predetermined?
Does the colour of our skin depreciate the worth of our blood?
Either way it is red,
And we have paid our ransom.

And those that spew that apathy,
That these are just crimes,
That the one in five that could be you, my sister, my mother,
my niece,
my daughter.
That these numbers have no value,
Their hands are thick with red.
I cannot expect a number to convey the loss,

To absolve the weight of grief or the empty space consumed by
the echoes of our absence.
One is too many.
I look at my daughter,
And I hope she will be different,

I will rally, I will empower, and I will challenge
The definition.
I will let her imagine her future differently,
so she will have vision.
I will teach her our ways,
so she may know where she comes from,
and so she may define her own path.

Like our women,
Who fell into seafoam,
Who shaped the earth,
Who birthed balance,
Who became the moon,
Who married and killed the serpent,
Who changed the world by changing her mind.
These women are our ancestors,
Our blood,
We must remember the strength we come from
Because it is the strength we still carry
And our women,
They deserve more than a name, and face on a wall.
They deserve future.

Endnotes

1. This poem was originally published in *Forever Loved: Exposing the Hidden Crisis of Missing and Murdered Indigenous Women and Girls in Canada* and is published here with the permission of Demeter Press.

Part Two

Community Action and Education to Address MMIWG2S+

6.

Closing Thoughts: River Women Collective's Reflections on the Final Ceremonial and Artistic Installation of Walking With Our Sisters

Cheryl Troupe and Janice Cindy Gaudet

August 15–18, 2019, marked the final installation of Walking With Our Sisters (WWOS), a community-led commemorative art installation and ceremony honouring the lives of missing and murdered Indigenous women and girls (MMIWG). The vision of Métis visual artist and activist Christi Belcourt, WWOS began in 2012 with a social media call for MMIWG family and community members to create and submit decorated moccasin vamps or "uppers" ("Project"). Belcourt received over two thousand pairs of vamps, generally decorated with Indigenous designs and materials and made by people from all over Canada (Anderson et al.). Many also came from abroad, signalling the significance of the issue of MMIWG beyond Canadian borders. Requesting only vamps and not finished moccasins represented the lives of missing and murdered Indigenous women. They also represented the importance of celebrating our missing and murdered sisters' lives. In seven years, WWOS visited twenty-seven communities in Canada and the United States. Indigenous-led grassroots collectives hosted each of

these events, often with the support of settler-allies and in partnership with community organizations, museums, and art galleries engaging as good relatives.

This chapter reflects on the River Women Collective's (RWC) year-long process of organizing and hosting the final 2019 installation. The RWC is a grassroots collective of Métis women with kinship ties to the historic Métis communities of St. Louis, St. Laurent, St. Isidore de Bellevue, Batoche, Duck Lake, and other small communities that line the South Saskatchewan River, including the primarily Anglican Scottish and English Métis communities on the north side of the South Saskatchewan River in the Halcro, Lindsay, and Red Deer Hill districts. RWC women are mothers, sisters, cousins, aunties, and grandmothers from families who have lived on this land for as many as four or five generations. The RWC formally came together in 2017 to reaffirm the role of Métis women's kinship in achieving family, community, and land wellness. The women from the St. Louis region were already a well-established network engaged in community planning and activities in various capacities.

Our paper demonstrates how our organizational process and vision for the final WWOS event expressed the continued leadership roles Métis women have held in their families and communities. From this place of strength, generosity, and love, we drew on Métis concepts of female-centred community engagement and governance, commonly held values, traditions, and historical experiences. In doing so, we reaffirmed our connection to the land knowing that the issue of MMIWG is deeply rooted in displacement from our territories and the colonial history of gendered discrimination and violence. The two are not isolated issues; our efforts were mindful of these intersections.

Four RWC members, including this article's authors—Cindy Gaudet and Cheryl Troupe, along with educator Angela Rancourt and designer Christine Tournier-Tienkamp—led this WWOS work. A council of grandmothers guided us in planning and decision-making, generously giving their time and energy throughout the year. Our Grandmothers were Louise Tournier, Claudette Lavergne, Brenda Hrycuik, Terri-Lynn Beavereye, Ann Lepine, Vivian Meabry, Faye Flaminio, Norma Gaudet, and Maria Campbell. While Campbell served as the lead Grandmother for WWOS nationally, she participated on our Grandmothers' council because she is a member of the RWC, and Batoche is her home community. Additional members of the RWC were Carole Roy, Val Gaudet,

Connie Regnier, Anna Corrigal Flaminio, Nicole Roy, Reann Jennie, Janelle Paul, Loretta Vandale, Donna Tessier, Jackie Gaudet, and Tricia Sutherland. We name all the women in recognition of their hard work in contributing to WWOS. In naming them, we honour their ancestors, families, and connections to this place. All members of the RWC were Métis, except for Tricia Sutherland, who is Cree. She also currently serves as Chief of One Arrow First Nation. Her participation in WWOS and the RWC was significant, signalling the importance of maintaining and strengthening relationships between the First Nations and Métis community in the South Saskatchewan River region whose ties have been impacted by colonialism.

Preparing to host WWOS strengthened existing relationships within the RWC and helped us build and strengthen relationships among and beyond the collective. Through these relationships, we interrupted the state- and church-defined labels of identity that can divide kinship, "making us smaller," as Maria Campbell explained within the context of her family and extended kinship system ("ni'wahkomakanak"). Taking seriously our caretaking role for our lands, one another, and our guests was of paramount importance and continues to inform the Collective's work. This approach reflects historical Métis family and community organizational practices, where Métis lived in interconnected extended family groupings carried over from the organizational structures of the buffalo hunt (Ens; Foster; Macdougall and St. Onge; Payment, *Free People* and "Vie"; Troupe, *Mapping* and *Métis Women*). The extended family nature of these communities reflected the communal values ensuring that all necessary social, economic, and political roles were filled. Living this way expanded the network of individuals that could be relied on in times of need and served to maintain culture and tradition, making it easier for Métis families to adapt in an increasingly settler environment. Many of these Métis communities, including those in the South Saskatchewan River region, were organized along female kinship lines, where groups of related women—sisters, mothers, aunts, and cousins—made up the nucleus of these extended family groupings (Foster; Macdougall and St. Onge; Payment, *Free People* and "Vie"; Troupe, *Mapping* and *Métis Women*). We strategically organized for WWOS in the same fashion to remain strong, sharing labour responsibilities and looking after one another as we would care for members of our extended kinship circles.

The final WWOS ceremony was held outdoors, which was different

from previous installations. The RWC collaborated with Parks Canada—Batoche National Historic Site and took time to visit and walk the land together, imagining the event's layout about the significance of the place and our stewardship responsibility as Métis women. The physical location of the installation at the site of the 1885 Métis Resistance was historically and culturally significant. This is Métis homeland and a sacred space. This was where Métis families resisted the Canadian government and settler interventions into their lives and livelihoods, seeking recognition of their land rights, occupancy, and way of life. It was where Métis leaders fought alongside their fathers, grandfathers, brothers, uncles, and cousins to defend Métis nationhood and way of life. It was where Métis women nursed the sick and wounded, cared for old people and children, and supported the fighters. It is a place to be remembered, honoured, and celebrated as we walk alongside our sisters, the ones missing and murdered, and with one another as a collective of women, drawing strength from our respective matriarchs and the land.

Historically, the South Saskatchewan River Métis communities were Michif-French speaking settlements comprised of buffalo hunting Métis families that took up residency, first on a seasonal and then on a year-round basis, in the 1860s. By 1863, approximately two hundred Métis, led by Gabriel Dumont, spent winters in the region, hunting buffalo and taking advantage of the food and shelter the river valley provided. Roman Catholic Church missionaries arrived in the 1870s and with the community quickly erected a mission church, school, and residence for the priest. A burgeoning economic centre grew in part because the Carlton Trail, one of a network of Red River Cart Trails that spanned the prairies, ran through the region. By the early 1880s, interrelated Métis communities with a population of approximately fifteen hundred lived in the region, divided into settlements at Batoche, Fish Creek, St. Laurent de Grandin, St. Louis de Langevin, and Duck Lake (Payment, *Free People*). Here the Métis developed a vibrant economic, social, and cultural community and made a living by hunting, trapping, trading, freighting, and farming (Payment, "Batoche," *Free People*, and "Vie"). They farmed in a river lot system of long narrow plots of land that fronted the water, providing families access to all available and necessary resources and ensuring that families lived in proximity, helping to maintain kinship relationships. This land tenure practice reflected the Métis worldview and reinforced family- and community-held values including the

importance of sharing, equality, and honouring kinship relationships. The values of hospitality and generosity were also foundational to the maintenance of kinship relationships across communities. Food was always shared, and visitors were always welcomed. Visiting, playing cards, smoking, and drinking tea were popular pastimes, and dances and music were popular. The role of the church was significant, and many, particularly older men and women, remained devout Catholics (Payment, "Batoche," *Free People*, and "Vie"). Many, including community leader Gabriel Dumont, also practised Indigenous spirituality alongside Christianity (Thompson).

The site we selected to lay the vamps was along the remaining Carlton Trail, a wooded path that meanders six hundred-plus feet down the banks of the South Saskatchewan River to the water's edge. This spot was adjacent to the place where Métis women camped during the 1885 Resistance. When fighting broke out at Batoche, women, children, and old people fled their homes, seeking refuge from the fight. They erected a temporary camp near the river's edge where they would be safe, where they could feed the Métis fighters and tend to the sick, wounded, and dying. In this space, women were able to continue caring for their children, extended family, and community, despite the violence and upheaval that surrounded them. It was fitting that we held WWOS in this space of resistance that reflects women's work, care, and agency. It was also a way to enact Métis women's experiences that have too often been forgotten in dominant historical narratives.

The installation space, beyond the path of vamps placed along the wooded path, included a tent village where visitors could rest, reflect, experience, and immerse themselves in local Métis history and culture. Given that the final installation was the only WWOS event hosted by a Métis collective and that it was also hosted on Métis territory, the RWC felt it was essential to appropriately reflect our history, culture, and experience. Métis cultural values of visiting, feeding, caring for visitors, and knowing we are more powerful when we work together guided all our decisions. Part of our Métis ethics also involved caring for ourselves as a collective of women by visiting with each other and participating in various activities as a community of women. The structure of the RWC upheld equality in the sense that we all arrived knowing who we are as Métis people, knowing too the experiences of the historical and contemporary struggle of being treated and feeling like second-class citizens.

As Jackie Gaudet explained, "not one being louder and one more silent." We were helpers to one another.

To create a sense of community about the WWOS installation, the RWC erected a temporary women's camp as their female ancestors did in 1885. Called the tent village, this was a space that provided refuge, safety, and cultural wellness for MMIWG family members and WWOS visitors. The tent village was a space where Elders, visitors, and community members could rest, relax, visit, reflect, receive counselling and wellness support, take part in cultural activities, and a place where children could play. The centre of the village was the Grandmothers' Tent, which we strategically placed at the entrance to the vamp installation. The Grandmothers decorated their space resembling a Métis kitchen, complete with patterned tablecloths, rocking chairs, blankets, wildflowers adorning the tables, and a portable stove for making tea to serve with bannock and jam. Their tent was the most dynamic space in the village and a place where our Grandmothers enacted the cultural value of hospitality and visited and exercised their roles as matriarchs. Visiting in Métis communities has historically not always been just for having fun, dancing, playing cards, and gossiping; it is important for reinforcing kinship relationships, working out family and community differences, dealing with conflict, and checking in on one another (Corrigal Flaminio et al.; Farrell-Racette; Gaudet, "Keeoukaywin"). Over the four days of the event, the Grandmothers' Tent was the heart of the tent village. As one of the Grandmothers, Louise Tournier, shared, "Anybody could stop in later coming or going, stopping for coffee, sit down and watch us make those little tobacco ties, or just talk and tell us what they felt after going through the exhibit." Creating a special space was of utmost importance to the Grandmothers, and they did just that.

Local Métis organizations and service delivery agencies hosted additional visiting spaces in the tent village, providing wellness and cultural learning opportunities for visitors. One of our partners, the Gabriel Dumont Institute (GDI), hosted a cultural tent with Margaret Harrison, a Métis Elder and artisan, sharing her embroidery work. Visitors could sit, relax, and reflect on their experience with the vamps as well as learn how to embroider, making a small red dress pin in honour of MMIWG. Several partners also hosted counselling and wellness tents staffed with cultural, clinical, arts-based, and mental health support for the visitors needing support after touring the installation. In addition, a

separate space was available for those requiring private support. There was also a children's tent, staffed with volunteers and plenty of games and activities for small children. Ceremonial protocol prohibited small children, pregnant women, and the infirm from going through the installation, so it was essential for us that we have space available for children, given that our Métis kinship upholds a meaningful place for children in our families (Anderson). We had a dedicated Two-Spirit Tent, a Volunteer Tent, and a few additional tents with chairs and cots for those who might need a quieter space to rest. We also dedicated one tent to the RWC coleads as a safe space to reflect, talk through organizational challenges, and support one another. We colloquially called this tent our "giggle tent." The collection of these tents provided culturally grounded hospitality, food, care, entertainment, and wellness support, like how Métis women provided these in their camp during the 1885 Resistance.

As this was the final installation, we anticipated that individuals and families involved in WWOS installations over the previous seven years would attend. We envisioned that individuals and families from across Canada would attend, remaining for the four days, allowing them to participate in the final closing ceremony. The Métis Nation-Saskatchewan (MNS) provided their Back to Batoche grounds as a campsite and gathering place for families and visitors. These are the grounds where the Métis from across Canada come together each July, since the late 1960s, to celebrate Métis history and culture. There are serviced camping and a large, covered stage, multiple large kitchens, picnic tables for serving outdoors, several small cabins, washroom and shower facilities, and a large Elders pavilion on site. The grounds are located approximately three kilometres from the Batoche National Historic Site and about two kilometres from the East Village, so it was an ideal location for families, visitors, and volunteers to camp. The MNS provided us full access to the space in kind, which helped ensure that visitors and volunteers had places to camp, gather, visit, and be fed. We had about thirty different camps set up and visitors staying in ten of the cabins.

Cooks and volunteers planned and prepared nutritious, wholesome meals for volunteers and visitors each day in the Back to Batoche kitchens. Planning and preparation were essential as the nearest grocery store was over twenty kilometres away, in the rural town of Rosthern, or seventy-five kilometres away, in the city of Prince Albert. We relied on the fresh vegetable produce provided by volunteers and local growers,

and from the vegetable gardens, grown and harvested on the Batoche National Historic Site. In anticipation of WWOS, Batoche staff expanded the size of their gardens and grew additional produce for donation. Vivian Meabry, one of the RWC grandmothers, also planted extra vegetables in her garden. Similarly, the MNS arranged for a gift of fresh fish to be brought in from the province's north so that visitors and volunteers could have a feast of traditional Métis foods. These generous donations significantly reduced the funding required to host the event. However, more importantly, they created a sense of community—taking care of our visitors and demonstrating Métis values in sharing available food resources with others. Each day, several community volunteers and RWC members happily chose to work in the kitchens rather than work directly with the installation and hosting of the event at the East Village. Reflecting on their experience, RWC member Val Gaudet recalled how much fun it was to work alongside community members in the kitchen. The joy emanating from the kitchen did not go unnoticed, as Connie Regnier remarked, saying that the kitchen was full of laughter and storytelling, so much so that it didn't even seem like work. Humour has always been foundational in how Métis individuals and families visit and work together. This remained true not only in the kitchen but throughout much of the preparation and in WWOS spaces. Kitchen volunteers took ownership of preparing and serving meals. For Métis families, kitchens have always been women's spaces. Kitchens were where women worked to prepare food to nourish their family's bodies, hearts, and minds. Grandmother Claudette Lavergne noted that kitchen tables were special places where women shared stories, rocked their babies, and freely gave advice, care, and support. Val Gaudet and her cousin Carole Roy, also a RWC member, even brought herbs and special ingredients from home to cook traditional family- and community-held recipes. The actions of these women, and others they worked alongside, reveal how they extended the firmly held Métis value of being a good host and a good guest, providing food and a place for visitors to rest and share a meal with guests outside of their homes and in the public spaces created by RWC.

The final installation was ambitious and, at times, daunting and emotional. The RWC began preparing in the summer of 2018 by first meeting with Maria Campbell and members of the WWOS Grande Prairie Collective. We met at Maria's home at Gabriel's Crossing where Grande Prairie women handed off wellness supplies and offered their support

to the RWC. From here, the RWC met regularly, as mentioned earlier, in two of St. Louis's community spaces to discuss and plan the installation and define our roles based on our talents and interests.

We shared laughter, stories, and pot-luck food at each of our planning meetings, reinforcing our way of being. The Grandmothers guided our meetings, opening them with prayer and a smudging ceremony so that we could focus on the challenging work we were doing. Many of the RWC, including our Grandmothers, were introduced to smudging practices and complementary cultural knowledge through these meetings, such as preparing specific foods for the closing ceremonial feast. Historically, the South Saskatchewan River Métis communities have been predominately Roman Catholics, and the role of the Church has been significant in shaping our lives, which included its efforts to reinforce Eurocentric values of femininity and womanhood (Anderson). Consequently, most of the RWC grew up in the church, distant from Indigenous ceremonies and spirituality. Despite this, most were eager to learn and reconnect with spiritual teachings and practices. One of the Grandmothers shared the importance of reconnecting to these teachings that had not been passed down due to various reasons, including the role of colonialism and the church. We prioritized regenerative learning of these practices within our RWC gatherings in preparation for WWOS, as per the cultural protocol and relational ethics. This included teachings around smudging, the practices of harvesting and preparing sage, teachings around the use and protocols of making tobacco offerings, and the practice of making tobacco ties. For some members of the RWC, this was their first time engaging in these activities. For others, learning about harvest and using sage in ceremonial ways extended their knowledge and connection to the land, expanding the foods and medicines they already routinely harvested.

Understanding that we potentially would host more than a thousand family members and visitors over the four days of the final installation, broader community support and engagement were important. The RWC worked hard to educate the larger Métis, Indigenous, and non-Indigenous community on the MMIWG issue, to build partnerships, and to encourage participation and welcome volunteers. We led a series of fundraising activities and community conversations in the immediate Batoche region and community conversations in Prince Albert, Saskatoon, Bellevue, and One Arrow First Nation. The RWC made a conscious effort to visit

within their own families and immediate communities to share information and create awareness of the event. Acknowledging our interdependence was another regenerative practice tied to Métis-kinship wellness and leadership ways. Connecting to the ways of our grandmothers and replicating these were often shared as an inspiration to keep carrying on and to work collaboratively despite the numerous uncertainties.

The installation was a huge undertaking that came with unknowns, given that most of the RWC had not attended previous WWOS installations and we did not know how many visitors to prepare for. Hosting the event outdoors also came with uncertainty. The RWC began preparing the Back to Batoche grounds and physical space at the historic site a week before the arrival of the vamps. On Saturday, August 10, the bundle of vamps and ceremonial items arrived from Ontario, transported by members of the National Collective in a truck and trailer. We ceremonially welcomed the bundle, beginning with a pipe ceremony, song, and feast and then made a procession with the ceremonial eagle staffs and sacred items, walking from the Back to Batoche Grounds to the East Village. The truck and trailer containing the vamps followed behind. Approximately thirty people drummed, sang, and reflected as we walked the approximately two kilometres to the East Village. Once there, volunteers led by members of the National Collective and our RWC colead, Christine Tournier-Tienkamp, began unpacking and sorting the vamps and prepping the ceremonial space where the vamps would be displayed.

Over six hundred feet of sixty-inch-wide red cloth was laid on the path winding down towards the river and staked down with small wooden pegs tied with ribbon. Helpers carefully selected and lovingly placed each pair of vamps on the cloth with measured precision in two rows, with toes leading toward the water. Male helpers erected a tipi and lit a ceremonial fire during an opening ceremony. Firekeepers remained on site to protect and keep the ceremonial fire burning for the four days of the installation until the closing ceremony on August 18.

Opening day, August 15, began with a media scrum, and then the installation was opened to the public. Upon arrival to the tent village, our Grandmothers invited guests into their tent to visit and to enjoy bannock and tea. Volunteers greeted guests and directed them towards the start of the path. As per cultural protocols, guests smudged before entering the installation, and they received a small tobacco tie to carry

with them as they walked along the path. The tobacco tie was an offering made to the Creator to help provide strength to the individual as they moved through the installation. Volunteers also offered guests tissues and asked that they dispose of them in designated places at the end of their visit, guided by the understanding that all tissues, holding the tears of family members and loved ones witnessing the vamps, would be offered to the ceremonial fire at the end of the installation. As this was a ceremony, ribbon skirts were offered for women to wear, but it was not mandatory that they do so. Some RWC members made extra skirts and skirts for themselves in the months leading up to and in preparation for WWOS. For many of the RWC, sewing together and learning about Métis skirt teachings was an important part of strengthening our connections to one another, our grandmothers, and our land (Dorion).

The four days ended with a pipe ceremony, feast, and giveaway. Over two hundred people took part in the final ceremony. There were twenty-four pipes used during the ceremony, seventeen of which were women's pipes, six were men's pipes, and one was a two-spirited pipe. The number of pipes included, specifically the number of women's pipes and the two-spirited pipe, speaks to the significance of the issue of violence against Indigenous women and MMIWG for our families and communities and the resurgence of gender balance. During the ceremony, seven eagles were flying high overhead, which the Elders understood to represent the seven years the vamps travelled in the community. The closing ceremony included honouring the role of the Grandmothers, pipe offerings, giveaways, a traditional feast, and cultural teachings about death that included not looking back as we made our final walk up the vamp-laden path. After the feast, participants walked in a procession with the eagle staff and sacred objects from the riverbank to the Back to Batoche grounds. Christine Tournier-Tienkamp, one of our coleads, led the procession, carrying one of the eagle staff. This was a profound experience that we will all forever cherish.

Reflecting on the opening ceremony for the final installation, Christi Belcourt shared the personal significance of the installation and the impact she feels it has had on the communities visited. She stressed the importance of WWOS being a grassroots initiative, allowing itself to take shape as communities saw fit and allowing everyone involved to enter and participate as equals. She spoke at length about equality and her belief that there was no hierarchy when working with the vamps

because individual participation was about honouring our missing sisters. Belcourt acknowledged that the power of WWOS was also in its organization and production. The installation, she said, is a powerful tool that holds a mirror up to communities, revealing the issues that communities often face. While she was undoubtedly speaking to the problems of racism, marginalization, discrimination, and violence faced by Indigenous women, girls, and two-spirit individuals, she also spoke to some of the important lessons and opportunities for change that WWOS has created. For instance, one of the results of this work, she explained, was that WWOS has helped create a safe space for LGBTQ2S to participate in Indigenous ceremonies. While not explicit, she could also have been speaking to how grassroots communities were able to come together around an important issue, working to educate and make social change.

For the RWC, the mirror revealed many important lessons. It reminded us of the significance of relationships in working together, the importance of being the caretakers of our lands, and thinking critically about our rights and responsibilities as Métis women in our homelands. It also reaffirmed teachings about what it means to be a good host and what it means for others, even other Métis people, to be good guests in our territory. While many, if not most, Métis view Batoche as their homeland or territory, there are rights and responsibilities in its stewardship for those who continue to live in this territory. For those of us who are part of the contemporary community of Métis living on these lands, we have an ongoing responsibility and relationship with the land. As RWC, we take our responsibility to be stewards of the land seriously, and this means having a good relationship with others, such as Parks Canada-Batoche National Historic Site, which have a vested interest in the land. The RWC has worked hard, individually and collectively, to build and maintain strong working relationships with Parks Canada before WWOS. In preparation for the event, we had negotiated with Batoche National Historic Site to allow us to burn a ceremonial fire on Parks property for the four days of the event, provided we agreed to not light the fire until a fire protection team was on site. Despite discussing this with the National Collective, decisions were made to light the fire ahead of schedule. This was an obvious concern to the RWC, as we had a responsibility to honour the directives of our partner, Parks Canada. It was our responsibility to right this relationship and repair the damage done in not abiding by their wishes, as inaction had the potential to

impact the RWC's ongoing and long-term relationship with Parks Canada-Batoche National Historic Site, a relationship that is crucial to the ongoing work of the collective beyond WWOS.

The work of WWOS also reminded us about the importance of working together in a respectful way, which includes communication. The strength of our collective was the result of time spent building a strong, safe, and supportive relationship with one another over the previous year. Many of the RWC members had familial and extended relationships with one another. The same type of relationship did not exist between members of the RWC and the National Collective, and we did not take time to develop these relationships in the same way. This was most evident on the second day of the installation when decisions were made about using the Grandmothers' Tent to host a complementary public event without expressly requesting permission from the RWC Grandmothers to do so. The space the Grandmothers had so lovingly created was temporarily dismantled to accommodate a large crowd, displacing our Grandmothers and leaving them with no space to fulfil their role in visiting, feeding, and welcoming visitors. The displacement of the Grandmothers from their space, even temporarily, reflects the colonial legacy of our historical dispossession and displacement from our lands that continues today in various forms.

The displacement of our Grandmothers and the lighting of the ceremonial fire before the agreed-upon date are but two of many challenges we faced in organizing and presenting the final installation of WWOS. These challenges, our RWC Grandmother Maria Campbell reminded us, are also teachings. As a result, it important to talk about them and acknowledge the lessons that they provide so they do not fester within us. As Métis people, she shared, we no longer sit down and talk about conflict. We ignore and deny it and are often complacent with it. These are issues that have plagued our people. Removal from the land, forced assimilation, and the imposition of church and government policies have resulted in our colonization and have sought to legitimate violence against Indigenous women and our lands. As colonized peoples, we have inherited a colonial strategy that has taught us to not confront challenges, to shy away from hard conversations, and to not deal with interpersonal, family, and community conflict. To decolonize, we need to move through our conflicts, understand why they happen, and find solutions in moving forward and righting our relationships with each other and with the land.

Maria helped us see that by viewing challenges in this way, we move against the domination and socialization influenced by our colonial history that has attempted to silence and divide us. As Métis women, we are strong, and we have always spoken up for ourselves. Maria urged us to talk about the challenges and to write about them, so we can learn and share our learnings. In not doing so, we fail to give voice to the root causes of MMIW and the significance of our role as women.

WWOS was an expression of Métis women reclaiming a historical space, affirming our power as a kinship collective of women, and taking a stand against colonial violence that justifies taking the lives and bodies of Indigenous women. This must stop, as Christine Tournier-Tienkamp expressed so clearly. Demonstrating that we are still here and that our families, ways of knowing, values, ethics, and practices remain strong, as a collective, we needed to confront the challenges that arose in this work. This was part of the work we had not anticipated, yet with the guidance of Maria, the medicines, and the teachings of how to care for one another, and to remember the work of honouring our missing and murdered Indigenous sisters, we moved through the discomforts, shared honestly around the kitchen table, and found solutions to carry forth the important work we all deeply cared about.

This collective work created an opportunity to heal and to build community networks across Saskatchewan and nationally. We continue to maintain strong working relationships with supporting organizations such as Parks Canada-Batoche National Historic Site, Métis Nation-Saskatchewan, and the Gabriel Dumont Institute. For the RWC, the mirror Belcourt discussed reflected the strengths of our Métis community and the determination and resilience of Métis women both in historical and contemporary ways. It reflected the values we hold, share, and pass on and how we continue to fulfil essential and traditional roles within our extended families system. While WWOS was a ceremony of honouring our missing and murdered sisters, for the River Women Collective at Batoche, the final installation also meant honouring generations of Métis women we love, our mothers, aunties, grandmothers, and great-grandmothers who have lived, shared, and led on the banks of the South Saskatchewan River for generations. As a collective, we learned, unlearned, and reaffirmed ceremonial and cultural protocols, ethics, and practices by expressing our values regarding visiting, hospitality, reciprocity, and care. We operated within a recognizable Métis

kinship system that privileges relationships between women, and places women at the centre of our families and communities, revealing a Métis women's leadership and governance model grounded in our worldview.

Works Cited

Anderson, Kim. *Life Stages and Native Women: Memory, Teachings, and Story Medicine.* University of Manitoba Press, 2011.

Anderson, Kim, et al., editors. *Keetsahnak: Our Missing and Murdered Sisters.* University of Alberta Press, 2018.

Campbell, Maria. "Ni'wahkomakanak: All My Relations." Big Thinking Series. Congress of the Humanities and Social Sciences, 2 June 2021, University of Alberta, Edmonton.

Campbell, Maria. Personal interview. 11 August 2019.

Corrigal Flaminio, Anna, et al. "Métis Women Gathering: Visiting Together and Voicing Wellness for Ourselves." *AlterNative*, vol. 16, 2020, pp. 55-63. https://doi.org/10.1177/1177180120903499.

Dorion, Leah, et al. "Celebrating the Wisdom of Our Métis Matriarchs: Sewing Our Wellness All Together—Kood Toot Aansamb." *Around the Kitchen Table: Métis Aunties' Scholarship.* Edited by Laura Forsythe and Jennifer Markides. University of Manitoba Press, 2024, pp. 212-30.

Ens, Gerhard J. *Homeland to Hinterland: The Changing Worlds of the Red River Métis in the Nineteenth Century.* University of Toronto Press, 1996.

Farrell-Racette, Sherry. "Kitchen Table Theory." Sâkêwêwak Artists' Collective Storytellers Festival, 3 February 2017, University of Regina, Regina.

Foster, Martha Harroun. *We Know Who We Are: Métis Identity in a Montana Community.* University of Oklahoma Press, 2006.

Gaudet, Jackie. Personal interview. 11 August 2019.

Gaudet, Janice Cindy. "Keeoukaywin: The Visiting Way—Fostering an Indigenous Research Methodology." *Aboriginal Policy Studies*, vol. 7, no. 2, 2019, pp. 47-64. https://doi.org/10.5663/aps.v7i2.29336.

Lavergne, Claudette. Personal interview. 11 August 2019.

Macdougall, Brenda, and Nicole St. Onge. "Rooted in Mobility: Métis Buffalo Hunting Brigades." *Manitoba History*, vol. 71, 2013, pp. 21-32.

http://www.mhs.mb.ca/docs/mb_history/71/metisbrigades.shtml.

Payment, Diane. "Batoche After 1885, A Society in Transition." *1885 and After: Native Society in Transition*. Edited by F. Laurie Barron and James Waldram. Canadian Plains Research Centre, 1986, pp. 173-82.

Payment, Diane. *"The Free People—Otipemisiwak": Batoche, Saskatchewan 1870–1930*. Ottawa, National Historic Parks and Sites, Parks Service, Environment Canada, 1990.

Payment, Diane. "La Vie en Rose"? Métis Women at Batoche, 1870–1920. *Women of the First Nations: Power, Wisdom and Strength*. Edited by Christine Miller and Patricia Chuchryk. University of Manitoba Press, 1996, pp. 19-37.

"The Project." Walking With Our Sisters, 8 May 2019, http://walkingwithoursisters.ca/about/the-project/. Accessed 16 Apr. 2024.

Regnier, Connie. Personal interview. 11 August 2019.

Thompson, Charles Duncan. *Red Sun: Gabriel Dumont, Folk Hero*. Gabriel Dumont Institute, 2017.

Tournier, Louise. Personal interview. 11 August 2019.

Tournier-Tienkamp, Christine. Personal interview. 11 August 2019.

Troupe, Cheryl. *Mapping Métis Stories: Land Use, Gender and Kinship in the Qu'Appelle Valley, 1850–1950*. 2019. University of Saskatchewan, PhD dissertation. https://harvest.usask.ca/handle/10388/12122.

Troupe, Cheryl. *Métis Women: Social Structure, Urbanization, and Political Activism, 1850–1980*. 2010. University of Saskatchewan, MA thesis. https://harvest.usask.ca/handle/10388/etd-12112009-150223.

7.

A Walking With Our Sisters Syllabus

Rebecca Beaulne-Stuebing

Part One: Context and Description

This public syllabus was created as an extension of the work of helping with the Walking With Our Sisters (WWOS) project. I am Métis through my late mother (with roots in the Sault Ste. Marie Métis community and Manitoba, registered with the Métis Nation of Ontario) and was adopted into the bald eagle clan in the Three Fires Midewiwin Lodge. Since 2014, I have been a helper to the WWOS national collective, working with its bundle through to the closing ceremonies. As a young person, I experienced significant learning through the relationships and work involved. The WWOS bundle has been an incredible teacher to people and communities, so this syllabus is shared to expand what can be learned from this cross-community effort. This syllabus is an offering. Please pick it up, engage with it, and share in any way that works for you.

Syllabus Description

This syllabus engages with critical questions and conversations that flow into and from the WWOS commemorative art installation and ceremony, honouring Indigenous women, girls, and two-spirit people who are missing or who have been murdered. Made possible through the love of thousands of collaborators and the guidance of Elders, young people, and organizing collectives from twenty-seven host communities, WWOS is

a project that reaches across time(s) and place(s) into and between worlds. This syllabus seeks to learn directly from people and communities affected by #MMIWG2S and engage in WWOS to more thoroughly understand the context of gendered, sexualized colonial violence and ways to reduce its harms. WWOS is a critical, living offering from which much can be learned about the intersections and interstices (Recollet) of Indigenous artmaking, resistance, and ceremony, where honouring is a central theory of change (Tuck).

Extended Description

This syllabus has been put together carefully and intentionally in recognition of the real pain and complex, specific relationships to loss that different people and communities have. In this way, the course learns from how WWOS attends to honouring, respecting, and showing love for our relatives whose lives have been stolen and for their families and communities who must find a way to live without them. WWOS began as a call for submissions of vamps—the top part of a makizin—over Facebook, initiated by Métis artist Christi Belcourt in 2012. This call was made in response to the overwhelming, ongoing disappearances and violent deaths of Indigenous women and girls and a vision for honouring their spirits and families. Over sixteen hundred pairs of vamps were sent in and with guidance from lead ceremonial Elder Maria Campbell, the seven-year travelling memorial came to life. The vamps visit communities—and are visited by communities—in installations created through ceremony and opened to the public for periods. While WWOS is often thought of as an art exhibit, Belcourt writes: "It isn't. Walking with our Sisters defies categorization. It's a commemoration. It's ceremony, it's an honouring, it's art, it's community taking action, it's a way to demonstrate we care" (xii).

This syllabus considers what can be learned from WWOS as a collective effort that reaches across time(s) and place(s)—a ceremony that moves into and between worlds. WWOS is an honouring response to violent deaths and disappearances with impacts at multiple scales (Goeman) from the most intimate level of the spirit to the broader structures and relations that comprise the full context of gendered, sexualized colonial violence. WWOS has grown into a ceremony of over two thousand unfinished makizinan; love and sorrow poured into each pair, arranged side by side and held within a lodge. Each missing woman, each missed

person, is a whole world destroyed; and all of their loved ones, those worlds are taken down, too. This is the landscape of grief, the map of colonial violence upon which we have to keep living, creating, remembering, and organizing. This is where Indigenous resistance springs and where a collective approach to ceremony, sustained by an ethic of honouring, makes new worlds possible in devastation.

There are four primary ways that this syllabus learns from WWOS, aiming to reflect its central ethic of honouring. First, the texts emphasize connection rather than separateness in seeking to understand the context of violence and #MMIWG2S, balancing specificity and full vision to exemplify what I describe as an approach that learns from Migizi. Second, a citational practice is prioritized so that learning about #MMIWG2S and WWOS foregrounds the contributions of directly affected people and communities. Third, the syllabus situates critical Indigenous articulations of, and theorizations towards, harm reduction as necessary frames for community organizing and movement building. Finally, this syllabus cares about the worlds made in the connections and spaces between Indigenous artmaking, resistance, and ceremony, when honouring is a theory of change.

To articulate this course's approach to the complex context of gendered, sexualized colonial violence, I rely on what I know about ndoodem, my clan, Migizi. Migizi offers a particular way of seeking understanding and vision at multiple scales and carrying messages between worlds. Migizi soars to see the whole landscape, the full context as lived and experienced by all of their relatives. As they travel farther and fly higher, more connections become discernable from what may otherwise seem like separate perspectives, experiences, and structures. Migizi also swoops down with intention, towards specificity, while maintaining a sense of and commitment to the bigger picture (including what cannot be seen).

For example, texts in Week 1 closely examine the experiences of WWOS host communities, while Weeks 2 and 3 consider the fuller context of violence. Just as Migizi swoops down for specificity as they travel, Weeks 4 and 5 focus on learning about how Indigenous sex workers and Indigenous trans women distinctly experience, live through, and resist violence. This swooping down happens again in Week 10, with further offerings of queer, trans, and two-spirit perspectives on reducing harm in the ceremony. This syllabus learns from Migizi by refusing to

approach this work in a linear or tokenizing way; instead, we travel in circles, across scales, to grow understanding and analysis. Perhaps most importantly, Migizi goes about their work for the protection of all of their relatives. It demonstrates that the purpose of seeking to understand violence is to end it, in all ways, for all relations.

In Week 2, chapters by Dian Million ("Gendered Racialized Sexuality"), Mishuana Goeman, Beverly Jacobs, and Helen Knott offer thorough analyses of the multiple scales of violence that comprise the map upon which WWOS came to life, as part of broader movements for #MMIWG2S. Systemic and state violence, experienced at the scale of the body and most intimately of the spirit, are structurally necessary for the development and continuation of settler colonial states (Million, "Gendered Racialized Sexuality"). Goeman emphasizes the connectedness here, rather than separateness, and the movement that occurs between scales: "Violence has multiple connections that spread out on vertical and horizontal scales ... [and] builds from an individual's story in a particular place to a story that entangles multiple generations of stories and journeys through temporalities and spaces" (100). Put another way, violence experienced in the present is compounded by histories of violence (Million, "Gendered Racialized Sexuality" 37). And in "thinking of the body as a geography connected to other geographies" (Goeman 102), violence experienced at the levels of the body and spirit is compounded by violence on the land (Women's Earth Alliance & Native Youth Sexual Health Network).

Writing from her home in Treaty 8 territory, Knott clarifies how environmental violence, state violence, and violence against women and girls in Northern British Columbia are linked. The oil and gas industry boom in the area corresponds with the highest rates in the country of missing and murdered Indigenous women and girls; Knott connects these dynamics to environmental violence and environments for violence, referring to the "man camps" set up for industry workers. Even while these connections may seem evident, Knott also points out that movements to protect lands and waters are painfully detached from those to protect Indigenous women and girls and to support their families. These relationships are explored further in Week 4 in the *Violence on the Land, Violence on Our Bodies* report (Women's Earth Alliance & Native Youth Sexual Health Network).

Knott's chapter is enriched by Eve Tuck's and Sarah Deer's contributions in Week 3, calling into question how research and statistics frame how we know what is known about violence in settler states. An over-reliance on damage-centred and statistical research constrains not only our understanding of the problem(s) but also our responses—and how Indigenous people and communities think of ourselves. Million's felt theory describes how Indigenous women's experiential narratives can upend this colonial knowledge. Indigenous women's voices connect individual experiences to structural violence through ways of knowing that are "felt, intuited as well as thought" (Million, "Felt Theory" 57). Such firsthand accounts move between scales, in all directions, and offer the depth and complexity necessary to express what it feels like to experience violent systems. This felt theory is critical in coming to understand the whole context of gendered, sexualized colonial violence and environmental violence. While these are all connected, connection does not mean conflation. An ethic of honouring acknowledges specificity and a full picture at once, as Migizi seeks understanding to protect and sustain all life.

By considering the multiple, intersecting ways in which "relatives are violenced" (Women's Earth Alliance and Native Youth Sexual Health Network), this syllabus attends to specificity through an intentional citational practice. This involves centring the work of directly affected people and communities and relying on not only academic texts but also video, poetry, blog posts, and visual and public art. Such an approach responds to questions emerging from texts in Week 3 to consider how we know what we know. In Million's felt theory, learning about specific experiences with violence and ways to reduce harm means learning directly from those living it. This is an approach also taken in the *Violence on the Land, Violence on Our Bodies* report, which highlights the voices of Indigenous young people and those active in reproductive justice and land and water defence movements (Women's Earth Alliance and Native Youth Sexual Health Network). In considering the full context of gendered, sexualized colonial violence, this approach means learning directly from two-spirit people, trans women, youth, those involved in sex work, those who experience homelessness, those who are ill, disabled, or both and those who use substances. It also involves centring the voices of family members who have lost loved ones, and the people and organizations recognized as foundational to movements for #MMIWG2S. In

learning about the many experiences of communities involved in WWOS, this syllabus prioritizes the voices of those active in host community collectives (Dewar; Knott; Jacobs; Rahman et al.) and the WWOS national collective (Anderson; Beaulne-Stuebing; Bear; Belcourt; Kappo; Konsmo). Several chapters are included from the *Keetsahnak* collection, edited by Kim Anderson, Maria Campbell, and Christi Belcourt of the National Collective, and created as an educational resource to extend the reach of WWOS across communities.

WWOS is a meaningful project not only in the context of how Indigenous people and communities experience violence but also for our resistance and responses to that violence. The histories of movements for #MMIWG2S and their families are critical in learning about WWOS, so multiple texts in this syllabus discuss foundational activism such as organizing in Vancouver's Downtown Eastside, and efforts of the Native Women's Association of Canada (Harjo et al.; Livingston and Hunt; Jacobs). Other texts connect WWOS to other movements, including artists' responses to the summer of 1990 at Kahnesetake (Nanibush), and Idle No More (Simpson; Recollet; Harjo et al.). Erin Marie Konsmo and Karyn Recollet critically discuss land and water defence movements and how purity narratives, ableism, homophobia, and transphobia persist in Indigenous activism and ceremony spaces. Their analysis builds on Arielle Twist's and Jaye Simpson's offerings in Week 5, which challenge readers to think critically about what it means to honour and support Indigenous trans women. Sarah Hunt, Erica Violet Lee ("For Cindy"), and Naomi Sayers describe the compounded dehumanization experienced by Indigenous sex workers and how these specific acts of violence ultimately harm all Indigenous people and communities. Tara Williamson and Konsmo and Recollet further consider the exclusions that often take place in ceremony spaces toward those who use drugs, alcohol, or both; purity narratives enact even further violence on community members who deserve safety and support. Kai Pyle and Alex Wilson extend this analysis in consideration of two-spirit people's experiences in ceremony, complicating insufficient analyses, which position ceremonies as necessarily healing or helpful in Indigenous communities, when "many queer and trans Indigenous youth do not feel supported, welcome, or safe in their own families or communities or ceremonial spaces" (Wilson 161). Homophobia, transphobia, and misogyny intersect to create conditions within which "we police ourselves" (Pyle) with

"rigidity and singular interpretations of protocols" (L. Simpson 226), leading to further harm. As Wilson so importantly points out, simply adding "2S" (for "two-spirit") to the #MMIWG2S acronym cannot be enough: "We must go further and embrace what all of this means" (172). WWOS is one initiative which has, through the leadership of two-spirit people, encouraged communities to engage in these conversations in unprecedented ways (Rahman et al.). All of these texts offer critical Indigenous articulations of harm reduction, or in other words, what it means to "bring the safety back" to our communities (Jacobs 32). These offerings push forward conversations that are critical to the ethic of honouring necessary in discussions of Indigenous responses to violence.

Weeks 6 and 7 circle back to themes from Week 1 to consider with even greater complexity how WWOS makes space for honouring relatives at the intersections and interstices (Recollet) of Indigenous artmaking, resistance, and ceremony. Creating ceremony to hold space for grief is a distinct contribution of WWOS to movements for #MMIWG2S, reflecting a quieter, softer, and slower way of organizing (Rahman et al.). Writing from direct experience, Ann-Marie Livingston and Sarah Hunt describe how families have been impacted since #MMIWG2S has become an increasingly public issue:

> [E]ven before the community activism began, and before the public became aware... family members were searching for, talking about, and mourning the loss of their loved ones.... The emotional landscape of family members' intimate loss, grief, memories and hope differs in significant ways from the aggression and anger that often fuels rallies and awareness campaigns that have come to represent the issue. (47)

As much as public awareness and community organizing around #MMIWG2S has led to some moves toward justice (Jacobs), it has also transformed intimate losses into "a generalized social issue" (Livingston and Hunt 54). Increased public attention has created conditions for further violence, as was demonstrated in the disturbing, dehumanizing media spectacle surrounding the murder of Cindy Gladue (Lee; Sayers). Laura Harjo et al. describe the "sacred ontology of beadwork" central to WWOS, where "the spirit of the beads ... speak to the absence"; the use of beadwork on unfinished makizinan "renders visible the lives of [the] missing and murdered ... and the pain their families and loved ones still

endure, without putting their faces and bodies on display" (292). Honouring as a theory of change, rather than awareness-raising or other strategies (see Morrill, Tuck, and the Super Futures Haunt Qollective), means that WWOS is "more about what's quietly happening and the impact that this has had on people really intimately" (Beaulne-Stuebing). To Livingston, truly honouring her mother Elsie must involve "connect[ing] the intimate acts of mourning and remembrance with the societal efforts to address the issue" (45). I think this is what Angie Morrill, Eve Tuck, and the Super Futures Haunt Qollective meant in the "opposite of dispossession is not possession…. It is unforgetting. It is mattering" (1).

In Week 9, remembering practices are considered with public art and settler colonial imperatives to erase Indigenous peoples from the land. How Indigenous people and communities remember violence and history is dangerous to the settler colonial state and its "archival memory" (Ghaddar). Indigenous ways of remembering—especially those expressed as public art—offer critical interventions into public infrastructures as they "assert their own space, demanding to be read on their own terms" (Robinson and Zaiontz 35). In the context of WWOS, communities create ceremonies on their terms for honouring. Making ceremony involves moving and collaborating between worlds, relying on leadership from land, spirit(s), Elders, and youth (Belcourt). In this way, "WWOS displaces logics that force communities to disavow their cosmologies and teachings and make settler colonial logics appear 'natural'" (Harjo et al., 288). Critical conversations in Indigenous communities more broadly about harm reduction and two-spirit people's self-determination and access to ceremonies have influenced WWOS organizing at local and national levels (Rahman et al.; Wilson). These conversations further disrupt the colonial logics of homophobia, transphobia, ableism, and purity (Konsmo and Recollet).

The texts in the final week theorize what it means to make worlds in devastation. These texts extend the meaning of WWOS about decolonization, justice, and right relations as projects that are always beginning (Hargreaves and Jeffress), happening both next and now (Tuck and Yang 10). When relatives are violenced, whole worlds are torn apart; violence on bodies and lands over generations remakes the landscape as "an aching archive—one that contains all our growing grief" (Morrill, Tuck, and the Super Futures Haunt Qollective 2). WWOS supports commu-

nities to make new spaces, on their terms, for honouring loved ones and holding collective grief. Leanne Simpson describes this organizing approach as "creating another being—a community-based travelling ceremony of [2000] makizinan vamps and a series of community conversations" (235). WWOS has been entirely organized by volunteers and made possible through community fundraising. Through WWOS, communities have made worlds from what seems like nothing. This is the hope possible in grief when relatives are honoured, and their families are cared for:

> To provide care in the wastelands is about gathering enough love to turn devastation into mourning and then, maybe, turn that mourning into hope.... Hope, then, is believing that some worlds must exist for us.... Even when we must piece those worlds together from gathered scraps, slowly building incandescent ceremonies out of nothing but our bodies, words, and time. (Lee)

WWOS is a bundle of gathered scraps and makizinan vamps lovingly created by over thirteen hundred contributing artists. These sacred pieces were gathered together and cared for by twenty-seven collectives from different communities and a national collective; they have been visited and honoured by thousands of people over the seven years the bundle has travelled. WWOS is one way that communities are providing care in devastation, making "ceremonies out of nothing" in the context of ongoing violence and loss. Eve Tuck and K. Wayne Yang write that decolonization is a project that is practised; it is not "a promised land or future" but is "happening now" (10). In this way, "decolonization defies ongoing colonization" (11). This course as a whole is concerned with what can be learned from a project like WWOS which, by centring honouring, defies ongoing violence.

Part Two: Reading Schedule

Week One: Introducing WWOS and Learning from Communities

These texts centre the voices and experiences of the WWOS national collective and host community collectives to introduce WWOS as a collaborative community experience and ceremony.

Belcourt, C. "Waking Dreams: Reflections on Walking with Our Sisters." *Keetsahnak: Our Missing and Murdered Indigenous Sisters.* Edited by K. Anderson et al. University of Alberta Press, 2018, pp. xi-xvii.

Kappo, T. "Tanya Kappo at Violence No More–May 24, 2014 in Toronto." *YouTube*, 2014, https://www.youtube.com/watch?v=FwncfZSAwK0. Accessed 16 Apr. 2024.

Dewar, J. "Walking with Our Sisters in Sault Ste. Marie: The Commemoration of Missing and Murdered Indigenous Women and Indian Residential School Students." *The Land We Are: Artists & Writers Unsettle the Politics of Reconciliation.* Edited by Gabrielle L'Hirondelle. ARP Books, 2015, pp. 87-95.

Rahman, S. "Q&A with Walking with Our Sisters Toronto." *Inspirit Foundation*, 2017, https://inspiritfoundation.org/qa-with-walking-with-our-sisters-toronto/. Accessed 16 Apr. 2024.

Week Two: The Context of MMIWG2S, Violence, and Resistance

These chapters theorize violence and its impacts on people and communities at multiple scales in ways that are compounded over time. They also describe recent histories of community organizing about justice for MMIWG2S and their families.

Million, D. "Gendered Racialized Sexuality: The Formation of States." *Therapeutic Nations: Healing in an Age of Indigenous Human Rights.* University of Arizona Press, 2013, pp. 33-55.

Goeman, M. "Ongoing Storms and Struggles: Gendered Violence and Resource Exploitation." *Critically Sovereign: Indigenous Gender, Sexuality, and Feminist Studies.* Edited by J. Barker. Duke University Press, 2017, pp. 99-126.

Jacobs, B. "Honouring Women." *Keetsahnak: Our Missing and Murdered Indigenous Sisters.* Edited by K. Anderson. University of Alberta Press, 2018, pp. 15-34.

Knott, H. "Violence and Extraction: Stories from the Oil Fields." *Keetsahnak: Our Missing and Murdered Indigenous Sisters*. Edited by K. Anderson et al., University of Alberta Press, 2018, pp. 147-59.

Week Three: How Do We Know What We Know about MMIWG2S?

These texts critically examine the role of research and statistics in how we come to know about violence and how Indigenous narratives from direct, felt experience disrupt settler colonial knowledge.

Million, D. "Felt Theory: An Indigenous Feminist Approach to Affect and History." *Therapeutic Nations: Healing in an Age of Indigenous Human Rights*. University of Arizona Press, 2013, pp. 56-77.

Deer, S. "Knowing through Numbers? The Benefits and Drawbacks of Data." *The Beginning and End of Rape: Confronting Sexual Violence in Native America*. University of Minnesota Press, 2015, pp. 1-15.

Tuck. E. "Suspending Damage: A Letter to Communities." *Harvard Educational Review*, vol. 79, no. 3, 2009, pp. 409-28.

Week Four: Considering Healing and Harm Reduction in the Context of Ongoing Violence

These texts introduce the concept of harm reduction from critical Indigenous feminist perspectives. They contend with the profound pain experienced by whole communities "when relatives are violenced" and the urgent need to reduce harm for those whose lives are most under threat—specifically, those involved in sex work.

Women's Earth Alliance and Native Youth Sexual Health Network. "When Relatives Are violenced." *Violence on the Land, Violence on Our Bodies: Building an Indigenous Response to Environmental Violence*, 2016, pp. 20-35, http://landbodydefense.org/uploads/files/VLVBReport Toolkit2016.pdf?. Accessed 16 Apr. 2024.

Lee, E. V. "For Cindy, for Ourselves: Healing in the Context of Colonial Gender Violence." *Moontime Warrior*, 2015, https://moontimewarrior.com/ 2015/04/02/for-cindy-for-ourselves-healing-in-the-context-of-colonial-gender-violence/. Accessed 16 Apr. 2024.

Sayers, N. "Our Bodies Are Not Terra Nullius." *Kwe Today: Fierce Indigenous Feminism*, 20 Mar. 2015, https://kwetoday.com/2015/03/20/our-bodies-are-not-terra-nullius/. Accessed 16 Apr. 2024.

Hunt, S. *Selling Sex: Experience, Advocacy & Research on Sex Work in Canada*. Edited by Emily van der Meulen. UBC Press, 2013, pp. 82-100.

Week Five: Specificity of Two-Spirit People's Lives and Experiences with Violence

These texts generously teach about two-spirit and trans women's lives in relation not only to violence and grieving, but also to life, love, and language.

Twist, A. "On Translating the Untranslatable." *Canadian Art*, 20 June 2018, https://canadianart.ca/features/on-translating-the-untranslatable/

Twist, A. *Disintegrate/Dissociate*. Arsenal Pulp Press, 2019.

Simpson, J. *It Was Never Going to Be Okay*. Harbour Publishing, 2020.

Week Six: The Life and Love of This Ceremony

These selections introduce the concept of ceremony from Indigenous feminist perspectives, a spirit-centred, safe, and loving experience that moves between worlds.

Bear, T. "Walking with Our Sisters: An Art Installation Centred in Ceremony." *Aboriginal Policy Studies*, vol. 3, no. 1, 2014, pp. 223-30.

Williamson, T. "This Is a Ceremony." *The Winter We Danced: Voices from the Past, the Future, and the Idle No More Movement*. Edited by The Kino-nda-niimi Collective, Arbeiter Ring Publishing, 2014, pp. 379-85.

Anderson, K. "Doorkeepers to the Spirit World." *Life Stages and Native Women: Memory, Teachings, and Story Medicine*. University of Manitoba Press, 2011, pp. 154-60.

Week Seven: Indigenous Artmaking and Resistance

These texts explore how Indigenous artmaking and resistance intersect and interact with ceremony, as active, living, and life-giving processes of creation.

Simpson, L. "Bubbling like a Beating Heart: A Society of Presence." *Dancing on Our Turtle's Back: Stories of Nishnaabeg Re-creation, Resurgence, and a New Emergence*. ARP Books, 2011, pp. 85-100.

Recollet, K. "Glyphing Decolonial Love through Urban Flash Mobbing and Walking with Our Sisters." *Curriculum Inquiry*, vol. 45, no. 1, 2015, pp. 129-45.

Harjo, L., et al. "Leading with Our Hearts: Anti-violence Action and Beadwork Circles as Colonial Resistance." *Keetsahnak: Our Missing and Murdered Indigenous Sisters*. Edited by K. Anderson et al., University of Alberta Press, 2018, pp. 279-304.

Week Eight: On Honouring and Unforgetting

These collaborative works offer ways of thinking about what honouring means about direct loss and the broader, aching landscape of grief.

Livingston, A., and S. Hunt. "Honouring Elsie: Was She Just a Dream?" *Keetsahnak: Our Missing and Murdered Indigenous Sisters*. Edited by K. Anderson, University of Alberta Press, 2018, pp. 45-62.

Morrill, A., E. Tuck, and the Super Futures Haunt Qollective. "Before Dispossession, or Surviving It." *Liminalities: A Journal of Performance Studies*, vol. 12, no. 1, 2016, pp. 1-20.

Week Nine: On Public Art and Remembering

These pieces reflect on relations between Indigenous art(ists) and resistance, and how Indigenous remembering practices challenge settler-colonial imperatives of displacement and erasure.

Nanibush, W. "Love and Other Resistances: Responding to Kahnesata:ke through Artistic Practice." *This Is an Honour Song: Twenty years since the Blockades*. Edited by K. Ladner and L. Simpson, Arbeiter Ring Publishing, 2010, pp. 165-93.

Robinson, D., and K. Zaiontz. "Public Art in Vancouver and the Civic Infrastructure of Redress." *Land We Are: Artists & Writers Unsettle the Politics of Reconciliation*. Edited by G. L'Hirondelle and S. McCall, ARP Books, 2015, pp. 22-51.

Ghaddar, J. "The Spectre in the Archive: Truth, Reconciliation, and Indigenous Archival Memory." *Archivaria*, vol. 82, 2016, pp. 3-26.

Week Ten: Honouring All of Our Relatives: Reducing Harm in/through Ceremony

These texts challenge the ways that homophobia, transphobia, ableism, and purity narratives create unsafe conditions for participation in ceremonies and on the land; safety for all relatives must be prioritized in any resistance or resurgence project.

Wilson, A. "Skirting the Issues: Indigenous Myths, Misses, and Misogyny." *Keetsahnak: Our Missing and Murdered Indigenous Sisters.* Edited by K. Anderson et al. University of Alberta Press, 2018, pp. 161-74.

Pyle, K. "When Ceremony Is Not Enough." *GUTS Magazine*, 2018, http://gutsmagazine.ca/when-ceremony-is-not-enough/. Accessed 16 Apr. 2024.

Konsmo, E. M., and K. Recollet. "Meeting the Land(s) Where They Are At: A Conversation between Erin Marie Konsmo (Metis) and Karyn Recollet (Urban Cree)." *Indigenous and Decolonizing Studies in Education: Mapping the Long View.* Edited by L.T. Smith et al. Routledge, 2018, pp. 238-51.

Simpson, L. "Centring Resurgence: Taking on Colonial Gender Violence in Indigenous Nation Building." *Keetsahnak: Our Missing and Murdered Indigenous Sisters.* Edited by K. Anderson et al. University of Alberta Press, 2018, pp. 215-39.

Week Eleven: Decolonizing Now: Making New Worlds from Devastation

These texts ask us to think about how people and communities make worlds from what seems like nothing in the context of profound pain and devastation. These worlds made from/in the wastelands defy ongoing violence; they are decolonization, happening next and now.

Lee, E.V. "In Defense of the Wastelands." *GUTS Magazine*, 2016, http://gutsmagazine.ca/wastelands/. Accessed 16 Apr. 2024.

Belcourt, B. *This Wound Is a World.* Frontenac House, 2017.

Tuck, E., and K. W. Yang. "Born under the Rising Sign of Social Justice." *Toward What Justice: Describing Diverse Dreams of Justice in Education.* Edited by E. Tuck and K.W. Yang. Routledge, 2018, pp. 1-19.

Hargreaves, A., and D. Jefferess. "Always Beginning: Imagining Reconciliation beyond Inclusion or Loss. *The Land We Are: Artists & Writers Unsettle the Politics of Reconciliation*. Edited by G. L'Hirondelle et al. ARP Books, 2015, pp. 200-10.

Part Three: Learning Activities

These activities are offerings to extend our learning, to carefully and thoughtfully do something with the knowledge and understanding we have gathered through the many texts in this syllabus. What we can do depends on who we are, how we are feeling, and what our relationships are in these discussions. Doing something with our learning is a way of honouring what has been generously offered up by the writers, artists, and community members whose works make up this syllabus. These activities are prompts for a certain kind of thinking, one that is consistent with the quiet, careful, slow, and honouring approach of WWOS. They are not intended to conclude our learning but rather ask us to think deeply, from who and where we are, about our responsibilities about the ongoing learning in our lives.

You are encouraged to take up these questions or prompts in your own way and in your own time. You might think for a while without expressing anything; you can decide to take these up in your life in any way. It is up to you.

Activity One: Honouring the Water(s) as a Lived Daily Practice

What can you do, in your own life, to make a daily practice of honouring the water(s)? Make this a quiet practice that does not need to be shared. What would it mean for you to honour the life of the water(s) where you are in a quiet and ongoing way?

Optional Assignment:

Choose one daily, quiet practice that you can realistically commit to for one week. In a journal or on a sheet of paper, track your experience and observations each day. What did you notice? How did you feel? What was challenging? What felt new or surprising?

After you have tracked your experience for one week, summarize your reflections in a short paper (about five hundred words). Describe

what you learned about honouring as a daily practice about your life and world. Express your thoughts and any questions you may have about what it would mean for you to continue with a daily practice of honouring the water(s).

Activity Two: Honouring the Land(s) as a Lived Daily Practice

What language does the land speak where you are? Who knows this language? What is your relationship to those who care for the land where you are?

What would it mean for you to relate to the land(s) where you are in an honouring way? How could you carry this, quietly, into your way of living every day?

Optional Assignment:

Research the initial questions above. Whose land are you living on? What language(s) have been spoken in that place for millennia? What are the treaties, agreements, or happenings that created the conditions for the present relations in that place? What is your relationship to these events, people, and places? What is the relationship of your ancestors to these events, people, and places? How is this place connected to other places and times? Are there projects, policies, or politics that threaten the life of the land or the people caretaking it?

With what you have learned in your search, write a personal acknowledgement and commitment about the land where you live (about five hundred words). Think about writing *to* the land. Imagine the land is your audience. Describe what you have come to understand about this place and what it means to live your life there, now. What is your distinct relationship with the caretakers of this place? Name what you find beautiful. What brings a sense of awe or joy? What you are grateful for that the land gives or does that you feel deserves to be honoured? Acknowledge what you have learned about the harm experienced by the land and the ways that this harm continues. Lands, waters, humans, and older-than-human relations are all part of the complex web of connections that are (in) a place, leaving tracks for past and future generations. Note your intentions or hopes for this place and write a statement of commitment describing how you can have or desire to have an active role in the continued life of the lands, waters, and all relations where you are.

Suggested Resources:

Vowel, C. "Beyond Territorial Acknowledgements." Apihtawikosisan, 2016, https://apihtawikosisan.com/2016/09/beyond-territorial-acknowledgments/. Accessed 16 Apr. 2023. https://native-land.ca/territory-acknowledgement/

Activity Three: Sharing (Parts of) This Syllabus with People in Your Life

Think of people in your life who may want to learn about any, or all of the topics discussed in this syllabus. Which of the texts, gathered together here, might you want to share with people you care about? You can also think about how to engage in conversation with people in your life about the readings and topics taken up in this syllabus.

Optional Assignment:

Choose one text from this syllabus to share with a person in your life (a friend or loved one). Think of the reason(s) why you want to share this particular resource with them. Write a note to this person to express this caring intention. If you can do so, create a bookmark out of your note with as much creativity and expression as you wish. Use plain, colourful, or patterned paper; dress up or decorate the bookmark in any way you choose. Give this note to the person directly, or you can mail it to them, along with the resource. Perhaps you offer them a link to the text if it is online, or you lend them a borrowed library copy of a book, or you purchase the text for them as a gift. Follow up with this person in your own time, maybe inviting conversation about what has been shared and what you are learning. While learning can be personal, intimate, and quiet, we also cannot do it in isolation. This assignment extends your learning into the existing relationships in your life.

Part Four: Closing Words

Although the WWOS project has formally concluded, I continue to learn from the relations, practices, and experiences involved in the work. This syllabus has been brought together in hopes of extending what can be learned through the WWOS bundle, a bundle of relations that includes me. It also includes you. It will include each one who finds meaning in the offerings gathered together here, as well as what has been missed,

the offerings not included in this syllabus. The WWOS bundle will continue to have life through the thoughts, feelings, dreams, and actions of everyone who was impacted by its presence and teachings. Some of these lessons were profound. Some were so, so difficult. In time, though, learning can shift and change. New or different connections can become possible. We can apply our learning in new or different ways, and contexts, as seasons change and time passes. With every step, we add our tracks to the land so that they are there for our ancestors and for the future to know of our work. WWOS was a collaborative effort with expansive relations and learning, now imprinted in the places it drew people together in loving collaboration. We are still making meaning of that which continues to flow from the ceremony we put our hands to. Miigwech bizindawyeg.

8.

Pedagogical Considerations on Teaching "Missing and Murdered Indigenous Women from a Global Perspective"[1]

Brenda Anderson

As a non-Indigenous person who has directly benefited from the colonization of prairie soil into white settler farmland, I am confronted with the question of what roles and responsibilities I now have in my privileged position as a white feminist academic choosing to be a witness to the past and an ally for the future. The issue of missing and murdered Indigenous women (MMIW) was the catalyst for turning my questions into action. The repeated horror of listening to news stories and reading posters on pharmacy windows asking, "Have you seen ... Please call ..." led me to ask Indigenous women—Elders, activists, mothers, and daughters—what key lessons a non-Indigenous ally needs to learn about standing alongside and how those with social privilege can make space for things to happen.

This chapter is a practical reflection on my experiences since 2008 of teaching a university course on MMIW with an emphasis on Indigenous and feminist methodologies and pedagogies. I write in the spirit of the truth and reconciliation process, which has challenged all Canadians to locate themselves in the narrative of colonialism and commit to the full acknowledgement of our joint history, no matter how painful, as a means

of beginning reconciliation. I write mainly for those who may wish to teach in this area, as I move back and forth between theoretical questions and personal observations from the classroom. I challenge readers, as I challenge students, to consider whether Canada needs to name our historic and current treatment of Indigenous women as femicide, as has been done in countries like Guatemala and Mexico, to acknowledge not only the violence but the complicit acceptance of this phenomenon within our social and legal fabric.

Three ethical questions guide my teaching: what are effective steps that can be taught to non-Indigenous allies to facilitate movement through the inevitable but immobilizing "white guilt" to a more productive and accountable position of witnessing or standing alongside?; how do we teach about trauma without further traumatizing, particularly for Indigenous students for whom this has tragically become a personal journey or, to put it another way, how do we equip our future activists with concrete tools for self-care to prepare them to redress violence and inequity?; and what theoretical feminist and Indigenous methodologies work well in bringing Indigenous and non-Indigenous students together in community-engaged research? These themes are reflected throughout this chapter as I discuss content and pedagogy. I conclude by offering a sample syllabus for a third-year women's and gender studies course called MMIW: A Global Perspective.

The course is designed to teach students about the history of colonialism in Canada and its effects on all Canadians in general, Indigenous Canadians in particular, and Indigenous women and girls specifically. A theoretical emphasis on the intersections of racism, sexism, capitalism, and neoliberalism, among many other layers of oppression, demands that the students and I recognize our personal location in the oppression or experiences of oppression. The majority of students are females from white-settler backgrounds, along with many self-identified Indigenous and Métis students, and one or two from more recent immigrant backgrounds. We usually number about thirty students, which is ideal for table-talk exercises designed to blend analysis with personal debriefing opportunities.

From the Local to the Global and Back Again

The course is modelled after the goals and principles that guided a 2008 conference held in Regina, SK on MMIW. The conference created a forum for voices to be heard from a variety of social locations and professional perspectives that address this issue with their particular lens; to formulate a global analysis of colonialist gender violence from which we can recognize patterns of violence that occur in Canada; and to care for the whole person in this painful recognition that the problem goes far further and deeper than the individual acts of a few violent men. I bring those principles into the classroom with the 2008 MMIW conference proceedings, *Torn from Our Midst: Voices of Grief, Healing and Action from the Missing and Murdered Indigenous Women's Conference, 2008* (Anderson et al.). To move forward, we cannot afford to scapegoat any one group in Canada (e.g., police, media, and government), lest it mollify our complicity in a colonialist country. Perspectives from all areas are needed to grasp the full complexity of how a colonialist and sexist nation was created and is currently perpetuated. The global nature of colonialist violence against Indigenous women and the subsequent resistance movements clarifies what happens in our backyard and offers paths forward to redress the problems.

We begin the semester by locating the history of Indigenous women within Canada's pioneering history by showing their relationship to white settlers. We discuss the Pocahontas-squaw motif described by Janice Acoose in *Iskwewak–Kah' Ki Yaw Ni Wahkomakanak: Neither Indian Princesses nor Easy Squaws* to illustrate how and why the fantastical native is framed in our national imagination as either the noble, exotic savage to be conquered or as the beast of burden to be despised or pitied (49). We move to current media representations of Indigenous women, particularly the stories of victimized women, and pay attention to the language used and the assumptions made. These representations are juxtaposed with personal stories shared by family members who visit the classroom. Journalists also talk with us, and one in particular recounts how her representation of the issue has changed as she became more aware of Canada's history and the personal stories of families. Journalism students accept the challenge to change the narrative when they enter the workforce. Resisting the pattern of blaming the victim is possible when white-settler language and assumptions become recognizable and students see the opportunities they have to shape the national narrative of MMIW.

Although I begin the course with Canadian history, I frame violence against Indigenous women in the global context, examining Mexico, Guatemala, and Australia. Moving outside our frame of reference illustrates that colonialism survives off violence against brown-skinned women everywhere, for even though each country has its unique history, the violence is replicated in similar ways. For instance, the effects of neoliberal trade agreements connect misogyny with economics. Activists in Mexico and Canada bring attention to the decline of local artisan sales, particularly detrimental to Indigenous women when multinational companies are allowed to become monopolies (Erno 57). They attest to the governmental and military violence perpetrated in Mexican towns, such as San Salvador Attenco, where attempts to remove Indigenous people from their land in preparation for free trade plans include premeditated kidnapping and raping women (Perez). Pastor Kim Erno's analysis of the effects of neoliberal economics on Indigenous women pinpoints their vulnerability to "exclusion, exploitation, expulsion, (and finally) extermination" (60). Students are asked to locate if, and where, these stages occur for Canadian Indigenous women.

Mexican gender roles were shaped by eighteenth-century wars between the Spanish, by Catholic conquerors, by the manifest destiny that permitted American frontiersmen to expand and conquer the continental United States (M. Anderson 22), and by the Mexican revolutionaries. Continuing today as the hegemonic masculine ideal, the caudillo (military strongmen) became "rooted in the family" as the independent breadwinner in contrast to the idealized feminine of domestic production (Healy 5). When neoliberal economics no longer support traditional livelihoods, instead favouring young, easily coerced women as workers in sweatshops (Portillo), traditional machismo roles are displaced and increased domestic violence makes women vulnerable at home as well as at work (Healy 154). Women's deaths in the maquiladoras (sweatshops) in northern frontier cities, such as Ciudad Juarez, have been linked to the lethal blend of misogyny, neoliberal economics, political corruption, and drug cartels (Bowden).

Recent works on Canadian Indigenous masculinities, such as Sam McKegney's *MASCULINDIANS: Conversations about Indigenous Manhood*, mark a similar pattern for Indigenous men. The class discusses the displacement of traditional male roles from an economic, social, and spiritual perspective. The systemic exclusion, exploitation, expulsion,

and extermination of Indigenous people through Canada's reserve system, residential schools, the Sixties Scoop, increased foster care and incarceration, and the resulting rise in gangs and exploitative forms of the sex trade and sex trafficking reads like a global manual on colonialism.

Identifying global patterns of dislocation and alienation from traditional social values encourages students to see Canada's history differently. However, distant stories are not enough, so I invite professionals who work with MMIW to talk about their experiences and tell the stories of MMIW. Police officers from the missing persons unit discuss local cases; hearing about the lack of necessary resources and support for family members allows students to see how individuals often struggle within the systems purportedly designed to assist. In contrast, government policymakers from the Saskatchewan Provincial Partnership on Missing Persons have shown what is possible when things are done differently, when all voices, including government officials, representatives from social organizations, and victims' families, are present at the table (Pottruff). Speakers from local activist groups, such as Sisters in Spirit or Amnesty International, ensure we hear firsthand how systems of governance replicate the oppression against First Peoples generally and Indigenous women specifically. In one three-hour class, students see a PowerPoint presentation with the faces of Indigenous women from Saskatchewan who have gone missing or been murdered, listen to police and provincial government responses, and write the names of those who have most recently been taken onto an Amnesty banner. It becomes not just a question of the need for correct information and education but shows students the measure of power, or lack of power, those who work within the government have. The students begin to ask what challenges they will face if they find themselves working in police, judicial, or social work capacities.

What I have observed over the years of teaching this class is the increasing number of Indigenous people employed in the professions who can bring their stories of what it is like working within a white-dominated profession on issues that may be near to their own experiences. How it changes the messages and perceptions when an Indigenous journalist or police officer tells the story! That problematic perception of white settlers "helping" Indigenous people dissipates when everyone is understood as an active and essential agent for change. The balance of power is slowly but incrementally shifting, and students take note of that change.

Moving beyond Canada again, the familiar pattern of British colonialism in Australia mirrors the historic violence against Indigenous women here. The racist notion of "breeding out" Indigenous blood inspired the creation of the half-caste system in Australia. It is a jolting reminder of the intentions and consequences of Canada's Indian Act and Bill C-31, particularly in its implications for Indigenous women who experience the double burden of sexist and racist ideologies (75). My class examines the Australian half-caste school system2 through the 2002 film *Rabbit-Proof Fence* because it opens up space to speak about the potential of retraumatizing people when their stories are told by outsiders (Noyce). Is it helpful, harmful, or both to recount stories of girls being torn away from their mother's and auntie's arms and driven away to the school when the actors themselves experienced that very trauma when they were girls? Is it okay for a white male director, no matter how sympathetic, to direct Aboriginal girls to "get in touch with the pain" of trying to return to their families when they may suffer from intergenerational trauma?

In the Canadian context, the film *The Healing Circle* describes Canada's residential schools and the complicity of the churches in carrying out the government's program of cultural genocide. The film was created by the Anglican Church of Canada as one of its earlier reconciliation projects. It portrays the history of the schools and their lasting effects on the children and on the adults from whose arms the children were torn, who experienced such a massive cultural disruption in terms of family norms, cultural values, spirituality, languages, governance structures, and land-based knowledge. The class discusses intergenerational trauma and connects today's increased domestic violence within Indigenous communities to the unaddressed trauma of the residential school system. The intentionality behind the deliberate actions of the residential school system is stark, and Canadians can no longer wilfully think of the present as an unfortunate and unintended consequence of centuries-old practices.

What students find most disturbing about the film, perhaps, are comments made by the teachers. Although most of the teachers in the film express considerable confusion over why they felt it was the right thing to do at the time, some say it was, and would still be, an appropriate response to "the Indian problem." Naturally, this raises the youthful ire of the classroom. However, it is not as simple as blaming people from

the past. Anglican priest Cheryl Toth speaks to this response. She calmly notes to the class:

> While I understand you being upset at those types of comments, as am I, I'd like to suggest that many of us in this room, compelled to be here because of our sense of justice and wanting to make this a better world, might in fact have been amongst those who taught and worked in the residential schools. The sad and frightening fact is that many of those well-intentioned people genuinely felt they were helping those children.

This is met with silence because the next logical question is "What am I doing right now that I think is helpful that might be looked at decades from now with similar horror?" Perhaps this is the strongest message to non-Indigenous students: the best role of an ally is to learn to stand alongside the efforts of those who have experienced the abuse and to ask what they need to reconcile the past and move forward.

The compelling notion of deep healing helps move students forward to a new narrative in Canada. To begin helping students discover that narrative, I first contrast it to the concept of deep colonizing as the covert "practices ... embedded in the institutions that are meant to reverse processes of colonisation" (Rose 1), which Deborah Bird Rose raises in the Australian context of land claims procedures. She describes Aboriginal peoples' gendered relationships to the land and how deep colonizing continues to erase Aboriginal women when this relationship is ignored in modern land claims court challenges (3). Differentiated sacred spaces traditionally demand women's voices be present at the negotiating table, yet court practice has been to exclude them (4), which neglects knowledge to be gained from understanding which spaces, with their associated rituals, are, indeed, sacred to Indigenous women. Deep colonizing is the erasure of women's presence in sacred rituals and court systems alike under the guise of land claims talks. Here are some questions students can pose in the Canadian context. What form does deep colonizing take in Canadian legal treaty contestations and environmental challenges? And what does the absence or presence of women at our highest courts say about our national views on Indigenous women?

In contrast, deep healing becomes a form of active witnessing associated with everything from sacred rituals to legal procedures. Family members of the missing and murdered, Elders, and Indigenous leaders

require intentional, deep listening from the rest of Canada. How do students imagine deep healing could happen in Canada's court systems during trials relating to missing and murdered women? How will deep colonizing be replaced by deep healing in the Canadian context? Considering the original narrative, and how that can lead to important questions about systemic erasure of Indigenous women, helps students understand their role in changing harmful practices.

With this wealth of global and national stories interwoven throughout the semester, we arrive at a point where the class debates whether the word femicide fits our national context. My colleague, Leonzo Barreno, originally from Guatemala, describes that country's struggle with drug cartels and female mules (drug couriers who often do not know they are carrying drugs) who disappear along the drug routes to North America. He shows how activists in Guatemala and Mexico define femicide in terms of not only enculturated violence against Indigenous women and girls but also in the nation's complicity in its denial of any systemic problem (71). A national inquiry in Canada—particularly when led by family members and the findings and recommendations of Sisters in Spirit researchers and backed by legislative deep healing across the country—can redress Canada's femicide. Acknowledging its existence is the first step towards preventing it.

Weaving the local and global contexts together throughout the semester allows students to recognize patterns, reorganize their perspectives and priorities, learn about global efforts to end violence against Indigenous women, and commit to effective decolonizing and deep healing in Canada. The commitment is crucial for the well-being of all who call this land home—Indigenous Peoples, newcomers, settlers, and my students.

Accountability and Belonging in a Classroom Community

Locating ourselves in this issue is a thread throughout the course. I relate my story of growing up in a farming community that did not acknowledge its white privilege. Racism was assumed, rarely challenged. In its best light, this at least affords me an awareness of what white guilt and tears of shame are all about and how, as the late Elder Ken Goodwill advised me, they are neither required nor wanted. I learned that my heritage as

the grandchild of a white Scottish settler from Prince Edward Island gives me certain insights into the task of reconciliation. I can tell where others' white privilege turns to white guilt. The class discusses those terms and how neither can be the default position of an ally. When we learn about a history that has been withheld from us, despite twelve years of grade school and university classes, and learn of its direct consequences in every Canadian life, we often feel rage and shed tears. Tempered, that realization becomes motivational. Untempered, it can lead to dissociation, as evidenced in rhetorical questions like, "How could they have done that to other human beings?" Carol Schick and Verna St. Davis note the essential task of pressing students to realize the "they" is them today and now (57). Just as men need to stand alongside feminists, non-Indigenous allies need to move from the historical to the present and from the "tsk tsk" to a personal awareness of and accountability for their white privilege. That transforms pity into deep healing.

White guilt is often accompanied by its fellow traveller: trauma. The potential for triggering students who themselves have suffered from abuse is real. I am not a psychologist, nor should a professor assume a counselling role. What I can provide is several ways to become aware of our trauma. I tell the students I am concerned about the effects that studying trauma has on our classroom community, including myself. I bring in a psychologist to talk about the symptoms of, and responses to, posttraumatic stress disorder. I ask students to carefully consider whether this class is suitable for them given their own experiences. It is not uncommon to have students in the class who have had a family member stolen from them. Students are asked to talk about what they already do regarding self-care. What are the simple habits we do but usually forget at the peak of semester deadlines? When do we know that we need a break from the topic? We share our simple stories and ways, discuss the efficacies of friendship and support groups and of spending time in nature, and, if necessary, speaking with counsellors available at the university. Students are required to continue to assess their capacity to respond to trauma as part of their journal reflections.

I have to be comfortable with how making space for things to happen means relinquishing control. I do not know what the guest speakers are going to say or how the students will respond. Students tell me that they go home to "have a good cry." Sometimes what they hear is upsetting because they do not agree with the speaker—what a wonderful opportunity

to analyze the problems! It makes a difference to the students to point out that the fact they are in this class means they are already contributing towards the reconciliation process.

The notions of accountability and belonging within the classroom are often new constructs for students. One transformative learning tool is the interactive "blanket exercise." This was developed by KAIROS to involve people in reenacting the history and effects of colonialism on First Peoples and can be led by anyone comfortable working with groups and with sensitive material. My college has partnered with the Canadian Roots Exchange Program to form a reconciliation team of young adult leaders made up of Indigenous and non-Indigenous youth. The effect of students sitting on blankets, only to be moved or removed from this Turtle Island of blankets as the history is recounted, including a narrative on MMIW, is profound. When followed by a talking circle, the experience and learning time lead to personal accountability. The movement of the body engages and commits the whole person to the story. As one student noted to me, it made her feel physically connected to Canada's history.

This can be a painful experience for Indigenous participants. One student told me that although his family was affected by the residential schools, he had been kept largely in the dark about the stories. This was the first time he had "felt" the history. Although it is a sobering exercise, it shows what educational decolonization looks like. Acknowledging the past moves the nation forward; the blanket exercise creates witnesses who are now accountable to the decolonizing process. A relationship is established between the past and the present, not to mention between the participants.

Recognizing the intersections of sexism and racism for Indigenous women is heavy work. Intersectional feminist and Indigenous practices both emphasize that the personal is political. Melding the two into Indigenous feminism combines principles of individual rights with social accountability and the theoretical understanding of the intersections of oppression and privilege. Indigenous feminism echoes traditional Indigenous practices, such as the talking circle and the teaching of balancing personal rights with social accountabilities. What has been particularly appreciated by students is my adaptation of Kim Anderson's work from *Life Stages and Native Women: Memory, Teachings, and Story Medicine*. Anderson uses the teachings from Elders to counsel inner city youth

about how the four stages in life—birth, childhood, adult, and Elder—bring membership and ownership to the whole community. In each stage, a balance is struck between personal accountability and the reciprocal knowledge that one belongs to a caring community. As babies bring joy, they require safety and nurturance. As youth bring energy and new questions, they require teachings and guidance. As the middle-aged provide material wealth, they require their children to be guided and sustained by Elders. Elders bring their time and knowledge; they require care and respect. Feminist? Indigenous? The labels do not matter, but the teaching means a blending of the individualist and the collectivist with the aim of a healthy community. This portrayal of the ideal community is offered not to romanticize and locate Indigenous teachings in the past, nor is it to be understood as essentialist or normative. It is offered as nongendered guiding principles that identify needs and gifts throughout our life journeys. Balancing notions of individual rights with accountability and social duty underscores what powerful decisions students can make in their lives.

An Indigenous feminist approach that redresses issues of violence against Indigenous women is found in Lina Sunseri's book *Being Again of One Mind: Oneida Women and the Struggle for Decolonization*. Laying the personal stories of women—mothers, daughters, Elders, and activists—alongside the history of the Haudenosaunee nation, the book illustrates how Oneida women have negotiated the meanings of traditional womanhood as the drummers of the nation (16) and by "mothering a nation" (126), with the feminist commitment to nonessentialist gender roles. This understanding is not linked to reproduction but to all who "sustain the community and (support) women's achievement of self-empowerment" (131). The process of students evaluating methods of decolonization situated in women's self-empowerment speaks directly to redressing the vulnerability of Indigenous women and girls in Canada. Who are our nation's drummers and mothers?

In her work on decentring damage, Indigenous theorist Eve Tuck calls attention to the damage that is done when the focus remains on the victimization of Indigenous people. Not only does it maintain the hegemonic metanarrative of settler culture as the source of liberation from colonialist policies, language, and systems, but it also instills and perpetuates the victim imagery in its language and focus. For me, it even raises the question of whether it is appropriate or legitimate for an ally,

a non-Indigenous person, to teach this class. Currently, I continue my commitment to the belief that it models a way of moving forward together, but to do this, I have to reiterate my commitment to making space for things to happen. Like Tuck, I believe the answer rests in showing the power within Indigenous knowledge systems and the roles of Indigenous female leaders both historically and currently. Readings, films, and guest speakers can bring that forward in every single class. Literature by Indigenous authors, such as Teresa Marie Mailhot's 2018 book *Heartberries: A Memoir*, resonates with students, as do taped lectures on land and treaty rights by Mi'kmaw lawyer Pam Palmater (Woodrow Lloyd) or videos of the Algonquin *Water Song* (Jerome). Perhaps most importantly, finding ways for students to become involved in local and global Indigenous communities, spiritual ceremonies and activist work inscribes new ways of knowing and might prevent prescriptive colonialist practices. In these ways, change does not "rely upon the benevolence of the state or of the dominant in society" (Tuck, *Toward* 17). Ultimately, I believe the next person to teach this class must be Indigenous. This is not merely a question of representation; it is about ensuring that we are not content with the consciousness-raising or educational phase of change but rather, as Tuck again reminds us, be willing to radically question what "change" even means (I Do Not Want to Haunt You).

Conclusion

This is the most difficult course that I teach. The reconciliation process that academics can engage in—must engage in—makes us all vulnerable as a nation, as a community, and as individuals. But vulnerable to what? To painful and often unresolved stories, certainly, but also vulnerable to change. A national inquiry on MMIW, the gifts from the Truth and Reconciliation Commission, and the growing leadership from within Indigenous women's circles mean the nation's deep healing work can begin. There is hope. The students who, of their initiative, bring the REDress Project to campus, who hold awareness nights on MMIW, who faithfully attend the Sisters in Spirit annual vigils, and who demonstrate, ring bells and say, "Not One More! Ni Una Mas!" show that every one of us has an integral part to play in countering and ending our nation's legacy of femicide. This is no fairy tale with a guaranteed happy ending, but we are capable of unwinding ourselves from the colonial project, and

we are capable of weaving a new future. The evidence is already before us in the writing of this book.

Endnotes

1. This chapter was originally published in *Forever Loved: Exposing the Hidden Crisis of Missing and Murdered Indigenous Women and Girls in Canada* and is published here with the permission of Demeter Press.
2. Mission schools in Australia, much like residential schools in Canada, were ways to manipulate and control Aboriginal adults and children. They were political, rather than educational institutions that were open from 1864 to 1964. Successive governments characterized Aboriginal people as "helpless children" who needed to be protected from themselves and integrated into white Australian society (McCallum).

Works Cited

Acoose, Janice. *Iskwewak–Kah' Ki Yaw Ni Wahkomakanak: Neither Indian Princesses Nor Easy Squaws.* Women's Press, 1995.

Anderson, A. Brenda, et al., editors. *Torn from Midst: Voices of Grief, Healing and Action from the Missing Indigenous Women Conference, 2008.* Canadian Plains Research Centre, 2010.

Anderson, Kim. *Life Stages and Native Women: Memory, Teachings, and Story Medicine.* University of Manitoba Press, 2011.

Anderson, Mark Cronlund. *Cowboy Imperialism and Hollywood Film.* Peter Lang Publishing, Inc., 2007.

Anglican Church of Canada. *The Healing Circle.* The Anglican Book Centre, 1995.

Barreno, Leonzo. "From Genocide to Femicide: An Ongoing History of Terror, Hate, and Apathy." *Torn from Midst: Voices of Grief, Healing and Action from the Missing Indigenous Women Conference, 2008.* Edited by Brenda Anderson et al. CPRC, 2010, pp. 69-74.

Barry, Lisa, and Jim Boyles. *Topahdewin: The Gladys Cook Story.* Anglican Church of Canada, Toronto, 2006.

Bourassa, Carrie. "The Construction of Aboriginal Identity: A Healing Journey." *Torn from Midst: Voices of Grief, Healing and Action from the*

Missing Indigenous Women Conference, 2008. Edited by Brenda Anderson et al. CPRC, 2010, pp. 75-85.

Bowden, Charles. *Juarez: The Laboratory of Our Future.* Hong Kong: Aperture Foundation, Inc. Everbest Printing Company Ltd., 1998.

Chakarova, Mimi, director. *The Price of Sex.*: Women Make Movies, 2011.

Erno, Kim. "Political Realities: The Effect of Globalization on Indigenous Women." *Torn from Midst: Voices of Grief, Healing and Action from the Missing Indigenous Women Conference, 2008.* Edited by Brenda Anderson et al. CPRC, 2010, pp. 57-68.

Healy, Teresa. *Gendered Struggles against Globalization in Mexico.* Ashgate Publishing Ltd., 2008.

Jerome, Irene Wawatie. "Algonquin Water Song." *Vimeo,* uploaded 25 Oct. 2020, https://vimeo.com/273112273?1&ref=fb-share&fbclid=IwAR0YFI6BQzuPl76Z6HFTXtCYSjJr-KKtYI5VqkXmrCB58V_ZOeSMcunLLiQ. Accessed 17 Apr. 2024.

Mailhot, Terese Marie. *Heartberries: A Memoir.* Doubleday, 2018.

McCallum, David. (November 29, 2017) "How school has been used to control sovereignty and self-determination for Indigenous peoples." *The Conversation,* 29 June 2019, https://theconversation.com/how-school-has-been-used-to-control-sovereignty-and-self-determination-for-indigenous-peoples-87440. Accessed 17 Apr. 2024.

McKegney, Sam. *MASCULINDIANS: Conversations about Indigenous Manhood.* University of Manitoba Press, 2014.

Noyce, Phillip, director. *Rabbit-Proof Fence.* Miramax Movies, 2002.

Palmater, Pam. "The Woodrow Lloyd Lecture Series February 2018." *YouTube,* uploaded 25 Oct. 2020, https://www.artandeducation.net/classroom/video/253794/eve-tuck-i-do-not-want-to-haunt-you-but-i-will-indigenous-feminist-theorizing-on-reluctant-theories-of-change. Accessed 17 Apr. 2024.

Perez, Marta. "Public Presentation on DVD." *Torn from Midst: Voices of Grief, Healing and Action from the Missing Indigenous Women Conference, 2008.* Edited by Brenda Anderson, et al. CPRC, 2010.

Portillo, Lourdes, director. *Senorita Extraviada.* Women Make Movies, 2001.

Pottruff, Betty Ann. "Presentation of the Provincial Partnership Committee on Missing Persons." *Torn from Midst: Voices of Grief, Healing*

and Action from the Missing Indigenous Women Conference, 2008. Edited by A. Brenda Anderson et al. CPRC, 2010, pp. 104-109.

Ralston, Meredith, director. *Hope in Heaven*. CIDA & Ralston Productions, 2005.

Rose, Deborah Bird. "Land Rights and Deep Colonising: The Erasure of Women." *Aboriginal Law Bulletin*, vol. 69, no. 3.85, 1996, https://classic.austlii.edu.au/au/journals/AboriginalLawB/1996/69.html. Accessed 17 Apr. 2024.

Schick, Carol, and Verna St. Davis. "Critical Autobiography in Integrative Anti-Racist Pedagogy." *Gendered Intersections: An Introduction to Women's & Gender Studies*. Edited by C. Lesley Biggs et al. 2nd ed., Fernwood Publishing, 2011, pp. 57-61.

Sunseri, Lina. *Being Again of One Mind: Oneida Women and the Struggle for Decolonization*. University of British Columbia Press, 2011.

Tuck, Eve. "I Do Not Want to Haunt You, But I Will." *Art and Education*, uploaded 25 Oct. 2020, https://www.artandeducation.net/classroom/video/253794/eve-tuck-i-do-not-want-to-haunt-you-but-i-will-indigenous-feminist-theorizing-on-reluctant-theories-of-change. Accessed 17 Apr. 2024.

Tuck, Eve, and K. Wayne Yang, editors. *Toward What Justice? Describing Diverse Dreams of Justice in Education*. Routledge, 2018.

9.

Human to Human

Chevelle Malcolm

An intake of breath, a shake of the hand, what do we all have in common human to human?

Behind her smile are tear-stained cheeks, in solitude she soothes her soul,

oh, how she bleeds.

She bleeds,

with an empty stomach and two mouths to feed,

She bleeds,

in a world that passes her by without a second look—too much brown on its pristine white canvas,

oh, how she bleeds.

She whispers, "Mama, it's cold outside"

She bleeds,

when white supremacy forces itself onto her—again assuming illegitimate ownership

As it rears its ugly head while showing its white teeth

Oh, how she bleeds.

She bleeds,

when white supremacy left her for dead, battered and bruised,

too much brown on its white canvas—although crimson it could choose.

She bleeds,
her heart, her soul bleeds.
She whispers, "Mama, it's cold outside."
An intake of breath, a shake of the hand, what do we all have in common human to human?
She was here,
her tears familiar to the earth
She was here,
her cries familiar to the heavens—
to lady justice.
She was here.
Abused by man as she took her last breath, her dignity—
robbed by white supremacy,
She was here.
Abused by man,
But not forsaken,
not forgotten—by her kin
But not forsaken,
not forgotten by those who also bleed
Not forsaken, not forgotten by the heavens.
it whispers, "My sister, you're safe to breathe."
An intake of breath, a shake of the hand, what do we all have in common human to human?
When you look in the mirror, she looks back at you,
when your tears fall those are her tears too.
When you give life your all,
when you put on a smile,
not allowing the cold outside on the inside,
That's our sister in you.

Part Three

Transforming Our Worlds

10.

Indigenous Women's Literature: The Power and Truth of Our Words[1]

Jennifer Brant

> Woman's body found beaten beyond recognition.
> You sip your coffee
> Taking a drag of your smoke
> Turning the page
> Taking a bite of your toast
> Just another day
> Just another death
> Just one more thing you easily forget
> You and your soft, sheltered life
> Just go on and on
> For nobody special from your world is gone
>
> —Sarah de Vries (qtd. in Maggie de Vries 233)

The above words are shared in "a poem that resonates with particular force now that [Sarah] is gone" (233). *Missing Sarah: A Memoir of Loss* honours the story of Sarah de Vries, one of the women who went missing from the Downtown Eastside of Vancouver. Her sister wrote the memoir describing it as a "collaboration between two sisters, one living and one dead" (268). By drawing on Sarah's journals, Maggie brings forth a powerful message—one that Sarah wanted people to hear. As Maggie writes, "Throughout her journals, she addresses

a readership. When she wrote, she imagined readers. She imagined you" (xv).

Sarah's words express the lack of value placed on Indigenous women and serve as a profound call for action. Indigenous women have been actively working to bring the issue of racialized and sexualized violence against Indigenous women and girls to the forefront. They have been doing so through creative acts of resistance, such as poetry, literature, artwork, craft, and film. Their work not only raises awareness, demands action, and invokes compassion; it also serves as a counternarrative to the victim-blaming stories often presented about Indigenous women. Within a society that devalues Indigenous women, Sarah's poem demands that Indigenous women and girls are valued. Her poem also addresses an important truth: Too many people turn a blind eye to this crisis.

This chapter prompts readers to delve into the Indigenous women's literature sharing the hard truths expressed in Sarah de Vries's poem. I will reflect on my experiences teaching Indigenous women's literature courses and offer a glimpse into the literature that students are called on to theorize. I intend to share the power and truth of Indigenous women's words and call upon readers to consider the lessons that are embedded throughout their stories. As we work to put an end to the racialized and sexualized violence that threatens Indigenous women and girls, Indigenous literature must become part of the informed national dialogue.

I first became aware of the extent and severity of missing and murdered Indigenous women and girls (MMIWG) during my last year as an undergraduate student at Brock University in 2006. Later that same year, our community was planning a twenty-four-hour drum feast to bring awareness to Amnesty International's *Stolen Sisters: A Human Rights Response to the Discrimination and Violence against Indigenous Women in Canada* and ultimately to honour our stolen sisters, their families, and promote community healing. Two years later, I began working for student services at the local college where I noticed a poster on the wall of a missing woman from Six Nations of the Grand River, my family's home reserve. I did not know who Tashina General was at the time, but coming from the small and close-knit community of Six Nations, I would soon learn that she was well known to family and friends from the Six Nations community.

I completed my master's degree and became more involved in the Indigenous academic community and attending academic conferences.

There are many differences between Indigenous and non-Indigenous conferences. For example, ceremony and the presence of Elders and Traditional Knowledge Holders tend to be prominent at Indigenous conferences and the events are opened in a traditional manner to bring attendees together, establish relationship building, and honour the good mind teachings that are important to a successful gathering. A common occurrence during these traditional openings is a moment of silence to honour a young woman or girl missing from the local community or the community of an attendee. In these moments, we stand in solidarity and offer our support for the families who have lost a loved one. This is a disheartening reminder of the violence surrounding Indigenous women and girls. The moment of silence is also a constant reminder of the racialized and sexualized violence that all Indigenous women in the room are faced with. The shared threat of violence became strikingly clear as I pursued my research on Indigenous women's educational experiences.

My research involved revealing the barriers that Indigenous women face within university institutions and promoting both access and success. I learned general statistics on Indigenous women in education, and I quickly realized that the statistics I was using in my research mirrored the statistics of both Indigenous women in prison as outlined by the Canadian Association of Elizabeth Fry Societies as well as Indigenous women who are missing and murdered as documented by Amnesty International. As I did my research, I developed a demographic profile that reflects my reality as an Indigenous woman in Canada:

As an Indigenous woman in Canada, I can anticipate a life-expectancy rate that is ten years less than that of other women in Canada (Royal Commission on Aboriginal Peoples 1996). Data from the Canadian Population Health Initiative tell me that I belong to the unhealthiest group in the country. As an Indigenous woman, I am likely to earn 30 per cent less than non-Indigenous women. I am three times more likely to contract HIV, and I am five times more likely to die as a result of violence (Amnesty International, *The Need*).

In addition to the above statistics, I can reasonably expect to face racism from police officers, healthcare professionals, and the Children's Aid Society. It is reasonable to fear that family and children's services will intervene in my life at some point. In fact they did, and as a younger mom, I felt that I was under a constant scope of surveillance. The threat of state apprehension is common among Indigenous women regardless

of our credentials, as shared by the late Patricia Monture-Angus, lawyer and professor, in her work *Thunder in my Soul: A Mohawk Woman Speaks*. In her book, Patricia shares her own experiences with the child welfare system, describing the time she took her infant son to the hospital for a broken arm, later found to be the result of a bone disorder. Noting that the doctors at the hospital "vigorously pursued the abuse allegation" and "laughed when they heard [her] professional credentials," she describes her experience as being "layer upon layer of racist treatment" (208). Her son was taken from her for eight days. Monture-Angus notes the fear of taking her children to the doctors knowing how easily another allegation of abuse can occur. In a country where Indigenous women are flown into a hospital to have their babies delivered and leave with tubal litigations as a result of being coerced into a procedure following birth, often during moments of vulnerability, the connection between fear and ongoing violence in the places we should feel safe is clear. I understand this threat as an extension of settler colonial violence as I will describe later.

As I continued with my research, the examples of violence haunted me. I was completing my master's thesis and in my first year as a sessional instructor teaching Indigenous women's literature when I found out that Loretta Saunders, an Inuk woman, was missing. Loretta had been working on her undergraduate thesis on MMIWG when she went missing. Her disappearance brought a new lens to the issue of violence against Indigenous women and girls for the approximately twenty Indigenous and non-Indigenous students in my class. The class was delivered through a seminar style that allowed for engaged discussion and personal connections to course material.

The Indigenous women's literature course highlights the connection between stereotypes in mainstream literature, media and film to the high rates of sexualized and racialized violence against Indigenous women and girls. Extending this, I share the work Indigenous women are doing by counteracting these stereotypes and presenting positive images of Indigenous womanhood. The stories highlight the bravery, warriorship, and resilience of our women who overcome extensive tragedy and are still standing tall and sharing beautiful stories of cultural transmission. I have now taught Indigenous women's literature for seven years and other Indigenous-focussed courses that cover the topic of violence against Indigenous women and girls. I teach to raise awareness and bring honour to the stories of the women and girls and their families and to position

Indigenous women's literature as a counternarrative to racialized, sexualized, and colonial violence.

In my first five years of teaching, I would survey the class to find out how many students were aware of the topic. In most classes, only one or two students would raise their hand to indicate they were aware of the extent of the violence. The students who were aware were among the Indigenous students in my class. In my sixth year of teaching, this changed; half of the class, Indigenous and non-Indigenous students, raised their hands. For the most part, this was because the launch of the National Public Inquiry had been all over the news. Finally, a different kind of media coverage had emerged, or so I thought.

In August 2014, fifteen-year-old Tina Fontaine disappeared. Her body was later found in Winnipeg's Red River while police were searching for a missing man whose disappearance was unrelated to Tina's. I will not repeat all of the insensitive headlines of the news reports that were released when Tina's body was found, but I would like to highlight the words of Winnipeg's Police Sgt. John O'Donovan, who declared: "She's a child. This is a child that has been murdered…. Society should be horrified" (qtd in the *National Post*). Tina's case became part of the push for immediate action as Indigenous women and allies across the country demanded action from the Canadian government. On December 8, 2015, the Government of Canada announced plans for the launch of an independent national inquiry into MMIWG. The government pledged $53.86 million over two years for the inquiry and held a preinquiry to seek input from stakeholders across Canada.

In some ways, when I consider that over fifty reports with seven hundred recommendations have already been put forth, I am reluctant to put my faith in the inquiry. Moreover, we have seen a significant number of commissioners and other staff resign from the commission, as it appears this is not the inquiry that Indigenous communities asked for; Indigenous people and allies have a deep-layered understanding of why Indigenous women and girls remain the target of violence. Indigenous women's narratives echo this understanding, and, through literature, have been calling for attention to the misrepresentations of Indigenous women and girls for well over a hundred years, as I will elaborate below.

The details surrounding the disappearance of Tina Fontaine also highlights this deep-layered understanding. Tina was failed by several

people leading up to her disappearance. For one, she was a child who was in the care of Winnipeg's Family and Children's Services, and she was being housed in a hotel with minimal supervision. For a moment, consider the word "care" and remember that she was a child left alone in a hotel room by child protection services. As a mother of a fifteen-year-old, I am horrified and heartbroken when I think about the lack of care for her safety and wellbeing. Tina was in contact with hospital staff only hours before her disappearance and was a passenger in a vehicle that was pulled over by two officers who let the vehicle go after asking a few questions. The officers allowed this man to drive off with Tina even though she was listed as a missing person.

In 2018 when the man accused of killing Tina Fontaine was on trial, the *Globe and Mail* released a victim-blaming report titled: "Toxicologist testifies Tina Fontaine had drugs, alcohol in system when she died." This report, published on January 30, 2018, is only one more insensitive and shameful response to the death of an Indigenous child. As the Assembly of Manitoba Chiefs notes, the article "helps shape the discourse on the bigger issue of missing and murdered Indigenous women and girls." Moreover, as Grand Chief Arlen Dumas writes: "It isn't until the fourth paragraph that the reporter reveals that the alcohol and THC levels could be artificially high." Furthermore, Arlen Dumas has pointed out that "Most readers do not read that far into a story ... the public opinion has already been formed. It was formed with the headline" (Assembly of Manitoba Chiefs, Open Letter).

As an educator on these issues, I am far too familiar with the kind of public opinion that demonstrates the effects of victim-blaming headlines when it comes to issues of racialized and sexualized violence against Indigenous women and girls in Canada. Intertwined within the grand narratives that racialize and sexualize Indigenous women and girls is a slew of other ideas that manifest in the multiple stereotypes reflected in normalized experiences of racism. In *#NotYourPrincess: Voices of Native American Women*, stories of the effects of these stereotypes are expressed by Indigenous women. Coeditor Lisa Charleyboy dedicates the collection to "every Indigenous woman who has ever been called 'Pocahontas'" (3). I have personally been referenced by the name numerous times and, like the contributors of *#NotYourPrincess*, have been on the receiving end of seemingly harmless comments.

Similar stereotypes are initially held by students when they enter my courses. Now, with a distinct shift in the number of students who have heard of MMIWG, from one or two to nearly the entire class, I better understand the perceptions they hold about the reasons for violence against Indigenous women and girls in this country. One of the questions that I am often asked is why so many Indigenous women are involved in the sex trade. Yes, some women are involved in the sex trade at the time they go missing; this does not make their lives any less valuable than the lives of other women. The opening poem by Sarah de Vries makes this point clear. However, contrary to what media reporting has led the public to believe, only a percentage of Indigenous women are involved in the sex trade when they go missing. Others are children in state care, and some are university students. Making assumptions that perpetuate victim-blaming narratives further removes settlers from the violence, which they believe exists in particular areas from which they are far removed. Perhaps this notion of being far removed allows others to remain untroubled and undisturbed—to completely ignore the violence and easily digest what is happening along with their morning toast as the opening poem by Sarah de Vries points out.

Surely such perceptions are, in part, informed by the prevalent victim-blaming headlines along with a long history of harmful stereotypes against Indigenous people. Some students express their belief that Indigenous men are the perpetrators of the majority of violence against Indigenous women and make remarks about the consequences of the high-risk lifestyles that Indigenous people lead, akin to the "Indian Problem" narrative. Sarah Hunt articulates the connection between the media reports and the "Indian Problem" narrative by asking: "Why are we so hesitant to name white male violence as a root cause, yet so comfortable naming all the 'risk factors' associated with the lives of Indigenous girls who have died? Why are we not looking more closely at the 'risk factors' that lead to violence in the lives of the perpetrators?"

As a counternarrative to the "Indian Problem" narrative and the associated stereotypes, I draw on the stories presented within Indigenous women's literature as a pedagogy of humanity and compassion. As Heather Hillsburg expresses, Indigenous women writers have contributed to a particular kind of literature that brings "their experiences back into focus" while refuting "a long-standing pattern of policies and societal beliefs that naturalize racial segregation, reify the legacy of colonization

and ultimately blame Aboriginal women for the violence they confront" (300). Moreover, as Hillsburg explains, settler responses to Indigenous women's writing involve a recognition of the "invisible and unearned privilege that many Canadians enjoy" (300). Indeed, this recognition is certainly part of the counternarrative of Indigenous women's literature.

The Power of Indigenous Women's Words

I position Indigenous women's literature as a counternarrative to the stereotypical representations that continue to be propagated about Indigenous women. I do, however, acknowledge that Indigenous women's literature cannot simply be reduced to a counternarrative, as it draws from something much deeper and exists as something much more powerful. Alongside themes of resistance and stories of survival are testimonies of resilience, cultural continuity, rebirth, and renewal. Some writings extend the Indigenous storytelling tradition. Moreover, the contemporary realities of Indigenous women, communities, and families shape Indigenous women's writing in moving and profound ways. The racialization, sexualization, and violence experienced by Indigenous women and girls are expressed in numerous stories that bring back their honour and humanity, which is dismissed by the insensitive victim-blaming reports. As Lisa Charleyboy expresses in *#NotYourPrincess:* "Too often I've seen, we've all seen, those headlines that send shivers down spines, spin stereotypes to soaring heights, and ultimately shame Indigenous women. Yet when I look around me, I see so many bright, talented, ambitious Indigenous women and girls, full of light, laughter, and love" (9).

Other stories do not speak of this violence but present the beauty of Indigenous cultures and the "light, laughter, and love" noted above. Some share memoirs of motherhood, stories of the land, voices of resurgence, and present "a recognition of being" (Anderson) and a strong sense of Indigenous identities that are significantly different from the words that have been written about Indigenous women by others. For Indigenous women, as the late Beth Brant says, literature becomes a source of power: "Pauline Johnson's physical body died in 1913, but her spirit still communicates to us who are Native women writers. She walked the writing path clearing the brush for us to follow. And the road gets wider and clearer each time a Native woman picks up her pen and puts her mark on paper" (*Writing* 7-8).

The following quotations are from the anthology *Reinventing the Enemy's Language: Contemporary Women's Writings of North America*. This collection includes entries from eighty-seven Indigenous women from across Turtle Island. Each author was invited to open their writing with a note to share about what calls or inspires them to write. For Marcie Rendon (Anishinabe), her writing was called for by "all the Native women who died without being heard" (p. 279). Here I share a few of the notes included in *Reinventing the Enemy's Language* to express the depth of Indigenous women's literature and to highlight the shared realities that call Indigenous women to write about their anger, passion, and wisdom:

> The purpose of my writing has always been to tell a better story than is being told about us. To give that to the people and to the next generations. The voices of the grandmothers and grandfathers compel me to speak of the worth of our people and the beauty all around us, to banish the profaning of ourselves, and to ease the pain. I carry the language of the voice of the land and the valiance of the people and I will not be silenced by a language of tyranny.
>
> —Jeannette Armstrong, Okanagan, 498-99

I write for the same reason that mountain climbers do what they do: because it's there. As a younger woman, I remember a few dreadful weeks when I wept and raged because all I did was write when there were so many ills to correct, so much to be done. Eventually, I came to understand that the pen is mightier than the law books, and that the image is where the action is begotten.

—Paula Gunn Allen, Laguna Sioux, 150-51

Ultimately, writing is a process of confronting what is human in oneself as well as in others. Good, honest writing makes us tell the truth about the oppressor and the oppressed in us all. This is also why we must write about "all our relations."

—Emma LaRocque, Cree and Métis, 361

I write about the issues that trouble me, stories of my family and my people and myself that keep me awake at night, the stories that call me to drive dark roads at midnight, to return again to the

small lakes and streams that are lit by moonlight. I write to find understanding, to find peace. I write in the hope that I will give voice to those who have never had an opportunity to tell their stories. I write to give voice to myself.

—Debra Earling, Flathead, 454

To further express the depth of Indigenous literature, I draw on the following passage shared by Brant:

The amount of books and written material by Native people is relatively small. Yet, to us, these are precious treasures carefully nurtured by our communities. And the number of Native women who are writing and publishing is growing. Like all growing things, there is a need and desire to ensure the flowering of this growth. You see, these fruits feed our communities. These flowers give us survival tools. I would say Native women's writing is the Good Medicine that can heal us as a human people. (*Writing* 9)

Since these words were shared in 1994, the number of books and written material by Indigenous women has certainly grown and continues to fill our bookshelves and feed our spirits. As Maria Campbell writes in the Foreword to Kim Anderson's *A Recognition of Being: Reconstructing Native Womanhood*:

When I published *Halfbreed* in 1973 there were very few books about Native people and even less written by Native authors. I could walk into any bookstore and buy all the titles—and I did—saving money, going without so I could buy native authors' works. I did this because I was hungry to see myself and my people. Today I cannot go into a bookstore and buy all the books written by Native authors, as there are so many. Thousands in fact, and it is those books that have given me strength and inspiration to continue my work. (xi)

Campbell's work draws attention to the empowerment that comes through Indigenous literature, as she writes, "Recognition is powerful" (xi). Her work documents and positions Indigenous women's literature within a long history of confronting colonizers and moving Indigenous women to action by organizing and marching. Campbell recalls the feelings that were stirred during a reading of nineteenth-century Mohawk

poet Tekahionwake's (E. Pauline Johnson) *The Cattle Thief* at a 1990 women's gathering in Edmonton, AB. Campbell describes being "woken up" by the keynote speaker Maryanne LaValley, who shared stories of Indigenous women, the aunties, the grandmothers, and the songs they shared. As Campbell notes, by the end of the day, they were so moved that they had organized a march to the legislature building. This is the power of Indigenous women's literature. It propels us into action by naming injustices and presenting or reawakening a strong recognition of being. I have witnessed students in my class become propelled to action upon learning about the shared experiences of violence Indigenous women and girls face and organizing events on campus to spread awareness. Other students have now published work, including academic essays and poetry, to continue to spread that awareness.

Deconstructing the Squaw-Princess Binary

> Her ears stung and she shook, fearful of the other words like fists that would follow. For a moment, her spirit drained like water from a basin. But she breathed and drew inside her fierce face and screamed until the image disappeared like vapour.
>
> —Marilyn Dumont (qtd. in *An Anthology of Native Canadian Literature*, 436-37).

The above words are part of Marilyn Dumont's "Squaw Poems," a poem in which she writes "Indian women know all too well the power of the word squaw" (437).

The princess-squaw binary that reduces Indigenous women's humanity through racialized and sexualized objectification is certainly not part of our recognition of being but rather something imagined by the colonizer's gaze. However, this gaze filters into the everyday threat of violence against Indigenous women and girls. Within this context, we understand what Brant means by the survival tools of Indigenous women's literature ("The Good"). The extent of the princess-squaw binary is the tragic and disheartening reality of the horrific numbers of Indigenous women who go missing. E. Pauline Johnson wrote about these stereotypes 125 years ago. In an essay titled "A Strong Race Opinion: On The Indian Girl in Modern Fiction," which was originally published in the *Toronto Sunday*

Globe on May 22, 1892, Johnson speaks out about the images of the "Indian squaw" presented in mainstream literature and calls on writers to move beyond their fantasies of Indigenous women: "[A]bove all things let the Indian girl of fiction develop from the "doglike," "fawnlike," "deerfooted," "fire-eyed," "crouching," "submissive" book heroine into something of the quiet, sweet womanly woman she is, if wild, or the everyday, natural, laughing girl she is, if cultivated and educated; let her be natural, even if the author is not competent to give her tribal characteristics" (6).

Similarly, in her book, *Iskwewak—Kah'Ki Yaw Ni Wahkomakanak: Neither Indian Princesses nor Easy Squaws* (1995), author Janice Acoose also draws attention to the racialized and sexualized legacy of settler colonialism that has led to an acceptance of violence. As Acoose writes, these colonial attitudes have justified many of the legally sanctioned policies that have targeted Indigenous women and families, such as the Indian Act and residential schools. Indigenous women's literature brings the effects of Canada's deep history of settler colonialism on Indigenous families and communities to the forefront to shape understandings of the pervasive mindset that fosters violence against Indigenous women and girls.

Indigenous women's literature—including autobiographies, short stories, and poetry—expresses the social, historical, colonial, and political contexts of Indigenous women's identities. The literature also includes Indigenous maternal identities, contemporary realities, and connections between the two. Powerful autobiographies include Maria Campbell's (1973, restored edition 2019) *Half-Breed* and Morningstar Mercredi's *Morningstar: A Warrior's Spirit*, which both showcase the life stories of the authors who overcame oppressive forces that led them to prostitution and addictions and of their journeys towards recovery that brought them to their vocations as writers, mentors, and frontline workers. Beatrice Culleton's *In Search of April Raintree* and *Come Walk With Me* offer powerful narratives that highlight hardships to which many Indigenous women can relate and also inspire hopes and dreams through examples of perseverance. The short stories of Lee Maracle and Brant weave in cultural and historical memory and connect it with contemporary realities. Poetry, from the earlier works of Pauline Johnson to the works of Chrystos, Marcie Rendon, and Marilyn Dumont to the recent works of Lesley Belleau, Katherena Vermette, and Sara General, present cultural

teachings that connect past, present, and future. Indigenous women's literature also provides a space for presenting queer Indigenous theory by drawing on the work of scholars, such as Brant (*A Gathering*) and Chrystos. For me, this body of Indigenous women's literature has become a teaching tool that inspires cultural identity development while also complicating the patriarchal influences that have suppressed the variations of gender performativity within Indigenous communities. Indigenous women's literature also offers a space to consider the threat of settler colonial violence, specifically a particular kind of hypermasculinity that is rampant throughout society. Unfortunately, it is still not a recognized part of the threat by reporters and politicians as Hunt points out: "It seems that while reporters and politicians feel entitled to weigh in on what First Nations should do to address this issue, they are unwilling to name what is right in front of them. They are unable to see the culture of whiteness that excuses violence against Indigenous women and girls by blaming Native people for the violence they face."

A hypermasculinity is now being confronted by Indigenous scholars who consider how it implicates Indigenous wellbeing (for example, see Innes and Anderson). Through such work, Indigenous literature helps to create a holistic understanding of settler violence against Indigenous women and girls. The power of Indigenous women's literature is such that it not only moves us to action but also unravels deeply ingrained misperceptions about our daily lives and serves as a pedagogy of humanity and compassion.

Indigenous Women's Literature: A Pedagogy of Humanity and Compassion

> To begin to understand the severity of the tragedy facing Indigenous women today you must first understand the history.
>
> —Nick Printup, director and producer of *Our Sisters in Spirit*.

The issue of MMIWG in Canada is as old as the development of Canada itself and must be understood within the historical context of settler colonialism that has led to the ongoing racialization and sexualization of Indigenous women. Historically, Indigenous women were sexualized and held against dangerous cultural attitudes that defined them as promiscuous and dangerous. Today, these stereotypes permeate many facets of

Canadian society, and Indigenous women and girls continue to be sexualized. My Indigenous women's literature course begins with reading Acoose's *Iskwewak Kah'Ki Yaw Ni Wahkomakanak: Neither Indian Princesses nor Easy Squaws,* providing an opportunity for the students to learn about white-European-Canadian-Christian-patriarchy (WECCP) institutions and their associated ideological forces that have interfered with the lives of Indigenous women. Acoose writes about her points of contact with WECCP institutions throughout her life and connects their authority to the negative images of Indigenous women that have been expressed and maintained throughout mainstream Canadian literature. According to Acoose, literary representations describing Indigenous women as lewd, licentious, dissolute, dangerous, or promiscuous, along with those that lean more towards the polar opposite Indian princess representation, trap Indigenous women within a squaw-princess binary—one that renders Indigenous women's identities highly visible and invisible. Indeed, such ideologies continue to inform public notions of Indigeneity through the troubling headlines noted earlier. As Acoose writes:

> Indigenous women are misrepresented in images that perpetuate racist and sexist stereotypes … [T]hose images foster cultural attitudes that encourage sexual, physical, verbal, or psychological violence against Indigenous women. Stereotypic images also function as sentinels that guard and protect the white eurocanadian-christian-patriarchy against any threatening disturbances that might upset the status quo. (55)

Acoose explicitly connects the derogatory images of Indigenous women presented in mainstream literature to the racialized and sexualized violence we continue to face. To explain this further she notes, "In much of Canadian literature, the images of Indigenous women that are constructed perpetuate unrealistic and derogatory ideas, which consequently foster cultural attitudes that legitimize rape and other kinds of violence against us" (71). This is further clarified through the story of Helen Betty Osborne, a nineteen-year-old Indigenous student who was abducted by four white men and killed in 1971. As Acoose explains, the young men who killed her were influenced by particular cultural attitudes, and she draws on the Report of the Aboriginal Justice Inquiry of Manitoba to make this case: "The attackers seemed to be operating on the assumption that Aboriginal women were promiscuous and open to

enticement through alcohol or violence. It is evident that the men who abducted Osborne believed that young Aboriginal women were objects with no human value beyond sexual gratification" (70). It took sixteen years for any charges to be laid in her death, and only one of the four men who abducted her was charged. As Holly McKenzie points out, such cases set a dangerous precedent: "These men may also choose to attack Indigenous women based on the assumption that they will not be held accountable by the justice system because of the indifference of white-settler society to the well-being and safety of Aboriginal women" (144). McKenzie's work connects this to Indigenous women's exclusion from Canadian society, which has pushed them into vulnerable situations, such as homelessness, poverty, and sex work.

The Violent Erasure of Indigenous Women and Girls

> Indian women "disappear" because they have been deemed killable, able to be raped without repercussion, expendable. Their bodies have historically been rendered less valuable because of what they are taken to represent: land, reproduction, Indigenous kinship and governance, an alternative to heteronormative and Victorian rules of descent. Theirs are bodies that carry a symbolic load because they have been conflated with land and are thus contaminating to a white, settler social order.
>
> —Audra Simpson 156

Audra Simpson highlights the power of Indigenous womanhood in connection to land, reproduction, and kinship in contrast to the patriarchal order of settlement that involved land theft and the imposition of the nuclear family. Her words describe the power of matrilineal and egalitarian societies that honour the role of Indigenous women. Indeed, Indigenous women physically and spiritually give life to the community and sustain the spiritual, cultural, and political domains of matrilineal societies. Consider this statement in light of the well-known Cheyenne Proverb: "A nation is not conquered until the hearts of its women are on the ground. Then it is done, no matter how brave its warriors nor how strong its weapons." These two statements tell of the vulnerability of Indigenous people when women are targets of violence; together, they illuminate the intentions of settler colonialism and the multiple attacks

on Indigenous women through both legislated policy and the dangerous ideologies that have governed the development of Canada. Indeed, the ennoblement of the stereotypical beliefs and the associated policies that control Indigenous women's bodies have a long history rooted in assimilation and dispossession of land.

I familiarize students with the work of Sarah Carter, who has documented the increasing segregation of Indigenous people and settlers and has described the 1880s as a time when there was a "sharpening of racial boundaries and categories" and "an intensification of racial discrimination in the Canadian West" (146). As Carter points out, assimilationist policies were justified by images of Indigenous women as "dissolute, dangerous, and sinister" (147), and these negative images were promoted by government officials, political leaders, and the national press. Students learn that these representations are not only upheld by WECCP institutions but have also been used to justify many of the legally sanctioned policies that have targeted Indigenous women. If Indigenous women were deemed dangerous and promiscuous, the policies designed to control them were welcomed by settler society. I raise these conversations in the classroom to identify this particular form of racism and structural violence as ongoing and position it as a platform for understanding contemporary realities that continue to target Indigenous women and girls today. Indeed, as the final report of the National Inquiry into MMIWG concludes in a supplementary report: "Genocide is a root cause of the violence perpetrated against Indigenous women and girls, not only because of the genocidal acts that were and still are perpetrated against them, but also because of all the societal vulnerabilities it fosters, which leads to deaths and disappearances and which permeates all aspects of Canadian society today" (8).

Students learn about the gender discrimination embedded in the Indian Act of 1876, with emphasis on Section 12(1)(b)—the removal of status upon marriage to a non-status man, which was repealed in 1985 under Bill C-31, and they come to understand the ongoing forms of gender discrimination that still exist in the Indian Act today. Students learn about the eugenics movement, which involved the forced sterilization of women deemed unfit to have children. They learn that Indigenous women were specifically vulnerable to these racist and sexist procedures and often deemed unfit to have children. The sexual sterilization legislation in Canada was repealed in 1973; however, the forced and coerced

sterilization of Indigenous women in Canada continues today (Boyer and Bartlett). Students learn that the pass system of 1882 to 1935 was created to control Indigenous movement off the reserve. Without a pass from the Indian agent, Indigenous men and women could not leave their reserve. This severely limited their access to resources and employment opportunities and left them in positions that further justified intervention from family and children's services. Students also learn that the residential school system and the Sixties Scoop were attacks on the rights of Indigenous women to mother their children. Policies against Indigenous women were deeply entrenched in gender discrimination in the Indian Act. This continued through the pass system, residential schools, and the Sixties Scoop. They were the result of deliberate and forceful efforts to assimilate Indigenous people by restricting their movement to reserve lands so that development and settlement could quickly take place by non-Indigenous settlers across Turtle Island. This is a form of structural violence described as a deliberate "tool of genocide" (L. Simpson). Many years later, the trend of targeting Indigenous women and girls continues and is reflected in the overrepresentation of Indigenous children in child protective services, the lack of protection for Indigenous women and girls, and the disproportionate rates of violence against Indigenous women and girls. Thus, as Acoose expresses, the dangerous ideologies embedded in mainstream literature media and film serve a purpose—one that is indeed connected to the racialized and sexualized violence experienced by Indigenous women and girls today.

The stories shared in Indigenous women's literature expose the everyday experiences of racism that are deeply rooted in the aforementioned history of Indigenous and settler relationships. As an example of what I mean by everyday experiences of racism, Francine Cunningham shares her experience in a poem entitled "A Conversation with a Massage Therapist," noting some of the comments that I think many Indigenous women have heard on multiple occasions. Her entire poem resonates with my personal experiences in numerous settings. The poem describes a conversation with a massage therapist. The woman receiving the massage, an Indigenous woman, is asked about her identity. When she answers, the therapist says that she does not "really look Native." The therapist asks if she lives on a reserve, and when the woman explains she was raised in the city, the therapist tells her that she is not a "real Native." The therapist continues to ask probing questions: "What do you

do?" and the woman replies by sharing that she is pursuing a master's degree. The therapist responds with the following comments, "Good thing you got the taxpayers to pay for it" and "You're not a drunk or anything, good for you" (59). These kinds of offensive interactions take place often and are not isolated incidents. After *Forever Loved* was published in the final year of my doctoral program, a woman told me that "I was an exception to the rule" and explained to me that the only Indigenous peoples she knew were drunks. The sad part is that this woman actually thought she was complimenting me. Offensive comments similar to those noted above are made by educators, law officers, and healthcare professionals and they reflect a grand narrative about the racialized and sexualized perceptions of Indigenous women. This deep-seated narrative remains rooted in the dominant colonial mindset and has existed for many generations. Keep in mind that this is the mindset that exists among the very people whom Indigenous women and girls are expected to trust and turn to for safety. This is evident in a 2012 interview between an RCMP officer and an Indigenous girl who was reporting a sexual assault. A video of the troubling two-and-a-half-hour interrogation was released in 2019, showing the officer asking the young girl if she was turned on by the rape and questioning the truth of her story.

As Maria Campbell declared during her opening address at the 2008 Missing and Murdered Indigenous Women's Conference held in Regina, Saskatchewan: "Patriarchy and misogyny are so ingrained in our society, and our silence makes them normal." These words describe the society we live in today—a society where women disappear and nobody seems to have seen or heard anything. The aforementioned Report of the Aboriginal Justice Inquiry of Manitoba made this silence evident, as it took sixteen years for anyone to be charged with the death of Helen Betty Osborne, who was killed in 1971. In the same province today, Indigenous communities call for justice in the death of Tina Fontaine. There is a deafening silence that perpetuates the violence against Indigenous women and girls. The number of students I have taught over the years who had not heard of the Stolen Sisters report or the issue of MMIWG is a testament to this silence.

The slogan "silence is violence," highlighted in Amnesty International's 2004 report, *Stolen Sisters: A Human Rights Response to the Discrimination and Violence against Indigenous Women in Canada,* takes on a deeper meaning for students, as they are urged to reflect on the silencing of

Indigenous women despite their powerful roles in matriarchal and egalitarian societies. I urge students to think critically about the Indigenous leaders written about or documented more widely throughout history. Names like Sitting Bull and Crazy Horse usually come to mind. The erasure of Indigenous women from dominant Canadian narratives is evident in the words of Marcie Rendon, Anishinaabe:

> My own grandmothers have no names, their heroic actions erased from history's page. Freedom stories left untold ... shared only in the deepest dreams. In lessons to the world, the enemy has recorded our greatest warriors' names: Crazy Horse, Sitting Bull, Geronimo, Cochise. Resistance fighters all ... yet my own grandmothers have no names, their heroic actions erased from history's page. (46)

I ask my students to consider the names of Indigenous women throughout history and the students usually name Pocahontas, but no one else comes to mind even though many had valuable and powerful roles in traditional societies; there are few stories known to my students of Indigenous women leaders throughout history. To extend my argument and connect it to the binary described earlier, the story of Pocahontas that is most familiar to my students is one in which she is presented as the young highly sexualized virginal princess. By drawing on the squaw-princess binary that imprisons Indigenous women, I express the importance of literature written by Indigenous women as expressions of traditional and contemporary identities that provide true representations of Indigenous womanhood. With the story of Pocahontas, for example, Brant offers a different version in "Grandmothers of a New World," where Pocahontas is described as a woman of authority who fought for her nation until her final days (*Writing*). By deconstructing mainstream literature, Indigenous women can find liberation from the false images perpetuated by the squaw-princess binary (Acoose), and today more and more Indigenous women writers take on this role.

Prevailing Attitudes towards Indigenous Women

In July 2015, two paintings appeared on a storefront window during the Hospitality Days cultural festival in Bathurst, New Brunswick. One painting depicted two Indigenous women with their hands tied behind their backs, their ankles tied, and their mouths forced shut with what appeared to be duct tape. These images appeared during the height of the push for a national public inquiry into MMIWG. In response, social media backlash prompted the removal of the images. In an article published by *The Halifax Media Co-op*, Miles Howe describes the reaction of Patty Musgrave, one of the hosts of the local annual Sisters in Spirit Vigil and Indigenous Student Advisor for New Brunswick Community College. Musgrave wrote a letter to the city council "to address the appalling disregard to First Nation people in [New Brunswick] and across the country" and expressed that the paintings trivialized violence against Indigenous women. According to Musgrave, after an apology that links readers to the legend of the phantom ship, a common legend told in New Brunswick, a sincere and suitable apology should be made as well as further action, including consultation with Indigenous communities before such images are presented. President of the Bathurst Art Society, Rita May Gates expressed the following:

> We just didn't think at the time that the images would be painful and upsetting and of course we do respect their culture and stories very much. This depiction does open thought and dialogue regarding the plight of Aboriginal women, the abuse and femicide they have suffered over the centuries. We just send prayers for hope and healing going out to First Nations' people. It was never our intention to hurt anyone. (qtd. in Howe)

The issue of the paintings, especially at the height of the push for the national public inquiry, demonstrates that there is much work to be done in many facets of society as prevailing attitudes have not changed much since E. Pauline Johnson published "A Strong Race Opinion: On The Indian Girl in Modern Fiction," in May 1892. Nor have we seen an answer to the calls for justice in the death of Helen Betty Osborne in 1971 that prompted the Aboriginal Justice Inquiry of Manitoba. Today, families across the country call for justice for Tina Fontaine and the thousands of Indigenous women and girls who have gone missing since contact.

Conclusion

> A mother that wakes and finds her babies gone
> A young girl with blood down her thighs
> A grandmother without any daughters left
> And a lone woman under a man that she loves
> Breathing to the drum of one heart
> And giving themselves to morning
> To wash this all away and return to a place like home
> Where these things never happen
> Where men don't take these women
>
> —Lesley Belleau 55

In *IndianLand*, Lesley Belleau shares poems of home, memory, and missing Indigenous women and girls. Lesley's poetry is a profound expression of the home that Indigenous women and girls have always called Turtle Island, and her words are a testament to the memories that echo throughout the land and reverberate within our waters. In her poem "Niibinabe," she asks, "How many missing and murdered Indigenous women are there? ... [f]amilies and memories speak thousands and thousands until our lips are closed." She asks readers to "Imagine a woman. Your mother. Imagine a woman that created your first stories. And then she is gone" (47).

For Indigenous women, Belleau's poetry resonates all too well. The extent to which stories of settler violence against Indigenous women are deeply rooted within Indigenous literature tells us that these are not isolated incidents. Rather, they are powerful expressions of the violence that threatens all Indigenous women and girls. Settler violence is indeed a sociological phenomenon that has taken place on these lands since contact because the theft of Indigenous lands has become intertwined with the theft of Indigenous women's bodies.

Brant's description of Indigenous women's writing as "recovery writing" against repeated attempts of "cultural annihilation" at the hands of the "State" (18) underscores Indigenous women's literature as a "survival tool," which serves as a weapon against colonial violence (*Writing*). In a recent class, a student furthered this sentiment by describing Indigenous women's literature as a powerful source of protection and spiritual medicine against the collective threat of violence. By serving as both a

pedagogy of humanity and compassion and a weapon of protection, Indigenous women's literature calls attention to this ongoing and pervasive threat of settler violence and reawakens us to a time when Turtle Island women "had no reason to fear other humans" (14) as shared by Lee Maracle in *Daughters are Forever.*

 I will end by drawing attention to the Haudenosaunee narrative "Thunder Woman Destroys the Horned Serpent" as described to me by Alyssa M. General and the stories of Jikonsaseh as shared by Sara General in *Spirit and Intent: A Collection of Short Stories and Other Writings.* Inspired by Alyssa's artwork that covers the front of *Forever Loved: Exposing the Hidden Crisis of Missing and Murdered Indigenous Women and Girls in Canada*, I consider the Haudenosaunee story of Thunder Woman to be a story of strength, determination, and protection. Thunder Woman destroyed the horned serpent, offering a profound lesson about the threat of patriarchal violence and the strength and power of Indigenous women to call an end to colonial violence. Not only does the story of Thunder Woman teach us that we are survivors and we carry the strength to overcome the forces that bring danger into our lives, but it also teaches us that this is a collective strength. I was reminded of this vision of a collective strength when I read Sara General's short stories about Jikonsaseh who is referred to as the Peace Queen. As Sara eloquently expresses, in the work that Indigenous women are doing to collectively bring us back to a time of peace, safety, and love when we can freely write our stories, create our art, sing our songs, dance our dances, and speak our languages, perhaps Jikonsaseh is a part of all of us. Her legacy lives through us and, like Thunder Woman, our literature will help us to destroy the horned serpent. Through connections of the past, present, and future, Indigenous women's literature shares deep-layered understandings of the long history of colonial violence through stories that bring humanity and compassion and honour the legacies of our missing women and girls. I dedicate this chapter to the spirit of Tina Fontaine and all of our missing sisters, daughters, aunties, and mothers. Their stories leave us with a powerful legacy of hope as we continue to do this work by destroying the horned serpents, naming the genocide we continue to face, and collectively calling for justice.

Endnotes

1. This chapter was originally published in *Global Femicide: Indigenous Women and Girls Torn from Our Midst* and is published here with the permission of the University of Regia Press.

Works Cited

Acoose, Janice (Misko-Kìsikàwihkw). *Iskwewak Kah'Ki Yaw Ni Wahkomakanak. Neither Indian Princesses nor Easy Squaws.* Toronto, ON: Women's Press, 1995.

Amnesty International. *No More Stolen Sisters: The Need for A Comprehensive Response to Discrimination And Violence Against Indigenous Women in Canada.* Amnesty International, 2009.

Amnesty International. *Stolen Sisters: A Human Rights Response to Discrimination and Violence Against Aboriginal Women In Canada.* Amnesty International, 2004.

Anderson, Kim. *A Recognition of Being: Reconstructing Native Womanhood.* Sumach, 2016.

Anderson, Kim. "Giving Life to The People: An Indigenous Ideology of Motherhood." *Maternal Theory: Essential Readings.* Edited by A. O'Reilly. Demeter Press, 2007, pp. 761-81.

Belleau, Lesley. *Indian Land.* ARP Books, 2017.

Boyer, Yvonne, and Judith Bartlett. *External Review: Tubal Ligation in the Saskatoon Health Region: The Lived Experience of Aboriginal Women.* Saskatoon Health Region, 2017.

Brant, Beth. "The Good Red Road: Journeys of Homecoming in Native Women's Writing." *American Indian Culture and Research Journal,* vol. 21, no. 1, 1997, pp. 193-206. doi:10.17953/aicr.21.1.x371363538 n4074q.

Brant, Beth. *Writing as Witness: Essay and Talk.* Women's Press, 1994.

Brant Beth, editor. *A Gathering of Spirit. A Collection of Writing and Art by North American Indian Women.* Firebrand, 1988.

Campbell, Maria. *Half-Breed.* 1973. Goodread Biographies, 2019.

Carter, Sarah. "Categories and Terrains of Exclusion: Constructing The 'Indian Woman' in The Early Settlement Era in Western Canada." *In the Days of Our Grandmothers.* Edited by M. E. Kelm and L. Townsend. University of Toronto Press, 2008, pp. 46-169.

Charleyboy, Lisa, and Mary Beth Leatherdale, editors. *#NotYourPrincess: Voices of Native American Women*. Annick Press, 2017.

Chrystos. "I'm Making You Up." *A Gathering of Spirit: A Collection by North American Indian Women*. Edited by Beth Brant. Firebrand, 1988, p. 53.

Culleton, Beatrice. *Come Walk with Me: A Memoir*. Winnipeg, MB: Highwater, 2009.

Culleton, Beatrice. *In Search of April Raintree*. Pemmican, 1983.

Cunningham, Francine. "A Conversation with a Massage Therapist." *#NotYourPrincess: Voices of Native American Women*. Edited by Lisa Charleyboy and Mary Beth Leatherdale. Annick Press, 2017, pp. 58-59.

Dumont, Marilyn. "Squaw Poems." *An Anthology of Canadian Native Literature in English*. Edited by Daniel David Moses et al. Oxford University Press, 2013, pp. 436-38.

General, Sara. *Spirit and Intent: A Collection of Short Stories and Other Writings*. Spirit and Intent, 2015.

Grand Chief Arlen Dumas, Assembly of Manitoba Chiefs, Open Letter, 31 Jan., 2018.

Global News. "Toxicologist Testifies Tina Fontaine Had Drugs, Alcohol in System When She Died." *Global News*, 30 Jan. 2018, https://globalnews.ca/news/3996700/toxicologist-testifies-tina-fontaine-had-drugs-alcohol-in-system-when-she-died/. Accessed 20 Apr. 2024.

Harjo, Joy, and Gloria Bird, editors. *Reinventing the Enemy's Language: Contemporary Native Women's Writings of North America*. W. W. Norton, 1998.

Hillsburg, Heather. "Reading Anger, Compassion and Longing in Beatrice Culleton Mosionier's *In Search of April Raintree*." *International Journal of Media & Cultural Politics*, vol. 11, no. 3, 2015, pp. 299-313.

Howe, Miles. "We Didn't Think at the Time the Images Would Be Painful and Upsetting." *Halifax Media Co-op*, 27 July 2015, https://halifax.mediacoop.ca/story/we-didnt-think-time-images-would-be-painful-and-up/33782. Accessed 20 Apr. 2024.

Hunt, Sarah. "Why Are We Hesitant to Name White Male Violence as a Root Cause of #MMIWG?" *Rabble*, 5 Sept. 2014, https://rabble.ca/feminism/why-are-we-hesitant-to-name-white-male-violence-root-

cause-mmiw/. Accessed 20 Apr. 2024.

Innes, Robert Alexander, and Kim Anderson, editors. *Indigenous Men and Masculinities: Legacies, Identities, Regeneration.* University of Manitoba Press, 2015.

Johnson, E. Pauline. (Tekahionwake). "A Strong Race Opinion: On the Indian Girl in Modern Fiction." *Toronto Sunday Globe*, 22 May 1892.

Kenny, Caroline. "When the Women Heal: Aboriginal Women Speak about Policies to Improve the Quality of Life." *American Behavioral Scientist*, vol. 50, no. 4, Dec. 2006, pp. 550-61. doi:10.1177/0002764 206294054.

Lavell-Harvard, Dawn Marie, and Jennifer Brant, editors. *Forever Loved: Exposing the Hidden Crisis of Missing and Murdered Indigenous Women and Girls in Canada.* Demeter Press, 2016.

Maracle, Lee. *Daughters are Forever.* Polestar, 2002.

McKenzie, H. "'She Was Not into Drugs and Partying. She Was a Wife and Mother': Media Representations and (Re)presentations of Daleen Kay Bosse (Muskego)." *Torn from Our Midst: Voices of Grief, Healing, and Action from the Missing Indigenous Women Conference.* Edited by Brenda Anderson et al. University of Regina Press, 2010, pp. 142-61.

Mercredi, Morningstar. *Morningstar: A Warrior's Spirit.* Coteau, 2006.

Monture-Angus, Patricia. *Thunder in My Soul: A Mohawk Woman Speaks.* Fernwood, 1995.

National Post. "'Society Should Be Horrified': Fifteen-year-old aboriginal girl's body found in Winnipeg River." *The Canadian Press*, 19 Aug. 2014, https://nationalpost.com/news/canada/society-should-be-horrified-fifteen-year-old-aboriginal-girls-body-found-in-winnipeg-river. Accessed 20 Apr. 2024.

Printup, Nick, writer, director, producer. *Our Sisters in Spirit*, 2015, https://www.youtube.com/watch?v=zdzM6krfaKY. Accessed 20 Apr. 2024.

Rendon, Marcie. "Untitled." *Sweetgrass Grows All Around Her.* Edited by Beth Brant and Sandra Laronde. Native Women in The Arts, 1996, p. 46.

Royal Commission on Aboriginal Peoples. *Report of the Royal Commission on Aboriginal Peoples—Volume 3: Gathering Strength.* Indian and Northern Affairs Canada, 1996.

Simpson, Audra. *Mohawk Interruptus: Political Life across the Borders of Settler States.* Duke University Press, 2014.

Simpson, Leanne. *As We Have Always Done.* University of Minnesota Press, 2017.

Vermette, Katherena. *The Break.* House of Anansi Press, 2016.

Vries, Maggie de. *Missing Sarah: A Memoir of Loss.* Penguin, 2008.

11.

Disentangling Victimhood in Canadian Antihuman Trafficking: A Transformative Justice Response

Rosemary Nagy

Introduction

A significant number of missing and murdered Indigenous women, girls, and two-spirit persons (MMIWG2S+) are involved in the sex industry through trafficking, survival sex, and sex work. Indigenous women and girls may comprise up to 50 per cent of victims of trafficking in Canada (Canadian Woman's Foundation). Furthermore, Indigenous women, girls, and 2SLGBTQ folks are overrepresented in street-level sex work, where the risk of violence is highest (National Inquiry on Missing and Murdered Indigenous Women and Girls 656). While people in the sex industry experiencing human trafficking, murder, rape, exploitation, and other forms of abuse are indeed victims of terrible crimes, we need to be cautious about how the state takes up the victim label. Historically, Indigenous women were stereotyped as inherently sexually available, whereas today they are hypervisible as victims of human trafficking. However, as Maile Arvin et al. warn, projects of inclusion too often serve to confirm hierarchies of power (17).

In this chapter, I examine the historical evolution of the racialization of the victim label vis-à-vis gender-based sexual violence. The analysis

exposes the "relational othering" (Dhamoon) at work in state processes of exclusion and inclusion in victimhood. I argue that the homogenizing language of "vulnerability" to trafficking of Indigenous and racialized/migrant women fails to account for the differential racisms at work in the victim label, both historically and today, as well as the role of the settler state in producing the structural conditions of vulnerability. The chapter proposes the idea and practice of transformative justice as a means of resisting the victim label and relational othering. The chapter concludes with an overview of community-based transformative justice strategies that do not rely on the settler-colonial state.

Situating oneself within this kind of research is crucial. This paper grows out of my work as codirector of the Northeastern Ontario Research Alliance on Human Trafficking (NORAHT), which was a 2013–2020 university-community research partnership based in the Anishinabek lands protected under the Robinson-Huron Treaty of 1850. During our participatory action research workshops and interviews, some women with lived experience in the sex industry and service providers voiced concerns about antihuman trafficking that are addressed in this paper. NORAHT maintains a clear distinction between human trafficking and sex work. We also advocate for antiviolence work for all persons involved in the sex industry and the provision of services centred on empowerment and self-determination rather than colonial, paternalistic rescue.[1] Writing as a white settler cisgender woman, I try to be cognizant of the risks of researching from a position of privilege and to centre BIPOC scholars and experiential voices.

Legal and Policy Framework

In 2013 the Supreme Court of Canada ruled that Canada's prostitution laws violated Article 7 of the Charter of Rights and Freedoms, which refers to the security of the person (Canada v. Bedford). It determined that the prohibitions against "living on the avails of prostitution" (Criminal Code s. 210) and "keeping a bawdy house" (Criminal Code s 212.1[j]) prevented the implementation of safety measures that could protect sex workers from violent clients. This included measures such as hiring security or drivers or working alongside others as a means of mutual protection. The Court further ruled that the ban on "communicating in public for the purposes of prostitution" (Criminal Code s. 213.1

[c]) prevented sex workers from screening clients and negotiating terms, such as the use of condoms. The Court gave the government one year to develop a new law.

In 2014, the Conservative government tabled Bill C-36, the Protection of Communities and Exploited Persons Act (PCEPA). The PCEPA partly recreates the invalidated prior law, continuing to criminalize third parties through a rephrasing of the impugned provisions—that is, a prohibition against "material benefit" (s. 286.2), "procuring" (s. 286.3(1)), and "advertising" (286.4). The PCEPA also heralds a paradigm shift by criminalizing the purchase of sex in an effort to "end demand" for prostitution.

This abolitionist approach, also known as the "Nordic model," enables the conflation of sex work and human trafficking through its claim that exploitation is "inherent in prostitution" (PCEPA preamble). Canada's Criminal Code definition of human trafficking, in contrast to the United Nations Palermo Protocol, omits the "means" of trafficking—that is, the threat or use of force, coercion, deception, or fraud.[2] The inclusion of "means" under international law provides a basis for distinguishing an individual's labour and movement as voluntary versus involuntary. This helps differentiate human trafficking from sex work and human smuggling (Nonomura 6). In comparison, Canada's definitional focus on the control of movement has led to the policing and prosecution of so-called trafficking activities that "historically would have been considered 'pimping'" (O'Doherty et al. 109; Roots).

Canadian law reflects broader international trends that conflate human trafficking with sex work. This conflation denies the complexities of lived reality as well as the agency and self-determination of individuals. For example, a trafficked woman may knowingly migrate for sex work but is lied to about the conditions of labour. Or, for example, someone engaging in survival sex is likely being exploited, but this is not the same as being trafficked because a "calculated" survival strategy "cannot be neatly categorized as either 'forced' or 'chosen'" (Ting and Showden 267). As one of NORAHT's service provider participants put it, "There is a spectrum from sex worker to trafficking, and women are fluid along the spectrum."

Critical antitrafficking scholars debunk social perceptions of the ideal victim who is worthy of rescue. The ideal innocent is depicted as a brutally coerced "sex slave," whereas "impure" women are seen as complicit in

their own exploitation and abuse due to their participation in sex work and/or irregular migration (Rodríguez-López; Wijers; Hoyle et al.). In Canada, we are seeing an inordinate policy, funding, and policing focus on human trafficking that ignores other experiences of violence in the sex industry (Nagy 5). "Human trafficking" is overly broad in that it is misleadingly applied to all kinds of situations, yet also quite narrow in that women in abusive or exploitative situations that do not fit the trafficking victim framework may not be able to access services. Women and 2SLGBTQ people who do not fit the ideal victim stereotype or those who resist exiting the sex industry may not receive services or services are conditional and paternalistic (Shalit et al. 10; Maynard "Do Black Sex Workers' Lives Matter?"; Canadian HIV/AIDS Legal Network). As I detail in the next section, the ideal victim is also highly racialized and in complex and evolving ways.

Relational Othering in Discourses of Victimhood

The White Slave Panic

Rita Dhamoon explains relational othering as "a set of triangulated relations of power between subjugated group—subjugated group—dominant group" (875). The racial, settler-colonial state maintains domination through violence and converging and diverging forms of oppression "for the purposes of variously and simultaneously governing subjugating forms of Othering" (875).

The racialized construction of morally impure women has deep historical roots. Due to constraints of space, I will start the analysis with the "white slavery panic" of 1885–1925. Beginning in the 1860s, there was a large increase in migration as a result of urbanization, industrialization, and new technologies, such as the steamship, making it easier to travel throughout the British Empire (Doezema, "Loose Women" 39). Women formed a large part of this migration, moving to urban centres or other countries in search of work, including work as prostitutes. Sensationalized and greatly exaggerated claims began to emerge about the trafficking of innocent white women by dark-skinned men, notably in a landmark 1885 exposé published in an English newspaper (Valverde 90). As the number of reports grew, working-class women in foreign bordellos were cast as "white slaves" rather than "common prostitutes" because it was seemingly "inconceivable" that white women "would willingly

submit to sexual commerce with foreign, racially varied men" (Guy qtd. in Doezema, "Loose Women" 29).

As Doezema recounts, gaining public sympathy for women typically conceived as "fallen women" or "sexual deviants" was key to the campaign to abolish prostitution: "Only by removing all responsibility for her condition could the prostitute be constructed as a victim to appeal to the sympathies of middle-class reformers, thereby generating support for the end goal of abolition [of prostitution]" (Doezema, "Loose Women" 29). Whiteness, virginity, innocence, youth, and purity became completely entangled in the public imagination and, consequently, the migrant prostitute was constructed as completely helpless. Notably, the 1904 International Agreement for the Suppression of the White Slave Traffic made little distinction between prostitution and trafficking, stating that women or girls of foreign nationality engaged in an "immoral life" as prostitutes should be repatriated. The idea of female autonomy was neatly discounted and circumscribed.

The "cultural myth" (Doezema, "Loose Women" 40) of white slavery, then, served as a metaphor for white, middle-class Victorian anxieties about moral and racial purity and white women's growing independence. A necessary counterpart to the helplessly enslaved white trafficking victim was the nonwhite slaver. As Doezema notes, the very term "white slavery" is racist because it implies that "the slavery of white women was of a different, and worse, sort than black slavery" ("Loose Women" 30). The enslavement of and ongoing sexual violence against Black women was not part of the discourse. Moral reformers advanced what Robyn Maynard describes as a "whitewashed notion of slavery voided of its relationship to Black dehumanization" ("Do Black Sex Workers' Lives Matter?" 284). The focus on protecting white women from men of colour indicated a clear hierarchy of who counted as a victim—something further evidenced by the lynching of Black men in the American South in the same period for allegations of sexual violence against white women. While some social reform groups at the time noted the trafficking of Indigenous and Asian women, none challenged the overarching racial narrative of white innocence, victimhood, and purity (Valverde; Ball). Even whiteness itself was contingent. For example, in this period, Irish Canadian working-class women were racialized as morally inferior and arrested for prostitution at higher rates than women with English or Scottish roots (Backhouse 400).

To understand the victim hierarchy as a form of relational othering, it is helpful to examine the broader context during this period. Sunera Thobani, in her analysis of "White Canada" policy during early Confederation (1867 to 1920s), identifies a "triangulated citizenship" comprised of "the Aboriginal, marked for physical and cultural extinction, deserving of citizenship only upon abdication of indigeneity; the 'preferred race' settler and future national, exalted as worthy of citizenship *and* membership in the nation; and the 'non-preferred race' immigrant, marked as stranger and sojourner, an unwelcome intruder" (75).

Thobani shows how gendered violence and discrimination work through white supremacy in related but irreducible ways. Black and Asian migration was severely curtailed due to the state's fear of women immigrants' "unchecked fecundity" and racial miscegenation, which would overwhelm and pollute the exalted white-settler nation. In comparison, Indigenous women were targeted for genocide through forced sterilization, residential schools, the legislated loss of identity through revoking Indian status when "marrying out," (i.e., marrying a non-Indigenous man), and the imposition of heteropatriarchal governance structures.

Multiple scholars have demonstrated how Indigenous women were constructed as inherently sexually available outside the confines of marriage (Bourgeois, "Race, Space, and Prostitution"; Kaye). This was key to the gendered dispossession of Indigenous land because prostitution was linked to being on "white land." The Indigenous woman was "legislated as [a] prostitute" (Boyer 16) in the 1879 Indian Act through provisions on prostitution, being intoxicated off-reserve, and vagrancy. Julie Kaye writes:

> [T]he inclusion of prostitution in the Indian Act cannot be separated from the purpose of the Act ... [which] sought to dehumanize Indigenous women (humanitas nullius), appropriate Indigenous land (terra nullius), destroy Indigenous ceremony (cultural genocide) and discipline autonomous women in general through principles founded in heteropatriarchy and hierarchical binary gender orders. (50)

The 1884 Indian Act's banning of the potlatch, a ceremonial feast held by First Nations mainly on the West Coast, is especially notable for understanding the links between cultural genocide, land dispossession, and the dehumanization of Indigenous women. Potlatch ceremonies

represented "an important act of [I]ndigenous sovereignty and self-determination" where nations built alliances, engaged in trade, and shared knowledge (Bourgeois, "Race, Space, and Prostitution" 386). Settler society equated the arrangement of marriages during the potlatch as a form of prostitution. As Robyn Bourgeois observers, the banning of the potlatch not only served to reinforce the presumed sexual deviancy of Indigenous women, and by extension Indigenous communities, but it also positioned the ban as a humanitarian measure to protect Indigenous women and girls ("Race, Space, and Prostitution" 386).

The prostitution-related provisions in the Indian Act ensured that Indigenous women and men (as brothel keepers and clients) were criminalized and prosecuted more often and more severely than white people engaged in similar activities (Bourgeois, "Race, Space, and Prostitution" 384). In 1892, the government transferred the prostitution-related provisions in the Indian Act to the new Criminal Code. The settler-colonial legal hierarchy continued because, as an example, Indigenous engagement in prostitution was deemed an indictable offence, an "offense against morality," whereas white engagement was only a summary offence, a "common nuisance" (Bourgeois, "Race, Space, and Prostitution" 384).

Antivagrancy law served as the main legislative tool governing prostitution from 1892 until 1972.[3] In this period, Section 175(1)(c) of the Criminal Code deemed every woman a vagrant who "being a common prostitute or nightwalker is found in a public place and does not, when required, give a good account of herself." Indian agents were authorized to enforce these provisions, and this gave them "the power to control Indian women through designating them as 'common prostitutes'" (Lawrence qtd. in Kaye 51)

As an alternative to criminalizing Indigenous women involved in commercial and survival sex, the Indian residential school system and loss of Indian status when married to non-Indian men ostensibly sought to produce good Christian wives—that is, to save and civilize through genocidal assimilation and by making them the property of their husbands. But in the colonial imagination, there were limits to such reform because, ultimately, moral purity required racial purity (Valverde). As the Native Women's Association of Canada writes, "The sacredness of women's bodies, honoured through ceremonies celebrating menstruation and the capacity to create life was replaced with the belief that the bodies of women and girls are inherently savage, dirty, impure and sinful;

therefore violable" (10). In short, the victim label was simply unavailable to Indigenous women.

The victim label was also unavailable to Black women. As Robyn Maynard writes, whereas historically white women could become deviant through particular behaviours, Black women "were always and already presumed to be sexually deviant" (*Policing Black Lives* 138). White men had full access to Black women's bodies as chattel slavery. This sanctioned sexual violence continued well after abolition, including through the criminalization of Black women's sexuality (Phillips). As with Indigenous women, prostitution and vagrancy laws were used to control Black women's access to white public space, and they were subject to arrest or deportation for suspected immorality and/or prostitution. At the same time, Black women's purportedly natural sexual deviance and promiscuity served to justify their rape by white men, who enjoyed leniency in the eyes of the public and the law.

In comparison to Indigenous and Black women in this era, however, it seems that Chinese prostitutes could be considered victims but only of their own degenerate culture. The building of the national railway on stolen Indigenous land relied upon the exploited labour of Chinese men and, later, men from India. These men were brought in as temporary labourers and were not allowed to bring their families. The state tolerated the semiclandestine importation of Chinese women (by Chinese merchants as "merchandise") to be domestic slaves, serving girls, prostitutes, or concubines for Chinese "bachelor societies" because this prevented racial miscegenation (Valverde; Woon).

Most white settlers perceived the presence of Chinese brothels, prostitutes, and organized crime as further evidence of Chinese men's sexual licentiousness and of Chinese immorality and lawlessness in general. However, there were some efforts to rescue and rehabilitate Chinese prostitutes (Dua; Valverde). As Lucie Cheng Hirata writes in the San Francisco context, "The more they [reformers] saw Chinese women as helpless, weak, depraved, and victimized, the more aroused was their missionary zeal. Saving the Chinese slave girls seemed to have become the 'white woman's burden'" (28).

In this late nineteenth/early twentieth-century configuration of victimhood, then, Indigenous, Black, and Asian women experienced different structures of exclusion from the norms of moral purity and sexual consent. At the same time, early international law stipulated that white

women were victims of human trafficking regardless of consent. Thus, while no woman was seen to be in a position of sexual autonomy, white women were constructed as never available, Black and Indigenous women as always available, and Asian women as passive and submissive, debauched and sinful (Lee 15; Hirata).

These constructions are rooted in the gendered dispossession of Indigenous land and life, in the attack on Black personhood and life, and in the un/wanted role of Chinese prostitutes in protecting white women's morality against miscegenation and in maintaining "an artificially cheapened labor pool of Chinese immigrants" based on the notion of bachelor wages (Lee 13). These histories shape how the victim label is now affixed to different groups in contemporary antitrafficking.

Contemporary Antitrafficking: The Changing Racialization of the Victim Subject

Human trafficking was a fairly dormant issue during the Cold War.[4] Although Asian and African women started appearing in European brothels during the 1980s, concerns with and responses to trafficking did not arise until the 1990s, when women from the former Soviet Union started to show up in the French, British, German, and American sex industries (Bertone 211). Thus writes Doezema, the "ghost of white slavery haunted the halls of the UN" during negotiations for the 2000 Protocol to Prevent, Suppress and Punish Trafficking in Persons, Especially Women and Children ("Now You See Her" 67). But the "perfect victim" soon evolved to include not only the innocent white girl but also the abject, helpless, and racialized third-world woman or girl—an iconic representation that serves to reinforce longstanding saviour self-perceptions in the West (Kapur; Uy). The reasons for this shift are related to global patterns of south-to-north migration, the fact that most victims of trafficking (and migrants) are not white (Todres 607), and how this uncontroversial image unified the Christian right and abolitionist feminists (Uy 218).

Canada's first decade of modern antitrafficking focussed almost entirely on cross-border trafficking. Leslie Jeffrey argues that Canada externalized the problem and constructed itself as a "white knight in a dark world" that would save migrant women from Asian gangs and other "bad" foreign men (39-40). The trafficking of Indigenous women was largely unseen. As Anette Sikka observed more than ten years ago:

"Things that happen to [the Indigenous woman] are not viewed as exploitation or trafficking in persons, but rather as a natural consequence of the life that she has chosen to occupy. The image of the trafficked 'victim,' therefore, does not include her story" (2).

The hypervisibility of racialized migrant women as victims positions the state as rescuer while absolving it of structural complicity in human trafficking. Concerning cross-border trafficking, the 2019–2024 National Strategy affirms that Canada is a "global leader in human rights, particularly for women and girls" (Government of Canada 21). This kind of claim erases the state's blatant disregard for the rights of MMIWG2S+ and their families—a disregard so deep that *Reclaiming Power and Place*, the report from the National Inquiry on MMIWG2S+, has named it genocide. Canada's current policy also plays into the sense that cross-border trafficking is a problem from "over there" as seen, for example, in its commitment to supporting "developing countries in their efforts to address the root causes of human trafficking" (Government of Canada 22). This benevolent positioning fails to acknowledge Canada's role in the closing of borders in the global north, such as with the Safe Third Country Agreement, and how precarious immigration status facilitates human trafficking and labour exploitation.

Within Canada, antitrafficking casts too wide a net that "consistent[ly] targets" and negatively impacts Asian and migrant sex workers (Lam and Leppe 96). Precarious immigration status may fuel labour exploitation by managers, and people on open work permits are not allowed to work in the commercial sex industry (Lam and Leppe 94). Antitrafficking police operations in 2015 and 2016 resulted in the deportation of eighteen Asian women with varied immigration statuses, some of whom were also held in detention as a "protective measure" (Lam and Leppe 99). In speaking out against the deportations, Elene Lam of Butterfly, the Asian and Migrant Sex Workers' Support Project, states:

> Because they think Asian [means] weak, vulnerable, [that] they have no brain, and then they are vulnerable, waiting for rescue…. So when the Asian identity integrates with the sex worker identity, it is so easy to use the racism in the people's minds, that they are weak, cannot make decisions for themselves, they are so passive…. So that we need to rescue them. (Network of Sex Work Projects)

The nineteenth-century discourse of Asian women as helpless, weak, and victimized has, arguably, carried through to today. The label of being at risk of human trafficking rests on racialized and gendered assumptions and, in the case of the above-mentioned antitrafficking investigations, with "no evidence of coercion, exploitation, or human trafficking" (Lam and Leppe 98).

There is little research on the experience of Black women in the face of antitrafficking in Canada, whether as recent migrants or as Canadian citizens. Maynard compiles street-level evidence to demonstrate that Black sex workers experience disproportionately high levels of criminalization and police violence, especially Black women (*Policing Black Lives*). She further observes that cisgender and transgender Black women continue to be associated with deviant sexuality and are subject to police and citizen profiling as prostitutes (Maynard, "Do Black Sex Workers' Lives Matter?" 287).

South of the border, Jasmine Philips notes that Black women and girls are more likely to be criminalized as prostitutes than be seen as victims of trafficking. Importantly, Phillips's argument is not to include Black girls and women in the victim-subject position but rather to acknowledge the diversity and complexity of experiences in the sex industry as well as the need for empowering and nonjudgmental peer-led responses. This is an important point because inclusion within the victim trope is fraught with risk, as we are now seeing with the repositioning of Indigenous women and girls as victims in Canadian antitrafficking policy and discourse.

It is only since roughly 2013, when the RCMP published its report on domestic trafficking, that the victimization of Indigenous women and girls has been much more recognized and addressed. With growing public awareness of colonial injustices, "the victim label ... is bolstered as a mechanism to resolve racist and colonial constructions of Indigenous women" (Kaye 29). However, domestic human trafficking policy in Canada ignores the historic role of the state in the trafficking of Indigenous peoples through forced relocations, confinement to reservations, the Sixties Scoop, and the residential school system (Bourgeois, "Colonial Exploitation"). Antitrafficking strategies, such as the Royal Canadian Mounted Police's "I'm Not for Sale" campaign, simplistically encourage Indigenous women and girls to "just say no" to trafficking and ignore social and economic pathways into the sex industry (Maynard, "Fighting Wrongs").

Furthermore, this new framework conflates human trafficking with "a messy range of other types of violence" (Hunt, "Representing Colonial Violence" 32) against Indigenous women and girls, which denies the complexities of life in the sex industry and street economies and ignores the structural violence of colonialism. As Sarah Hunt warns, "Painting all Aboriginal sex workers as victims does nothing to empower their situation, and has the damaging effect of stripping them of their agency" ("Colonial Roots" 29). Putting survival sex and every abusive or exploitative relationship in the sex industry under the umbrella of human trafficking serves to produce harmful policies, such as the increased policing and surveillance of Indigenous communities (Hunt, "Representing Colonial Violence").

Today, Indigenous and migrant women (along with other groups) have been grouped under the homogenizing labels of vulnerability and victimhood. For example, the Canadian Parliamentary Standing Committee on Justice and Human Rights notes in its 2018 report on human trafficking:

> Risk factors include poverty, social isolation, homelessness, precarious housing situation, isolation, child abuse, history of violence, drug addictions, mental health issues as well as a lack of education and employment opportunities. The more vulnerable groups identified in the National Action Plan and by several witnesses during this study are Indigenous women, girls and children, LGBTQ2 individuals, migrants and new immigrants, children in foster care and young runaways. (Government of Canada, *Moving Forward*)

The Standing Committee report superficially aggregates "risk" as a background problem and ignores the role of the state in structural violence. Not a single recommendation in the report incorporates things like antipoverty measures, the underfunding of First Nations child welfare, or addressing how the securitization of borders in the Global North renders irregular migration more dangerous than it need be. Rather, the language of risk and vulnerability in the report largely pertains to detecting, reaching out to, and being culturally sensitive toward the victims of human trafficking. The focus on cultural sensitivity through Indigenous-tailored programs or the provision of interpreters lumps together the most "vulnerable" victims of human trafficking in a superficial

manner that obscures relational othering and structural violence.

As Kaye argues, Canada's antitrafficking policy serves to separate "us" (i.e., white settler Canadians) from "them" through the intertwined notions of "at risk" victim groups and "risky" (i.e., nonideal) victims (Kaye 55). This occurs through the policing of racialized, foreign, and Indigenous bodies on Indigenous land, including deportations of migrant sex workers, which contributes to the legitimation of settler-colonial sovereignty. She critiques the separation of international and domestic trafficking as an artifice that has a "domiciling effect" (Kaye 29) on Indigenous women, girls, and two-spirit+ people in the sex industry. The implications for Indigenous self-determination are both collective and individual, placing the protection of Indigenous women, girls, and two-spirit folks, whether or not they identify as victims, in the hands of the settler-colonial state.

Transformative Justice: Beyond the State and the Victim Framework

This final section takes up Kaye's call for "transformative solidarities" that will build "reciprocal relations, respect for Indigenous sovereignties, and the self-determination and autonomy of Indigenous, migrant, and sex working communities" (Kaye 197). I point to the theory and practice of transformative justice as Kaye's "alternative model of justice" (5), which challenges, as she puts it, "the harms occurring from and within the nation-state" while also providing "conceptual space to locate resistance and subvert cycles of exclusion" (205-6).

The National Inquiry on MMIWG2S+ in its deeper dive into violence in the sex industry found that police services "struggle to effectively respond to cases of human trafficking, sexual exploitation, and violence against women and 2SLGBTQQIA people in the sex industry" (National Inquiry on Missing and Murdered Indigenous Women and Girls 669). This is due to flaws in the current laws and a lack of trust with police because of the historical and ongoing criminalization, racism, sexism, and social stigma attached to the sex industry. In its recommendations, the National Inquiry calls upon police services to develop guidelines for policing the sex industry in consultation with women and 2SLGBTQQIA people engaged in the sex industry (Call for Justice 9.11). It calls upon Child Welfare Services to do a better job of preventing the recruitment of children into the sex industry while under care (Call for Justice 12.14).

It further directs various social service and hospitality sectors to engage in training to identify sexual exploitation and human trafficking (Call for Justice 8.1).

These recommendations are perhaps not unreasonable in some ways, but they also rely upon the settler-colonial state. The Black Lives Matter movement brought global attention to something Black, Indigenous, and racialized peoples have known for centuries: In North America, "policing emerged as and remains a form of racial, gendered and economic violence shaped by the logics of slavery and settler colonialism" (Maynard, "Police Abolition/Black Revolt" 71-72). Furthermore, Black and Indigenous children are removed by child welfare services at disproportionate and discriminatory rates (Ontario Human Rights Commission). Racialized and migrant sex workers caution that antitrafficking training in the hospitality sector has extended racial profiling, police surveillance, and border control in the name of rescue (Clancey and Wiseman). As Indigenous activists Erin Konsmo and Kahea Pacheco write, state-based "circular" responses may end up causing more harm and therefore "more options for justice" are required (52).

Transformative justice is "a political framework and approach for responding to violence, harm, and abuse," and "it seeks to respond to violence without creating more violence and/or engaging in harm reduction to lessen the violence" (Mingus). In particular, transformative justice approaches seek to reduce, if not abolish, reliance on state policing, prisons, and criminal justice. Transformative justice entails specific strategies on the ground as well as the "naming of structures responsible for causing harm" (Phillips 1672). It refutes the mantle of victimhood because it is based on resistance, resilience, self-determination, safety, healing, community, and changing the systemic conditions that precipitate and reproduce violence.

Transformative justice works through what Andrea Smith describes as "communities of accountability" that lie outside of state violence, domination, and criminalization ("Indigeneity"). As Sandra Wesley, executive director of Stella, l'Amie de Maimie in Montreal, stated at a 2019 Sex Workers Conference: "If you're in solidarity with sex workers, then you need to be in solidarity with drug users, especially mothers who use drugs, the trans community, Muslim women, racialized communities in general, migrants, MMIWG2S, labour rights activists, and incarcerated people."

Building communities of accountability, or transformative solidarities, across these groups challenges the relational othering evident in Canadian policy and practice. This does not mean that decolonization should be collapsed into other social justice struggles; as we have already seen, relational othering in group experiences of violence and discrimination is "incommensurable" due to differential logics (Tuck and Yang). Rather, as Eve Tuck and K. Wayne Yang explain, an "ethics of incommensurability" lies in what is different and demands accountability to restore Indigenous life and land. At the same time, as Dhamoon argues, "any liberation struggle that does not confront the larger matrix of power cannot undo any one part of it, for the parts have historically operated relationally" (888).

Transformative justice frontline strategies include:

- Harm reduction, safety planning, and self-care (Nagy et al.)

- Paid peer support and paid peer involvement in the development of programs and evaluation (Nagy et al.)

- Creating safer spaces, such as places to shower, sleep, change, or check in; keeping track of "bad clients"; offering to be a safe call when someone visits a client or goes to a party (Sayers qtd. in Konsmo and Pacheco 57)

- Rapid community-based responses to identifying newcomers to sex-working areas (Jana et al.)

- Finding strength in Spirit, teachings, and ceremony; developing community and peer-led initiatives; and defending the land (Konsmo and Pacheco)

- Decolonizing sex work through strategies of humanizing and listening to Indigenous sex workers; strengthening Indigenous communities; and meeting the basic needs and rights of Indigenous (and other) women in the sex industry (Hunt, "Decolonizing Sex Work")

- Developing community-based tracking systems for documenting violence; establishing neighbourhood check-ins; door-to-door organizing; building connections with other communities; and conflict resolution and de-escalation strategies (Smith, "Indigenous Feminists Are Too Sexy")

- Community outreach and education strategies aimed at reducing the stigmatization of the sex industry, challenging anti-trafficking myths, and building community with neighbours (Living in Community).

Longer-term campaigns aimed at structural transformation might include advocating for the decriminalization of prostitution. As various prostitution cases wind their way through the court system, political advocacy might hasten this process, and it is needed to ensure that sex workers' voices and perspectives are included in the process of decriminalization. Another key area to address is the need for migrant justice but with an ethics of incommensurability that works for the decolonization of borders and Indigenous sovereignty. Transformative solidarities ought to be grounded in explicit recognition of what Soma Chatterjee calls the "racialized labour-capital-nation nexus" that is inherent to settler colonialism (12). Chatterjee suggests that focusing on this nexus moves us away from an overly reductive settler-Indigenous binary because the artificial separation of Indigenous justice and migrant justice is "constitutive of the racialized colonialist Canadian state" (1). Transformative solidarities rest upon the relinking of Indigenous dispossession and migrant settlerhood/migration as "socially, historically, economically, and politically entangled practices" (3).

In my own group's research, NORAHT found that poverty and the lack of transitional housing and safer, affordable housing in our region were key barriers to women, girls, and 2SLGBTQI people achieving safety and security. Our participants also noted that emergency rooms are often the first or only point of contact that trafficked persons might have to seek support. Yet sometimes there is overt racism and stigmatization of commercial sex in the delivery—or denial—of healthcare services (Nagy et al.). Chronic lack of funding, as well as funding prioritization for antitrafficking over other types of antiviolence work, is another systemic and paradigmatic challenge. As the report from the National Inquiry into MMIWG2S+ recommends, there is a need for core and sustainable funding for support and services for people in the sex industry and peer-led, grassroots organizations (Call for Justice 4.3).

Conclusion

In this chapter, I identified the relational othering at work in state applications of the victim label for gender-based sexual violence. By building communities of accountability across different groups affected by violence in the sex industry, transformative solidarities are a form of resistance against relational othering. At the same time, dismantling the overarching matrix of power requires an ethics of incommensurability that is attuned to differential requirements for justice. Transformative justice provides an alternative to responses that rely on the settler-colonial state, and it rejects the victim label. It can also undertake antiviolence work for all people in the sex industry, trafficked or not, following their self-determination and not rescue or conditional services. Notably, sex workers, instead of being the "collateral damage" (Global Alliance) of antihuman trafficking, can and should be at the forefront of detecting human trafficking.

Endnotes

1. For more information, see https://noraht.nipissingu.ca.
2. Section 279.01 of the Criminal Code states that any person who "recruits, transports, transfers, receives, holds, conceals or harbours a person, or exercises control, direction or influence over the movements of a person, for the purpose of exploiting them or facilitating their exploitation is guilty of an indictable offense." The Criminal Code definition applies to both domestic and cross-border trafficking. There are also provisions within the *Immigration and Refugee Protection Act* about cross-border trafficking.
3. In 1972, Parliament replaced the vagrancy section 195.1 with language around "solicitation." The next decade was a period of various adjustments and examinations, including the 1983 Fraser Committee on Pornography and Prostitution. In 1985, Bill C-49 was tabled. It made "virtually all activities necessarily associated" (Robertson) with prostitution illegal (i.e., communication, keeping a bawdy house, pimping, procuring, and living on the avails) but not the act itself. Iterations of these provisions remained in place until the 2014 PCEPA. Various municipalities also created bylaws aimed at suppressing prostitution.

4. The relevant international law at this time was the 1949 Convention for the Suppression of the Traffic in Persons and of the Exploitation of the Prostitution of Others. This convention entrenched what is often called the "abolitionist" perspective because sex trafficking was a punishable offence even with a woman's consent.

Works Cited

Arvin, Maile, et al. "Decolonizing Feminism: Challenging Connections between Settler Colonialism and Heteropatriarchy." *Feminist Formations*, vol. 25, no. 1, 2013, pp. 8-34.

Backhouse, Constance B. "Nineteenth-Century Canadian Prostitution Law: Reflection of a Discriminatory Society." *Histoire Sociale – Social History*, vol. 18, no. 36, 1985, pp. 387-423.

Baker, Carrie N. "An Intersectional Analysis of Sex Trafficking Films." *Meridians: Feminism, Race, Transnationalism*, vol. 12, no. 1, 2014, pp. 208-26.

Ball, Richard A. "Changing Images of Deviance: Nineteenth-Century Canadian Anti-Prostitution Movements." *Deviant Behavior*, vol. 33, no. 1, 2012, pp. 26-39.

Bertone, Andrea. "Trafficking for Sexual Exploitation." *Human Rights: Politics and Practice*. Edited by Michael Goodhart. Oxford University Press, 2009, pp. 201-17.

Bourgeois, Robyn. "Colonial Exploitation: The Canadian State and the Trafficking of Indigenous Women and Girls in Canada." *UCLA Law Review*, vol. 62, 2015, pp. 1426-63.

Bourgeois, Robyn. "Race, Space, and Prostitution: The Making of Settler Colonial Canada." *Canadian Journal of Women & the Law*, vol. 30, no. 3, 2018, pp. 371-97.

Boyer, Yvonne. *First Nations, Métis, and Inuit Women's Health*. National Aboriginal Health Organization, 2006.

Canadian HIV/AIDS Legal Network. *Brief to the House of Commons Standing Committee on Justice and Human Rights on Human Trafficking in Canada*. Canadian HIV/AIDS Legal Network, 2018.

Canadian Women's Foundation. *Report of the National Task Force on Sex Trafficking of Women and Girls in Canada. "No More": Ending Sex-Trafficking in Canada*. Canadian Women's Foundation, 2014.

Chatterjee, Soma. "Immigration, Anti-Racism, and Indigenous Self-Determination: Towards a Comprehensive Analysis of the Contemporary Settler Colonial." *Social Identities*, vol. 25, no. 5, 2019, pp. 644-61.

Clancey, Alison, and Andi Wiseman. *Transforming Anti-Trafficking Sentiment into Effective Action*. SWAN Vancouver Society, 2020.

Shalit, Ann de, et al. "Social Service Responses to Human Trafficking: The Making of a Public Health Problem." *Culture, Health & Sexuality*, vol. 23, no. 2, 2020, pp. 1-16.

Dhamoon, Rita Kaur. "Relational Othering: Critiquing Dominance, Critiquing the Margins." *Politics, Groups & Identities*, vol. 9, no. 5, 2021, pp. 873-92.

Doezema, Jo. "Loose Women or Lost Women? The Re-Emergence of the Myth of White Slavery in Contemporary Discourses of Trafficking in Women." *Gender Issues*, vol. 18, no. 1, 2000, pp. 23-50.

Doezema, Jo. "Now You See Her, Now You Don't: Sex Workers at the UN Trafficking Protocol Negotiations." *Social & Legal Studies*, vol. 14, no. 1, 2005, pp. 61-89.

Dua, Enakshi. "Exclusion through Inclusion: Female Asian Migration in the Making of Canada as a White Settler Nation." *Gender, Place & Culture*, vol. 14, no. 4, 2007, pp. 445-66.

Global Alliance against Traffic in Women. *Collateral Damage: The Impact of Anti-Trafficking Measures on Human Rights around the World*. Global Alliance against Traffic in Women, 2007.

Government of Canada. House of Commons. *Moving Forward in the Fight against Human Trafficking: Report of the Standing Committee on Justice and Human Rights*. Standing Committee on Justice and Human Rights, Speaker of the House of Commons, 2018.

Government of Canada. *National Strategy to Combat Human Trafficking, 2019–2024*. Government of Canada, 2019.

Hirata, Lucie Cheng. "Free, Indentured, Enslaved: Chinese Prostitutes in Nineteenth-Century America." *Signs: Journal of Women in Culture & Society*, vol. 5, no. 1, 1979, pp. 3-29.

Hoyle, Carolyn, et al. "Labelling the Victims of Sex Trafficking: Exploring the Borderland between Rhetoric and Reality." *Social & Legal Studies*, vol. 20, no. 3, 2011, pp. 313-29.

Hunt, Sarah. "Colonial Roots, Contemporary Risk Factors: A Cautionary Exploration of the Domestic Trafficking of Aboriginal Women and Girls in British Columbia, Canada." *Alliance News*, vol. 33, 2010, pp. 27-31.

Hunt, Sarah. "Decolonizing Sex Work: Developing an Intersectional Indigenous Approach." *Selling Sex: Experience, Advocacy, and Research on Sex Work in Canada*. Edited by Emily van der Meulen et al. University of British Columbia Press, 2013, pp. 82-100.

Hunt, Sarah. "Representing Colonial Violence: Trafficking, Sex Work, and the Violence of Law." *Atlantis*, vol. 37, no. 2, 2015/2016, pp. 25-39.

Jana, Smarajit, et al. "Combating Human Trafficking in the Sex Trade: Can Sex Workers Do It Better?" *Journal of Public Health*, vol. 36, no. 4, 2014, pp. 622-28.

Jeffrey, Leslie Ann. "Canada and Migrant Sex Work: Challenging the 'Foreign' in Foreign Policy." *Canadian Foreign Policy Journal*, vol. 12, no. 1, 2005, pp. 33-48.

Kapur, Ratna. "The Tragedy of Victimization Rhetoric: Resurrecting the Native Subject in International/Postcolonial Feminist Legal Politics." *Harvard Human Rights Law Journal*, vol. 15, 2002, pp. 1-37.

Kaye, Julie. *Responding to Human Trafficking: Dispossession, Colonial Violence, and Resistance among Indigenous and Racialized Women*. University of Toronto Press, 2017.

Konsmo, Erin Marie, and A.M. Kahealani Pacheco. *Violence on the Land, Violence on Our Bodies: Building an Indigenous Response to Environmental Violence*: A Partnership of Native Youth Sexual Health Network and Women's Earth Alliance, 2016.

Lam, Elene, and Annalee Leppe. "Butterfly: Resisting the Harms of Anti-Trafficking Policies and Fostering Peer-Based Organising in Canada." *Anti-Trafficking Review*, vol. 12, 2019, pp. 91-107.

Lee, Catherine. *Prostitutes and Picture Brides: Chinese and Japanese Immigration, Settlement, and American Nationbuilding, 1870–1920*. The Center for Comparative Immigration Studies, University of California, San Diego, 2003.

Living in Community. "Sex Worker Toolkit: Tools for Building Community." *Living in Community*, https://livingincommunity.ca/

tools-for-building-community/. Accessed 21 Apr. 2024.

Maynard, Robyn. "Do Black Sex Workers' Lives Matter? Whitewashed Anti-Slavery, Racial Justice, and Abolition." *Red Light Labour: Sex Work, Regulation, Agency and Resistance*. Edited by Elya M. Durisin et al. UBC Press, 2018, pp. 282-92.

Maynard, Robyn. "Fighting Wrongs with Wrongs? How Canadian Anti-Trafficking Crusades Have Failed Sex Workers, Migrants, and Indigenous Communities." *Atlantis*, vol. 37, no. 2, 2015/2016, p. 17.

Maynard, Robyn. "Police Abolition/Black Revolt." *Topia (Montreal)*, vol. 41, no. 1, 2020, pp. 70-78.

Mingus, Mia. "Transformative Justice: A Brief Discussion." *Transformharm*, 2018, https://transformharm.org/tj_resource/transformative-justice-a-brief-description/. Accessed 21 Apr. 2024.

Nagy, Rosemary. *Policy Brief No. 5, the Impacts of Anti-Human Trafficking on Sex Workers*: Northeastern Ontario Research Alliance on Human Trafficking, 2020.

Nagy, Rosemary, et al. "Human Trafficking in Northeastern Ontario: Collaborative Responses." *First Peoples Child & Family Review*, vol. 15, no. 1, 2020, pp. 80-104.

Network of Sex Work Projects. "Butterfly—Asian and Migrant Sex Workers Support Network." *NSWP*, 2015, https://www.nswp.org/featured/butterfly-asian-and-migrant-sex-workers-support-network.

Nonomura, Robert. *Trafficking at the Intersections: Racism, Colonialism, Sexism, and Exploitation in Canada*. Learning Network, Centre for Research & Education on Violence Against Women & Children, 2020.

NWAC. *Culturally Relevant Gender-Based Models of Reconciliation*. Native Women's Association of Canada, 2010.

O'Doherty, Tamara, et al. "Misrepresentations, Inadequate Evidence, and Impediments to Justice: Human Rights Impacts of Canada's Anti-Trafficking Efforts." *Red Light Labour: Sex Work Regulation, Agency, and Resistance*. Edited by Elya M. Durisin. UBC Press, 2018, pp. 104-20.

Ontario Human Rights Commission. *Interrupted Childhoods: Over-Representation of Indigenous and Black Children in Ontario Child Welfare*. Ontario Human Rights Commission, 2018.

Phillips, Jasmine. "Black Girls and the (Im)Possibilities of a Victim Trope: The Intersectional Failures of Legal and Advocacy Interventions in the Commercial Sexual Exploitation of Minors in the United States." *UCLA Law Review*, vol. 62, no. 6, 2015, pp. 1642-75.

Reclaiming Power and Place: The Final Report of the National Inquiry on Missing and Murdered Indigenous Women and Girls. Ottawa: National Inquiry on Missing and Murdered Indigenous Women and Girls, 2019.

Robertson, James R. *Prostitution*. Parliamentary Research Branch, 2003.

Rodríguez-López, Silvia. "(De)Constructing Stereotypes: Media Representations, Social Perceptions, and Legal Responses to Human Trafficking." *Journal of Human Trafficking*, vol. 4, no. 1, 2018, pp. 61-72.

Roots, Katrin. "Trafficking or Pimping? An Analysis of Canada's Human Trafficking Legislation and Its Implications." *Canadian Journal of Law and Society/Revue Canadienne Droit et Société*, vol. 28, no. 1, 2013, pp. 21-41.

Sikka, Anette. *Trafficking of Aboriginal Women and Girls in Canada*: Institute on Governance, 2009.

Smith, Andrea. "Indigeneity, Settler Colonialism, White Supremacy." *Global Dialogue*, vol. 12, no. 2, 2010, pp. 1-14.

Smith, Andrea. "Indigenous Feminists Are Too Sexy for Your Heteropatriarchal Settler Colonialism." *African Journal of Criminology and Justice Studies: AJCJS*, vol. 8, no. 1, 2014, pp. 89-103.

Supreme Court of Canada. Attorney General v. Bedford. 3 SCR 1101. *Supreme Court of Canada*, 2013, https://scc-csc.lexum.com/scc-csc/scc-csc/en/item/13389/index.do. Accessed 21 Apr. 2024.

Thobani, Sunera. *Exalted Subjects: Studies in the Making of Race and Nation in Canada*. University of Toronto Press, 2007.

Ting, David Allan Jun-Rong, and Carisa R. Showden. "Structural Intersectionality and Indigenous Canadian Youth Who Trade Sex: Understanding Mobility Beyond the Trafficking Model." *AlterNative: An International Journal of Indigenous Peoples*, vol. 15, no. 3, 2019, pp. 261-70.

Todres, Jonathan. "Law, Otherness and Human Trafficking." *Santa Clara Law Review*, vol. 49, 2009, pp. 605-72.

Tuck, Eve, and K. Wayne Yang. "Decolonization Is Not a Metaphor." *Decolonization: Indigeneity, Education & Society*, vol. 1, no. 1, 2012, pp. 1-40.

Uy, Robert. "Blinded by Red Lights: Why Trafficking Discourse Should Shift Away from Sex and the 'Perfect Victim' Paradigm." *Berkeley Journal of Gender, Law & Justice*, vol. 26, 2011, pp. 204-19.

Valverde, Marianna. *The Age of Light, Soap and Water: Moral Reform in English Canada, 1885–1925*. McClelland & Stewart, 1991.

Wijers, Marjan. "Purity, Victimhood and Agency: Fifteen Years of the Un Trafficking Protocol." *Anti-Trafficking Review*, vol. 4, 2015, pp. 56-79.

Woon, Yuen-Fong. "Between South China and British Columbia: Life Trajectories of Chinese Women." *BC Studies*, vol. 156, 2007/08, pp. 83-107.

12.

Healing with Indigenous Feminisms: The Decoloniality of Embodiment, Self-Love, and Desire

Jo Billows

In the *Finding Our Way Podcast*, hosted by Prentis Hemphill, there is an episode on "Remembering with guest Alexis Pauline Gumbs," in which Gumbs talks about being in a lineage of Black feminists. Gumbs explains "I call [my practice] Black feminism really to say thank you, as a shout-out and as a beam back 'cause they asked for a future in which more would be possible and we are living it" (Hemphill and Hemphill, "Remembering"). Gumbs frames the publications made by Black feminists as acts of love for future Black feminist readers; it is how they made their writing available for those who were going to need it. In this chapter, I want to send my own beam back in gratitude to some of the Indigenous feminist writers whose writings have found me when I needed them. In particular, I will focus on what their writings have taught me about the Indigenous feminist practices of embodiment, self-love, and desire and the ways these practices have and continue to help me heal from trauma.

During my undergraduate studies, I began to work through my previous trauma for the first time—not out of my initiative, to be honest, but mostly out of the crisis of my trauma resurfacing through what I was learning about in classes as well as by subsequent experiences of sexual violence in my early twenties. Through my learning and processing, I was able to name patterns of colonial violence, such as patterns of

displacement and intergenerational trauma. I began to understand how—especially as Indigenous women, femmes, queer, and trans folx—the violence against our bodies and the violence against our lands are connected (Konsmo and Pacheco). This understanding helped me place certain acts of violence that had happened to me, to my body, in a broader context, giving me the language to connect, describe, and feel it and to not feel so alone.

Some of the ways that the topic of sexual violence was approached in class, while still difficult, were through reading beautiful texts, such as *The Roundhouse* by Louise Erdrich, a tender and brutal novel that I have revisited several times over the years. Other classroom experiences were unnecessarily harmful and triggering, like watching a film in a history class with a graphic sexual assault scene without any prior warning. The spaces where these topics were approached and attended to with care were spaces held by Indigenous women. In these spaces, Indigenous feminist writing, poetry, and art accompanied us into these difficult truths and showed us ways through. In as many ways as I was unravelling, Indigenous feminisms were weaving me back together.

In terms of the scholars and writers that I cite in this chapter, some may situate their work as Indigenous feminist work, and others may not use that language or framing. I choose this framing because each of the works that I cite here forwards a kind of care, ethic, queerness, and/or practice that I see as important contributions to and of Indigenous feminisms. To provide some grounding context and lineage to the term "Indigenous feminisms" I turn to Dory Nason, a scholar of Indigenous feminism and literature (and one of the first Indigenous professors I had the opportunity of taking a class with). In narrating the history of Indigenous feminisms, Nason writes: "We have to set aside the notion that feminism for Indigenous women begins as an outgrowth of white liberal feminist movements or as necessarily parasitic on feminist movements in the global south or by women of colour. Indigenous feminisms are generated within social and historical contexts that are distinctly Indigenous" (52).

In "Dreams and Thunder: A Window into Indigenous Feminisms," Nason offers a glimpse into two historical moments: a speech by Nancy Ward to United States treaty commissioners in 1781 and a letter to Carlos Montezuma from Zitkala-Ša in 1901. With these examples, Nason describes Indigenous feminist organizing as a response to colonial violence

and shows how Indigenous feminisms are grounded in kinship and responsibilities to land and community. Nason also offers the important reminder that "Indigenous feminist history is defined not by academics such as me, but by the women whose work is accountable to their communities and, most importantly, the land of their mothers" (54). In this chapter, I send a beam back to some of the Indigenous feminist writings that have influenced me, offering a series of reflections on the texts, poems, and practices that have helped me find my way so far. I structure these reflections in three parts through the decoloniality of embodiment, self-love, and desire. I also offer land/self-portraiture as a photography practice for decolonial self-love and healing, including portraits that I created and a description of this practice at the end of this chapter.

The Decoloniality of Embodiment

During my undergraduate studies, there was a year when I went to yoga every day. This was in Vancouver, a hub of yoga commercialization and appropriation. I went every day because, at the time, it felt like the only thing keeping me in my body. A tether that I used to pull myself back into my body. Little by little. Every day. During this time, I found that with the help of this embodied practice, my hypervigilance began to ease. I began to feel the difference between tension and release in my muscles again, and I began to be able to close my eyes and breathe without feeling panicked. I still appreciate the way yoga makes my mind and body feel, and I practise at home occasionally, although I have since found other ways of moving my body that I also enjoy. In yoga class, I also (re)learned that I could set boundaries about my body. Once during my year of yoga, a familiar teacher (someone I had grown to like and trust) gave me a physical adjustment during the final resting pose. My eyes were closed, and when her hands touched my body, I froze. Inside, the panic started. I tried to force myself to relax so she would think her adjustment was working and move on faster. At the moment, it did not occur to me that I could ask her to stop. At the time, it still did not feel possible to set boundaries about what other people got to do to my body—to the point where it did not occur to me as an option. After the class was over, however, I decided to say something. I remember that I was nervous; my heart was still beating rapidly, but I approached her and asked her not to give me that adjustment again. I braced myself for how she might react.

Surprisingly to me at the time, she was kind about it. She apologized and reassured me she would not do it again. She explained that she usually asked people to tuck the corner of their mat under if they did not want adjustments, but she had forgotten to do it this time. She said she would make sure to remember to give that option moving forwards. With that, something shifted in me. I realized that I could set boundaries for my body and that those boundaries could be respected. It was an option. That was new for me. A fundamental shift had happened, but the work had just begun.

Lately, I have been thinking more about embodiment since I started listening to the podcast *Finding Our Way*, hosted by Prentis Hemphill. Hemphill is a therapist, a somatics teacher and facilitator, and was the healing justice director at Black Lives Matter Global Network. In the podcast, Hemphill engages in slow-paced, deep-diving, and generative conversations with activists, authors, and artists about "how to realize the world we want through our healing and transformation" (Hemphill). In a Q&A episode, Hemphill answers a question about their training and lineage in somatics. They describe this lineage in terms of their formal training and education and as a lineage that precedes and extends beyond that formal study, grounded in their culture and community. Hemphill describes how "somatics as a field exists because of colonization, in part, because of the ways that cultures have been disrupted by colonization.... Somatics is part of bringing meaning back into our embodiment" (Hemphill and Hemphill, "Ask Us Anything"). I have also had the opportunity to be introduced to somatics through a workshop hosted by Nazbah Tom, a Diné counsellor and somatics practitioner. In a video featured on their website, Tom describes how "Somatics is a path, a methodology, a change theory by which we can embody transformation individually and collectively." In their work as a somatics practitioner, Tom puts forward the question: "What does it mean to reclaim our bodies?" For myself, yoga may have helped me to initially reconnect with my body, to move back into my body from a place of dissociation, but as I consider what it means to reclaim my body, I will have to look elsewhere, within my lineages and connections.

Hemphill describes how ritual, movement, dance, food, and song are some of the ways to culturally engage in somatic ways of knowing and connecting (Hemphill and Hemphill, "Ask Us Anything"). In *As We Have Always Done*, Leanne Betasamosake Simpson offers the framing of

"embodied resurgent practices." Simpson describes the resurgent potential of embodied cultural practices, responding to a call made by Sarah Hunt and Cindy Holmes to embody our decolonial politics and engage in acts of everyday decolonization (191). As Simpson writes: "Embodiment compels us to untie our canoes—to not just think about our canoes or write about our canoes but to actually untie them, get in, and begin the voyage. Embodiment also allows individuals to act now, wherever they are, city or reserve, in their own territory or in that of another nation, with support or not, in small steps, with Indigenous presence" (193).

Embodied resurgent practices for me, as a Northern Coast Salish person living in Tkaronto, currently look like walking (a lot), spending time with the urban rivers that I have access to, getting to know the plants and other beings that live in my neighbourhood, noticing and greeting medicines that I see growing in urban spaces, connecting to community growing spaces here, learning to preserve food with two-spirit folks in the city, and gifting and sharing that food—an ongoing life work as embodied resurgent practices are being cocreated and remembered. Recently, I built a tabletop loom to continue to develop my basic Salish weaving skills. I have also been starting to learn about the plants around me that are natural dyes and have started dyeing wool to weave with. Rather than being about producing an end product, weaving is about the embodied practice for me. I enjoy getting to know the feeling of the tension of the weaving on the loom, the texture of the wool, the repetition of the practice, and the calmness and connection it brings me, as well as the land-based and spiritual rituals that are part of preparing myself to weave, all of which contribute to weaving as an embodied resurgent practice.

The Decoloniality of Self-Love

In "Learning I Had a Body," Samantha Nock describes her experience as a fat Métis woman, and the struggles with self-image and self-love: "When you live in a fat body, [you are] constantly living in a world that tells you exactly why you are not deserving of love or desire." Describing herself as a child, Nock says: "I had these big chubby cheeks that squished my eyes into two upside crescent moons when I laughed. I had a belly and rolls on my thighs and arms. Basically, I was a little halfbreed bonhomme, and I was adorable." She describes growing up and the

socialization and bullying that caused her to begin to think of herself as the "fat kid."

As an adult, Nock describes the pain and heartbreak of unreciprocated love, of watching the "Big Three" loves of her life each opt to date skinny white women. She reflects on how she had labelled the Big Three as "different" because they were "nice boys": "They weren't the childhood boys from the playground calling me fat, they were nice! they talked to me! about books! and music! they became my friends. They became my close friends. They became loves of my life" ("Learning I Had a Body"). In writing about her experiences, Nock describes a pattern that is all too familiar to me, a pattern of feeling unlovable and looking for someone else's love to save you from it. In "Decolonial Love: A How-To Guide," Gwen Benaway reminds us that "Love does not fix you, heal your past, resolve your insecurities" (para. 7). In responding to this quote by Benaway, Samantha Nock asks: "Could it be that this whole time I was looking for love in the faces of these *nice boys*, looking for someone to love me despite my fatness, despite my colonial trauma, despite the laundry list of shitty things that have made me the anxious freak I am today, I was just playing into colonial narratives? Short answer: yes. Long answer: also, yes" ("Learning I Had a Body"). Well, SAME. Except that my Indiqueer heart rarely leads me to nice *boys*. In this piece, Nock comes to the epiphany (which should honestly be printed on a Native inspirational poster) that "radically loving yourself isn't a destination.... The decoloniality of loving yourself enough is the actual journey you embark upon" ("Learning I Had a Body"). Nock admits that this is easier said than done and notes that "Maybe this epiphany isn't new and countless other chubber halfbreeds are sitting there mending their broken hearts with cans of Old Mill and cups of coffee, writing about how they think they've cracked the code. Or maybe it is. Either way, it's new to me" ("Learning I Had a Body"). Since I'm still returning to this 2017 article in 2022, there is still at least one of us out here trying to figure this out.

This year, I also joined the club of broken-hearted halfbreeds watching a Big Love go on to date a white woman. For me it happened at the end of a five-year relationship, plunging me into depths of internalized self-hatred I didn't realize I still had to swim through. This context of the breakup was a hit to my already precarious feelings of lovability, self-worth, and self-image, revealing the gap of self-love I had tried to fill by looking for someone else to love me. In an earlier piece of writing, Nock

writes about coming to realize self-love through the love we have for the land: "This land is exquisite and so are we. If we can take the time to appreciate sunsets and mountain peaks, we can take the time to look in the mirror every morning and appreciate the curves of our bodies" ("Our Bodies Are of This Land"). Looking in the mirror and appreciating our bodies is a practice of self-love. I decided to take up Nock's invitation to appreciate our bodies the way we appreciate the beauty of the land. I did this through a practice of land/self-portraiture.

As I started doing this practice, I realized self-portraiture was a bold choice for cultivating self-love in the wake of hurt and heartbreak. It was hard for me to take pictures of myself and to look through those pictures afterwards. When I started this practice, I initially treated each photo of myself as a stand-in: I told myself I would use this shot for now so that I could pair it with the land portrait to see how they worked together, and then I could spend more time getting a better self-portrait shot later. However, each time, after I paired the photos together, the beauty I saw so easily in the aspects of land in the portrait began to transfer to how I saw myself in relation to and as a reflection of the land. This transference was not perfect or complete. If I analyze the photos, I can still get stuck in negative messages about myself and my body. But it is a practice, and when I look at the layered images, I no longer feel the need to retake the self-portraits to get a better shot.

A description of the practice of land/self-portraiture, and examples of the portraits I created, are included at the end of this chapter. Practicing self-love for me is a practice of reclaiming love as something that I can give myself, something that is abundantly available, something I simply exist in, rather than something I need to be given by others, rather than something scarce. Land/self-portraiture was a way for me to step into the practice and into the decoloniality of loving myself.

The Decoloniality of Desire

When I first encountered the poetry of Chrystos, it was like I had never before encountered a mirror. I think my undergrad was the first time I read any texts by Indigenous writers, let alone queer ones. Over the years, I have picked up five collections of Chrystos's poetry: *Not Vanishing*, *Dream On*, *In Her I Am*, *Fugitive Colors*, and *Fire Power*. Some I was lucky enough to find in used bookstores, some I had to search for online. I am

not exaggerating when I say they are among my most valued material possessions. Although my reading practice and community relations have expanded so that encounters with Indigenous queerness are no longer at all rare for me, I still remember and appreciate that initial rush at having these various pieces of myself mirrored back to me on the page—from the realities of living with trauma, experiences of colonial and sexual violence, and to the queer erotics that reminded me there are other ways of inhabiting my body based on desire. I see pieces of myself reflected in the ways Chrystos writes about urban Indigeneity, in the tensions they describe between racist encounters in queer communities and homophobic encounters in Native ones, in their writings about breakups and hookups, and so many other things. In "Re*Entry," a poem on surviving sexual violence, Chrystos writes: "These words are tiny / raindrops that will bring me to flower again / These words got me out / *You can grab on too if you need them*" (Chrystos, *Dream On* 126-27). I did grab on. These words, among so many others, got me out. I recently decided to reread these poetry collections, focussing on all the poems that make me blush and the ones that celebrate queer desire, intimacy, and pleasure. As a survivor of sexual violence, reclaiming pleasure and desire has both required and contributed to my healing—an ongoing process. My favourite poem by Chrystos right now starts:

> This is
> the blackberry jam I picked & boiled in swift sky August
> mooning over your arrival in November
> I imagined with sweet anticipation licking
> the corners of your mouth dark with fruit
> (Chrystos, *In Her I Am* 47)

I love this poem because it teaches me about planning and creating from a place of desire. It shows me an embodied resurgent practice of cultivating queer pleasure.

A desire-based framework is also something I want to bring to my academic work, taking seriously the invitation Eve Tuck put forth in "Suspending Damage: A Letter to Communities." In this open letter, Tuck emphasizes that we should "refuse to be complicit in our further categorization as only damaged, as only broken" (417). Instead of allowing the continuance of research that is focussed on documenting our damage or research that fetishizes our damage, we can insist on research

that celebrates our survivance (422). Tuck posits desire-based research as an antidote to damage-based and damaging research. Describing desire, Eve Tuck writes that "Desire is involved with the not yet and, at times, the not anymore…. Desire is about longing, about a present that is enriched by both the past and the future" (417). This time-travelling quality of desire is also present in Laura Harjo's conceptualization of "futurity." In *Spiral to the Stars: Mvskoke Tools of Futurity*, Harjo writes that "The notion of futurity challenges a conventional reckoning of time and the future, and pushes us to create right now—in the present moment—that which our ancestors, we, and future relatives desire" (5). This notion of futurity compels me to create, right now, from desire. Focussing on desire as an antidote to damage shows me a pathway for continued healing.

In Process, in Practice

Though not linear enough and still too in the process of unfolding to be a map of healing, this chapter traced some of the healing that I have found (and am finding) in the decoloniality of embodiment, self-love, and desire. I offer it as a beam back and a thank you to some of the Indigenous feminists whose writings have helped me find my way so far. When approaching this chapter, I wanted to include an aspect of creative practice, both as something that I could undertake alongside writing and as something that I could offer to you, dear reader, if you want to create something too.

Below are examples of land/self-portraits I created, followed by a description of the process. I also included a series of poem captions to accompany the photos. The poem captions were developed with prompts and processes offered by Fan Wu and Zoe Imani Sharpe during a session I attended with them on fragmentary writing. As a photography practice, land/self-portraiture does not need to be high-tech. I took and edited the photos just with my phone and the self-portrait photos I took in my apartment, propping the phone on stacks of books or cushions. Being able to take the self-portraits in my apartment also helped me feel more comfortable during what was, for me, a vulnerable process.

Land/Self-Portraiture: Examples, Self-Love in Practice

Figure 1. The grove
old growth
left towering unimpeded

new growth
restarting from old seed
and spore
continuance

Figure 2. Fragments
pieces of wholeness
whole pieces
offered from brokenness (where we all are)
enough
(which we all are)

Figure 3. Sumac

One of the best compliments I've ever received:
your curls remind me of the bends of sumac trees
I'm not used to seeing myself mirrored back to me
feels like being told I have my mother's smile,
my grandfather's nose,
my auntie's cheekbones
(I imagine)

Figure 4. Stone

Did you know
otters keep their favourite rocks in folds of loose skin
pockets to safekeep precious things

What precious things can I learn to store in skin?

Figure 5. kʷumkʷumay

some of the best advice I've ever received:
practice being untrapped

the arbutus tree
kʷumkʷumay
bends towards the sun
shows me how to(o)
bend towards desire

Image Descriptions

Figure 1. The grove: The author is wearing a pink jacket and black jeans; they are standing tall looking down at the camera. There are two trees in the background and a light pink overlay.

Figure 2. Fragments: A close-up of the author's torso. They are wearing a black top with a deep v-neck. The image is layered with fragments of broken ice on a lake surface in the background and a light teal overlay.

Figure 3. Sumac: A close-up of curly hair spread out and a hand covering part of a face, layered with sumac trees in the background and a red overlay.

Figure 4. Stone: A close-up of a hand resting across a bare torso, layered with ocean and mountains in the background and a dark blue overlay.

Figure 5. kwumkwumay: A close-up of two arms reaching up and crossing at the wrists, layered with an arbutus tree in the background with an orange overlay.

Land/Self-Portraiture: The Process

Step 1: Land-Portraiture

Begin with a photo of the land. It could be any aspect of land or landscape. Perhaps begin by looking through your camera to see what aspects of land you have already admired and photographed. Or go out and take new photos.

Step 2: Self-Portraiture

Once you have a photo depicting an aspect of the land that you want to work with, consider how you might pair it together with an aspect of self-portraiture. Play with perspective and frame. You could focus on only one part of your body or take a full-body picture. For example, a photo of an arbutus tree that had been struck by lightning made me want to take photos of just my arms. My left arm has a permanent bend in it from an old fracture, and I wanted to capture the bend, as well as a sense of reaching. For a different perspective, try taking photos from different angles and positions. Another photo I wanted to work with had the perspective of looking up at trees from below. I captured a similar

perspective for my self-portrait by placing the camera on the floor and taking the photo from a low angle.

Step 3: Editing and Mixing

The last step is editing and layering the images together. I used a free app Multi Layer to mix and layer the images, using the land portrait as the background and layering the self-portrait on top. Playing with the transparency of the self-portrait layer allows different amounts of the land portrait to show through. I decided to add an additional layer of coloured shapes to the images— to accentuate the angles and colours present in the portraits and create an additional visual element. You could also create captions or write poems to accompany the images.

Works Cited

Benaway, Gwen. "Decolonial Love: A How-To Guide." *WIOT*, http://workingitouttogether.com/content/decolonial-love-a-how-to-guide/. Accessed 22 Apr. 2024.

Chrystos. *Dream On*. Press Gang, 1992.

Chrystos. *In Her I Am*. Press Gang Publishers, 1993.

Konsmo, E., and K. Pacheco. *Violence on the Land, Violence on Our Bodies: Building an Indigenous Response to Environmental Violence*. Women's Earth Alliance & Native Youth Sexual Health Network, 2016.

Tom, Nazbah. "Example of a Somatic Session with Nazbah Tom." *Vimeo*, 2015, https://vimeo.com/126996056. Accessed 22 Apr. 2024.

Harjo, Laura. *Spiral to the Stars: Mvskoke Tools of Futurity*. The University of Arizona Press, 2019.

Hemphill, Prentis. "Podcast." *Prentis Hemphill*, https://prentishemphill.com/new-page-4. Accessed 22 Apr. 2024.

Hemphill, Prentis, and Eddie Hemphill. "Remembering with Alexis Pauline Gumbs." *Finding Our Way Podcast*. Season 1 Episode 7, 19 Oct. 2020, https://www.findingourwaypodcast.com/individual-episodes/s1e7. Accessed 22 Apr. 2024.

Hemphill, Prentis, and Eddie Hemphill. "Ask Us Anything with Prentis and Eddie." *Finding Our Way Podcast*. Season 2 Episode 10, 21 June 2021, https://www.findingourwaypodcast.com/individual-episodes/s2e10. Accessed 22 Apr. 2024.

Nock, Samantha. "Learning I Had a Body." *Discorder Magazine*, Nov. 2017, https://open.library.ubc.ca/collections/discorder/items/1.0364044?o=3. Accessed 22 Apr. 2024.

Nock, Samantha. "Our Bodies Are of This Land: Decolonization and Indigenous Women's Radical Self-Love." *Rabble*, 2014, https://rabble.ca/feminism/our-bodies-are-this-land-decolonization-and-indigenous-womens-r/. Accessed 22 Apr. 2024.

Simpson, Leanne Betasamosake. *As We Have Always Done: Indigenous Freedom through Radical Resistance.* University of Minnesota Press, 2017.

Tuck, Eve. "Suspending Damage: A Letter to Communities." *Harvard Educational Review*, vol. 79, no. 3, 2009, pp. 409-428.

13.

kimiyokîsikaw: Iskwewak Reclaiming Sovereignty, a Love Letter from Decolonial Self-Lovers

Lana Whiskeyjack, Janice Cindy Gaudet,
Tricia McGuire-Adams, and Jennifer Ward

Our stories are knowledge. We begin by offering our nehiyawewin (Cree language) greetings. The short and simple English translation of "kimiyokîsikaw" is "have a nice day." The root words of kimiyokîsikaw is ki (you) miyo (good) (kîsikaw) day. The word "miyo" is connected to "miyaw"—body; the root word of "kîsikaw" is "kîsik" (sky), which is also interconnected to miskîsik (eye) and kihcikîsik (heaven/cosmic). When we greet each other with "kimiyokîsikaw," we are giving a blessing or reminder to be spiritually grounded and aligned to being present in your body in the most beautifully connected way to all life. Our paper is adapted from a conference presentation and offers an alternative form of narrating, identifying, and conceptualizing decolonial love, and colonialism in our bodies as we live it. Our process is by no means static; it is ever evolving, as we interact and engage in the weight of our labour, so to love not in isolation but with others in the community in our struggle for freedom (hooks, *Communion*). We aim to share our living experiences as a collective of Indigenous female scholars and leaders as we learn together to navigate the colonial and patriarchal structures of the changing face of academia. There is a strong element of isolation to the work we do as Indigenous women in the academy at this time when

reconciliation, decolonization, and indigenization are being conceptualized and operationalized (Gaudry and Lorenz 218; Ward et al. 4). Each of our stories is entitled uniquely to reflect how we re-imagine leadership, love, wellbeing, and justice as a collective of iskwewak—that is, thriving Indigenous women of this earth.

Jennifer Ward: "I Don't Belong to White Feminism"

Our collective knows firsthand how settler-colonial structures and by extension, the academy, invests in the commodification of "otherness" and as bell hooks describes as "eating the other" (21). White feminism wants to eat us, absorb us, and hold up our work as a beacon that signals to other white feminists: "We did it. We aren't racist. See how we included work from the Indigenous group in BIPOC initiatives." We, Indigenous people, become an addition to or nothing more than an acronym, losing our body sovereignty, our kinship connections, and our living experiences when we allow white feminists to use our work for their benefit. They are racist, some of those white feminists. They want to become us, eat us, and pretend Indian without experiencing the harms of our collective grief and struggles. They want to engage in powwows while never being the lowest human in hierarchical towers.

When we sought (Jennifer, Tricia, and Cindy) to submit a book chapter to a feminist collection, our abstract was applauded, eaten up, held up, and given cachet. Our excitement to submit our chapter was short lived, however. The chapter, which embodied so much of ourselves and what it means to be Indigenous women and scholars, was read and reviewed by more than one reviewer within twelve hours of submission. There was no sitting in the discomfort for these editors. They had eaten us and spit us out. The distaste in their mouths was palpable (as will be shown in Tricia's epistemic violence piece).

They were called out as representatives of settler colonialism and not called in as kin. The cacophony of their words in review of us emboldened us to say "no," to refuse to play their game, as Audra Simpson implores us to do, and to take our work elsewhere. This is decolonial self-love in action.

This is our wellbeing bundle to come together in ways that our ancestors and women kinfolk wanted us to do—to work with one another, embolden one another, and support one another's wellbeing to come out

of isolation, as the academy wants us to be in isolation.

Métis poet Marilyn Dumont shares the following in her poem "Not Just a Platform for My Dance":

> this land is
>
> my tongue my eyes my mouth. (65)

The land as an embodiment of Indigeneity is what she wants readers to take with them as they hear the poem, which reflects her experience.

Jennifer Ward: What I've Learned about Intersecting with White Feminism

i've been told that my intersectionality doesn't belong, here
my nativeness is not accepted in the academy
my epistemologies and methodologies are not robust
but what bothers you the most is
my fucking tongue

my tongue which uses profanities is not
the arc of a civilized woman
a true academic with tenured responsibilities to the patriarchy
my tongue has no place
in academia
somehow their lily-white senses became
off-kilter
harmed
discombobulated
degraded

by my tongue
by my truth
by my Indigeneity
by my body sovereignty

by having to read
fuck
in poetry and in prose
to hear me, they can't

to see me, they turned a blind eye
to feel me, they erased me
to eat me, they couldn't

i wasn't palatable
so they told me,
you don't belong

And you know what? They're right. I don't belong in white feminism. I belong to my women, kinfolk, and relations. I belong to the Indigenous matriarchs. I am a decolonial self-lover who is part of an Indigenous iskwewak collective.

Our collective in search of decolonial self-love, invited women to share their teachings and gifts with us over several months. Often, we return to the land through ceremony, song, medicine, self-love, and embodied practice. This was a return to ourselves and our relations. This is how we are creating our wellness bundles.

Figure 1. Photo by Jennifer Ward. The photo features traditional teas and a rattle.

Sherryl Sewepagaham, musician and teacher, taught us how to sing, drum, and rattle (Sewepagaham, "Decolonial Gatherings: Drum & Rattle Workshop"). She taught us the travelling song, which brought me home while I sang and tried to keep a rattle beat. I felt like I was at my centre. It made me cry. In my core, I know this song. The words came to me as I travelled home.

Wey, hey, yah, wey, yah, hey, yo.

Tricia McGuire-Adams: Epistemic Violence in the Academy, Lessening the Burden

We initially submitted our codes of wellbeing chapter, which explains how we enact decolonial love, to a peer-reviewed edited collection titled *Sister Scholars on Tackling Issues of Identity as Woman in Academia*.[1] The following poem is a depiction of what happened. I use poetry to piece together the actual feedback we received from the reviewers. The direct quotes in the poem indicate the feedback from the reviewers. The photos you will see are of places and items that give me joy, which is to provide a counterbalance to what we are about to encounter. Before I continue, however, I must first offer a content warning.

CONTENT WARNING: Settler colonial epistemic violence against Indigenous women's voices.

"Of course, the phenomenon in question [microaggressions] would not ordinarily be thought of as violence. It is too respectable, too academic, too genteel for that. It is violence all the same, and it deserves to be seen for what it is" (Norman 253).

A Poem: Harmful Settler-Colonial Reviews

"Make explicit"

(Epistemic violence says: Tell me exactly the way I want to hear it)

"Theoretical framework is absent"

(Epistemic violence says: Your Indigenous voices and stories make no sense to my settler-colonial thinking)

"Not developed"

(Epistemic violence says: Deficit, lacking, we are not developed enough)

When we said: The trickster's medicine is a mindfuck

They said: "There are risks to this type of colloquialism. Please reconsider." And "I am uncomfortable with swearing in an academic text. It is not culturally relevant, nor about voice; it is inappropriate."

(Epistemic violence says: Controlling Indigenous women's voices and how we choose to express our experience of colonial harm)

"Still trying to articulate"

(Epistemic violence says: Deficit, lacking, we are not articulate enough)

"Awkward and difficult to follow"

(Epistemic violence says: Your Indigenous voices and stories make no sense to my settler-colonial thinking)

When we said: "Showing our vulnerabilities, we will be assumed as if we are incapable or incompetent to succeed in these spaces."

She only said: "Yes."

(Epistemic violence says: Your Indigenous voices and stories are not competent enough for this colonial-driven publication)

"Significantly underdeveloped"

(Epistemic violence says: Deficit, lacking, your Indigenous theory is not enough)

"Relevance?"

(Epistemic violence says: Your Indigenous voices and stories have no relevance to my settler-colonial thinking)

"No one will listen"

(Epistemic violence says: Your Indigenous stories and voices do not matter)

Figure 2. Photos by Tricia McGuire-Adams, personal items and photo of Rainy Lake. The first photo features Tricia's eagle feathers, sage, and an eagle feather holder that features two bears on the front. The second photo is a picture of dawn, where the night sky and a star can still be seen. The dawn light is rising over Rainy Lake where two trees stand.

In an act of love, I told my iskwewak sisters, "Do not read the comments." I will respond, and we will find a better, more supportive home for our Indigenous women's stories of how to enact decolonial love and wellness in this academy.

A Poem: A Decolonial Self-Love Response

A reviewer who does not practise care or kinship in their responses

A reviewer who thinks they can hide behind the veiled cloak of "anonymous peer review"

Only to demonstrate the weaponization of their assumed authority over Indigenous women's voices

A reviewer who is threatened by Indigenous women, resurgent Indigenous women, who are doing the hard work that personal decolonization demands rather than just theorizing about it

Continue to be brave "sister scholars"

Never stand down in the face of presumed settler-colonial authority over

Our stories

Our theories

Our truths

Our voices

Our power

In saying NO to colonial power over our stories, we protect ourselves

You see, it wasn't about receiving a critical review of our piece. It was an experience of how Indigenous women often experience epistemic violence in the academy. As seen through the lens of settler colonialism, Indigenous women are not meant to have a voice, let alone thrive.

The examples of epistemic violence are a reminder and an experience of how colonial authority attempts to silence our experiences of harm in the academy and how we are enacting wellness practices in response.

We did find a supportive, caring, and constructive home. One that allowed our voices to flourish rather than languish. The edited collection is called *Decolonial Feminist Praxis: Centering Knowledge & Resistance at the Margins*.

It is a space that was created by women BIPOC scholars, where they carefully and mindfully crafted a counter experience to the typical anonymous peer review. The editors said, "There is no white gaze here." And we released the collective tension and the hurt we carried from the epistemic violence we previously experienced.

They invited academic aunties, women who have been in these spaces for decades, to hear our stories and to guide our next steps. Their generous and caring comments were provided in a collective circle where BIPOC scholars came together to learn, not in an email, not anonymized.

We collectively met in an academic circle where decolonial feminist praxis deeply informed the entire process. This. This is what we need to create more of—to lessen the burden of settler-colonial academia on our minds, hearts, and spirits.

Cindy Gaudet: Taking up Decolonial Love in the Academy

"Remember my girl, we always did it together," reminds my nimaamaa (mom), Norma Gaudet.

"Women must gather again if we want to create change," counsels the late Michif Matriarch, Rose Fleury. "A Métis is never stuck. And be proud of who you are," affirms Mataant, Sophie McDougal. "Go home, theory lives inside of you," advises Métis Matriarch and Auntie Maria Campbell. "The real work happens in your moon lodge. Focus on those woman's teachings," inspires Ojibwe grandmother, Isabelle Meawasige. "We know how to rise," asserts my spiritual teacher, Berdhanya.

Through the way of visiting, keeoukaywin (Gaudet), the seeds of wise women knowing began to grow a new garden within my consciousness, body, heart, and thinking.

keeoukaywin, I am part of the visit. We are part of the visit, not separate. keeoukaywin, the heartbeat of our wellness ways, our wisdom, traditions, and way of being in relation with ourselves, relatives, and more than human relatives.

It's been the way of keeping our kinship, healthy and happy all along. These are some of the teachings, the living and enduring wisdom that guides my work, my inner and outer knowing, and helps to shape and reframe what pimatisiwin, life, is asking of me.

I came to believe that somehow being myself was not enough. External reflectors that are not mine glare innocently without responsibility at the not-so-subtle microaggressions that are disregarded. My existence is perceived as inconvenient, or it comes with a cost. Some days, I'm full of fear imagining a life that's not my own. Separation. Feeling separate from my own experience, from life, pimatisiwin, is the most harmful colonial myth repeated and regenerated too often in the academy.

Produce, publish, bring in money, mentor, educate, serve, collaborate, repeat, do more, be more, want more. And please look good while you're doing it. Be gracious, thoughtful, and oh grateful and kind while you are in the repeat cycle, year after year, evaluated year after year.

Do not burden the system. Do not be a burden. Don't ask questions. Do not question and please don't be in your power and ohh make us look good. I'm never enough for this place. Will I even make it I wonder? Whatever that means. The feelings of insecurity, inadequacy, and being defective as a human being of this earth, as a Faam Michif, lose their power over me, as I return home to the wisdom within myself, to my Matriarchs, and to the land.

Gathering and coming together as women is a form of collective knowledge making, creating, and coming to know. To know love, to feel loved, and to express love. And by doing so, to resist and interrupt the systems that want to hold power over, erase, degrade, and benefit from my self-doubt. Being and seeing myself as a decolonial self-lover, as a part of the iskwewak collective, is a deep and life-affirming form of resistance—a gift that emerged out of our reconciliation work, out of ceremony as we lifted the pipe, fasted, dreamt together, and valued each other's wellbeing, and each other's contributions in each other's gifts. This way of being, doing and thinking counters the colonial narratives of academic success.

We want to centre our flourishing codes of wellbeing for ourselves and each other. As I sit in circle with my decolonial sisters, I invite the spirit of my name, coming home to the one who creates in beauty. With this name, I'm called to return home—to love, beauty, and truth.

My mother and I have sung a love song to and with one another for over a decade now. One day, she turns to me and smiles and says, "I never thought it was okay to love myself." I respond, "Me neither. Patriarchy has conditioned us to deny this kind of love."

Growing seeds of love into a garden of decolonial self-lovers for the next seven generations—that's my dream. Let this be the new practice: Love myself first, as bell hooks inspires, then work and recognize love as a form of justice, resistance, and freedom (Communion, All about Love, Eating the Other). Unsettling patriarchy in every generation, in every cell of my body, with the regenerative stories of my matriarchs remembering those stories as medicine as Kim Anderson inspires (Life Stages and Native Women 3). Perceiving them as the golden light of my uterus. That's my work. That's my reconciliation. That's my justice.

Figure 3. Photograph by Cindy Gaudet. nimaamaa and daughter walking hand in hand, wearing SS River Design by Christine Tournier Tienkamp's Métis art to wear. We are reminded that we are the land.

Lana Whiskeyjack: I Am Who I Am

awina nîya? Who am I? nîya oma nîya. I am who I am. nîya ayisiyiniw ôma ohci asiskiy. I am a human being of this earth. Before we became human beings of this earth, we each were given ahcahk iskotew, a spirit fire, from the kind compassionate Creator's flame (kisemanitow iskotew) (McAdam, 2015). As a newborn baby, this is the closest we get in our earthly human existence to kisemanitow (Auger, 2017). We are pure spirits until we become a whole earthly human, with our mind, emotions,

body, and spirit, each gifted with a name, a purpose, and with important roles and responsibilities that contribute to wahkohtowin (our kinship systems).

The Canadian state-funded churches to manage and govern Indian residential schools, which indirectly impacted my life through the direct interference of colonization, oppression and assimilation onto three generations of my ohtisiy, my belly button connections, all in the name of education. Since I was born, I have been searching for my ohtisiy so I may know who I am, where I come from, and breathe love into the generations of my ohtisiy disconnections, so I may know where I'm going without carrying the heavy weight of colonial trauma. Some call this decolonization; I call it becoming a whole human being of this earth again (ayisîyiniw ôma ohci asiskiy).

So much much labour is required to confront and transcend the systemic racism and spiritual trauma that generations of my family and I have endured within Western educational systems. As ayisîniwak, beings of this earth, we have what we need to reclaim our mind, emotions, body, and spirit within our ceremonial ways. Calling back my spirit through our songs, dances, feasting, and creative expressions has been foundational to feeding my ahcahk iskotew. Art is my ceremony. It is the way I bring spirit back to learning, teaching, and researching, as well as to my body and mind. When I name my ohtisiy connections, the wombs I come from, I am acknowledging and collectively honouring my spirit through their names and stories. When I speak nehiyawewin, I no longer see myself through the colonial lens but see myself as a kind and loving relative to all living beings, including our more than human relations.

When I sing our songs, I no longer carry the shame and guilt of being ayisîniw. But I feel centred and grounded to nikawiy askiy (Mother Earth) and all those âniskocâpânak (ancestors) who walk with me. When I reclaim and love my ahcahk iskotew, I know I am walking, talking, and honouring my medicine. When the colonial taxonomies and systemic patriarchal oppression begin to smother my matriarchal ahcahk iskotew, I gather my medicine, prepare my protocols, and go offer my radical ayisîniw intentions to the spirit helpers. I do this with a fierce love, an open heart, and a mind layered with kokum humour that helps me through the challenging privileged conversations, actions, and behaviours our world has come to normalize. My ahcahk iskotew is overwhelmed

with an urgency to connect, reflect, and create from the wisdom and love of nikawiy askiy and all the spiritual helpers whose names I am only beginning to learn.

We are our ancestors' prayers. To be an ayisîyiniw ôma ohci asiskiy, we must begin and be grounded in ceremony. When we show up in ceremony, bringing our reclaimed bodies, minds, and spirits together, when we speak the truth, share our dreams, and braid our visions into actions, we walk and speak our ancestors' prayers. When my relatives ask, awina kiya? Who are you? I remember where I come from, my ohtisiy connections, and answer "nîya oma nîya." I am who I am, a human being from this earth. âyihay mistahi.

Figure 4. "Devouring picikwas (Apple)" by Lana Whiskeyjack and Rebecca Lippiatt, 2016.

Living and Leading as Decolonial Self-Lovers

As leaders in knowledge making and processes, we are educational innovators based on Indigenous ways of knowing and being. Our stories were prepared independently and thoughtfully embroidered together by our Metis matriarchal firekeeper, Amanda Almond, giving a bigger voice to our collective work around wellbeing. Our creative process speaks to

some of the harms that we experienced in our professional roles in the academy. But it also speaks to the deep love and the teachings that we carry to fulfill us through this journey. We are very mindful that we cocreated this together and this work was made possible as we began in ceremony. When you show up in ceremony, you are making a spiritual commitment to one another, as a deepened connection is established and strengthened in our whole beings. The restrictions of COVID-19 did not allow us to come together in person but we gathered virtually from our different places. Four Grandmothers accepted our protocols; they led and supported our vision of decolonial love in our academic work by lifting their pipes from their homes across Canada, from Nova Scotia to the east side of the Rockies. Beginning in that ceremonial space created a vibrational loving energy through each of us with those grandmothers, gathering our medicine to remind us of why we are in academia and how to navigate the microaggressions we often experience. Within that deep reflective ceremonial and visiting space, we gather our loving medicine to share with others in the academy.

The journey that we've been on with each other, starting around reconciliation in the academy and thinking about how this journey together, has transformed us in ways that are tangible and intangible. We gathered together to talk about how to keep our bodies, minds, and spirits grounded and restore wellbeing. What does our wellbeing governance look like in the academy?

We found our wellbeing through ceremony, songs, traditional medicine, and honouring our creativity with the support of our matriarchal Aunties. In so doing, we developed lifelong relationships with one another—to support one another in those moments when we did not feel we could be courageous enough to move through the challenges in the academy. And through our relationships, we gain strength. Our regular meetings filled with our humour and belly laughter are intentionally set aside, which is challenging to do when the day-to-day academic responsibilities compounded with the decolonial love work and unacknowledged reconciliation labour take up that time.

Conclusion

Each of our stories speaks to how we carry colonial harms. Ceremony helps to disrobe the patriarchal and colonial corsets we are born with, undress the oppression, and strip down to our vulnerabilities to be reclaimed by our lands, our spiritual and living grandmothers, and one another. When we are in ceremony, we connect to our ahcahk iskotew (aah-Tcha-Kish-Ko-Te-O), our spirit fire. The Western view sees our vulnerabilities as weakness, but in our Indigenous worldview, it is our medicine. Our bodies carry ahcahk iskotew, a powerful decolonial love, and that is the medicine we need to thrive in the academy.

iskwew (woman) and ohteh (heart): Those two words together to create iskotew (fire). ahcahk iskotew (spirit fire). Our spirit is not vulnerable. In our Indigenous worldview, fire is a powerful relative within our ceremonies and land. In ceremonies, we are fanning and lifting each other's iskotew (fire, our woman's heart). We acknowledge the powerful academic Aunties and all the spiritual matriarchs' work, as because of them we can dream of bringing out wellbeing into the academy and reimagine leadership with love and justice as a collective of iskwewak (thriving Indigenous women of this earth).

Figure 5. Decolonial self-lovers logo designed by Lana Whiskeyjack.

Works Cited

Anderson, Kim. *Life Stages and Native Women: Memory, Teachings, and Story Medicine*. University of Manitoba Press, 2011.

Auger, Darlene. "Mossbag and Swing." *YouTube*, University of Toronto, 31 Aug. 2017, youtu.be/kEn_pyJYi0g?si=hj4KX6SHKcEOc7UL.

Dumont, Marilyn. *A Really Good Brown Girl*. Brick Books, 1996.

Gaudry, Adam, and Danielle Lorenz. "Indigenization as Inclusion, Reconciliation, and Decolonization: Navigating the Different Visions for Indigenizing the Canadian Academy." *AlterNative: An International Journal of Indigenous Peoples*, vol. 14, no. 3, 2018, pp. 218-27. https://doi.org/10.1177/1177180118785382.

Gaudet, Janice Cindy. "Keeoukaywin: The Visiting Way—Fostering an Indigenous Research Methodology." *Aboriginal Policy Studies*, vol. 7, no. 2, 2019, pp. 47-64. https://doi.org/10.5663/aps.v7i2.29336.

hooks, bell. "Eating the Other: Desire and Resistance." *Black Looks: Race and Representation*. South End Press, 1992, pp. 21-39.

hooks, bell. *All about Love: New Visions*. 1st ed. William Morrow, 2000.

hooks, bell. *Communion: The Female Search for Love*. William Morrow, 2002.

McAdam, Sylvia. *Nationhood Interrupted : Revitalizing Nêhiyaw Legal Systems*. Purich Publishing Limited, 2015.

Norman, Andrew. "Epistemological Violence." *Institutional Violence*. Edited by Deane Curtin and Robert Litke. Brill, 1999, pp. 353-62.

Sewepagaham, Sherryl. "Decolonial Gatherings: Drum & Rattle Workshop." 26 January 2021. Edmonton, Alberta.

Simpson, Audra. *Mohawk Interruptus: Political Life across the Borders of Settler States*. Duke University Press, 2014.

Ward, Jennifer, et al. "The Privilege of Not Walking Away: Indigenous Women's Perspectives of Reconciliation in the Academy." *Aboriginal Policy Studies*, vol. 9, no. 2, 2021, pp. 3-24. https://doi.org/10.5663/aps.v9i2.29374.

14.

Poems

Thamer Linklater

Five Hundred Years

took the land, the food, our children too
poisoned the water, tore the trees
our bodies used, women abused, men forgotten
beat us, then locked us away
for refusing to conform to capitalism, consumerism,
concepts foreign to our blood.

exposed to things too horrible for words
yet we still use our voice
ribbon skirts and drums, standing strong.

then they said
get over it.
reconciliation is now.
one day
 for five hundred years.

Dear Children, Rest

For so long I couldn't speak
so much heartache tearing at me.
A thousand stolen children.
So many narratives that were covered up.
Only five of those stories can I tell
in this amount of time we carved out.

One, a girl torn from her home:
who had siblings but never love,
who had "parents" but never truth.

Two, a baby left on her own
who had a crib but never safety.

Three, a girl lost in grief
who had systems but never support.

Four, a woman stolen from home
who had families but never belonging.

Five, family we will never meet:
who had structure but never a home
who were buried but never truly known.

Only five stories of a thousand more.
So many emotions course through me,
each one as overwhelming as the next:
Grief
Anger
Pain
But somehow I'm still numb.
Rest dear children, we've got you now.
We can talk about the horrors you endured
—a community that has holes in the shape of you

They All Bleed Together Now

She's certain her scars
hurt when they were fresh
but her mind buried
those moments away.

They all bleed together now.
Her lover added his marks,
pulled at the scabs
he says he never meant to touch.

She drifted along, numb again,
down the carefully crafted lock,
unaware of the danger she faced.
Bruises and bumps collected
in the nooks and crannies of her skin.
She once felt them gather
but the pain was too much
to keep remembering.

They all hurt together now.
She's had to let go
of people who once gave her hope,
people she never suspected
could add to her collection of pain.
Now all she can do
is scavenge for the hope
they robbed her of,
climb out of bed that hugs her tight,
put on a fresh mask
pray for the day
being content and feeling safe
becomes the foundations of her home.

15.

To My Sister I Have Never Met[1]

Sherry Emmerson

We are not related by blood, nor have we ever met
Still I call you sister
Your sorrow is my sorrow and your happiness is my happiness
Your story is my story for we are all interconnected
Sadly we will never meet as I am still here and you are gone
Your life taken carelessly by someone who could not see your worth
I see your worth
I see a strong and brave Indigenous woman
Capable of rising up and changing a nation
As a daughter, mother, wife, aunty, sister, friend and most importantly
a human being with purpose
Not as a whore or just another easy squaw who asked for it, a
victim of your circumstances
A guise they use to justify the cruel treatment you received
Nothing you did warranted the inhuman treatment you experienced
during your final moments here on mother earth
Fear not sister for your death will not be in vain
We are standing here thousands strong telling your story
Screaming it out for the world to hear

Ensuring no one forgets you died a death that should have outraged a nation
They are starting to hear us now and can no longer deny the justice you deserve
You are not alone
You are not voiceless
We hear you sister

Endnotes

1. This poem was originally published in *Forever Loved: Exposing the Hidden Crisis of Missing and Murdered Indigenous Women and Girls in Canada* and is published here with the permission of Demeter Press.

16.

Reflections and Virtual Tea

Jennifer Brant
with
Maria Campbell and Kim Anderson

At the 2008 Missing and Murdered Indigenous Women's Conference held in Regina, Saskatchewan, Elder Maria Campbell shared a powerful opening address about the need for action and asked everyone to use their power to make a difference. Maria concluded her opening remarks by stating, "I hope that something can be accomplished this weekend besides us having another gathering to talk about missing women." We think about her words often while doing this work. Some days, it is easy to get bogged down in frustration as we witness the continued violence and victim-blaming narratives; we too often feel powerless. In these moments, we turn towards the aunties and grannies, whose work continues to move us. We think of the collective responsibility we hold to move their work forward, and we too hope that something can be accomplished here besides us writing another book about MMIWG2S+.

In the introduction to *Forever Loved: Exposing the Hidden Crisis of Missing and Murdered Indigenous Women and Girls in Canada*, we explain that we intentionally did not write a concluding chapter. Rather, because this story is far from over, we hoped the book would urge readers to become part of the national dialogue to push for justice. *Forever Loved* was published just before the launch of the National Public Inquiry into Missing and Murdered Indigenous Women and Girls, and several years later on June 3, 2019, the final report of the inquiry was published:

Reclaiming Power and Place. This report documents 231 individual Calls for Justice and a supplementary report that identifies MMIWG2S+ as an ongoing genocide.

The persistence of ongoing violence in recent years moves us again in our decision not to offer a conclusion but rather to inspire our readers to become part of an informed national dialogue that centres the safety of MMIWG2S+. *Forever Loved* came full circle with the chapter "A Dialogue between D. Memee Lavell-Harvard, Gladys Radek, and Bernice Williams." As we struggled to think of how we could bring this book full circle, we were already invested and thinking about the work that still needs to be done—thinking of the next book, the next community forum, and at times feeling buried in our collective grief. This book now comes full circle by sharing insights from a virtual tea between Jennifer Brant, Kim Anderson and Elder Maria Campbell.

Since the release of *Forever Loved*, we have continued to teach, advocate, and do our work to push the national dialogue forward. As we write in the introductory chapter of this collection, we are concerned that the Calls for Justice remained unacknowledged in public discourse as they take a back seat to superficial reconciliatory moves across the nation. In fact, we witnessed conversations positioning culture in mainstream education as a tool for responding to the Calls for Justice. As educational scholars, we are familiar with the moves to incorporate culture into classrooms and are aware that well-intentioned settler teachers believe teaching about treaties and bringing more culture into the classroom is an act of reconciliation. Such a response, however, fails to address not only the legacy but the persistence of genocidal policies and practices and the underlying foundation of white supremacy that continues to target Indigenous women, families, and communities. Moreover, the focus on culture is an inappropriate response because highlighting the restoration of culture as the solution to #MMIWG2S+ suggests that a lack of culture in our families and nations is the source of the problem. This line of thinking continues to problematize Indigenous communities, as if this violence is an Indigenous problem and not a national colonial problem (Monchalin).

In the political realm, the focus on culture has also become an attempt to distract the nation from the true nature of colonial violence. As Prime Minister Justin Trudeau and many others have noted, they are more comfortable with the more palatable term "cultural genocide" rather

than "genocide." Not only is the emphasis on culture a deflection tactic, but it also places accountability on educators and communities rather than acknowledging the complicity of the Canadian nation-state. Perhaps this deflection has led to the lack of accountability following the release of *Reclaiming Power and Place*. As we explain in the introduction of this collection, we have seen little movement on the Calls for Justice, and, arguably, many Canadians are not aware of the Calls for Justice at all. What we have witnessed is a rise in racialized, sexualized, and gender-based violence against Indigenous peoples and the same old colonial narrative that dismisses this as an Indigenous problem rather than a colonial one.

Like Kim Anderson writes in *Keetsahnak: Our Missing and Murdered Indigenous Sisters*, each time we see a photo of another Indigenous sister missing, our spirit tightens and we "experience gnawing feelings of fear, trauma, or threat to our own safety and that of our sisters, daughters, nieces, mothers, aunties, and grandmothers" (21). Amid the lack of a national public discourse that effectively responds to the Calls for Justice, we continue to experience heartbreak, anger, and fear as we witness the growth in the numbers of missing and murdered Indigenous women, girls, and two-spirit kin from our communities and across the nation. With each social media post pleading for support to locate a loved one, with every moment of silence at one of our community gatherings, or with news that another sister has gone missing, we continue to witness the despair and feel the horrifying silence. In our community-facing work, we have experienced threats and intimidation related to our advocacy and demands for justice. Whether it was the series of anonymous email threats received by Jennifer Brant, the trolls that attacked D. Lavell-Harvard in news media comment sections, or the efforts of a contributor to *Forever Loved*, a Mexican journalist from Ciudad Juarez, who was granted political asylum and writing from Spain, these moments remind us that we are not removed from the threat of violence that has targeted Indigenous women and that we must circle together to ensure our safety. We will continue to rally, march, write, and advocate for justice for #MMIWG2S+ even when it is not necessarily safe to do so. Rematriating Justice to reclaim power and place is a collective responsibility, and we take this sacred responsibility seriously and urge those around us to do likewise and commit to doing their part to ensure the safety and well-being of Indigenous women. Thinking about this as a

collective responsibility is also a humble reminder that we are not alone in this work; in fact, as articulated throughout this collection, this work spans decades.

With this in mind, we reached out to Kim Anderson and Elder Maria Campbell, who have dedicated much of their work to empowering Indigenous women, families, and communities. The reach of their work includes local, national, and international community advocacy. Elder Maria Campbell, an academic grannie to many, holds numerous honorary doctorates and is well known for her bestselling debut memoir, *Halfbreed*. Maria is also the national grandmother for Walking With Our Sisters, a commemorative art installation to honour the lives of MMIWG2S+ (see chapter six of this collection by Rebecca Beaulne-Stuebing). Kim, an academic auntie to many, is the author of *A Recognition of Being: Reconstructing Native Womanhood* and *Life Stages and Native Women: Memory, Teachings, and Story Medicine*. Together, Maria and Kim advance community healing through work on lifestage advocacy that ripples from their kitchen tables to community spaces, from classrooms to the streets, healing facilities, and detention centres. The reaches and flowering growth of their work reverberate across classrooms and academic programming to empower community wellness and narratives of strength and "prompt empowered dialogue that engages [us] in drawing from and forming renewed relations that bring us to imagine safer homes, families, and communities" (Brant 61).

An Intergenerational Tea with Jennifer Brant, Kim Anderson, and Elder Maria Campbell

On November 22, 2023, I participated in a virtual tea with Kim Anderson and Elder Maria Campbell. We opened by talking about our children and Maria's grandchildren and great-grandchildren and the intergenerational reaches of this work. Kim Anderson has been an academic auntie to me and many others, and Maria is well known as an academic community grandmother. Over the years, Kim and I have written about Indigenous maternal theory and the importance of Indigenous kinship in academia as the "power of the each other" (Brant and Anderson). This virtual tea was my first time meeting Maria Campbell, although I had been assigning her book in my Indigenous literature course for more than a decade and already felt as if I had met her through my work with

Kim. Our virtual tea was deeply heartfelt. We laughed, cried, talked about grief, and shared about healing. There were stories shared in that virtual tea that cannot be shared in this book, but they affirmed several realities that must be understood:

1) **Weaving the Stories**: Violence against Indigenous women and girls is intergenerational. By intergenerational, we mean the ongoing genocidal attacks—the colonial and patriarchal violence—are intentionally layered and rooted in years of efforts to exert control over Indigenous lives. In immediate families there are survivors of the residential schools, the sixties scoop, forced sterilizations, and missing and murdered grandmothers, mothers, daughters, sisters, and aunties.

2) **Mapping Cartographies of Violence:** The majority of the perpetrators of these intergenerational attacks are non-Indigenous men who walk and work among us in professional and human services, including front-line staff, police officers, educators, and so on. We need to draw attention to the sectors where violence against Indigenous women and girls has been normalized through the persistence of patriarchy and misogyny.

3) **Speaking to the Hearts of Our Communities:** We need to be translating this work in ways that are empowering for our younger generations. We talked about language, translating knowledge, and speaking to the hearts and minds of our communities. These three key points helped me to unpack Kim and Maria's core message about developing a vision of community safety that speaks to our communities and reclaims our responsibilities towards nurturing our future generations.

Weaving the Stories

There is an intergenerational pattern to these acts of violence that deepens the understanding of MMIWG2S+ as a national genocide against Indigenous peoples illustrated by a supplementary report entitled *A Legal Analysis of Genocide* from the National Inquiry into Missing and Murdered Indigenous Women and Girls. As the inquiry documented, these violent acts are inextricably linked to other legislated policies, such as the Indian Act of Canada, the residential school system, and the child welfare systems. Moreover, the National Inquiry's mandate included "institutional racism in health care, child welfare, policing, and the justice system; and

other forms of violence that stem from the same structures of colonization such as those who died from negligence, accidents, or suicide, or those whose cause of death is unknown or disputed" (15). This "genocide has been empowered by colonial structures, evidenced notably by the Indian Act, the Sixties Scoop, residential schools and breaches of human and Indigenous rights, leading directly to the current increased rates of violence, death, and suicide in Indigenous populations" (MMIWG National Action Plan 14).

The intergenerational reality of #MMIWG2S+ is something that was well understood long before the inquiry began, as it characterizes the lived experiences of Indigenous peoples. This was evident in my conversation with Nick Printup, published in *Forever Loved*, where he recounts interviewing a group of Indigenous students at the University of Ottawa to learn about their connections to #MMIWG2S+. Nick, who was connected to nine missing sisters among his family, friends and community, produced the film *Our Sisters in Spirit* to shed light on the #MMIWG2+. I grew up only a few houses from Helyna Riveria, whose story is shared in the film. Helyna was only a few years younger than me. The tragic loss of Helyna cuts through our community but the strength of her mother, her sister, and her children guide us as we continue to call for an end to this violence. But her mother Linda John, featured in the film, makes it clear that we need to take this violence and transform it into love: "We need to teach our children to love and protect." This film was instrumental in the push for the national public inquiry into missing and murdered Indigenous women. Understanding the severity of racialized, sexualized, and gender-based acts of violence requires conversations about the multiple forms of colonial violence that have historically targeted Indigenous peoples and communities in Canada. Realizing the Calls for Justice requires an informed genealogy about the multiple and layered ways racialized, sexualized, and gender-based acts of violence are experienced and an understanding of the institutions that remain complicit in MMIWG2S+.

As I shared with Kim and Maria, it seems that Canadian society itself exists as a breeding ground for racialized, sexualized, and gender-based violence against Indigenous women and girls. Maria noted that she has been repeating the same message for over sixty years. Indeed, the nation-state of Canada was built on these acts of violence, and they persist as a result of the damaging narratives that justify myriad racist and

sexist legislations against Indigenous women. The historical persistence of violence against Indigenous women and girls is reflected in the Cheyenne proverb that opens this collection. It might be surprising to some that I learned more about the intergenerational pattern of this violence in my work as an academic developing transitional programming for Indigenous women in higher education. My first year of teaching the Indigenous women's literature course was in 2012, the year that Loretta Saunders, an Inuk woman from Atlantic Canada, went missing. Saunders was writing a thesis on missing and murdered Indigenous women at the time she went missing. It was with heightened anxiety and the political will to demand justice for all Indigenous women that I continued to teach and publish about missing and murdered Indigenous women. Several years later following the release of *Forever Loved*, I was asked to present my work at St. Thomas University in Fredericton New Brunswick. Some of Loretta Saunders's family members were in the audience. Diem Saunders, a sibling of Loretta, became a fierce advocate and testified for the national public inquiry. Diem suddenly died in 2021 following years of advocacy work to raise awareness about MMIWG.

My first year as a faculty member was at the University of Manitoba in 2017, the same year the trial for the man accused of killing fifteen-year-old Tina Fontaine took place. Tina's remains were recovered from the Red River, and I learned that the night of her death she had been housed by Children's Aid Society in the same hotel that I stayed in for my job talk—an Indigenous girl and an Indigenous woman and two very different realities. I often reflect on the intricately layered factors that shaped our outcomes differently as I grieve the loss of individual and collective safety for my Indigenous kin. In the days following the nonguilty verdict, Christi Belcourt created an image in honour of Tina entitled: a daughter to us all. As we (Indigenous kin across Turtle Island) collectively called for justice for Tina Fontaine, Christi's artwork was shared across social media platforms and used as our profile pictures. I returned to Winnipeg as a visiting scholar in the summer of July 2022 to teach about Indigenous methodologies in Education. This was a beautiful experience, and I cherished my stay in Winnipeg with my youngest son. We visited the Canadian Human Rights Museum, where I purchased a red dress pin.

Months later, I would learn that there had been a serial killer targeting Indigenous women while I was there. I returned to Winnipeg in July

of 2023 as part of a research trip for a study on Indigenous cultural safety in teacher education. I took time to visit Camp Morgan, where a sacred fire had been lit behind the Canadian Human Rights Museum as part of a larger call to search the Brady Road Landfill for the remains of the Indigenous women who were killed in 2022. I joined the sacred fire in Winnipeg with a friend who is a Sixties Scoop survivor, and she connected with another survivor around the fire. In our circles, there is often this sense of knowing about these realities, and as we gather to demand justice, we also share in laughter and find joy in the intimate connections of understanding shared realities. When I shared that I was returning to Niagara, I was reminded by one of the fire keepers that Niagara is the Gathering Place, and I knew at that moment that a solidarity demonstration was necessary there. A week later, in August of 2023, I returned to Atlantic Canada and met with one of the contributors for this book. As I arrived at the Indigenous student centre at the St. Thomas University campus, I was welcomed with the smell of sweetgrass, cookies, and tea. A woman was beading a beautiful pair of earrings, and I asked if I could take pictures of the artwork on the wall. The physical welcome of the space eased us into deeper conversations about how we demand justice for missing and murdered Indigenous women and girls in Canada and ensure the voices of Atlantic Canada are heard.

I shared these experiences with Maria and Kim to offer context and background into how this reality has been threaded throughout my academic career in ways that cannot be ignored. For instance, I shared that the statistics I gathered about Indigenous women pursuing higher education mirrored demographic profiles of Indigenous women who have been missing and murdered. This brought me to a demographic snapshot of Indigenous women in prison developed by the Canadian Association of Elizabeth Fry Societies that also mirrored the demographic profiles of Indigenous women in higher education. While I found this jarring as a younger graduate student, I now realize that this tells me more about Canadian society and its devaluing of Indigenous women. Violence against Indigenous women and girls is ongoing and persistent and can only be understood as part of the ongoing genocide of Indigenous peoples in Canada. As we know, it is a reality that touches all Indigenous women across Turtle Island. Elder Maria Campbell and Kim Anderson also shared intergenerational stories during our virtual tea. Many of them come from the community-facing reaches of their work and cannot be

shared here, but one thing was clear: Indigenous women and girls cannot count on the people that many Canadians turn to for safety. When it comes to upholding the safety of Indigenous women and girls, we need to look within our own communities. The next section on cartographies of violence maps out the sites where misogyny has been accepted throughout society.

Cartographies of Violence

> Patriarchy and misogyny are so ingrained in our society that they are normal, and our silence makes them normal.
> —Maria Campbell

Maria Campbell shared these words at an international conference on violence against Indigenous women and girls in Regina, Saskatchewan, in 2008. As we discussed this comment during our virtual tea, Maria brought it back to language and noted that the word "misogyny" cannot be translated into our languages because the hatred of women and the devaluing of women in our communities conflict with the teachings that transcend Indigenous communities where Indigenous women are revered, honoured, and protected. Consider, for example, the matrilineal structure of Haudenosaunee clanship, where the safety of Indigenous womanhood is upheld by a kinship network of protection.

I shared with Kim and Maria about the work I do with students where we map cartographies of violence to illustrate the sites where patriarchy and misogyny are normalized. As I outline in chapter ten of this collection, students are asked to consider Maria's statement alongside social sectors where the racialization and sexualization of Indigenous women and girls have become accepted and normalized. Students begin to think deeply about the portrayal of Indigenous women and girls in mainstream media and film and then map out sites that fuel racism and sexism. One example that I discussed with Maria and Kim was the menu at the Holy-Chuck Eatery, a restaurant in downtown Toronto. The menu featured hamburger items with names inspired by common racial slurs, such as "The Dirty Drunken Half-Breed." This menu was brought to the attention of Pamela Palmater in 2012, who pointed out the connection to the hamburger names and well-known racial slurs. In response, the hamburger items listed on the menu were changed to names like the "Misunderstood Breed." This name remained as Indigenous communities continued to

push for a national inquiry into missing and murdered Indigenous women and girls.

These contemporary examples offer only a snapshot of sites where misogyny is normalized. Kim, Maria, and I also talked about the disempowerment and silencing of Indigenous women. The persistent silencing of Indigenous women's accounts of violence is also evident in the publishing industry and mainstream press. The removal of two pages of Maria's memoir in the original publication of *Halfbreed in* 1973 is a striking example of this persistent silencing. *Halfbreed* was reprinted in 2018 to include the two pages that were removed from the original memoir without Maria's consent. These pages recount an experience when RCMP officers invaded Maria's home. Maria was only fourteen years old, and one of the officers dragged her into a bedroom and raped her (Reder & Shield, 2019). Upon finding the original manuscript in the library archives at McMaster University in Hamilton, Ontario, Deanna Reder and Alix Shield reached out to Maria Campbell who encouraged them to write about their findings. As Reder and Shield write: "Had this passage not been removed, the effect is, of course, impossible to say. It would have allowed the author to publicize a rape she never reported out of fear she would have been disbelieved; this might have inspired an earlier generation to consider the mechanisms that silence women"(13). Reder and Shield highlight the importance of sharing the stories that remain largely untold as a strategy that empowers other women to share theirs. Maria's story also highlights the structures of silence that are upheld through intimidation tactics. Moreover, coupled with these silencing and intimidation tactics are algorithms or codes that devalue Indigenous women's experiences. These codes are threaded throughout institutions and social services marking particular sites as unsafe for Indigenous women and girls. No wonder Indigenous women feel both overpoliced and underprotected. The 231 Calls for Justice in *Reclaiming Power and Place* also offer important insights for mapping cartographies of violence and calling attention to the sites that must provide safety for Indigenous women and girls.

I shared frustration that the Calls for Justice remain largely ignored and that many Canadians continue to understand #MMIWG2S+ as an Indigenous problem. In response, Maria explained that she has been saying the same thing for the last sixty years without change but urged me to focus on the changes from within our own communities. Kim echoed this sentiment noting: "If we can't change the mind of the people

that aren't willing to search the landfill, or the owner of the hamburger restaurant, that's slower progress than if we can turn things around in our communities." We talked at length about the reaches of this work, the audience of this book, and the need to focus our energies on empowering our youth. We talked about going back to the responsibilities of our relations to protect our Indigenous sisters. Kim's and Maria's messages were clear: We need to engage the work in ways that speak to the hearts of our communities.

Speaking to the Hearts of Our Communities

> We're not going to change the people who are not going to let us look in the landfill, but we can change the kinds of power that our young people carry so that those people will listen to them.
> —Maria Campbell

> There should be thousands of people standing with that young woman!
> —Maria Campbell

Maria gently reminded me that this book alone is not going to change the minds of those who are refusing to stand with Cambria Harris and honour her call to search the landfill. Maria reminded us that we will not find community safety by searching for justice in the places that continue to harm us. We must look within our own communities. We must write in languages that speak to our own communities. Kim also highlighted the importance of focussing our energies on empowering our own communities and reminded us of the importance of word bundling and storytelling. Maria shared that one of our most important words is responsibility and that our communities need to be thinking about the responsibilities to the families who are searching for their loved ones.

As Maria and Kim reminded me about the importance of language revitalization and the teachings about living peacefully and in harmony with one another, I was thinking about Mojave writer Natalie Diaz, whose essay I had read shortly before the virtual tea with Maria and Kim. In the essay, Natalie asks, "What is the language we need to live?" and urges us to consider if this language of relationality and livingness might be in song, "in the way we turn our heads or hands" (58) or in the organization of community safety.

Maria, Kim, and I discussed this idea about the language we need to live and the importance of fostering our models of community safety. The search for our missing sisters is often led by our communities. As an example, consider the searches led by Indigenous families and communities or organizations such as Winnipeg's Bear Clan Patrol—a nonprofit group of Indigenous community members that work to secure the safety of Indigenous lives. It was the Bear Clan Patrol that first walked with Cambia Harris when her mother first went missing. They searched hotels and soup kitchens and scanned hours of security footage (Cecco). With the memories of how Tina Fontaine was failed by Winnipeg's police services only several years before and of Alisha Hudson who was shot and killed by a Winnipeg Police officer in 2022, the language we need to live cannot be found by turning to local police.

Maria, Kim, and I reflected on those supporting Cambria Harris and joining in her plea for the Brady Landfill to be searched. Rallies supporting Harris and calling for the landfill to be searched took place in cities across Canada. Members of the Redrum Motorcycle Club rode to Winnipeg to camp out at the Brady Landfill site, and others held rallies and vigils in city centres across the country. As always, while Canada fails to take seriously the 231 Calls for Justice, we take matters into our own hands in our collective demands to secure the safety of our Indigenous sisters.

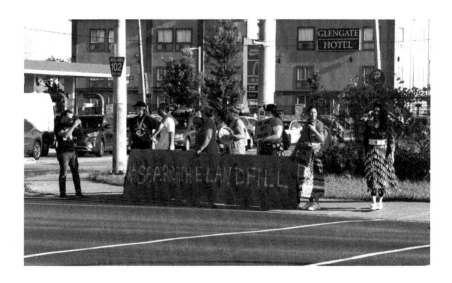

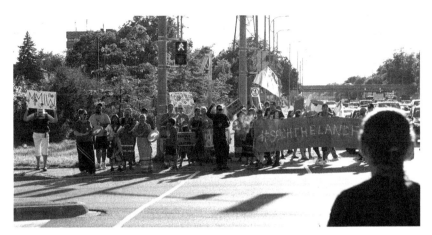
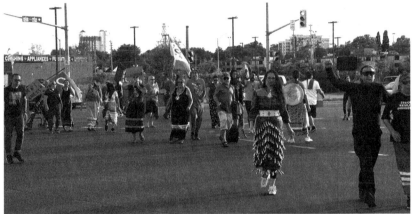

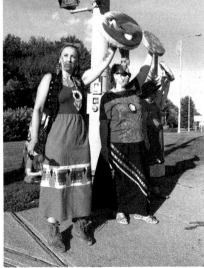

Words to Carry Forward

In the spirit of story bundling, we opened this book with a list of further readings to guide informed dialogue and were intentional about the voices that we included in this collection. Some of the stories we hold in our hearts did not make it to this book, but we hold ceremony for these stories. This book, like *Forever Loved*, stands on the shoulders of many Indigenous women, and the language they have offered helps push this work forward. We are grateful for the story medicines entrusted to us in their work. This work can be understood as part of the flowering growth of Indigenous women's writings (B. Brant) that moves us in our "will to keep moving forward" (Laronde vii) and planting seeds of rebirth and renewal. This reseeding is both a spiritual and an intergenerational quest, and we walk softly with humility as we remain guided by our ancestors to keep moving forward for the generations to follow.

To bring this chapter full circle, we would like to echo the sentiments expressed in the final report—that the genocide of Indigenous peoples is ongoing, and teaching about this violence when another sister has gone missing is heavy. It is not lost on us that we are writing this from the comfort of our homes while a young woman, Cambria Harris, is still camped outside of the Brady Landfill to demand the search for her mother's remains. It was our hope that the search will be completed long before this chapter moves to publication. Yet like our foremothers who have fuelled our writing and classroom praxis, we are not naïve. It is with fury and rage that we continue to write for justice, and it is with a vision of rematriation that we carry forwards the beautiful words of Lee Maracle that remind us of a time when "Turtle Islanders built an understanding of the world rooted in the goodwill of safe womanhood ... [when] Turtle Island women had no reason to fear other humans" (13-14).

Works Cited

Anderson, Kim. *A Recognition of Being: Reconstructing Native Womanhood.* Sumach Press, 2016.

Anderson, Kim. "Introduction." *Keetsahnak: Our Missing and Murdered Indigenous Sisters.* Edited by Kim Anderson, Maria Campbell, and Christi Belcourt. University of Alberta Press, 2018, pp. 21-32.

Anderson, Kim. *Life Stages and Native Women: Memory, Teachings, and Story Medicine.* University of Manitoba Press, 2011.

Brant, Beth. *Writing as Witness: Essay and Talk*. Women's Press, 1994.

Brant, Jennifer. "Finding Homeplace within Indigenous Literatures: Honoring the Genealogical Legacies of bell hooks and Lee Maracle." *Hypatia*, vol. 38, no. 1, 2023, pp. 45-64.

Brant, Jennifer, and Kim Anderson. "In the Scholarly Way: Marking Generations of Inroads to Empowered Indigenous Mothering." *What Do Mothers Need? Motherhood Activists and Scholars Speak out on Maternal Empowerment for the 21st Century*. Edited by Andrea O'Reilly. Demeter Press, 2012, pp. 203-08.

Campbell, Maria. *Halfbreed*. 1973. McClelland & Stewart, 2019.

Cecco, Leyland. "The Daughter Fighting to Recover Her Mother's Remains from a Landfill." *The Guardian*, 22 Dec. 2022, https://www.theguardian.com/world/2022/dec/22/canada-cambria-harris-indigenous-mudered-women-remains?CMP=share_btn_url. Accessed 30 Apr. 2024.

Diaz, Natalie. *Borders, Human Itineraries, and All Our Relations*. Knopf Canada, 2023.

Laronde, Sandra, editor. *Sky Woman: Indigenous Women Who Have Shaped, Moved, or Inspired Us*. Theytus Books, 2005.

Maracle, Lee. *Daughters Are Forever*. Polestar, 2002.

Monchalin, Lisa. *The Colonial Problem: An Indigenous Perspective on Crime and Injustice in Canada*. University of Toronto Press, 2016.

Printup, Nick, director. *Our Sisters in Spirit*, 2015, https://www.youtube.com/watch?v=zdzM6krfaKY. Accessed 20 Apr. 2024.

Reder, Deanna, and Alix Shield. "'I Write This for All of You': Recovering the Unpublished RCMP 'Incident' in Maria Campbell's *Halfbreed* (1973)." *Canadian Literature*, no. 237, 2019, https://go.gale.com/ps/i.do?id=GALE%7CA588838521&sid=googleScholar&v=2.1&it=r&linkaccess=abs&issn=00084360&p=AONE&sw=w&userGroupName=anon%7Ef7a97abe&aty=open-web-entry. Accessed 30 Apr. 2024.

The National Action Plan. *Missing and Murdered Indigenous Women, Girls, and 2SLGBTQQIA+ People National Action Plan, 2021*, https://mmiwg-2splus-nationalactionplan.ca/. Accessed 30 Apr. 2024.

Notes on the Contributors

Dr. Brenda Anderson is an associate professor in the Department of Gender, Religion and Critical Studies at Luther College, University of Regina. Brenda's research and teaching focus on the impact of colonialism on Muslim and Indigenous women, with particular emphasis on their resistance and leadership responses to attempted systemic erasure. Brenda's coedited second edition of *Global Femicide: Indigenous Women and Girls Torn from Our Midst*, can be accessed at https://opentextbooks.uregina.ca/femicide/

Dr. Kim Anderson (she/her) is a Métis writer, scholar and educator based at the University of Guelph where she is a Professor and Canada Research Chair in Indigenous Relationality and Storied Practice. Much of her work involves gender and Indigeneity. She has published seven books, including the single authored *Life Stages and Native Women: Memory Teachings and Story Medicine* (University of Manitoba Press, 2011) and *A Recognition of Being: Reconstructing Native Womanhood* (Canadian Scholars' Press, 2nd edition, 2016). Co-edited collections include *Keetsahnak/ Our Missing and Murdered Indigenous Sisters* (University of Alberta Press, 2018, co-edited with Maria Campbell and Christi Belcourt) and *Indigenous Men and Masculinities: Legacies, Identities, Regeneration* (University of Manitoba Press, 2015, co-edited with Robert Innes).

Rebecca Beaulne-Stuebing (she/they) is a Métis kwe with family roots in Sault Ste. Marie and Manitoba (descended from Belanger, McGregor, and Riel families, and registered with the Métis Nation of Ontario). Rebecca is completing a PhD in social justice education at the Ontario Institute for Studies in Education, University of Toronto. She was a helper with the Walking with our Sisters project in Sault Ste. Marie, Toronto, and as part of the national collective.

Jo Billows is swift waters, secrets, and salal berries. Northern Coast Salish (Homalco and Klahoose), they were adopted out and grew up on Vancouver Island. They are an Indigequeer PhD student in social justice education at the University of Toronto. They are approaching this writing as a survivor of sexual violence, currently continuing their process of healing through art therapy and embodied resurgent practices.

Dr. Robyn Bourgeois (Laughing Otter Caring Woman) is a mixed-race nêhiyaw iskwew (Cree woman) whose Cree family comes from Treaty Eight (Lesser Slave Lake) territory. She was born and raised in Syilx and Splats'in territories of British Columbia and is connected through her three children to the Six Nations of the Grand River. She is an associate professor in the Centre for Women's and Gender Studies at Brock, where her scholarly work focuses on Indigenous feminisms, violence against Indigenous women and girls, and Indigenous women's political activism and leadership. She is currently serving as Brock University's vice-provost for Indigenous engagement. In addition to being an academic, Robyn is also an activist, author, and artist.

Dr. Jennifer Brant is a mother of two boys and belongs to the Kanien'kehá:ka (Mohawk Nation) with family ties to the Six Nations of the Grand River Territory and Tyendinaga Mohawk Territory. Jennifer is an Assistant Professor at the University of Toronto and writes and teaches about Indigenous literatures; Indigenous maternal pedagogies, and methodologies; and ethical spaces for liberatory praxis. Jennifer is also the current faculty cochair of the Indigenous Education Network at the University of Toronto and a faculty editor of *Curriculum Inquiry*. Her work positions Indigenous literatures as educational tools to move students beyond passive empathy, inspire healing and wellness, and foster sociopolitical action. Jennifer is also the coeditor of *Forever Loved: Exposing the Hidden Crisis of Missing and Murdered Indigenous Women and Girls in Canada*, and her writings on Indigenous mothering are featured in several Demeter Press collections.

Maria Campbell is a Métis author, playwright, broadcaster, filmmaker, and Elder. Campbell is a fluent speaker of four languages: Cree, Michif, Saulteaux, and English. Her first book was the memoir Halfbreed (1973), which continues to be taught in schools across Canada, and which continues to inspire generations of Indigenous women and men. Four of her published works have been published in eight countries and translated into four other languages (German, Chinese, French, Italian).

Lisa Trefzger Clarke was born to the Trefzger family (from the Germanic root word "tref," meaning a resilient weed) and the Herbst family (the German

word for "autumn"). Her paternal family immigrated from Lörrach in South Germany to Canada in 1954 following WWII. Her mother's family was sponsored by the Jewish Canadian Association as Jewish refugees from Berlin to settle in Canada in 1952. As a non-Indigenous cisqueer mother, Lisa has settled for the last twenty-three years on the traditional territory of the Michi Saagiig Nishnabeg in Treaty 20 and Williams Treaty area. She is a generational survivor of the Holocaust, a fierce momma, queer and disabled, a survivor of gender-based violence, and a community developer and academic.

Sherry Emmerson is an Anishinaabe-kwe from Chippewas of Nawash Unceded First Nation, located in Neyaashiinigmiing, Ontario. She is a graduate of the Addictions and Community Service Worker program from Everest College and a graduate of the Aboriginal Adult Education Bachelor of Education and Gidayaamin program from Brock University. She is a loving mother of three, who actively advocates for her people by using the knowledge she has learned to bring awareness to the injustices that Indigenous communities face and to showcase their resilience and strength.

Dr. Janice Cindy Gaudet belongs to a strong lineage of Métis women's families who settled along the South Saskatchewan River and farming communities near Batoche, St. Laurent, St. Louis, Bellevue, and Duck Lake, Saskatchewan. Her research is committed to learning with and centring the stories and lives of women and families in this region. She is part of the Métis River Women collective, which has long-standing kinship ties to South Saskatchewan River land. She was one of the coleads on the final installation of Walking With Our Sisters held at Batoche in August 2019. She is an associate professor at Campus Saint-Jean, University of Alberta. Métis women's expression of sovereignty, with a specific focus on the cultural role of Auntie, is at the forefront of her health and wellbeing research. She is passionate about community-engaged and collaborative research that uplifts Indigenous research methodologies in relation to women's kinship health and wellbeing.

Alyssa M. General is an artist, poet, and resource developer from Six Nations of the Grand River Territory. She has created illustrations for the Kanyen'kéha children's show, Tóta tánon Ohkwá:ri, and has collaborated with other Mohawk speakers on a series of short, educational films in the language. She also received national recognition for her poem "Enkonte'nikonhrakwaríhsya'te."

Dr. D. Memee Lavell-Harvard, PhD, is a proud member of the Wiikwemkoong First Nation, on Manitoulin Island. A scholar in Indigenous education and postsecondary Education, she was the first Indigenous Trudeau scholar and has worked to advance the rights of Indigenous women and their families as

the past president of the Ontario Native Women's Association (ONWA), Native Women's Association of Canada, and ONWA Foundation. She continues her advocacy through her current role on the boards of the Canadian Women's Foundation, the National Indigenous Women's Entrepreneurship Ecosystem, Roots of Empathy, the Mothers Matter Centre, and a local community health centre. After fulfilling her promise to see the MMIWG Inquiry initiated through advocacy with the Inter-American Commission on Human Rights and the United Nations, Dawn left her role as national leader and took on the role of director at the First Peoples House of Learning at Trent University. In addition to her work in Indigenous student services and support, she is an instructor with the Trent University School of Education in the BEd and MEd programs and with Queen's University's Indigenous Education Program. She has several peer-reviewed publications and edited texts exploring Indigenous mothering, Indigenous postsecondary educational success, and missing and murdered Indigenous women, girls, two-spirit people, and alliances.

Sarah Lewis is an Ojibwe and Cree spoken word poet, mother, activist, and author from Curve Lake First Nation. She is a Trent U Alumni and most recently served as Peterborough's Inaugural Poet Laureate from 2021 to 2022. Sarah has been featured on CBC Arts, Global News, and stages across the world. Her poetry is birthed from an unapologetic woman sick of a colonial, capitalistic, and sexist society, who feels we can use our voices to dismantle and break free from these harmful systems. When Sarah is not performing poetry, you can find her in meditation, in ceremony, hiking in the forest, reading, or running.

Thamer Linklater (they/them) is Asiniskaw Inthiniwak (Rocky Cree) from Nisichawayasihk (NCN) Cree Nation in Northern Manitoba. They moved to Peterborough for graduate school focusing on child welfare and the millennium scoop and chose to stay, falling in love with the music and arts scene. Their current work explores storytelling as a way of influencing change. When not engaged in research or writing, they enjoy reading, painting, drinking coffee, singing, and admiring their two budgies.

Chevelle Malcolm, originally from Jamaica, is a recent graduate from the University of New Brunswick. While studying there, she became an award-winning poet and a frequent reader at community events supporting the Black minority and commemorating missing and murdered Indigenous women and girls. Her poem "We Rise, for Her—Our Sister" was commissioned for the Looking Out For Each Other project and published in their 2018 newsletter. Chevelle writes to bring awareness, empower, and heal.

Dr. Tricia McGuire-Adams is an Anishinaabekwe from Bingwi Neyaashi Anishinaabek and is an associate professor with the Faculty of Kinesiology and Physical Education at the University of Toronto. She received her doctorate in human kinetics from the Faculty of Health Sciences at the University of Ottawa and her Master of Arts in Indigenous governance from the University of Victoria. Her scholarship is rooted in physical cultural studies and Indigenous studies, in which she uses Indigenous research methodologies to research Indigenous health, wellbeing, and physical activity from Indigenous decolonization and resurgence frameworks. Her current program of research, which is highly collaborative with partners at universities across Canada, Indigenous communities and other community-based organizations, focusses on Indigenous women's wellness governance in the academy; martial arts and trauma-informed practices; implementing equity, diversity, inclusion, and accessibility in the sport and recreation sectors; and Indigenous disability.

Rosemary Nagy is a professor of gender equality and social justice at Nipissing University, located on the territory of Nbisiing Anishinaabeg, within lands protected by the Robinson Huron Treaty of 1850. From 2013 to 2020, Nagy served as codirector of the Northeastern Ontario Research Alliance on Human Trafficking (https://noraht.nipissingu.ca). A settler Canadian, Rosemary has written about residential schools, truth and reconciliation, settler colonialism and decolonization, and sex work and human trafficking. She is the mother of two teenage boys and enjoys sewing and gardening.

Josephine Savarese is a scholar from New Brunswick who has pursued studies in socio-legal and women's issues at the University of Saskatchewan, McGill University, and the University of Hawai'i at Mānoa. She was formally introduced to the tragedy of missing and murdered Indigenous women and girls in 2004 when her students launched the first Amnesty International report. Josephine has been writing, researching, and teaching on this topic since that time. Her most recent publication, evaluating the inquiry process, appears in *Unsettling Colonialism (2023)*, co-edited with Vicki Chartrand.

Sana Shah completed her master's in social justice and equity studies at Brock University. Her research focused on media representations of missing and murdered Indigenous women and girls (MMIWG) and the role of family and community activism in disrupting stereotypical mainstream media narratives. She is currently pursuing a PhD in sociology at the University of Waterloo, where her work focuses on Canada's complicity in the domestic sex trafficking of Indigenous women and girls.

Leona Grandmond Skye (Biim Osay Onay Kwat Kwe, "She Who Walks With Clouds") is an accomplished Indigenous visual artist and tireless social activist. Fiercely proud of her Indigenous heritage, she heralds from the Ojibwa tribe from Pic River and is a member of the Turtle Clan. Leona is a past member of the Niagara Falls Arts & Culture Committee, and her works are displayed locally and nationally. Her six-foot painting of a hand drum, representing the Indigenous peoples on the occasion of Canada's 150th birthday, is displayed at the Regional Municipality of Niagara headquarters. She was selected to paint a piano for PlayPlayPlay Niagara Falls, an initiative orgaized by the Niagara Falls Culture Department. Her Indigenous-influenced piano is on display at the Niagara Falls Public Library. Pieces are displayed in museums worldwide and can be seen in Switzerland and New Zealand. Leona is an outspoken and passionate advocate for victims of human trafficking and has designed the anti-trafficking logo for the Ontario Native Women's Society. She is a survivor champion of human trafficking and child exploitation and has dedicated much time and effort to researching and bringing to light this grievous injustice throughout the province. Her published report, *Missing and Murdered Indigenous Woman and the Parallels to Human Trafficking*, is referenced as a tool in preparing guidelines to combat this exploitation. She has spoken on this topic from a personal viewpoint to the Ontario Police College, Niagara Regional Police, and YWCA and is a sought-after guest lecturer at numerous universities. Leona believes that art brings peace and joy and is an integral component in her healing journey and that of others. She shares this belief through her art therapy programs, which have been held at Rodman Hall, Brock University, and the Niagara Regional Native Centre. Her paintings are resplendent with symbolism that denotes her Indigenous roots and personal journey. She is constantly aspiring to share her art and life journey to bring light to those who are in a dark place.

Anne Taylor Aaniin. MaangKwan n'di zh'nikaaz, ngig n'doodem, Wshkiigmong n'do n'jibaa, Michi Saagiig Anishinaabe Kwe n'da'aw. Hello. My 'Nishinaabe name is MaangKwan. My English name is Anne Taylor. I'm of the Otter Clan. I am from Curve Lake First Nation. I am a Michi Saagiig Anishinaabe woman. I am a dedicated Anishinaabemowin warrior. I am a history nerd. I am in love with the land and waters and all those other beings who allow us to live among them. I am forever grateful to all my teachers: my granny and papa, my greatgranny, my mumma, my uncles, aunties, dear friends, and beloved ones.

NOTES ON CONTRIBUTORS

Cheryl Troupe is an assistant professor in history at the University of Saskatchewan. Her research centres on twentieth-century Métis communities in Western Canada, examining and mapping the intersections of land, gender, kinship, and stories, including the multifaceted roles of Métis women in their families and communities and the significance of female kinship relationships in structuring these communities. She is Métis, originally from north-central Saskatchewan, and a member of Gabriel Dumont Local #11. She was one of four coleads for the final installation of Walking With Our Sisters and is a member of the River Women Collective.

Dr. Jennifer Ward is Umpqua, Walla Walla and Algonquin. She left our earth world in spring 2022 before our chapter was published. We started a research project in 2018, called the *Privilege of Not Walking Away*, that continues to inform our most profound intellectual and meaning-filled work. Jennifer cared deeply about amplifying Indigenous voices and brought an unshakeable commitment to centring Indigenous folks' strength, beauty, and power. Her work with the Centre for Teaching and Learning shows this commitment, particularly the *Territorial Acknowledgments: Going Beyond the Script* video she created. Her drive to integrate Indigenous knowledge systems within curriculums, research, and community-engaged pedagogy will forever inform our ongoing research program. Her brilliance shines brightly in our radical decolonial wellness research as Indigenous women kin in the academy, upcoming publications, future conferencing, kitchen table visits, sleepovers, and anti-oppressive curriculum initiatives. She is part of us. We are part of her. We love and miss her deeply.

Lana Whiskeyjack is a nehiyaw band member from Saddle Lake Cree Nation in Treaty Six, Alberta, now based in amiskwaciy waskahikan (Edmonton), where she practises as a multidisciplinary artist and spirit-based scholar-researcher in her role as an associate professor in the Department of Women's and Gender Studies in the Faculty of Arts, University of Alberta. Whiskeyjack received her doctorate at the University nuhelot'įne thaiyots'į nistameyimâkanak Blue Quills (Blue Quills University), a former Indian residential school where two generations of her family attended. She is a cofounder of okimaw kihew mekwanak, formerly known as Indigenous Parents and Friends of Lesbians and Gays, the first in Canada. Her nehiyawewak (Cree people) community-based research explores language reclamation, gender and sexuality diversity, rites of passage, iskwewewin (womanhood) governance, and leadership. She is featured in a documentary about confronting and transcending historical trauma through her arts-based practice, *Lana Gets Her Talk* (2017).

Deepest appreciation to
Demeter's monthly Donors

DEMETER

Brent & Heather Beal
Carole Trainor
Khin May Kyawt
Tatjana Takseva
Debbie Byrd
Tanya Cassidy
Myrel Chernick
Marcella Gemelli
Donna Lee, In Memory of Dee Stark, RN, LNHA,
Trailblazer for Women, Women's Rights Advocate
Catherine Cheleen-Mosqueda
Fiona Green
Paul Chu
Amber Kinser
Nicole Willey
Mildred Bennett Walker (Trainor)
Tina Powell